Freud 2000

Freud 2000

Edited by
Anthony Elliott

Routledge
New York

Published in 1999 by
Routledge
29 West 35th Street
New York, NY 10001

ISBN 0-415-92252-6
ISBN 0-415-92253-4 (pbk)

A catalogue record for this book is available from the British Library and from
the Library of Congress.

Typeset in 11 on 13 pt Stempel Garamond
by Ace Filmsetting Ltd, Frome, Somerset
Printed in Great Britain by MPG Books, Bodmin, Cornwall

This book is printed on acid-free paper.

Contents

To the memory of my grandparents
Bill and Vera Rowe

Editor's Note

Chapter 2 is a slightly modified version of an essay which appeared in Jacqueline Rose, *States of Fantasy* (Oxford: Oxford University Press, 1996) and is reprinted by permission. Chapter 4 appeared in a shorter version as Anthony Elliott, 'The ideology of sexual difference', *Meridian*, 15: 2 (1996), pp. 147–57. Chapter 5 is reprinted from Jessica Benjamin, *Shadow of the Other* (New York: Routledge, 1998). Chapter 6 is a modified version of an essay by Madelon Sprengnether which appeared in *American Imago*, 52: 1 (spring 1995), pp. 9–54.

'*Standard Edition*' in references to Freud's writings stands for *The Standard Edition of the Complete Psychological Works of Sigmund Freud*, edited by James Strachey, translated by James Strachey et al. (24 vols; London: Hogarth Press and Institute of Psycho-Analysis, 1953–74). Original dates of publication are given in parentheses.

The Contributors

C. Fred Alford is Professor of Government and Politics at the University of Maryland. He is the author of many books and numerous articles on psychoanalysis and society, including *Group Psychology and Political Theory* (1995) and *What Evil Means to Us* (1997). In 1997, he was a Fulbright Fellow in Korea, where he studied eastern conceptions of evil and wisdom. He is also the author of a novel, *Ashes of the Moon: An Amazonian Love Story* (1997).

Jessica Benjamin is on the Faculty of the New York University Postdoctoral Program in Psychoanalysis and Psychotherapy. Her most recent books are *Like Subjects, Love Objects* (1995) and *Shadow of the Other* (1998). She practises psychoanalysis in New York City.

Joanne Brown is Lecturer in the Department of Human Relations at the University of East London. She is deputy course tutor of the MA in Psychoanalytic Studies run jointly by UEL and the Tavistock Clinic, where she is also studying psychoanalytic observation methods. Her current research focuses on the psychoanalytic discourse of romantic love.

David S. Caudill is Professor of Law at Washington & Lee University in Lexington, Virginia, where he teaches law and psychology, radical legal thought, and legal ethics. His books include *Lacan and the Subject of Law* (1997), *Radical Philosophy of Law* (co-edited with S. Gold, 1995), and *Disclosing Tilt* (1989); he is also the author of numerous articles and essays in legal and psychoanalytic journals.

Anthony Elliott is Research Fellow at the Department of Political Science, University of Melbourne. He has written extensively on problems in social theory, psychoanalysis and postmodern culture. He is the author of *Social Theory and Psychoanalysis in Transition* (1992), *Psychoanalytic Theory: An Introduction* (1994), *Subject to Ourselves: Social Theory, Psychoanalysis and Postmodernity* (1996), and *The Mourning of John Lennon* (forthcoming). He is co-editor, with Stephen Frosh, of *Psychoanalysis in Contexts* (1995) and, with Charles Spezzano, of *Psychoanalysis at its Limits* (forthcoming).

Harvie Ferguson is Reader in Sociology at the University of Glasgow. He has written extensively on the intellectual history and sociological theory of modernity. His most recent books are *Melancholy and the Critique of Modernity: Søren Kierkegaard's Religious Psychology* (1995) and *The Lure of Dreams: Sigmund Freud and the Construction of Modernity* (1996).

Stephen Frosh is Reader in Psychoanalytical Psychology at Birkbeck College, University of London, and Consultant Clinical Psychologist and Vice Dean at the Tavistock Clinic, London. His many publications include *The Politics of Psychoanalysis* (1987), *Identity Crisis* (1991), *Sexual Difference* (1994) and *For and against Psychoanalysis* (1997). He is co-editor, with Anthony Elliott, of *Psychoanalysis in Contexts* (1995).

Steve Pile is Lecturer in the Faculty of Social Sciences at the Open University. He has published work relating to identity, politics and geography. He is the author of *The Body and the City* (1996) and co-editor, with Nigel Thrift, of *Mapping the Subject* (1995) and, with Michael Keith, of *Geographies of Resistance* (1997).

Barry Richards is Professor of Human Relations, and Co-Director of the Centre for Consumer and Advertising Studies, at the University of East London. He is the author of *Images of Freud* (1989) and *Disciplines of Delight* (1994). His current research is concerned with the relationship between states of mind, social values and political authority.

Jacqueline Rose is Professor of English at Queen Mary and Westfield College, University of London. Her books include *The Case of Peter Pan or The Impossibility of Children's Fiction* (1984), *Sexuality in*

the Field of Vision (1986), *The Haunting of Sylvia Plath* (1991), *Why War?* (1993), and *States of Fantasy* (1996).

Madelon Sprengnether is Professor of English at the University of Minnesota, where she teaches critical and creative writing. She is the author of *The Spectral Mother: Freud, Feminism and Psychoanalysis* (1990). She is the co-editor of *The (M)other Tongue: Essays in Feminist Psychoanalytic Interpretation* and *Shakespearean Tragedy and Gender*. She has also published a book of poems and is working on a book about the construction of an interstate highway through the St Louis neighbourhood in which she grew up.

Preface

This book is primarily concerned with the relevance of Freud to today's world. In some respects, the book can also be viewed as a companion to the volume I co-edited with Stephen Frosh which assesses post-Freudian psychoanalysis in the social sciences and humanities: *Psychoanalysis in Contexts: Paths between Theory and Modern Culture* (London: Routledge, 1995).

I would like to thank Tony Giddens at Polity Press for commissioning the book, and for his helpful suggestions during the planning stages. Also at Polity, thanks to John Thompson, Sue Pope, Pamela Thomas, Julia Harsant and Gill Motley. Thanks also to Susan Keogh at Melbourne University Press; and to Veronica Ions, who copy-edited the book. Special thanks are due to Andrew Newton, who carried out a great deal of the editorial labour on the project; his dedication, patience and support have been vital throughout.

The following scholars continue to inspire my personal and political interests in psychoanalysis, and I thank them for their support and help: Stephen Frosh, Cornelius Castoriadis, Jessica Benjamin, Jane Flax, Charles Spezzano, Nancy Chodorow and Jeffrey Prager.

Thanks to the following people, who have been of particular help to me in editing this book: Nick Stevenson, Fiore Inglese, Simone Skacej, Kriss McKie, Anthony Moran, Jean Elliott, Keith Elliott and Deborah Maxwell. Finally, and above all, heartfelt thanks to Nicola Geraghty.

Anthony Elliott

Introduction

Anthony Elliott

In the English-speaking world over the last few decades, there has been a strong and persistent interest in Freudian psychoanalysis across the humanities and social sciences. Partly as a response to the break-up of positivistic approaches to knowledge, and partly as a response to social and political upheavals in the late 1960s and early 1970s, Freud's ideas came to be analysed anew, and refashioned in novel ways, in disciplines such as social theory, feminism, political science, film theory, and literary and cultural studies more generally. In considering afresh the social and political meanings of Freudian thought, this confrontation between contemporary theory and psychoanalysis proved to be extremely productive, and sometimes explosive. The introduction into Anglo-American intellectual life of Lacan's Freud, with its stress on the intertwining of split subjectivity and language, played a central role in renovating social and cultural thought. So too, the encounter between Freud and feminism generated new political insights and challenges. More recently, the revision of Freud in the wake of post-structuralist and postmodernist theory has opened up a reflective space for understanding the intersections between identity, culture and politics in an age of globalization.

This volume aims to provide a critical examination of the relevance and importance of Freud to contemporary culture. Accordingly, the essays which follow examine some of the central concepts and theoretical terms of Freudian psychoanalysis, taking the socio-political world as the object of analytical attention. The contributors to this volume argue for the importance of Freudian concepts in analysing the constitution of identity and subjectivity; the production of sexual difference and the reproduction of gender asymmetries; problems of epistemology and method; the analysis of political violence and

international relations; time, space and social spatiality; the coherence of law and jurisprudences; the reframing of biography and autobiography; and the dynamics of modernity and postmodernism. *Freud 2000* is thus a book where the psychoanalytic imagination is expanded to encompass a multiplicity of issues and perspectives that preoccupy the social sciences and humanities at the turn of the twenty-first century.

The Freud Wars

'We live', writes Mark Edmundson, 'in the Age of Freud, a cultural moment in which the critical and descriptive terminologies readiest to use sound with unmistakably Freudian resonances.'[1] From Woody Allen's *Annie Hall* to Jacques Derrida's *The Post Card*, from Marie Cardinal's *The Words to Say It* to Paul Ricoeur's *Freud and Philosophy*: Freud's precepts and conjectures pervade our intellectual life and culture, and influence our everyday thinking about ourselves, others and the world in which we live. Yet despite – might it be because of? – the profound influence of psychoanalysis over twentieth-century culture, some critics have recently suggested we have now entered a post-Freud era. A campaign launched against psychoanalysis in the 1990s has done much to discredit its critical strength and scientific authority, as well as having inaugurated a culture of Freud-bashing in both the academy and public life. *Time* ran the question 'Is Freud Dead?' in 1993. The answer proffered was a resounding 'yes'. The argument was put that Freud botched many of his clinical cases and failed to prove the efficacy of psychoanalytic treatment. If that was not damning enough, Freud's 'talking cure' was declared obsolete owing to advances in pharmacology.

Broadly speaking, there are two key conceptual currents informing the wars over Freud. One is the presumed political irrelevance of Freudian theory. The other is the supposed scientific laxity of psychoanalytic theory and treatment. The political dead-ends of Freud's legacy have been put most forcefully, and indeed unambiguously, by Jeffrey Masson in books such as *The Assault on Truth* and *Against Therapy*. Masson argues that issues of sexual abuse have been suppressed in psychoanalysis. The historical origins of this he locates in Freud's alleged denial of the actuality of sexual violence towards children and women. 'By shifting the emphasis

from an actual world of sadness, misery, and cruelty to an internal stage on which actors performed invented dramas for an invisible audience of their own creation,' writes Masson, 'Freud began a trend away from the real world that, it seems to me, is at the root of the present-day sterility of psychoanalysis and psychiatry throughout the world.'[2]

In respect of the scientific merits of psychoanalysis, Frederick Crews (a literary critic, and one-time Freudian) launched in 1993 a much-discussed attack on Freud's methodology and epistemology in the *New York Review of Books*.[3] Drawing on Adolf Grünbaum's argument that psychoanalysis is a failed experiment, Crews insists that Freud's claims cannot be substantiated; that the causal connections he posits between unconscious repression and human motivation do not hold up; and that the links he sought to demonstrate between the retrieval of memory and personal well-being fail to conform to acknowledged standards of evidence and logic. In Crews's hands, psychoanalysis is less a doctrine about the emotional dynamics of mind and interpersonal relationships than a reflection of the perverse desires and demented imaginings of a bogus medical practitioner known as Sigmund Freud. As Crews writes in his book *Skeptical Engagements*:

> The only mind [Freud] laid bare for us was his own. Once we
> have fully grasped that point, we can begin inquiring how such
> a mind – rich in perverse imaginings and in the multiplying of
> shadowy concepts, grandiose in its dynastic ambition, atavistic
> in its affinities with outmoded science, and fiercely stubborn
> in its resistance to rational criticism – could ever have com-
> manded our blind assent.[4]

The era of Freud, it seems, was blinding; the era post-Freud promises to bring enlightenment.

It would be inappropriate in this introduction to attempt to develop a systematic analysis of the ideological distortions and epistemological deficiencies in this campaign against Freud. Such a task has, in any event, already been admirably accomplished elsewhere.[5] By situating the Freud Wars in relation to broader psychoanalytic dialogues, however, we can illuminate some of the misleading assumptions which have plagued these debates. Consider the following three quotations from different critics of the recent spate of attacks on Freud. The first is from John Forrester:

Both criticisms – the view that psychoanalysis ignores its patients and the view that psychoanalysis smothers its patients – show toward those patients a profound lack of respect for their more or less average trustworthiness, their more or less average skepticism, their more or less average powers of resistance to being manipulated, their more or less average independence as moral agents. These criticisms thus enact, as much as put forward as an argument, a deep distrust of anyone ever being a reliable source of evidence about the mind, a deep distrust of anyone ever being an independent moral agent.[6]

The second is from Charles Spezzano interpreting the anxiety inherent in Crews's critique that Freudian psychoanalysis fails to unmask the reality behind appearances:

Crews clearly believed that he had found the truth in Freud; and, when he later realized that the truth had eluded him, he felt betrayed. Had he begun by thinking that Freud had a language to offer, he might have been able to try out this language as a way of talking about literature and then left it behind without the bitterness he came to feel. He went looking for dogma, found it, embraced it, and then discovered that, like other dogmas he had satirized in his earlier writings, this one too did not offer permanent objective truth. Having devoted himself to Freud as the beacon of all truth about life and literature, he sounds, in his rejection of Freud, as if he took it personally when he learned about Freud's questionable encounters with Emma Eckstein and Dora and about Freud's having taken seriously some of Fliess's 'Crackpot doctrines'.[7]

The third is from Jeffrey Prager, in an article called 'On the Abuses of Freud', who concentrates on the latent wish-fulfilment in Masson's rejection of fantasy in favour of the event or the real:

Masson [expresses] nostalgia for a pre- (or early) Freudian world . . . a world where things are precisely as they appear, always reflecting a hard, obdurate reality that can be easily and readily perceived. No interpreting self, no unconscious one. What happens happens, and there is no mystery as to how one processes, interprets, and gives meaning to those occurrences.[8]

Each of these quotations suggests an unacknowledged – dare I suggest unconscious? – element which at once frames and overdetermines the critical assault on Freud.

Distrust operates at the levels of criticism and enactment for Forrester. For if the central objection to Freud's theories is that they were formulated from the evidence of manipulated or untrustworthy patients, it can also be said that this critique projects distrust onto the capacity of human beings to act as moral agents in any meaningful sense at all. Forrester's subversive move is to reveal that the critical assault on Freud is itself grounded in distrust, while noting that the affect of cynicism is projected elsewhere (specifically, onto Freud). Something similar goes on in Spezzano's reading of Crews; for Spezzano, Crews's disillusionment with Freud asserts itself as a rejection of psychoanalysis writ large. The demand for certitude, for Spezzano as for Freud, expresses itself as a desire for absolute control, mastery and domination, the violence of which is projected to the outside. Hence, the process of disillusionment can be experienced as overwhelming, or crushing. In Crews's narcissistic discourse, this seems to be translated thus: 'Because I've given up on Freud, so too should the world. Can't you see – the man's a swindler, a charlatan.' In Prager's reading of Masson, the dualism of inside and outside, of fantasy and reality, is said to suffer outright repression. No fantasy because the event is the ultimate point of reality, of meaning, of truth. In three stages, therefore, we find that the critique resulting from the Freud Wars is a discourse at odds with itself.

Ironically, this inside/outside dichotomy – enacted so violently in the writings of Crews, Masson and others – is actually subverted by Freud's theory of the fundamental and radical nature of human imagination. Freud's most subversive move, notwithstanding the reworkings of theory throughout his career, can be traced back to that elaboration of, and ensuing disenchantment with, his 'seduction theory' – the notion that every neurosis conceals a history of real sexual seduction and actual trauma. In the autumn of 1897, Freud abandoned the 'seduction theory'; but, crucially, he replaced it with a more critical interpretation of the relation of psychic life to the outer world. Central to this shift in Freud's approach was a radical revaluation of the internal processing of external reality, and especially of how individuals interpret, frame, and fantasize experience (including memories of sexual experiences in childhood). As John Toews comments:

> The collapse of the seduction theory in the fall of 1897 was
> marked by a collapse of Freud's confidence in his ability to use
> evidence from his patients' fantasies in reconstructing the real
> history of event sequences . . . [B]ut this collapse was trans-
> formed into a 'triumph' by his recognition that fantasies might
> be read a different way, as signs of the unconscious intentions
> that produced them rather than as the forgotten events to which
> they referred. From this perspective the 'embellishments' and
> 'sublimations' of fantasy were not so much outworks to be
> demolished as obscure revelations of a different kind of truth,
> the truth of unconscious psychical activity. They were open-
> ings into a hidden world of 'psychic reality' that was not pas-
> sive and objective but active and subjective, a world of
> unconscious psychosexual desire.[9]

Once Freud granted fantasy an active and subjective dimension,
therefore, the psychic realm no longer functioned as a mirror to
objective reality. Freud had uncovered, in one stroke, the creative,
radical imagination.

Stuck with only one half of the story, however, Freud's critics have
downgraded the whole concept of radical imagination, or fantasy, in
favour of the event. Through the Freudian lens, however, it is not a
question of denying the event, but of understanding it otherwise.
Consider the issue of human trauma. Freud's work, contrary to the
claims of some of his critics, strives to engage reflectively with the
reality of trauma – sexual or otherwise. It does not deny that it is
worth devoting attention to the event of trauma, nor the reality of
trauma. But for Freud the social recognition of trauma is only the
beginning of the matter. The following, critical step demands an ex-
amination of, and reflection upon, the *psychic representatives* which
necessarily underpin any experience of trauma. That is, in Freud's
opinion it is crucial to enquire into the imaginary components of
the experienced traumatic contradictions, so that the individual might
well come to understand the ways in which the event has been in-
vested with, or drained of, meaning.

What is important in the dimension of the imagination, or fan-
tasy, as concerns the individual is also crucial for society at large –
hence the relevance of Freud for the social sciences and the humani-
ties. To acknowledge the fundamental and radical creativity of hu-
man imagination, whether one considers the disciplines of sociology,
political science or cultural studies, is to take up issues about the

psychic orientation of social practices. In the Freudian frame of reference, questions about the social reproduction of symbolic networks or the cultural transmission of tradition and custom are examined through reference to the imaginary elaboration of significations – that is, the fantasies which underpin any social formation or institutional practice. Every life, every activity, every event, every social or cultural practice is constituted and reproduced through representational and affective modes of psychic processing. In the light of Freud's work, the world is, in the most general sense, at once an imaginative and social-historical project.

Subjectivity, Social Analysis and Emancipatory Critique

What I want to develop, in this final section, is a summary of some of the central themes in current debates about Freud's contribution to contemporary intellectual life. The following overview does not pretend to capture the full range and complexity of contemporary cultural debate; but hopefully it does provide a useful conceptual backdrop to understanding the contributions contained in this volume.

Freudian psychoanalysis is of signal importance to three major areas of concern in the social sciences and the humanities, and each of these covers a diversity of issues and problems. The first is the *question of human subjectivity*; the second is that of *social analysis*; and the third concerns *epistemology*. These concerns are at the heart of *Freud 2000*.

Freud compels us to question, to endeavour to reflect upon, the construction of meaning – representations, ideas, affects, desires – and the mode of subjectivity implicated in the fabrication of signification. Against the ontology of determinacy which has pervaded the history of Western social thought, Freud uncovers what is essential to the psychical world: namely, that this world is not predetermined but is actively created, in and through the production of psychical representations and significations. The psyche is the launching pad from which people *make meaning*; and, as Freud says, the registration of meaning is split between the production of conscious representation and unconscious representation. Another way of putting this point is to say that meaning is always *overdetermined*: people make more meaning than they can psychically process at any one time. This is what Freud meant by the unconscious; an under-

lining of the radical ruptures in the registration and storing of psy-
chical representatives, or significations.

Freud's argument that the ego is not the master of its own home
has been tremendously influential in contemporary social and po-
litical thought. A preoccupation with unconscious sources of hu-
man motivation is evident in social-theoretical approaches as diverse
as the critical theory of the Frankfurt School, the sociological writ-
ings of Talcott Parsons and the philosophical postmodernism of Jean-
François Lyotard. Indeed, the theme of the decentring of the subject
in structuralist and post-structuralist traditions of social thought
derives much of its impetus from Lacan's 'return to Freud' –
specifically, his reconceptualization of the conscious/unconscious
dualism as a linguistic relation. But while the general theme of the
decentred subject has gained ascendancy throughout the academy,
much current social-theoretical debate has focused on the detour
needed to recover a sense of human agency as well as account for the
multi-dimensional forms of human imagination. In Kristeva's dis-
cussion of the semiotic dimension of human experience it is prima-
rily a set of psychoanalytic observations about the formation and
structuration of psychic space. In Ricoeur, it is a series of claims
about the hermeneutics of imagination, giving of course special at-
tention to the narratives of ideology and utopia, experience and norm.
In Baudrillard, it is part of an attempt to reconnect the texts of im-
agination to the socio-symbolic contexts in which they emerge in
postmodern culture.

This leads, secondly, into a consideration of the multiplex ways in
which Freud's work has served as a theoretical framework for the
analysis of contemporary culture and modern societies. The Frank-
furt School was for many years the key reference point here. Well
before the rise of Lacanian social theory, Max Horkheimer, Theodor
Adorno and Herbert Marcuse articulated a conception of psycho-
analysis as a negative theory: an account of self-divided, alienated
individuals, which was understood as the subjective correlate of the
capitalist economic order. While Marcuse's work became celebrated
in the 1960s as offering a route to revolution, it has been Adorno's
interpretation of Freud which has exercised most influence upon
contemporary scholars seeking to rethink the ambivalences of mo-
dernity.[10] In this connection, Adorno's thesis that psychoanalysis
uncovers a 'de-psychologization' of the subject, or the triumph of
modern society over the individual, is now the subject of widespread
discussion. Those who share this vision of modernity place empha-

sis on the rise of consumer society, the seductive imagery of mass media and the pervasiveness of narcissism.

Some versions of Freudian-inspired social theory, however, have stressed more creative and imaginative political possibilities.[11] Against the tide of Lacanian and postmodern currents of thought, several general frameworks for understanding modernity and postmodern culture as an open-ended process have been elaborated. What is distinctive about this kind of Freudian social thought is its understanding of everyday life as a form of dreaming or fantasizing; there is an emphasis on the plurality of imagined worlds, the complexity of the intertwining of psychical and social life, as well as alternative political possibilities. This insistence on the utopic dimension of Freudian thought is characteristic of much recent social and cultural theory; but it is also the case that various standpoints assign a high priority to questions about repression, repetition and negativity. Freud was, of course, much concerned with the emotional problems generated by repetition, the actions people cannot stop repeating or the narratives people cannot stop recounting. He understood such repetitions as symptomatic of a failure to remember, the closing down of creative imagination. For Freud, the aims of analysis centred on the uncovering of the deep psychological roots of such repressed motivations; free association, the pleasures of imagination and the freedom to explore fantasy are at once method and outcome in psychoanalysis. Such concerns are also central to contemporary social and political thought, as Freud has been drawn upon with profit to map the paths through which modern institutions remember and repress the past, both psychical and social-historical.

For many social critics, the autonomy of the imagination is inescapably situated within the project of modernity, centred in identity-politics, feminism, ecological movements and the like. Notwithstanding modern techniques of domination and technologies of the self, there are many who would wish to claim that the postmodern phase of modernity unleashes a radical experimentation with alternative states of mind and possible selves. At the core of this perspective there is an interpretation about the restructuring of tradition as well as transformations of personal identity and world views which necessarily alters the conditions of social life today.[12] Broadly speaking, traditional ways of doing things are said to give way to actively debated courses of action, such that individuals confront their own personal and social choices as individuals. On this account, there is a reflexive awareness of an internal relation of sub-

jectivity to desire, for personal identity is increasingly defined on its own experimental terms. Such an excavation of the psychological conditions of subjectivity and intersubjective relations clearly has profound implications for the nature of contemporary politics as well as the democratic organization of society.

Finally, social thought has been revitalized through its engagement with Freud as a form of emancipatory critique. This concern is motivated by a conviction that critical social theory should offer paths of transforming self and world in the interests of autonomy. Habermas is perhaps the most important social theorist who has drawn from Freud in developing a model of emancipatory critique in social analysis.[13] Freudian theory, in Habermas's interpretation, is directed towards freeing the patient from the repetition compulsions that dominate her or his unconscious psychical life, and thereby altering the space for reflective, autonomous subjectivity. However, a reading of the emancipatory dimensions of Freudian psychoanalysis which is more in keeping with a radical postmodern perspective is one in which desire is viewed as integral to the construction of alternative selves and possible collective futures. In this reading, it is not a matter of doing away with the distorting dross of fantasy, but rather of responding to, and engaging with, the passions of the self as a means of enlarging the critical imagination.

For anyone who is concerned with the future direction of society, the encounter with Freudianism is central. This is so, not because Freud's work connects to a particular political programme, but rather because Freudian ideas pervade our social fabric, shape the meanings of our language, define our understandings of ourselves. For this very reason, the political implications of Freudianism are difficult to discern. That being so, the following speculations will be ventured (somewhat tentatively) in conclusion. To begin with, it can be said that Freudianism in the present day has no particular ideological direction to go. In a reflexive and pluralistic world, a world which has recently witnessed the global crash of Communism, the project of Freudo-Marxism has clearly become a dead tradition of thought. But what does that leave? The political pessimism of the Lacanians? The liberal revisionism of the post-Freudians? Rather than declaring Freud finished, as the recent culture wars have sought to do, I think radicals should draw on Freud to confront the big social issues again. Not only in the sphere of culture and gender, but in the institutional domain also. Issues such as the privatization of public resources, or the destruction of the earth's eco-sphere, are signal

examples. These issues require elucidation in terms of Freud's ideas on, say, unconscious representation or symbolic overdetermination, not so much as a means of 'revealing' the psycho-dynamics of our social practice, but rather in order to extend our understanding of human experience, to raise alternative political possibilities, and to contribute to critical social imaginaries.

The essays written for this volume focus squarely on the meanings and significance of Freudian theory for comprehending the inherent *affectivity of social life*. A key objective of *Freud 2000* is to highlight that Freud's underscoring of this affective dimension of our lives has never been of greater personal and political importance than it is today. Whether we are seeking to think politically about the transformation of intimacy, sexuality and gender; attempting to deal with the emotional strains and gains of the protrusion of new communication technologies in our daily interactions; or trying to understand the resurgence of nationalist and ethnic conflicts across the globe, Freudian psychoanalysis encourages us to reflect on the fact that we are *intrinsically affective beings*, internally divided but creative agents.

Notes

1 Mark Edmundson, *Towards Reading Freud: Self-Creation in Milton, Wordsworth, Emerson, and Sigmund Freud* (Princeton: Princeton University Press, 1990), p. 3.

2 Jeffrey Masson, *The Assault on Truth: Freud's Suppression of the Seduction Theory* (New York: Farrar, Straus, & Giroux, 1984), p. 144.

3 Frederick Crews, 'The Unknown Freud', *New York Review of Books*, 18 November 1993, pp. 55–66.

4 Frederick Crews, *Skeptical Engagements* (New York: Oxford University Press, 1986), p. 86.

5 Recent responses, psychoanalytic or otherwise, to the Freud Wars are too extensive to survey here; two important contributions are Janet Malcolm, *In the Freud Archives* (New York: Knopf, 1984); and Stephen Frosh, *For and against Psychoanalysis* (London: Routledge, 1997).

6 John Forrester, *Dispatches from the Freud Wars: Psychoanalysis and its Passions* (Cambridge, Mass.: Harvard University Press, 1997), pp. 227–8.

7 Charles Spezzano, *Affect in Psychoanalysis* (Hillsdale, NJ: Analytic Press, 1993), p. 19.

8 Jeffrey Prager, 'On the abuses of Freud', *Contention*, 4: 1 (fall 1994), p. 214.

9 John Toews, 'Historicizing psychoanalysis: Freud in his time and for our time', *Journal of Modern History*, 63 (September 1991), 504–45, p. 513.

10 See, for example, Peter Dews, *The Limits of Disenchantment* (London: Verso, 1995); Slavoj Zizek, *The Metastases of Enjoyment* (London: Verso, 1994).

11 See, for example, Cornelius Castoriadis, *The Imaginary Institution of Society*

(Cambridge: Polity, 1987); Anthony Elliott, *Social Theory and Psychoanalysis in Transition: Self and Society from Freud to Kristeva* (Oxford: Blackwell, 1992); Joel Whitebook, *Perversion and Utopia: A Study in Psychoanalysis and Critical Theory* (Cambridge, Mass.: MIT, 1995).

12 The thesis of modernity as a reflexive process of detraditionalization is proposed by Anthony Giddens, *Modernity and Self-Identity* (Cambridge: Polity, 1991) and Ulrich Beck, *Risk Society* (London: Sage, 1992). For psychoanalytically-informed elaborations of such an approach see Ian Craib, *The Importance of Disappointment* (London: Routledge, 1994), and Anthony Elliott, *Subject to Ourselves: Social Theory, Psychoanalysis and Postmodernity* (Cambridge: Polity, 1996).

13 Jürgen Habermas, *Knowledge and Human Interests* (London: Heinemann, 1972). For criticisms of Habermas's reading of Freud see Anthony Elliott, *Social Theory and Psychoanalysis in Transition*, ch. 3; Joel Whitebook, *Perversion and Utopia* (see above, n. 11).

1

Psychoanalysis, Science and 'Truth'

Stephen Frosh

The debate over the standing of psychoanalysis has often centred on the question of how one might establish the validity of its claims.[1] This is problematic partly because of the sheer breadth of psychoanalytic theory, which encompasses a vast range of phenomena and areas of activity, some of them only loosely related to one another. It is also made particularly contentious by the proposed mode of operation of the central construct in psychoanalysis, the dynamic unconscious. In psychoanalytic thought, the unconscious is not an object to be observed: its dynamism includes its power to disrupt all claims to coherence and rationality, including those of science, by irrational and emotive impulses. Psychoanalytic theory is itself susceptible in this way, as its history of schisms and vituperation reveals; and critical assaults on psychoanalysis are, it is thought by analysts, particularly likely to be unconsciously determined. If even apparently objective scientific activity has irrational components, unconscious motivations, then it is impossible to find a place to stand outside the circuit of unconscious disruption in order to judge the veracity of analytic concepts. As one tries to hold them still enough to examine them, they slip away.

As might be expected from this state of affairs, much of the debate has centred on the question of the status of psychoanalysis as a science. Despite his liking for classical metaphors and poetic gestures, Freud was a strong believer in scientific progress and wished to claim a place for psychoanalysis within this. 'Psychoanalysis, in my opinion, is incapable of creating a *Weltanschauung* of its own. It does not need one; it is a part of science and can adhere to the scientific *Weltanschauung*.'[2] Psychoanalysis is 'a specialist science, a branch of psychology',[3] dealing, it is true, with the 'mental field' but in so doing extending the reach of science, rather than betraying it. Indeed,

investigating the mind calls for exactly the same principles as scientific study of external objects – a point of view which places Freud in the company of the behaviourists and other positivists who form such a substantial element in the anti-psychoanalytic coalition. In contrast to many later advocates of psychoanalytic positions, Freud is exceedingly modest in his statement about the contribution of psychoanalysis to the philosophy and methodology of science; he manifestly does not see it as opening up any radically new procedure. In fact, if 'the investigation of the intellectual and emotional functions of men (and of animals) is included in science, then it will be seen that nothing is altered in the attitude of science as a whole, that no new sources of knowledge or methods of research have come into being.'[4] Psychoanalysis is affiliated to science, not art, and it is opposed to the manipulations of religion, because there is only one way of approaching the truth. Science is that way, and the future belongs to science. 'It is simply a fact that the truth cannot be tolerant, that it admits of no compromises or limitations, that research regards every sphere of human activity as belonging to it and that it must be relentlessly critical if any other power tries to take over any part of it.'[5]

Given the tenacity and intensity of Freud's affiliation with science, it is ironic that so much of the criticism of Freud's own work and of the psychoanalytic method in general centres on a claim that it shows a flagrant disregard for the basic principles of evidence required by scientific practice. This is why Ernest Gellner, for example, labels psychoanalysis a 'mystical experience', consisting of 'the penetration of a Special Realm, discontinuous from the ordinary world though dominating it, and accessible only to forms of exploration distinct from those prevalent in the ordinary world: success is heralded by intense emotion, and a deep transformation of the knower himself.'[6] Gellner is arguing here that one element in the mystical aspect of psychoanalysis is that psychoanalytic knowledge is of a special kind: unlike the usual, naturalistic forms of scientific understanding, it is available only as a form of personal *transformation*. Knowledge of this variety is experienced as intense and as a route to personal change; in an important sense, it is spiritual or therapeutic in effect. Understanding something psychoanalytically is not just a matter of explaining it cognitively; full psychoanalytic understanding involves a shift in feeling.

One reply to this, of course, would be to argue that it confuses two types of psychoanalytic understanding, the first being knowledge of the workings of the dynamic unconscious and the second being self-

knowledge; only the latter is transformative. But this is belied by the very many claims to be found in the psychoanalytic literature that it is only possible fully to appreciate psychoanalysis from the 'inside', and that purely academic knowledge misses the essence of the psychoanalytic approach. There is no way of fully understanding psychoanalysis unless one is part of it, particularly as a patient but also as an analyst; and this applies also to psychoanalytic 'science'. Given the emphasis on objectivity which is characteristic of science as it is usually conceived, on separating out the personal investment of the researcher from the collection and interpretation of data, the transformative aspect of psychoanalysis is deeply problematic. It reverses the usual argument by stating that scientific understanding of the psychoanalytic variety is not possible *without* personal investment and that 'objectivity' is really a kind of blindness. Gellner suggests that this is the way to mysticism, and this is likely to be true. As will be argued later, however, it might also be the way to a productive critique of received images of science; but there is a considerable amount of ground to be covered before that point is reached.

Interestingly, in *The Psychoanalytic Movement*, Gellner argues that it is possible to distinguish between relatively well supported and relatively unfounded psychoanalytic claims. Prime examples of the former are the existence of a dynamic unconscious and the phenomenon of transference, both of which are held by Gellner to have 'overwhelming and genuine' evidence to attest to their reality, much of it coming not from scientific experiments but from everyday experience. This is in contrast ('almost comic contrast') to what he terms the 'sketchy, dubious evidence for most other psychoanalytic ideas'.[7] However, Gellner proposes that the central problem with the validation of psychoanalytic concepts lies not so much in its wayward attitude towards evidence, but in something far more deeply enshrined in the psychoanalytic world view. This is the idea that, because of the existence of the dynamic unconscious, it is not possible, *in principle*, to regard any evidence as pure and reliable. The unconscious distorts and alters everything, covering its tracks as it goes so that one can never be sure of what it has done. Any piece of 'knowledge' is open to refutation on the grounds of it being unconsciously determined: there is no end to the possibilities for analytic action. Gellner writes, 'The Unconscious is a kind of systematic interference, which hampers full and proper contact between the mind and its object, and thereby prevents effective knowledge.'[8] Consequently, the much lambasted tendency of psychoanalysts to accuse

their adversaries of being defensive and one another of being 'insufficiently analysed' is not some accident or lamentable falling from the high standards of the psychoanalytic enterprise. It is *structured into* psychoanalysis, because there is no way that one can be sure that this claim (of resistance, for example) can be wrong. Indeed, in psychoanalytic terms it is almost certainly right: there are bound to be unconscious reasons why one person may hold a view critical of another. Gellner, again:

> The attribution of cunning to the Unconscious, and a habit of tampering with evidence, is not something added to the theory more or less surreptitiously when it flounders and is in difficulties. In all good faith, *it was always there.* The evasion was not brought in to save the theory: it is the theory.[9]

Psychological claims are always contaminated, because, according to psychoanalysis, that is the nature of the human mind. It therefore becomes difficult, perhaps impossible, to distinguish clearly amongst the various ideas brought into being by the unconscious of the individual, so that those which are 'purely' defensive can be discriminated from those with meaningful content.

The challenge arising from this account of the impregnation of psychoanalysis with the seed of its own dissolution is to balance an appreciation of the way the psychoanalytic enterprise – and science generally – is a product of human activity with all its flaws and departures from logic, against a rigorous practice of scrutiny of clinical and theoretical material. Gellner implies that, because psychoanalysis places the unconscious as so central to its own discourse, it is never possible to trust evidence. Others, however, have struggled to define areas of activity and ways of documenting and examining what goes on in psychoanalysis so that it is possible at least to recognize where one can be more, as opposed to less, confident about the extent to which claims to knowledge are grounded in something resembling 'reality'. In establishing the relationship of psychoanalysis to truth, this becomes a crucial issue.

The Search for Clinical 'Facts'

Many defenders of the scientific status of psychoanalysis have drawn attention to an apparent parallel between scientific hypothesis-

testing and what goes on in the analytic setting. The argument runs as follows. In a traditional scientific experiment, a researcher develops, on the basis of pre-existing theory, a hypothesis which is then operationalized so that it can be tested through the application of some procedure (intervention) under controlled conditions. This intervention produces data, which are then observed and recorded. The extent to which the data match the expected outcome of the experiment determines whether the hypothesis is refuted or whether it is regarded as corroborated; this in turn reflects back on the theory. Similarly, an analyst draws on psychoanalytic theory to produce hypotheses about a particular patient; these hypotheses are translated into interventions (interpretations) which are tried out in the controlled setting of the consulting room. The patient's response is then closely observed and used to refine the analyst's understanding, in the long term reflecting back on the theory.

This parallel is a very tempting one and does reflect the way in which many psychoanalysts see their business as entailing careful observation and cautious intervention, with an awareness of the possibility that their assumptions about a particular patient may be erroneous. However, it runs up against a number of problems, the most important of which concerns the trustworthiness of data collected in the clinical setting. Put bluntly, this is a question about the status of clinical 'facts', particularly the extent to which these are produced by the activity of the analyst, rather than observed in the patient. The most significant intervention in this debate has been that of Adolf Grünbaum, whose book *The Foundations of Psychoanalysis: A Philosophical Critique* has been drawn upon extensively by critics and defenders of psychoanalysis alike.[10] This is despite some obvious shortcomings in the book, in particular that Grünbaum focuses only on Freud's work and assumes that little of substance has changed in the way psychoanalysis works since Freud's time. The consequence of this confounding of historical with epistemological foundations is that the many complex and productive innovations in psychoanalytic theory and practice which have arisen in the past sixty years are ignored, making it easy to dismiss Grünbaum's critique as out of date and irrelevant to psychoanalysis today. However, whilst the restriction to Freud is a real limitation of Grünbaum's work, he nevertheless raises powerfully a set of concerns about clinical psychoanalytic evidence which are of considerable general importance.

Much like the putative defender of psychoanalysts' scientific

method described above, Grünbaum takes seriously claims to the objectivity of psychoanalytic methods in the clinical arena. Freud, he claims, 'saw himself entitled to proclaim the *scientificity* of his clinical theory *entirely on the strength of a secure and direct epistemic warrant from the observations he made of his patients and of himself*'.[11] For Freud, therefore, the quality of these observations was crucial for the claims of psychoanalysis to scientific status – more so than the nature of the theory as a whole. In this view, the rigorous and unbiased pursuit of accurate and objective evidence is what marks out scientific method and distinguishes it from speculation.

With this yardstick as his guide, Grünbaum disputes one line of reasoning about psychoanalysis, adopted for example by Popper, that presents it as unscientific because of the theoretical impossibility of falsifying its claims. Grünbaum argues that focusing on clinical evidence allows one to establish criteria which would make it possible to assess the standing of psychoanalysis objectively, so that the argument is not one of *principle*, but of fact: do the claims of psychoanalysis stand up to scrutiny? Indeed, Grünbaum presents textual evidence from Freud's writings to establish that he did regard it as possible for psychoanalytic predictions to be refuted by evidence, and that some of his case discussions are set up to examine this possibility rather directly. For example, Freud's paper 'A Case of Paranoia Running Counter to the Psychoanalytic Theory of the Disease' suggests the possibility of refutation even in its title, and Grünbaum believes it to demonstrate that 'the psychoanalytic etiology of paranoia is empirically refutable *and* that Freud explicitly recognized it'.[12] One might at times wonder if this was more than a rhetorical device on Freud's part, given that the instances of direct refutation of his own theory in his writings are very few; nevertheless, it is true that he promulgated and acknowledged major changes over the course of his lifetime, for example in the theory of narcissism, of the structure of the mind, of anxiety and of the drives. To some extent, these changes were driven by clinical observation, supporting Grünbaum's position.

Where Grünbaum regards psychoanalysis as failing the scientific test, then, is not at the level of general principle, but at a more concrete and practical level. He argues that psychoanalysis could, in principle, be tested against clinical observations and that to a considerable degree the outcome literature on psychoanalytic therapy constitutes such a test, one which psychoanalysis fails. In addition, he calls into question the objectivity of the clinical evidence em-

ployed by psychoanalysts when they claim that their theories are grounded in observable data. Where analysts see the patient, Grünbaum sees the analyst, influencing the material produced in the consulting room and hence invalidating it as a source of information. However much detailed material is produced in an analytic case-presentation, however rich is the evocation of the patient's inner world, however carefully the interpretations and the patient's responses are documented, this can never serve as independent evidence to be taken seriously by a detached observer. This is because of the operation of one of the earliest unresolved disturbances in Freud's work (a return of the repressed if ever there was one), that of what Grünbaum terms 'suggestion'.

Taking the issue of outcome evaluation first, Grünbaum portrays Freud as believing that the therapeutic efficacy of psychoanalysis is a specific indicator of the degree to which its theoretical claims can be supported. He calls this Freud's 'necessary condition thesis' and defines it as follows.

> (1) only the psychoanalytic method of interpretation and treatment can yield or mediate to the patient correct insight into the unconscious pathogens of his psychoneurosis, and (2) the analysand's correct insight into the etiology of his affliction and into the unconscious dynamics of his character is, in turn, *causally necessary* for the therapeutic conquest of his neurosis.[13]

As Grünbaum notes, if the necessary condition thesis holds, there should be evidence that psychoanalytic psychotherapy works and that it does so better than other forms of therapy. This is, in principle, a testable claim, even though some psychoanalysts seem to have gone out of their way to spoil it by arguing that only patients who improve have had genuine psychoanalysis, the others having received inadequate substitutes or 'terminated prematurely'. Unfortunately for the necessary condition thesis, the evidence attesting to the therapeutic efficacy of psychoanalysis is thin in the extreme.[14] Grünbaum regards this as a genuinely scientific test of psychoanalysis which has been failed. Moreover, because, he claims, Freud sees the warrant for psychoanalysis as lying in clinical work, the credibility of psychoanalytic theory as a whole depends on fulfilment of the necessary condition hypothesis. The failure to show that psychoanalytic therapy works thus calls into question the very 'foundations' of psychoanalysis.

Fortunately for psychoanalysis, the situation is not cut and dried. Not only are there enormous difficulties with all existing studies of psychotherapeutic outcome, but it is also unacceptably reductionist to make all of psychoanalysis stand or fall on such specific clinical grounds. Whatever Freud may have thought about the importance of grounding his wider claims in clinical understanding, psychoanalysis has grown to make contributions to an enormously wide array of different disciplines and practices, and is now organized as a network of ideas drawing on various sources of 'evidence', some of them close to the clinical arena but some – for example, in film theory and politics – a long way away. No single test of one aspect of psychoanalysis, however important, can be used to support or dismantle the whole – especially when the debate over the legitimacy of that test is as fraught as is the case for psychotherapy outcome research. Grünbaum's second area of argument about the trustworthiness of clinical evidence is more convincing and instructive, and it also takes us close to the heart of some of the most significant contemporary debates about science and knowledge. The central issue here is the degree to which analytic interpretations can be separated out from 'suggestions' made by the analyst; more broadly, this raises the issue of 'reactivity' in research – loosely, the impact of the researcher on the phenomena being studied. Freud's claim that psychoanalytic interpretation is different from suggestion is termed by Grünbaum the 'Tally Argument', with the following quotation as its source.

> After all, [the patient's] conflicts will only be successfully solved and his resistances overcome if the anticipatory ideas he is given tally with what is real in him. Whatever in the doctor's conjectures is inaccurate drops out in the course of the analysis; it has to be withdrawn and replaced by something more correct.[15]

Freud's argument is that, whatever the analyst says, it is only those interventions or interpretations which are consistent with 'what is real' that will have an impact. Any speculations of the analyst which are not based in truth will eventually fall away, so a successful analysis will always reveal what is actually troubling the patient. If this could be believed it would be a very attractive proposition, as it would mean that the accuracy of an interpretation (hypothesis, theory) could be judged by the degree to which it survives the test of the analytic encounter and promotes beneficial change. More generally, in dis-

tinguishing between what is really happening in the unconscious of the patient and what the analyst invents, it gives psychoanalysts an object for study separate from their own speculations. There is, however, an obvious tautology in the tally argument. Because an interpretation remains solid, it is thought of as accurate, because accuracy (tallying with what is real) is defined as the sole source of interpretative salience (inaccurate ideas drop out). Amongst other problems, there is the point that analysts do not usually evaluate their work in such a concrete way. For example, they might believe that an interpretation was ineffective not because it was 'wrong', but because it was given too early, before a patient's resistances had been sufficiently analysed, or too clumsily. It is also extremely difficult to find examples even of apparently successful cases where the analyst believes that all unconscious conflicts have been resolved by the end of treatment, implying that there are parts of the 'truth' of which the analyst is aware, but which the patient continues not to accept.

What Grünbaum focuses on here, however, is a question of even more centrality to the psychoanalytic enterprise, the question of transference and its effects. In pursuing this issue, he also reveals the problematic nature of the notion of 'contamination' about which he is so concerned. Criticism of the 'contamination' of evidence by suggestion implies that it is possible to conceptualize *uncontaminated* or pure data not influenced by the analyst, but truly objective. This notion is just about tenable from a Freudian position, in that transference is seen as a distorting process, whereby the reality of the analyst is infiltrated by the fantasy life of the patient, and vice versa in the case of countertransference. In this version of the psychoanalytic interchange, the task of the analyst is to help the patient see things more clearly, less under the sway of unconscious fantasies which truly should be directed elsewhere. However, a far more widespread reading of the analytic relationship in contemporary psychoanalysis is one in which fantasy is seen as *integral* to the analytic exchange. In this reading, influenced particularly by Kleinian ideas, transference is not a distorting fantasy which must be controlled, but the medium through which communications occur, and the countertransference of the analyst is the receptive instrument through which the patient's unconscious communications are understood and responded to. This means that 'contamination' is at the heart of the analytic process, as analyst and patient construct something together out of the inmixing of their fantasies, something which is connected to 'what is real in the patient' only because what is 'real' is itself a

product of unconscious life. Thus, the apparent meanings of things can be changed around completely by the impact of the transferential context, as new understandings are produced by the interpretative process. Freud himself legitimized a strategy whereby an energetic refusal of an interpretation might be taken as evidence of its significance;[16] post-Freudian object relational work suggests that there is no possible way of seeing things 'as they are', because all realities are constructed in a complex interchange with fantasy.

Grünbaum argues that the impossibility of separating fantasy from reality, or in his terms of avoiding contamination by the power of suggestion, is a fatal objection to Freud's claim that psychoanalysis identifies something real in the patient. This even applies, according to Grünbaum, to Freud's idea that it is necessary to present compelling additional evidence before contradicting a patient's negative view of an interpretation. That is, Freud states that a patient's response should be respected until such time as the analyst has convincing evidence from other aspects of the analysis to suggest that the patient is resisting a correct interpretation. Grünbaum points out that as the analyst has to rely on what she or he is told in the analytic session by the patient, there are no alternative lines of evidence: everything is contaminated in the same way by the presence and suggestive power of the analyst. Freud's appeal to 'consilience' (converging lines of independent evidence) cannot be admitted because the analytic setting contains no material which is separate from what goes on between analyst and patient. Even the simplest piece of reported speech or action from outside the consulting room arises in the context of the transference, under the influence of the analytic relationship, raising the possibility that it is being constructed in order to serve a function in this relationship. Indeed, analysts characteristically behave as if this is the case: patients may believe they are just passing the time by speaking of some trivial and remote aspect of life, only to find that the analyst links it with the core conflict for which they are seeking help. Thus, as there is nothing in analysis which takes place outside the relationship between analyst and patient, there is no evidence separate from the analysts's constructing, 'contaminating' presence. Grünbaum argues: 'the purported consilience of clinical inductions has the presumption of being *spurious*, and this strong presumption derives from the fact that the *independence* of the inferentially concurring pieces of evidence is grievously jeopardized by a *shared* contaminant: the analyst's influence.'[17] However much might 'drop out' in the course of treatment, what remains will never be pure, un-

contaminated 'truth'. Everything in analysis comes from analysis it-self, an interpersonal process that creates meanings and 'cures', when it does so, through the meanings it creates. The question here is whether this is, as Grünbaum suggests, damning evidence of the nonscientific nature of psychoanalysis, or whether it might be read as a pointer to the specific contribution of psychoanalysis to the expansion of knowledge, 'scientific' or other.

Evidence and Interpretation

Grünbaum's failure to consider post-Freudian developments in psychoanalysis was referred to earlier. Although it is still the case that Freud's writings form the foundation of psychoanalytic studies of all kinds, there have been very substantial changes in theory (for example the promotion of object relational over drive approaches), practice (the related tendency to focus on interpersonal aspects of the transference situation as they unfold, rather than to prioritize recovery of memories – a tendency subverted recently by work on sexual abuse and other trauma) and application (politics, feminism, cultural criticism). These changes bear directly on Grünbaum's thesis; at the very least they suggest that psychoanalysis has been able to respond to changes in the social environment and to its own difficulties and failures. More to the point, in relation to Grünbaum's critique of suggestion/contamination processes in the collection of data, recent psychoanalytic writings show considerable sophistication in understanding the issues involved in recognizing what are often termed 'clinical facts'. In common with many other social scientists, psychoanalysts have come to recognize that such 'facts' are constructions, and to take this into account when making claims based on clinical work.

This does not mean that the problem of how to collect psychoanalytic evidence has been solved. For example, the quotation below from the influential American psychoanalyst Otto Kernberg offers a clear account of what is needed to establish a psychoanalytic 'finding'. However, as will be seen, it leaves a multitude of problems unsolved.

The validation of an interpretation . . . requires the emergence of new information in the patient's free associations, thus broadening and deepening the understanding of a certain conflict; the

emergence of deeper understanding of a dominant, defensive object relation and its underlying, dynamically-opposite object relation, with a corresponding shift in affective expression; a change in the patient's transference relationship or in his/her internal relationship to an extra-analytic object; and a rapprochement between the patient's experience and the analyst's understanding of it. The new information available to the patient and to the analyst should somehow affect the patient's symptoms, character and fantasies, and broaden the patient's capacity for psychic experience, as contrasted with his expressing unconscious conflicts by somatisation or acting out.[18]

This formulation is clearly related to one which Freud might have made, for example in the assertion that an interpretation should produce new information, apparent in the patient's free associations and clarifying a relevant unconscious conflict. In addition, the final sentence could almost have come straight from the *New Introductory Lectures on Psychoanalysis*, with its reference to 'information' and the release from unconscious compulsion. However, Kernberg also moves beyond Freud in emphasizing understanding of the object relational basis of the conflict and in focusing on the impact that that should have on the patient's emotional state. He also places a striking accent on the interpersonal aspects of the analytic situation: the transference relationship should change, there should be a 'rapprochement' between the patient's experience and the analyst's understanding of it.

Despite these developments, it can be argued that Kernberg's formulation is still subject to Grünbaum's critique. Everything described in it, whether 'classical' (free association, widening the sphere of understanding) or object relational, is situated in the context of the patient's involvement with the analyst, and thus irremediably connected with the analyst's 'suggestive' influence. Even if the patient's symptoms improve, one cannot be confident that this is because of specifically analytic aspects of the situation: it may 'simply' be a pronounced placebo effect generated by the patient's wish to impress or please the analyst. (Parenthetically, the repeated failure of psychoanalytic outcome research to establish that change occurring in psychoanalysis is different from that occurring in 'supportive' psychotherapy bolsters this argument.[19]) Put more sympathetically, change might indeed be brought about by an interpretation, but for reasons other than its 'accuracy'. For instance, an analyst might in-

terpret a patient's repeated lateness to sessions in terms of her reluctance to become dependent and her inability to relinquish control over her own movements. This could produce, in a specific case, a rich flow of associations around dependency and control, and might also lead the patient to resolve successfully to turn up on time. But this does not necessarily mean that the initial interpretation was correct; it simply means that it was powerful enough to get the patient thinking, to move her along. Analysts might be satisfied with this, but Grünbaum would argue that there is nothing specifically 'analytic' about it: it is simply an example of the potent force of suggestion in this unusual interpersonal situation.

What is being engaged with here is not just the question of how 'accurate' or truthful psychoanalytic interpretations might be, but also the grounds on which such judgements can be made. Traditionally, beginning with Freud, psychoanalysts have claimed that when they uncover an unconscious conflict they are dealing with something real, and in the process of uncovering it they are making it amenable to resolution and control. Psychoanalysis uncovers the hidden traces of past trauma, demonstrates their continuing dynamic nature and helps the patient redeploy the emotional energy caught in them for more productive purposes. Interestingly, in contrast with the rather radical psychoanalytic treatment of language in other respects, this view of the analytic process is built on quite a conservative notion of how language operates. Language is conceptualized not so much as constructive and creative of meanings, but as transparent and in the service of already existing ideas. Thus, the analytic task is to name more clearly something which already exists; in Freud's terminology, to add a 'word-presentation' to the unconscious 'thing-presentation'.[20] An alternative view, increasingly pronounced in social science circles, regards language as constructive or 'performative': that is, it has specific effects of its own. Translated into the analytic situation, this means that interpretations might be thought of not as naming pre-existing meanings (identifying what is already there, hidden under the surface), but as producing new meanings, constructing new versions of things. A useful, 'good' interpretation then becomes one which has beneficial effects, and the question of truth falls away.

The emphasis on the generation of meaning in this account is a familiar aspect of the 'hermeneutic' approach to psychoanalysis. This seems to be having a strong impact even on those analysts who remain wedded to a more traditional notion of 'truth': 'When

I make a truth claim, I do not claim to know *the* truth, or *all* the truth, but only *a* truth. Other true formulations are always possible.'[21] Despite the shades of Humpty Dumpty here ('When I use a word . . .'), the move away from a mechanical notion of truth, as that which is uncovered, to a more fluid and open one promotes an approach to psychoanalysis which, in principle at least, is less dogmatic and 'knowing', and more in tune with the uncertainties of contemporary culture. For many psychoanalysts, it is also a way of humanizing the analytic process, focusing on what goes on between analyst and patient rather than on the recovery of some notional 'historical truth' deep inside the patient's mind. From this perspective, the meaning of the patient's unconscious productions can never be stable, because they are enunciated within the changing context of a specific relationship with the analyst; the unconscious thus becomes a site for *communication*, an 'intersubjective' process, with all the comings and goings that that implies.

'No interpretation is sacred. If context is boundless and ever-expanding, the grounds for reaching a conclusion about this or that meaning are forever shifting. An archive can be constructed, but its contents will always be open to interpretation and elaboration.'[22] Donald Spence is here adopting the postmodernist and hermeneutic position that there is never one 'truth' or full understanding of a person, but only partial and temporary constructions of meaning. In the context of psychoanalysis, this not only suggests that the clinical formulation of any patient must alter over time, but it also draws attention to the way different understandings will emerge as a consequence of the personalities, attributes and theories of different analysts and the social context in which they work. How else, it might be asked, can one explain the radical historical shifts in psychoanalytic practice and in the symptomatology of analytic patients? Spence, explicitly adopting a hermeneutic position, defines the analytic task as achieving an 'inside' stance based on identification with the patient – that is, a capacity to see the world from the patient's point of view. With this strongly individual-centred idea, any claims to full and general knowledge are severely weakened or ditched altogether: the 'final meaning' of a case 'is always colored by both theory and context'.[23] Clinical 'facts' and their psychoanalytic interpretation are provisional creatures, unconstruable outside the conditions from which they have arisen. 'If our hermeneutic position is correct, then it must follow that the meaning of the material is highly dependent on who is listening to

it, and that what was true for the treating analyst, at a particular time and place in the treatment, will never be true again.'[24]

The humility embedded in this notion of contingent truth offers an attractive alternative to claims of absolute knowledge, but it also raises the spectre of a relativism in which any story told by a psychoanalyst has to be accepted as viable and immune to criticism, simply because it must be 'true' for that analyst in that encounter with that particular patient. In other words, what are the grounds for differentiating between a hermeneutic truth and a hermeneutic (or actual) falsehood? If 'what's true for me' is all that matters, then psychoanalysis lays itself open to the barbs of those critics who regard it as a fantasy genre – an image of analysis which some analysts seem assiduously to cultivate. What are the constraints operating on interpretation and theory if no absolute dynamic cause is being claimed? The argument from those employing the hermeneutic perspective is that the narratives produced in interpretative settings have causal properties of their own, and it is through these that the quality of each narrative can be assessed. Literary texts offer a clear model here: any text could be said to hold within it some legitimacy, but a 'good' or convincing text will produce in the reader more alternative and even contradictory meanings than a poor one. Indeed, the power of a text may depend on the texture and richness of the network of emotions and associations to which it gives rise. Similarly, some interpretive narratives are more productive than others, they have more resonance and more effects, they link better with other theories and they allow meaning to emerge where there might previously have been obscurity and confusion. Incoherent, dead-end interpretations are possible and in all likelihood very common; these can be distinguished from productive interpretations by their communicative power.

The versatility required of hermeneutic explanations is clearly considerable: they must shift with the culture yet retain a capacity to do more than just rephrase experience. While there are many attractions in the idea that it is the performativity of a text – the productivity of an interpretation, for example – which is the measure of its quality, it is debatable whether the problems of establishing the legitimacy or otherwise of a particular psychoanalytic formulation are thereby resolved. Is it really the case that one narrative is to be preferred over another because it produces more associations and ideas? What about the many important things that should really be part of the narrative of our experience but that most of us would

prefer not to know? More generally, is there nothing at all to distinguish a richly evocative but speculative story from a sober account of the 'facts'?

Followers of the hermeneutic tradition have usually presented the conditions for narrative 'truth' in terms such as theoretical coherence, inner consistency and narrative intelligibility.[25] Applied to psychoanalysis, these conditions draw attention to the relationship between an interpretation and its context, given in terms of theory, internal logic and social resonance. What is apparent here is just how much depends on the fit between a particular interpretation and the agreed practices and perceptions of the wider disciplinary community. For example, take the following extract from a hermeneutic study of psychoanalysis:

> The ultimate criterion for the validity of an interpretation must consist in the consensus of the interpretive community that a text has indeed become intelligible. This in turn means that it has become integrated into the frame of meaning within which the interpretive community lives – a frame which for reasons of principle cannot be formalized. This is quite different from what happens in the natural sciences.[26]

The idea that the value of an explanation depends in large part on its acceptability to the scientific community to which it is addressed has considerable currency. However, at least in the specific instance of psychoanalysis, it leaves a great number of hostages to fortune. For one, psychoanalysts have rarely wished to claim that the truth of their ideas is to be measured by their popularity; indeed, they have been rather free with the notion that resistance to psychoanalytic claims is some kind of evidence of their disturbing potency. In any case, most psychoanalytic ideas hold sway over a very small community of believers, but it seems unwise to suggest that for this reason alone they are necessarily incorrect. If the unconscious 'really' exists and if its products are as disturbing and subversive as most analysts suggest, then one would not expect a theory dwelling on these products to gain easy acceptance. Conversely, it would seem unwise to hold too firmly to an idea just because it is popular; too much is known about the penetration of society by ideological forces to make this an attractive foundation for scientific discourse. More generally, 'the consensus of the interpretive community that a text has indeed become intelligible' might simply signal that nothing new

or challenging has been proposed. Holding fast to the specific context in which psychoanalytic interpretations take place, Jürgen Habermas returns us to the transformative intent of the process: an interpretation is validated by the patient to whom it is directed. Analytic insights, he writes:

> possess validity for the analyst only after they have been accepted as knowledge by the analysand himself. For the empirical accuracy of general interpretations depends not on controlled observation and the subsequent communication among investigators but rather on the accomplishment of self-reflection and subsequent communication between the investigator and his 'object'.[27]

In its simplest form, the proposal here is familiar from many analytic accounts and is closely related to the positions outlined above. Eventually, and notwithstanding the difficulties and subtleties of the procedures involved, an interpretation is validated by the effect it has – by its capacity to deepen the quality of self-reflection found in the patient, and by its impact on the communications with the analyst. In other circles, this might be referenced by a change in the emotional tone of, or degree of 'empathy' to be found in, the analysis. In the quotation from Kernberg given above, for example, the criteria for assessment of the value of an interpretation are given in terms of its impact on the patient (richer free associations, changes in the transference relationship, improved understanding of conflict). For Habermas, there is more to it, but the general idea is similar: analytic truth is as deep or as shallow as its ability to promote the emancipatory movement in the patient.

The notion that the value of the analytic narrative is measured by the patient's response has some obvious attractions. It focuses attention on the clinical situation, emphasizes the concrete nature of psychoanalysis as a theory about persons, and is consistent with the communicative, interpersonal model employed by most contemporary analytic schools. On the other hand, it continues to fall at the hurdle of the interpretation which an analyst might believe is perfectly 'true' but yet which has no effect on the patient because of the degree of resistance it produces. That is, there may be a very convincing story given to the analytic community concerning the dynamic structure of a particular individual's pathology, and this story might include an explanation of why no interpretation makes any

difference to the patient at all. Indeed, Grünbaum accurately notes that, unless and until a patient's resistances have been overcome, psychoanalysts would *expect* denial of any interpretation which is remotely meaningful.[28] Under these circumstances – very common in psychoanalysis – the patient cannot be arbiter of psychoanalytic truth except in the very long term, when it might be possible to tell retrospectively the harrowing story of conflict, confusion and resistance and how they were all overcome.

The hermeneutic point of view displays the complexity of the arguments about science and truth very clearly. Despite the attractions of a view of psychoanalysis as a way of telling useful stories to people for whom it is proving impossible to hold together a constructive narrative of their existence, the problem of how to validate this enterprise – how to decide when one story is more appropriate or fruitful than another – remains recalcitrant. In addition, many analysts want to hold at bay the idea that their patients may be best thought of as texts. Ricardo Steiner, for example, in an editorial on hermeneutics and psychoanalysis for the *International Journal of Psycho-Analysis* writes that certain applications of hermeneutics do deprive psychoanalysis of some of its fruitful potential: the insistence on psychoanalysis as a pure interpersonal dialogue, as a clinical encounter which, following the suggestions of the hermeneutic interpretive tradition, aims at understanding meanings and not at explaining causes, for example, leads to a reduction of the whole of psychoanalysis to a simple province of the exegetical disciplines applied to texts.[29]

The objection here is that while it may be reasonable to view the productions of analysts and patients as texts which can be explored for their meanings, they are not arbitrary and they may be different from other texts. This is because they arise out of something peculiar to people in this intense interpersonal situation. In general terms, they suggest the need for a causal language after all, one which can explain how and why these 'texts' take the form that they do. The answer will have something to do with the nature of persons, with the embodied, emotive, desiring elements of being, out of which these analytic encounters are formed. Hermeneutics, if it loses sight of this as the source of its textual productions, may miss the main point about psychoanalysis: that it is concerned with how people live their lives, including but not limited to the manner in which they develop narratives to help them along the way. Textual play is only one part of the story.

Questioning the Truth

If one is to try to take hold of the specific elements of psychoanalysis that lead to its peculiar brand of interpretation, both causal and hermeneutic, then the best place to start is once again with the transference. Jane Flax draws together a number of the issues touched upon so far in the following quotation:

> Both transference and rational insight are necessary for the patient's emancipation, but this rational insight is of a very special sort. It is necessarily intersubjective and is more like a mutually agreed-upon reading of a text than a solution to a problem of quantum mechanics. The patient has the particular experience which she/he is trying to remember and work through with the help of the analyst who has a general schema which is useful to both of them in explicating the meaning of the patient's experience past and present (especially transference phenomena). Their goal is not 'truth' in the empiricist sense of what 'really' happened to the patient, but rather *understanding* which includes a powerful affective and experiential component. The past is lived through the transference; it is not merely grasped intellectually.[30]

Flax is here identifying an important element in the espousal of rationality by psychoanalysis. Instead of adopting the conventional vision of rationality as linked with objectivity, psychoanalysis expands the concept so that it includes intersubjectivity: patient and analyst arrive at an agreement that the understanding they have developed between them is meaningful. Rationality is thus more a measure of communication than of the application of certain rules of thought, being based around the pursuit, by patient and analyst together, of a fuller appreciation ('affective and experiential', rather than, as in traditional scientific research, closed to emotion) of the meaning of the patient's experience. Although psychoanalysis delves into the past ('the patient has the particular experience which she/he is trying to remember'), the emphasis here is on emotional work taking place in the present ('the past is lived through the transference'), a view held reasonably consistently by most contemporary psychoanalysts. The central vehicle for all this is the transference, which is both the source of data for interpretation and the medium

through which change occurs. Psychoanalytic rationality is there-
fore not like rationality as it is usually imagined, but more like im-
agination itself: active, emotionally tinged, and thoughtful in a more
than purely intellectual way.

Flax's suggestion that analytic progress arises from the construc-
tion of a 'mutually agreed' reading of the patient's experience is in
line with the hermeneutic vision, with its reframing of questions of
discovery ('what is the real event at the source of the patient's neu-
rosis?') as acts of textual exegesis. This also brings out the relativity
of analytic findings and their interpersonal nature: they arise out of
a negotiation between the different 'readings' by analyst and pa-
tient. The argument Flax makes for a 'very special sort' of 'rational
insight', however, moves the discussion on a little further, as it takes
the area of most difficulty for psychoanalysis in relation to science
and identifies a possible route through it. Although the idea that
psychoanalytic 'insight' includes emotional, intersubjective and un-
conscious (e.g. transferential) components is familiar, the claim that
it is a form of rationality is bold, presenting a challenge to conven-
tional views on what constitutes rationality. By doing this, it also
opens out the possibility that data open to 'contamination' by the
researcher, because interpersonal and subjective, might nevertheless
– at least under some conditions – be stable and compelling.

The notions of insight and subjective understanding as they ap-
pear in psychoanalysis are central here. Psychoanalysis envisages 'in-
sight' as far more than simply a form of cognitive understanding. It
is seen as combining an intellectual grasp of the unconscious dy-
namics of a psychological situation – the reasons 'why' the person
acts in this or that way – with a transformative experience in which
the power of these dynamics is felt and worked with (in Flax's words,
'The past is lived through the transference; it is not merely grasped
intellectually'). There is thus no dispute with Gellner over the fact
of the matter: psychoanalysis does claim that understanding – genu-
ine knowledge – is an emotional, transformative affair. All the clever
criticism in the world is of secondary significance when compared
with the kind of knowledge that really makes a difference. Learning
of the psychoanalytic kind means not only gaining more informa-
tion than one had before, but achieving a different state of mind.
Knowledge like this will often be deeply resisted because it is dis-
turbing or challenging; nevertheless, it is the only form of know-
ledge worth having. Again, as Gellner suggests with his strictures
about the 'mystical' nature of psychoanalysis, such knowledge arises

not from dispassionate scrutiny of facts, but from the mobilization of emotion, when irrational, unconscious structures are exposed and experienced in the context of the transference. Learning of this kind comes about through investment of the self in the situation, through a willingness to open oneself out to whatever the occasion might bring, letting it act on oneself, even in excess of one's initial capacity to keep track of it or comprehend it. Intellectual understanding – for example, making a coherent verbal narrative about an experience – is important, but it might come later, and might never be completely achieved; the main thing is to change.

Where this argument parts company with Gellner is in his regarding this form of knowledge as inferior and irrational because it is emotionally rather than cognitively driven. Freud's original privileging of consciousness and rationalist practices, in which the task of psychoanalysis was envisioned as a kind of conquering of irrationality and disorder, has given way over time to a different formulation of the psychoanalytic ethic. As Flax notes, this is no scientific error, but it is part and parcel of the mode of operation and subject matter of psychoanalysis: 'Much as Freud desired it otherwise, psychoanalysis simply does not and cannot fit within the empiricist or rationalist models of science or knowledge.'[31] As psychoanalysis has developed, it has become increasingly apparent that the unconscious is not a force which can be contained once and for all: after all the analysis in the world, it continues to operate, infecting even reason with its actions and (to use Gellner's term again) its cunning. Unconscious factors influence all aspects of human behaviour, including apparently rational behaviour; even the desire to achieve knowledge and the procedures whereby one pursues this are held by psychoanalysts to have powerful unconscious roots.[32] No simple separation is possible between rational thought, or reason, on the one side, and emotion and the unconscious on the other. Flax argues that this produces a view of human functioning radically distinct from traditional philosophical positions, particularly in its refusal to allow that there can be truly 'objective' knowledge. In particular, the Enlightenment tradition of rationality, from which empiricist science draws much of its strength, is undermined. According to Freud, Flax writes:

humans are originally and primarily desiring beings. Our being is not defined by the capacity to reason, as Plato and Kant believe; by the ability to speak, reason and engage in political deliberation, as Aristotle argues; or by the power to produce

objects of value and need, as Marx claims. 'The core of our being,' according to Freud, consists of 'unconscious wishful impulses' that cannot be destroyed.[33]

Knowledge of oneself or others which is built upon the denial of desire – of emotion and feeling states – is truncated knowledge. Emotion, seeming 'irrationality', is crucial here: the post-Freudian conceptualization of analysis as a setting in which knowledge comes about through personal interconnection involves a claim that forms of rationality which require the repression of subjectivity and desire are always incomplete.

All this circulates again around the question of how the analyst knows what particular interpretation to place on the patient's words. Being assertive here about what psychoanalysis offers, one might say that the measure of the meaning of a communication lies in its impact on the recipient's (the analyst's) feelings. The particular skill of the analyst, identified in the literature as countertransference, is to monitor and comprehend this impact in the context of the particular moment in which it occurs, taking into account the course of that specific individual analysis. Thus, not only does the patient's final level of insight depend on the extent to which emotional transformation has been achieved, but the moment-by-moment process of coming to know about self and other is also based on the deployment of emotion rather than, as might be the case with alternative accounts of scientific rationality, its suppression.

The argument here is that the notion of rational understanding cannot be restricted to 'pure reason' if it is to supply meaningful knowledge about human subjectivity. For one thing, it is not possible to separate reason and emotion in the way postulated by positivistic science. Awareness of this is not a simple reiteration of the traditional experimenter's problem that subjective factors tend to enter into the research process and need to be controlled, although it is in part built on the recognition of the impossibility of ever instituting such controls – consciousness has unconscious forces pushing it all the time. More importantly, psychoanalysis rules that comprehension of human psychological states *requires* the application of subjectivity if it is to be meaningful. Such knowledge emerges out of an intermixing of subject and object, of the process of being and becoming part of another. The scrupulous practice of 'reading' what happens inside the researcher or therapist is the route to knowledge of the unconscious; there is no other way through. Construc-

tion of a rational view of human psychodynamics can therefore only emerge in and through emotion and imaginative responsiveness: a process full of subjectivity is necessary if one is to be able really to understand human data at all.

This leads to a new take on the issues of the scientific standing of psychoanalysis and the kinds of evaluative evidence which are relevant to it. In promoting the idea of 'learning through experience', psychoanalysis offers a critique of versions of the scientific world view that dismiss subjectivity as 'contamination' and insist upon maintaining an absolute division between the subjects and objects of knowledge. In the sphere of human psychological research at least, psychoanalysis suggests, subjective and interpersonal processes have necessarily to be engaged with for 'data' to be understood and built into theoretical formulations, whether the frame adopted is explanatory or hermeneutic. In this way, psychoanalysis considerably extends the boundaries of what is considered 'rational', not only in that apparently irrational aspects of human psychology become explicable, but also because the procedures employed to achieve this are themselves constructed out of a systematic use of recognizably subjective skills. Thus, subjectivity is no longer a synonym for 'bias'; instead, it is welcomed in as a necessary foundation of full, rational understanding. Without it, the analyst could not enter into the kind of relationship with the patient out of which interpretations and theories emerge, for it is from intense, intersubjective exchanges that dynamic understanding arises. More formally, psychoanalysis proposes that the medium of communication in analysis, the transference, is the most powerful source of detailed clinical knowledge of the workings of the unconscious; experiencing the emotional impact of the transference as a spur to, and organizer of, interpretive activity is a large part of the analyst's task.

This does not free psychoanalysis from the responsibility to provide careful accounts of people which might be communicable to the research and therapeutic community and which might make rational 'sense'. Instead, the strong argument here is that such accounts are necessary, but can only arise from an approach to human data which is rooted in awareness of unconscious, irrational activity. Theories of personhood that acknowledge the existence of subjectivity and human meanings must use the kind of resources employed by psychoanalysis, particularly the personal meanings and subjective states of the researcher. 'Scientific' explanation of human conduct, if it is to be as full as possible, requires an extension of the

notion of science beyond empiricism and positivism. In answer to the general question of what, given this morass of subjectivity, can be the criteria for a 'good' theory as opposed to a 'bad' one, the answer must be: broader criteria than those which are simply empirical. These criteria will, for example, focus on human meanings, demanding the active spelling out of subjective and intersubjective processes, including acknowledgment of the location and feeling states of the 'researcher'. Such criteria can be rigorously pursued so as not to lead to mysticism. For example, the activity, regularly required in psychoanalytic supervision, of spelling out the countertransference processes that have led to an interpretation being made can be built on as a source of information about the grounds for a particular judgement or claim. This is potentially public information, open to a certain degree of scrutiny, even if it is also rooted in the subjective processes of the analyst. As will be obvious from this, the utilization of such sources of information requires skills which are traditionally located outside science as narrowly conceived, including the interpretive and literary skills which hermeneutic study has often privileged. More demandingly, it also requires skills of self-reflection and personal knowledge by which the investigator, whether clinician or researcher, demonstrates that her or his own feeling states have been engaged with and understood.

Notes

1 The arguments in this chapter are developed in S. Frosh, *For and against Psychoanalysis* (London: Routledge, 1997).
2 Sigmund Freud, *New Introductory Lectures on Psychoanalysis* (1933) (Harmondsworth: Penguin, 1973), p. 219.
3 Ibid. p. 193.
4 Ibid.
5 Ibid. p. 195.
6 E. Gellner, 'Psychoanalysis, social role and testability', in W. Dryden and C. Feltham (eds), *Psychotherapy and its Discontents* (Milton Keynes: Open University Press, 1992), p. 43.
7 E. Gellner, *The Psychoanalytic Movement* (London: Paladin, 1985), p. 53.
8 Ibid. p. 83.
9 Ibid. p. 164.
10 A. Grünbaum, *The Foundations of Psychoanalysis: A Philosophical Critique* (Berkeley: University of California Press, 1984).
11 Ibid. p. 6.
12 Ibid. p. 109.
13 Ibid. pp. 139–40.

14 I have reviewed some of this material at length in Frosh, *For and against Psychoanalysis*.

15 Sigmund Freud, *Introductory Lectures on Psychoanalysis* (1917) (Harmondsworth: Penguin, 1974), p. 452.

16 Sigmund Freud, 'Negation' (1925), in *On Metapsychology* (Harmondsworth: Penguin, 1984).

17 Grünbaum, *Foundations of Psychoanalysis*, p. 277.

18 O. Kernberg, 'Validation in the clinical process', *International Journal of Psycho-Analysis*, 75 (1994), pp. 1195–6.

19 For example: 'Effective conflict resolution turned out *not* to be necessary for therapeutic change. An almost overriding finding was the repeated demonstration that a substantial range of changes was brought about via the more supportive therapeutic modes cutting across the gamut of declared supportive *and* expressive therapies, and these changes were (often) indistinguishable from the changes brought about by typically expressive-analytic means.' R. Wallerstein, *Forty-Two Lives in Treatment* (New York: Guilford, 1986), pp. 304–5.

20 'We now seem to know all at once what the difference is between a conscious and an unconscious presentation . . . The conscious presentation comprises the presentation of the thing plus the presentation of the word belonging to it, while the unconscious presentation is the presentation of the thing alone.' Sigmund Freud, *On Metapsychology* (1915) (Harmondsworth: Penguin, 1984), p. 207.

21 E. O'Shaughnessy, 'What is a clinical fact?', *International Journal of Psycho-Analysis*, 75 (1994), p. 941.

22 D. Spence, *The Freudian Metaphor* (New York: Norton, 1987), p. 91.

23 Ibid. p. 111.

24 Ibid. p. 112.

25 P. Ricoeur, *The Conflict of Interpretations* (Evanston, Ill.: North Western University Press, 1974).

26 C. Strenger, *Between Hermeneutics and Science: An Essay on the Epistemology of Psychoanalysis* (Madison, Conn.: International Universities Press, 1991), p. 42.

27 J. Habermas, *Knowledge and Human Interests* (London: Heinemann, 1975), p. 261.

28 Grünbaum, *Foundations of Psychoanalysis*, p. 27.

29 R. Steiner, 'Hermeneutics or Hermes-mess?', *International Journal of Psycho-Analysis* 76 (1995), p. 441.

30 J. Flax, 'Psychoanalysis and the philosophy of science', *Journal of Philosophy*, 78 (1981), p. 566.

31 J. Flax, *Thinking Fragments* (Berkeley: University of California Press, 1990), p. 66.

32 For example, Klein describes the way the 'epistemophilic impulse' is derived from the desire to explore the inside of the mother's body and is derived from anal-sadistic wishes to appropriate the contents of the womb. See M. Klein, 'Early stages of the Oedipus Complex' (1928), in J. Mitchell (ed.), *The Selected Melanie Klein* (Harmondsworth: Penguin, 1986), p. 72.

33 Flax, *Thinking Fragments*, p. 53.

2

Just, Lasting, Comprehensive

Jacqueline Rose

The title of this chapter is taken from the repeated formula for political settlement in the Middle East. It is taken, secondly, from the fact that justice is so difficult – one could say 'impossible', but that would be too easy – to talk about. Justice is one of those terms which excites the most passionately committed investment but which, almost in proportion to that investment, seems hardest to actualize on the ground. Nowhere does this seem more vivid or pertinent than in South Africa and Israel/Palestine, whose haunting presence inside and on the margins of English literature and culture will be my theme. As I finished writing this essay in its original form as a lecture in April 1994, within days of each other the first non-racial democratic elections took place in South Africa, and Israel and the PLO signed their accord. It is not to underestimate the historic significance of both of these events to say that, in both cases, justice had only – and in the case of the Middle East Agreement, I would say, barely – begun.

Justice could be called an ideal, but the word is too bland; it settles the tension between wish and actuality, desire and embodiment, in advance (an ideal is only ever an ideal). We could call it rhetoric, but that would be to ignore or override too quickly the whole tradition, starting with *The Republic*, which pits justice against rhetoric as the mere play of empty verbal form. It might be called a performative, but it is rather the opposite: talking won't do it; say it and its substance seems just as likely to vanish or drift away. Justice may not be mere rhetoric, but there is no term quite like it for forcing our attention onto the possible gap between word and deed; no word which threatens so dramatically to empty itself of content at the very moment when it is declared. Whenever the word justice is spoken, you always have to look again. Justice always makes us suspicious. Whoever speaks it, chances are someone else is being conned.

I would prefer to call justice a fantasy, but on condition that fantasy is not understood as daydream, delusion, degraded desire. If the argument of this chapter is that the best way to think about justice is as fantasy, it is not because justice is something we cannot aim for, something by definition impossible to achieve. Nor is it because fantasy is something locked into private territory: your secret, my shame. Like morality or virtue, fantasy shapes the contours of our political worlds. It breaks through the boundary separating inner and outer space. To think of fantasy as private *only* is a form of possession; holding on to our fantasy, we blind ourselves to the way it circulates and empowers itself in other more public, collective domains. This chapter therefore reverses the psychoanalytic dictum that the patient acts out her or his fantasy in real life as a way of disowning the private, guilty fantasy-life of the mind. For you could just as well say the opposite (the two are in a sense the obverse of each other) – that the fantasy *of* fantasy as mine and mine alone is no less denial; going back in the other direction, we flee our potential and actual political selves. Frozen, on hold, in retreat. That fantasy is only a private matter is perhaps the supreme fantasy, fantasy *par excellence*.

The issue of justice hovers on the edge of literary debate. Changing the canon, voicing the silenced, becoming visible, tearing the veil (two of these are the tides of early feminist anthologies[1]) – each move, each formula, models itself at least partly on the discourse of rights. To whom have we denied a hearing? With what history of oppression have we been complicit by not noticing, not allowing the ghostly political subtext of this hitherto revered piece of writing to be read? When critics respond by arguing that politics should be kept out of literature, aren't they none the less, one way or another, sharing the same language, entering the same terrain? Studying literature, as one argument goes, is no way to redeem injustice – the wish is inappropriate, the activity unequal to the task (much of Stanley Fish's case in his 1993 Clarendon lectures could be encapsulated in the slide between these two).[2] Let literature and justice go their separate ways. Above all, when you read a piece of literary writing, do not *judge*. Judgement and judicious reading are incompatible. Writing of the feel for language essential to the second, Iris Murdoch states: 'Developing a *Sprachgefühl* is developing a *judicious* respectful sensibility to something which is very like another organism' (my emphasis).[3] How do you take the just measure of a text?

Somewhere in all these questions there hovers another, perhaps

founding, distinction – the conviction that you can only give litera-
ture its due (justice *for* literature) by detaching it from the sphere of
rights. Along not wholly dissimilar lines, Derrida describes justice
as an 'experience of the impossible': 'A will, a desire, a demand for
justice whose structure wouldn't be an experience of aporia would
have no chance to be what it is, namely, a call for justice.'[4] As a call,
justice is always suspended along the path of its anticipation, which
means that it is incalculable (requiring us to 'calculate with the in-
calculable') whereas law *(droit)* 'may find itself accounted for'.[5] But
if you follow this path and set the incalculable infinity of justice
against the regulated and coded prescriptions of rights, you run the
risk of reinforcing the link between literature and justice, by placing
them together beyond all measure, out of all legal and historical
bounds.

What are the links between justice, rights, and literature? Amos
Oz writes in judgement of his nation – by his own acknowledgment
the more it fails the more he writes;[6] but in the name of a found-
ing ideal of justice which, for all its violations, Israel never ceases
in his eyes, at least potentially, to represent. Oz's characters fall
ill, sink into despair, go mad on Israel's behalf. Their pathos is
Israel's saving grace. Cradling the nation's unconscious, however
ugly, in his writing, Oz redeems its soul. But justice on these terms
is partial; it can never go across fully to the other side. Solipsistic,
non-exchangeable, the very agony of justice means that it cannot
fully be shared. Only the Israelis have the privilege of justice as an
object of mourning; as if for the Arabs justice is never desire or di-
lemma, only pure need or demand. In this sense, Oz's passion, what
moves the writing in both senses of the term, undermines his own
claim for justice by letting it do only half its work. In *The Black
Box,* Michael Sommo writes to his stepson: 'In their Koran it is writ-
ten: the faith of Mohammed by the sword. And in our Torah it is
written: Zion shall be redeemed by justice. That's the whole differ-
ence. Now you choose which of the two suits you better.'[7] Or in
Oz's own words: 'We have become specialists in Arab mentality . . .
Force is the only language the Arabs understand.'[8]

For Wulf Sachs, a Jewish Lithuanian émigré in South Africa in the
1930s and 1940s, psychoanalysis is a discourse of justice, since it can
be used against scientific racism to show that the black and white
unconscious are the same. Even more, as his narrative progresses,
psychoanalysis crosses completely over and, via *Hamlet* (which you
might have thought would have saved it from so crude a political

destiny), passes into the service of a revolutionary ideal. 'Curing' the native diviner, John Chavifambira, means for Sachs releasing him into political agency on behalf of his race. Sachs's difficulty is, in a sense, the mirror of that of Amos Oz. Too little identification in the first instance which in the second becomes too much; even if Sachs is on the side of black liberation, it is still his psychic agenda, still therefore an appropriative gesture, which is involved.

Who, then, speaks for justice? Or to put it another way, what happens to the language of justice, is it in fact viable, when it appears in the mouth of someone other than the one claiming their own rights? Can you ever speak for justice on somebody else's behalf? When Kazuo Ishiguro adopts the voice of the English serving class and lets the butler tell his story in *The Remains of the Day*, he makes this issue the formal wager of his writing. The servant who was silent in the face of appeasement – who appeased the appeaser, we might say – now speaks. Speaks for his own class: the very fact that he achieves self-representation is an answer of sorts to the threat to democracy posed by the Second World War (it is much clearer in the book than in the film that, while the master spoke of justice, the rights of the servant were threatening to slip away). But – and here's the catch – he also speaks for the dishonoured class which right to the end he continues so honourably to serve. This is the irony, or what could be called the 'illocutionary' paradox of democracy for the oppressor class. Give voice to the oppressed, the hitherto unrepresented, and the risk is that they will endlessly reiterate your own shame.

So can you ever speak for justice on someone else's behalf? This might give another colour to the opposition between justice and rights in relation to contemporary literary debate. Perhaps one reason why there has been so much resistance to letting rights into writing is because it opens up this zone of uncertainty. If we take on the new agendas of literary studies, it is not in 'our' name or for 'our' own cause that 'we' speak (I use 'our' and 'we' advisedly and in quotes to mean not in the name of the critics who until recently had the monopoly of the profession). It is the classic dilemma of liberalism that, however crucial the gesture of solidarity, your voice might be the last one in need of being heard. The fact that most of the above writers do not belong unequivocally in one place, nation or history complicates the issue. But we have moved too fast, I would argue, if we think these forms of diversity and multiple belonging can simply do away with or cure the fundamental unease.

Another way of putting the question – who speaks for justice? – would be to ask instead how, or whether, the language of justice can be shared. This seems to be the question, or lesson, to be drawn from the Middle East Peace Process whose reiterated formula – just, lasting, comprehensive – provides the title of this chapter. Take the three terms together as they now often appear ('just' and 'lasting' first appear in the 1967 Security Council Resolution 242, the third in a 1977 joint declaration on the Middle East by the US and USSR), and it is their combined weight and finality which is so striking.[9] Let justice be done – completely, once for all. You can read them as equivalents ('just' *and* 'lasting' *and* 'comprehensive'), as progressive qualifiers (an all-inclusive justice that will endure), or as tautological (if justice is not comprehensive how could it be just?) In the words of the 1977 Joint Statement, comprehensive means 'incorporating all parties concerned and all questions'. 'Incorporate' seems apt. As one psychoanalytic account has it, you incorporate something by devouring it; unlike introjection, where you take someone in as part of yourself but recognize them as separate, still let them be.[10] As if it were being inadvertently acknowledged that so total a justice, instead of leaving the world standing, would simply swallow and abolish all differences, wipe out all parties to the deal.

It is a point often made in Critical Legal Studies that the language of contract is inherently self-deceptive. Roberto Mangabeira Unger, key proponent of the movement, sees the language of contract as containing a fundamental contradiction between freedom and power: 'The mechanisms of egalitarian, self-interested bargaining and adjudication cannot be made to jibe with the illiberal blend of power and allegiance.'[11] The modern law of contract 'preaches equality in distrust'.[12] Unger's point is part of a larger historical argument about rights. In pre-revolutionary aristocratic and corporatist Europe, rights were meant to 'exhibit on its surface the gross structure of society, like those Renaissance buildings whose facades transcribe their internal design'.[13] Modern legal thought begins when rights detach themselves from the social structure and become a universal category for describing the possible relations between citizens (the transition from special to equal rights). To these two founding moves in the history of rights, critical legal theory adds a further twist. No longer a reflection of social hierarchy nor its transcendence, the discourse of rights today serves above all to *deny* the constitutive forms of social inequality on which it rests. In critical legal parlance, the language of rights is most likely to provide cover for evasion; at the

very least it is unequal to the forms of inequality which it attempts to mediate, travel across, or resolve. As Judith Shklar puts it in *The Faces of Injustice,* in an unequal society the law falls unevenly on the desperate and the powerful, hence justice serves injustice, 'which has an exuberant life of its own'.[14] Or in the words of Sir Thomas Bingham, Master of the Rolls: 'We cannot forever be content to acknowledge that in England justice is open to all, like the Ritz Hotel.'[15]

Far from being an argument for abandoning the discourse of rights, Unger's manifesto is more a plea for exposure (a psychoanalytic argument, one could say). Whenever someone or something – resolution, declaration – says 'rights', look for what is not being said (ever since Pierre Macherey at least, this is something that critics and students of literature have been trained to do). Go from here back to UN Security Council Resolution 242 on the Middle East.[16] This is the resolution which calls for Israel's withdrawal from the occupied territories, hence its importance for so long. But read its silences. You will then find that 'rights' means the right of every state in the area to 'live in peace within secure and recognised boundaries free from threats or acts of force'; but the word Palestinian does not appear. The expression which does appear, 'just settlement of the refugee problem', does not specify *who* are the refugees. There is in fact no mention whatsoever of political rights in the sense most commonly understood.

If Palestinian rights are not named, then the phrase 'every state in the area' cannot include, not even potentially, a state of Palestine. Since the law against deportation under the Geneva Convention can be invoked only by states and not individuals, this has meant, amongst other things, that no stateless Palestinian can make use of it.[17] 'Every' is therefore a totalizer that veils an exclusion. In this case, the term 'just' provides cover for injustice; the term 'lasting' is there as the gesture towards a possibility which, because it is ruled out by the language, cannot even begin.

Only in 1974, a week after Yasser Arafat gave his historic address to the United Nations, does the expression 'inalienable rights' of the Palestinians, including self-determination, national independence, and sovereignty, appear in General Assembly Resolution 3236.[18] Not until the 1993 Declaration of Principles is the compound 'Palestinian people' used for the first time.[19] According to Israel Shahak, talking in 1975, if you used the word 'Palestinian' in Israel you were 'already half a rebel' ('usually you say 'Arab'').[20] The 1993 Declara-

tion states that elections in Jericho and Gaza 'will constitute a significant interim preparatory step toward the realization of the legitimate rights of the Palestinian people and their just requirements'.[21] 'Interim', 'preparatory', 'toward' – how many qualifiers of 'realization' can you find? (It is now acknowledged that at this point neither Rabin nor Arafat want the elections to take place.) As many commentators have pointed out – Edward Said has been foremost among them in the West – all mention of the 'occupation' has been dropped.[22] By omission, the declaration also spells the end of the right to return of the 1948 refugees (a right confirmed annually since the 1948 adoption of Resolution 194 by the UN): 'Their plight seems to be forever deleted from the lexicon of the Middle East ... it's time now to master the art of forgetting.'[23] In fact, as Rabin announced to the Knesset in May 1994, the final terms of agreement ensured the return neither of the 1948 nor of the 1967 refugees.

Like Resolution 242 which was, according to Noam Chomsky, left 'intentionally vague', the Oslo Declaration is formulated, in the words of Hanan Ashrawi, so that 'every side interprets it in his own way'.[24] Even vagueness, however, can be unequally distributed: 'In order to comprehend the real meaning of the Oslo accords ... refer to its text, which is purposely vague on issues of Palestinian rights while precise on issues of what power Israel will retain.'[25] Or in the words of one of the Kibbutzim interviewed by Oz in 1987 on the possible outcome of the Lebanon war (Israel invaded in 1982): 'We might just come out from this deal with a comprehensive, total peace, on our own terms.'[26]

None of this is to ignore, it should be stressed, the real issue for Israel, although not only for Israel, of secure and recognizable boundaries. But look again here and another version of the same problem appears. How, as Abba Eban, Israel's Foreign Minister put it in 1968, can you base the possibility of peace on secure boundaries when dispute over the boundaries is the major obstacle to peace?[27] How can you withdraw to the *status quo ante* when 'there is nothing normal or established or legitimate to which to return'?[28] How can peace be 'juridically expressed, contractually defined, legally binding'[29] when the foundations of contract – two parties to a deal – could only be the effect, and not the presupposition, of peace?

Above all, running under all of this there is a fundamental problem which no language – not of rights nor of justice – can resolve. It is one which has a particular resonance not only in the Middle East but also in central Europe today. And that is the problem of how the

grounds of national entitlement can ever be definitively secured. For if national assertion is precisely *self*-affirmation, it rhetorically and ritually blinds itself to the other on whose recognition its claim finally depends. In his 1976 essay 'Rights, Law and Reality', Yeshayahu Leibowitz writes: 'Fortunate is the people whose conception of its tie to its country is recognized by others, for should this connection be contested, no legal argument could establish it. . . . Considerations of historical "justice",' he continues, 'are irrelevant. The conflict is not one of imaginary "rights". Nor is it a clash "between Justice and Justice" – since the legal (or moral) category of justice does not apply.'[30] (Oz, who has often described the Israel/Palestine conflict as one of 'right' against 'right', qualifies this in 1992 as 'claim' against 'claim' precisely because of this problem of recognition).[31]

Leibowitz's comment does not, in fact, in his terms, spell the end of justice. His remark is specifically addressed to those who justify Israel's existence in terms of a historico-religious or immemorial right to the land: 'an eternal right that cannot be called into question', in the words of the Knesset Fundamental Policy Guidelines of 1981 (the ultimate unnegotiable right, one might say).[32] Nor does it prevent him from proposing his own solution; he ends his article by calling for the partition of the country into two nations. Rather, what I take from his comment is the way it underlines the subjective, imaginative component of national belonging. Not just in the sense of imagined communities as famously defined by Benedict Anderson, but in terms of recognition.[33] Whether I – or we – can be a nation depends on your desire. The viability of a nation does not rest with its own self-imagining, but on whether the other can (chooses, wants) to recognize *me*. We have entered the terrain of political fantasy, or rather of fantasy as it works its way underneath the political terrain. Above all, we have entered a realm where justice cannot be protected from the vagaries of conscious and unconscious desires. As Unger puts it in his discussion of legal indeterminacy, 'complexity, especially in the form of ambivalent or conflicting desires, must be kept under control.'[34]

So we might put the last question – 'Can justice be shared' – differently again, What is a just subject, or rather, what does justice assume or require a subject to be? It might be only at this level that justice could be called a performative, because of the image of subjectivity which has to be mobilized or called immediately into action whenever justice is evoked. Does justice have to assume a subject who is already somewhere just? The insane man, Socrates argues in

The Republic, is beyond the bounds of justice: if a sane friend lends you a gun, goes mad, and asks for it back, you don't comply; nor do you tell the whole truth to anyone who is out of his mind.[35]

Critics have often commented that John Rawls's famous theory of distributive justice relies on a very specific concept of the mind. In a recent article in *Critical Inquiry*, he extends the theory to the law of peoples.[36] As with his earlier theory, the participants are to operate under a veil of ignorance – they do not know in advance 'the size of the territory, or the population, or the relative strength of the people whose fundamental interests they represent'.[37] An unlikely scenario but one which precisely introduces an element of the speculative, or indeed fantasmatic, into justice. Justice, Rawls seems to be suggesting, has first of all and before anything else to take a purely disembodied place in the mind (critics who reject the whole project on the grounds that the starting premise is unimaginable have therefore missed the whole point).

Seen in these terms, the problem with Rawls is not that he starts way out in the blue, but that he does not go far enough. Once you usher the subjective component into justice, recognize its already constitutive place, why on earth should anyone be *reasonable* about it? Look at that starting premise again. Rawls's actors may be suspended in space and time, but they are absolutely self-identical, utterly *sure* of themselves. His so-called ignorance is disingenuous, not to say knowing, at least about what is going on inside everyone else's head. Everybody is 'reasonably situated and rational', 'deciding in accordance with appropriate reasons' – hence no ugly surprises, no mistakes.[38] The problem, however, is that, if this is true, then the people have already submitted to the moral law and this is already a perfect world: 'more than any other doctrine', Rawls states, the doctrine of this law 'ties together our considered political convictions and moral judgements at all levels of generality, from the most general to the most particular, into one coherent view'.[39] Compare Socrates: 'Hardly anyone acts sanely in public affairs.'[40]

Could there be something crazy about justice? This may sound like a somewhat crazy suggestion, but it is a way of drawing attention to the almost maniacal insistence on reasonableness that justice as a concept seems to provoke. 'The special assumption I make', Rawls states in his original *Theory of Justice*, 'is that a rational individual does not suffer from envy.' (A big assumption if you are talking about the law of nations since envy and nationalism are often blood-brothers: 'a panacea for nagging doubts, a way of coping with

envy').[41] Justice has to – how could it not? – aim for reason; but the fact that it is something we yearn for suggests that it belongs as much to our passionate as to our enlightened selves. 'They are in the right because I love them,' Jean Genet writes of the Palestinians, 'which is not to say', he adds, 'that justice has no role.'[42] But once that much has been granted, then we are up against the vagaries of desire for which contract has no place, and the partial insanity of our own self-relation which distributive justice inside nations and between peoples has to disallow. So, to put the question another way, what kind of object is justice inside the mind? What does justice (remember what does a woman) want?

Ironically, it might be that justice becomes harder to actualize the more the emotive, refractory, subjective dimensions of justice are denied (this would be the opposite of, although not unconnected to, the injunction – most often issued to feminism – that the best way to advance a cause is to 'keep emotions out of it'). But the point here is not that human beings are really unjust and selfish, an assumption which Rawls in a sense starts from and which is also the unspoken bastion of Conservative ethics. This is not an argument about the necessity, in the service of justice, of taming human desires (which assumes those desires to be more or less consistently aimed at my own advantage or good). What is at issue here is a far less cohesive, more slippery idea of subjectivity, one which starts from the assumption that subjects can be, and nowhere more than in the sphere of morality, riven – or driven, even – against themselves. Are we always on our own side? Are we, indeed, always just to ourselves? Arguing against what she calls Aristotelian common sense, Judith Shklar writes: 'We blame ourselves for acts we did not perform and feel guilty for imaginary faults. We punish ourselves irrationally.'[43] (She is also arguing against Aquinas, who said that no one ever willingly hurts themselves.)

By calling her book *The Faces of Injustice*, Shklar places the whole issue of justice in the framework of desire. Set justice, not in opposition to rights, but to injustice, and you are up against an 'irreducibly subjective component that the normal model of justice cannot easily absorb'.[44] To ask what injustice feels like seems obvious – in fact injustice is often unrecognizable except as a subjectively registered state. But it feels weird, to say the least, to ask the same question of justice ('how was it for you?'). If there is always a risk that revenge will get the better of justice, it might be, she suggests, because in the case of justice there is nothing like the same kind of pleasure involved.[45]

Justice and injustice are not 'psychologically complementary or symmetrical';[46] they neither fully cancel each other out, nor quite add up. Justice may be sought after, but it is also eminently forgettable; unlike injustice, which nobody asks for but which never goes away. Nothing establishes the psychic component of injustice more clearly than racism because of the factor of humiliation involved – a factor supplementary even if attached to the issue of rights.[47] (By trying to make pornography a civil offence against the rights of women, Catherine McKinnon, I would argue, confuses the two: systematic degradation does not necessarily involve the deprivation of rights.) Many of Nelson Mandela's speeches both before and after the 1994 election could be read in these terms, as his bid to stop the legacy of past injustice in South Africa from playing effective and affective havoc with the attempts, however partial and tentative in the first instance, towards a more just and equal world. Forgive, but above all do not humiliate the enemy – however unjust he once was (it is this which Desmond Tutu refers to as the 'miracle' of post-apartheid South Africa and one of Slovo's obituarists as the 'astounding metanoia and reconciliation which South Africa was to undergo').[48]

By stressing the passionate, subjective dimension of justice, I am, however, trying to point to something beyond, or not fully graspable, by the moral philosopher's vision of desire. To call subjects self-riven can imply stubborn but endearing contrariness; or it can imply, as with psychoanalysis, a far more radical cleavage of the soul. What does justice look like if you introduce into this discussion the idea of the unconscious? So far fantasy has been used in this chapter to signal those moments where the language of justice follows the path of the super-rational supra-sensible ego, magically inflating and fulfilling *itself* (in the words of Stephen Greenblatt, talking of the earliest colonial ventures: 'a self-authorizing, self-authenticating representation . . . that intensifies imaginative possession of the world').[49] But fantasy also has an almost exactly opposite meaning; it can just as well refer to the point where the subject 'vanishes' or 'fades' into the unconscious (to use Lacan's terms), to all those dimensions of subjectivity which most dramatically escape the ego's thrall. What happens, in the field of justice, if you use this second meaning of fantasy to call the bluff on the first, as a way of countering fantasy's masterful delusion of itself?

For many involved in recent literary and cultural theory, it has become customary to turn to psychoanalysis for a radical critique

of sexual norms. The idea of a bisexual unconscious can serve nicely to upset the stifling language of heterosexual normality which does service for virtue in so much of the bankrupt, moralizing discourse of the modern world. It might be, however, that all that (welcome) attention to the throes of sexuality has meant that those of justice have been left curiously unexamined and ex-posed: 'The require-ment . . . that there shall be a single kind of sexual life for everyone,' writes Freud in 'Civilisation and its Discontents', 'cuts off a fair number from sexual enjoyment, and so becomes the source of seri-ous *injustice*' (*Ungerechtigkeit*).[50] And yet, as he himself puts it only a few pages earlier, for a law to be just (*Gerechtigkeit*) it *must* be universal, that is, broken in no one's favour; although this tells us nothing, he adds, about the ethical value of such a law.[51]

Sexual 'injustice' (his word) thus becomes the supreme illustra-tion of the gap between law and ethics; it shows universality as jus-tice and injustice at one and the same time. This is a paradox internal to the concept of justice, but one which it seems to me that, in our keenness to use psychoanalysis to champion an 'other' sexuality against the dominant, some of us have overlooked. Or to put it an-other way, in turning to psychoanalysis as a potential discourse of justice, might we have inadvertently ignored what psychoanalysis itself has to say about the difficulties – no less complex than those relating to sexuality – of justice itself?

A long time ago, a friend suggested that it was so much easier to be a Marxist than a Freudian because whereas, whatever your social origins, you could wake up one morning and more or less decide to be on the side of the working class, you couldn't quite in the same way decide one morning that from that day on you would throw off all inhibition and be sexually free (or rather you put a somewhat different set of demands on yourself if you did). There is a strange belief underlying moral injunctions that inappropriate desires, whose entire 'rationale' is that they defy best intentions, can be sweet-reasoned away. 'Be good sweet maid and let who will be clever' – as I look at that formula today (one whole strand of my life could fairly be summed up as a rebellion against it), it is not just its discouraging chauvinism which seems so offensive, but its assumption, no less fraudulent, that being good is something easy or straightforward to be.

From where does the inner sense of morality arise? This would seem to be a rather important question for women, since if you are a girl it is somehow assumed that it arises spontaneously from the

inside; whereas what is involved for boys is obedience to an external
social law they will themselves finally appropriate and represent (this
is one reason why any feminist argument that starts by assuming
women are inherently more virtuous makes me so uncomfortable).
In this context it becomes a strength rather than a weakness of Freud's
writing that he finds it so difficult to give an adequate account of
how any of this comes about. Morality and justice, he writes in 'Mo-
ses and Monetheism', 'came about with a *renunciation of instinct*'
(emphasis original).[52] But, as has often been pointed out, this begs
the question, since presumably you will only renounce instinct if
you have already bought into societal values and accepted a non-
instinctual ideal. We can dismiss this as a flaw of psychoanalytic rea-
son, but it might also help to explain why the moral life is so hard to
achieve. It is because there are no grounds, no good, earthly reason
to obey you, that you bring your weight to bear on me with such
unjustified – unbearable – force.

For psychoanalysis, this is a problem structural or inherent to
moral law. Failure is never therefore just individual failing; it is al-
ways at the same time a measure of the impossibility of what is be-
ing required. Failure in this context is suggestive and provocative.
Rather like the impossibility of femininity, or indeed of Jewish na-
tional identity (indeed it could be argued that both these forms of
pained but strategic failing take their orders from the first). 'The
cultural super-ego . . . does not trouble itself enough', Freud states,
'about the facts of the mental constitution of human beings.'[53] It
doesn't bother to ask whether its commandments are possible, psy-
chically, to fulfil. Listen again, he suggests, to one of the 'ideal de-
mands' of 'civilized society': Love thy neighbour as thyself. Adopt
a naive attitude as though you were listening to it for the first time,
and 'we shall', he predicts, 'be unable then to suppress a feeling of
surprise and bewilderment': 'Why should we do it? What good will
it do us? But, above all, how should we achieve it?'[55] My love is
precious to me, the result of the finest discriminations, selections,
and histories, without which, in some sense, I cease to be. I diminish
it, and myself with it, if I offer it to every comer on the ground. 'A
love that does not discriminate [does] an injustice [*ein Unrecht*] to
its object.'[55]

Furthermore, it is only on the basis of such fine and self-defining
discriminations that collective identities are made: 'My love is val-
ued by all my own people', Freud continues, 'as a sign of my prefer-
ring them, and it is an *injustice [ein Unrecht]* to them if I put a stranger

on a par with them.'[56] 'The commandment, "Love thy neighbour as thyself" is . . . an excellent example of the unpsychological proceedings of the cultural super-ego. The commandment is impossible to fulfil.'[57] Or in the words of the Umbro football poster which appeared all over London in the summer of 1994: 'God says Love Thy Neighbour. Sorry God.'

This superego is a cruel taskmaster (necessarily, given the Sisyphean nature of its task). You cannot dispense with the problem of cruelty by obeying it because of the ferocity with which it imposes its ideals. Like Kant's categorical imperative, it is something of a fanatic ('Kant's imperative reeks of cruelty', 'it is a hanging judge seated within the mind').[58] Writing on the moral sense, the feminist moral philosopher Annette Baier proposes Aristotelian cultivation of virtue in the young as an alternative to a moral law which 'has to be burned in, and which tends to provoke return aggression, or more strongly working poisons' (in fact she places Freud alongside Aristotle on the side of more benign, albeit costly, forms of correction, but this is in fact a perfect description of the superego at work).[59] A line from the notes of Alexander Gideon, a character in Amos Oz's *Black Box,* captures something of the tone: ' "Thou shalt love thy neighbour as thyself" – at once or we'll fill you full of lead' (he is writing about fanaticism, but only just).[60] As if in reply, the young Israeli poet Sami Shalom Chetrit, cited by Ammiel Alcalay as representative of the new generation of 'Oriental' Jewish writers, ends his twenty-nine-stanza poem on the *intifadah* – 'Hey Jeep' – with 'but thou shalt love thy neighbour as thyself' reiterated, dully, pointedly, vacuously, thirteen times.[61]

Furthermore, the superego dispenses its moral favours unevenly, without ratio, since the more you obey it the more you feel answerable to its judgements (conscience torments the saint far more than the sinner, virtue is not its own reward). The superego draws its energies from the same unconscious impulses it is intended to tame; it turns against the ego the very force with which the ego strains to reject its commands (this gives a whole new meaning to the idea of a punishment that fits the crime). Superego and unconscious are antagonists, but they also have the most intimate, passionate relationship with each other: dedicated combatants, tired and devoted cohabitees. There is, as has often been pointed out, something sadistic about this version of morality. Enter this zone of punitive pleasures, and who, we may ask, is punishing, who pleasuring, whom?

Certainly, there is nothing in this account that will submit to a language of contractual negotiation which presupposes the rationality of the rules, or of the participants, in advance. Playful, perverse, savage – to call justice a fantasy in this context is to say no more nor less than that it is the supreme target and embodiment of our social aspirations, our most exacting ideal. Or, to put it another way, there is no ideal without fantasy, no shortcut through the trials of fantasy to the realization of our political dreams.

When justice attempts such a short-circuit, it threatens to destroy everything, including justice itself. These lines are from the Israeli poet Bialik, cited in *The Land of Israel* by Amos Oz:

> If there is justice, let it be seen at once.
> But if after I am desolated under the heavens,
> justice should appear,
> let it be destroyed for ever.[62]

He then makes the link to the slogan 'Redemption Now' of Gush Emunim. Redemption, justice, now, or redemption and justice can go to hell. Justice on these terms is apocalyptic. Like the cities of the old Mediterranean described by Alcalay: 'bracketed off in expectation of either perfect time and the final correspondence of words and things, or the aftermath of global disaster'.[63] Perfection courts disaster ('peace everlasting . . . take the world by storm').[64] As soon as justice becomes its own ultimatum, it gets vicious, hell-bent on fulfilling itself (the only frame, perhaps, in which the idea of an 'end of history' makes sense). During the 1983 Jerry-Falwell-sponsored tour of the Holy Land, Grace Halsell interrogated one of the Christian Zionists about the 'new Jerusalem' they anticipate and yearn for, the final Armageddon in the plain of Esdraelon when two-thirds of the Jews living in the region will be 'purged'; she was told that once eternity begins, 'after that there are no more sequences of events'.[65] In the words of Max Weber:

> the adherent of an ethic of ultimate ends suddenly turns into a chiliastic prophet. Those, for example, who have just preached 'love against violence' now call for the use of force for the *last* violent deed, which would then lead to a state of affairs in which violence was annihilated . . . The proponent of an ethic of absolute ends cannot stand up under the ethical irrationality of the world.[66]

For similar reasons, totalitarianism cannot be placed on the other side of justice as if it had no investment in it, as if justice was not one of its main concerns: 'Totalitarian lawfulness', writes Arendt in *The Origins of Totalitarianism,* 'pretends to have found a way to establish the rule of justice on earth.'[67]

In this context, the point of the turn to psychoanalysis is that it tears a rift in this vision of justice, opening up an aporia in our social, moral being no less radical than that affecting our sexual identities, the ones which the culture most coercively presumes to know. Against that presumption, that knowledge, we have been happy (some of us) to take on the concept of the unconscious, to tie sexuality to perversion, or rather to break down the distinction between the two. But the perverse component of justice? What good – to echo Freud's query about 'Love Thy Neighbour' – will it do? Unless we turn that question round – the classic psychoanalytic move – and ask instead: What might an account of justice look like that included that perverse component in its terms, one which allowed the most difficult psychic dimension of justice to be entertained? Can we demand justice without making a virtue of it? Could there be a theory of justice that does not require us all, miraculously and coercively, to be good (a recipe for disaster in my mind)? I desire justice; but not if it rules out the scrutiny of desire.

For you might instead argue that it is only when you try to expel desire from justice and start to believe in its absolute and total perfectibility (the second move only possible on condition of the first), that justice turns nasty and starts punishing the very world it was meant to save (it is not a belief in the possibility of reason, but over-investment in one's own sure possession of reason which is the trap).

There is a passing moment in *Whose Justice? Which Rationality?* when Alasdair MacIntyre argues that only psychoanalysis, notably that of Freud and Lacan, offers a cogent account of the 'schism' of the self which the liberal order has to repress and disguise (his words) in order to produce its 'false and psychologically disabling unity of presentation' (each individual a 'single, well-ordered will').[68] This is part of MacIntyre's overall project which started with *After Virtue,* his critique first of liberalism's assumption that there is a neutral ground from which competing claims to justice can be assessed; and then of the assumption behind that one, that justice and rationality can be understood independently, that theories of

justice do not always bring a very specific, historically variant account of what makes a reasoned subject in their train (hence his move from *After Virtue* to the project and title of this second book). But, as he sees it, psychoanalysis retreats from its insight into cure, patching up the liberal self by offering therapeutic solutions to an essentially historical problem: the demise of a liberal order, in itself the effect of a breakdown in consensual being to which it vainly tries to offer a solution, blind to the fact that its history has come to an end.

But supposing it is in the field of justice, far more than in the field of individual pathology, that the rational pretensions and curative aims of psychoanalysis could be shown most definitively to break down? As Freud himself acknowledged, the problem with the analysis of so-called social pathology is that, unlike the individual symptom, there is not even the pretence of a norm. You can at least argue as to whether the aim of psychoanalytic practice is the fortification of the ego as agent, or the release of the subject, against society's best (worst) moral intentions, into the vicissitudes of desire. But in Freud's account of how subjects take up their social identities, there is nothing to support what MacIntyre sees as happy, if misguided, liberal-social communing. Nothing to buttress a conviction that conflict in the modern world can be resolved in the sphere of pure reason alone ('each individual a single well-ordered will'). 'Ethics', Freud writes, 'is thus to be regarded as a therapeutic attempt – as an endeavour to achieve, by means of a command of the super-ego, something which has so far not been achieved by means of any other cultural activities.'[69] (This is to put the *placebo* delusions of therapy on the other, societal, foot.)

Psychoanalysis might then be seen as the unconscious of one specific liberal tradition, the one that by requiring – to use another of MacIntyre's own formulas – that we 'conceal the depths of our conflicts', social no less than psychic, makes it impossible for those conflicts, and above all for their *relationship*, to be acknowledged, let alone understood.

When Henry Louis Gates Jr delivered the lecture 'A Killing Rage – Black–Jewish Relations' in London in April 1994, his topic traced the historic and imaginative links between English culture, black, Palestinian and Jew.[70] Gates's lecture was a plea for an end to black anti-semitism and Jewish racism. It began with the problem of how collective guilt gets transmitted across generations, fixing and damn-

ing our political futures in advance, and ended with a call for the politics of identity (I know who I am) to be replaced by the politics of identification (I want to know you).

The politics of identity, one could say, shares all the problems of the particular version of liberalism just discussed. It is because the self it asserts against prior injustice remains forged in the image of reason, of false self-consistency – which is what it means to assert an identity – that it finds itself powerless in the face of identity's unreason, powerless to resolve the conflicts of allegiance, the incommensurable and often antagonistic demands that such a politics provokes. It is a problem which was invisible until the politics of identity actualized it so vividly (this is the opposite, note, of reacting to these new voices as if they had all the power and were on the point of taking over the world). But if you respond to this difficulty by calling for a politics of identification, then the question of what permits and forbids identifications, of what makes recognition (love of neighbour, for example) possible and impossible has to come next. Gates's crucial demand has to go further; his call for new forms of affinity, recognition, and identification ends exactly where, psychically speaking, we need to begin.

In May 1990, in an address to three hundred corporate businessmen, Nelson Mandela cited this famous speech of Shylock from *The Merchant of Venice*:

> hath not a Jew eyes? Hath not a Jew hands, organs, dimensions, senses, affections, passions? fed with the same food, hurt with the same weapons, subject to the same diseases, healed by the same means, warmed and cooled by the same winter and summer, as a Christian is? If you prick us, do we not bleed? If you tickle us, do we not laugh? If you poison us, do we not die? And if you wrong us, shall we not revenge? If we are like you in the rest, we will resemble you in that . . . The villainy you teach me, I will execute; and it shall go hard, but I will better the instructions.[71]

It was a stunning rhetorical move. Jews will undoubtedly have been present in his audience. Business and radicalism were the two main destinies of Jewish immigrants to South Africa (sometimes, as with Ruth First's family, both at the same time). But there is also a long tradition of anti-semitism in the country. When Daniel François Malan, founder of apartheid, introduced his Quota Bill in 1930,

limiting immigrants from 'non-scheduled' countries (Greece, Latvia, Lithuania, Poland, Russia, Palestine), it was generally recognized as an attempt, which proved successful, to halt the immigration of Jews. Since this was 1930, eighteen years before the official inauguration of apartheid, his speeches on this topic can be read as a rehearsal for what was to come: 'Nations desire to preserve homogeneity, because every nation has got a soul, and every nation naturally desires that its soul shall not be a divided one.'[72]

That, then, is the identification to which Mandela, citing those lines of Shylock, made his appeal: the line that links black to Jew as members, equally although distinctly of a persecuted race. A plea to remember, an attempt – in the words of Ammiel Alcalay – to turn 'the texture of memory ahead'.[73]

But Mandela's use of this speech was also a warning. It has another, more deadly potential future tense. From suffering to revenge, Shylock traces a curve which puts a stop, no less dramatically, to the very redeeming identification it seems to propose: 'and if you wrong us shall we not revenge? If we are like you in the rest, we will resemble you in that.' Mandela then took out these lines: 'If a Jew wrong a Christian, what is his humility? revenge! If a Christian wrong a Jew, what should his sufferance be by Christian example? – why revenge!' He took out the lines of the speech which show virtue – humility and then sufferance as ethos – turning violently inside-out on themselves. It would undoubtedly have complicated the argument. By leaving virtue standing, as it were, Mandela could communicate far more powerfully to this audience the extent to which their future actions would determine just how far it is at risk.

Of course, it has been the case for a long time that critics trying to defend Shakespeare's *Merchant of Venice* against the charge of anti-semitism have turned to these lines. But they tend to ignore the dark side of the message and of the humanity to which the Jew stakes his claim: that it is through self-perpetuating violence that oppressed and oppressor most often identify. It is too soon to say whether this political scenario has been averted in South Africa, although much of the energy is going towards making sure that it is. In Israel/Palestine, as I write this today, the conditions seem so unpromising that it is not even clear if the question can begin to be put. English life and letters have, of course, tended to purify themselves of all this. It has been the main purpose of this discussion to make the connection unavoidable for us all.

Notes

1 Claudia Koonz (ed.), *Becoming Visible: Women in European History* (Boston: Houghton Mifflin, 1977); and Sue Lipschitz, *Tearing the Veil* (London: Routledge, 1977).

2 Stanley Fish, 'Why literary criticism is like virtue', *London Review of Books*, 10 June 1993.

3 Iris Murdoch, *The Sovereignty of Good* (London: Chatto and Windus, 1970; Routledge, 1991), p. 90.

4 Jacques Derrida, 'Force of Law: The "Mystical Foundation of Authority"', in Drucilla Cornell, Michel Rosenfeld and David Gray Carlson (eds), *Deconstruction and the Possibility of Justice*, (London: Routledge, 1992), p.16.

5 Ibid.

6 Jonathan Freedland, 'A firebrand in the laundry', interview with Amos Oz, *Independent*, 4 September 1993.

7 Amos Oz, *Black Box*, (1987) trans. from the Hebrew by Nicholas de Lange in collaboration with the author (London: Chatto and Windus, 1988; Vintage, 1993), pp. 110–11.

8 Cited by Fouad Moughrabi, ('Arab Images in Israel', in 'Views from Abroad', *Journal of Palestine Studies* (Spring 1977), p. 167. It might be worth giving this quote in full: 'We have become specialists in Arab mentality. For twenty-seven years, every Jew, here in Hulda and in other places, has been a great expert on Arab mentality ... Force is the only language the Arabs understand. That's what they are like. Listen to me, I know them all the way back from Silberstein's orange grove in Nes Ziona in the 1920s.' Elsewhere Oz makes it clear that there is no symmetry between Israeli and Palestinian grievance: 'They say that the Arabs (Egypt excepted) have a 'Saladin complex' and the Israelis have a 'Masada complex' ... I reject this comparison. There is no symmetry between a destruction complex and an insecurity complex. ... Moreover, the Israeli insecurity complex is, to a large extent, a product of the ' "Saladin complex" of part of the Arab world.' Amos Oz, 'From Jerusalem to Cairo: Escaping the Shadow of the Past', (1982) in *Israel, Palestine and Peace* (London: Vintage, 1994), p. 41.

9 Yehuda Lukacs (ed.), *Documents on the Israeli–Palestinian Conflict 1967–83* (Cambridge: Cambridge University Press, 1984), pp. 1, 10.

10 Abraham and Torok, (1972) 'Mourning or Melancholia: Introjection versus Incorporation', in *The Shell and the Kernel*. First published as 'Deuil ou mélancolie, introjecter–incorporer', *Nouvelle revue de psychanalyse*, 6.

11 Roberto Mangabeira Unger, *The Critical Legal Studies Movement* (Cambridge, Mass.: Harvard University Press, 1983), p. 65.

12 Ibid.

13 Ibid. p. 24.

14 Judith Shklar, *Faces of Injustice* (New Haven: Yale University Press, 1990), p. 87.

15 Sir Thomas Bingham, 'Sayings of the Week', *Independent*, 7 May 1994.

16 Lukacs *Documents*, p. 1.

17 Rajeh Shehadeh, *The Third Way: A Journal of Life in the West Bank* (London: Quartet, 1982), p. 129.

18 Yehuda Lukacs, *Documents on the Israeli–Palestinian Conflict 1967–1983* (Cambridge University Press, 1984), p. 9.

19 *The Palestinian–Israeli Peace Agreement: A Documentary Record* (Washington, DC: Institute for Palestine Studies, 1993), p. 117.

20 Charles Glass and David Hirst, 'An interview with Israel Shahak', *Journal of Palestinian Studies* (Spring 1975), p. 15.

21 *The Palestinian–Israeli Peace Agreement*, p. 118.

22 Edward Said, 'The morning after', *London Review of Books,* 21 October 1993 id.,; 'Who is Worse?', *London Review of Books,* 20 October 1994; see also Robert Fisk, 'Remaining Issues', *London Review of Books,* 23 February 1995; and Anton Shammas, 'Palestinians must now master the art of forgetting', *New York Times Magazine,* 26 December 1993.

23 Ibid.

24 Jay Murphy, 'Interview: Noam Chomsky', *For Palestine* (1993), p. 229; 'I know that they are tapping my phone: interview with Hanan Ashrawi', *Yediot Ahoronot,* 17 December 1993.

25 Israel Shahak, 'The Oslo Accords: Interpreting Israel's Intentions', *Middle East International,* 22 October 1993. The Oslo agreement can be interestingly compared with the 1979 Camp David agreement with which Palestinian leaders almost uniformly refused to co-operate. This comment, made at the time by the émigré Palestinian scholar Fayez Sayegh, makes the similarities all too clear: 'A fraction of the Palestinian people . . . is promised a fraction of its rights (not including the national right to self-determination and statehood) in a fraction of its homeland (less than one-fifth of the area as a whole); and this promise is to be fulfilled several years from now, through a step-by-step process in which Israel is to exercise a decisive veto power over any agreement.' Cited by Howard M. Sachar, *A History of Israel,* ii. *From the Aftermath of the Yom Kippur War* (Oxford: Oxford University Press, 1987), p. 8.

26 Amos Oz, *Slopes of Lebanon,* trans. from the Hebrew by Maurie Goldberg-Bartura (New York: Harcourt Brace Jovanovich, 1989: London: Chatto and Windus, 1990: Vintage, 1991), p. 6.

27 'The Nine-Point Peace Plan, Israel's Foreign Minister Abba Eban, 8 October, 1968', in Lukacs, *Documents*, p. 81.

28 Ibid. p. 86.

29 'The Jarring Questionnaire and Replies, January 1971', ibid. p. 7.

30 Yeshayahu Leibowitz, 'Right, law and reality', in Eliezer Goldman (ed.), *Judaism, Human Values and the Jewish State,* trans. by Eliezer Goldman and Yoram Navon and by Zvi Jacobson, Gershon Levi and Raphael Levy (Cambridge, Mass.: Harvard University Press, 1992), pp. 230–1.

31 'The term 'right', at least in its secular sense, stands for something which is recognised by others, not for something which someone feels very strongly about.' Amos Oz, 'The Israeli–Palestinian Conflict', in *Israel, Palestine and Peace* (London: Vintage, 1994), p. 102.

32 'Fundamental Policy Guidelines of the Government of Israel as approved by the Knesset, 5 Aug. 1981', in Lukacs, *Documents*, p. 107.

33 Benedict Anderson, *Imagined Communities: Reflections on the Origin and Spread of Nationalism* (London: Verso, 1983).

34 Unger, *Critical Legal Studies*, p. 100.

35 Plato, *Republic*, trans. by G. M. A. Grube, revised by C. D. C. Reeve (Indianapolis: Hackett, 1992), p. 6.

36 John Rawls, 'The law of peoples', *Critical Inquiry,* 20: 1 (autumn 1993).
37 Ibid. p. 45.
38 Ibid. p. 48.
39 Ibid. p. 50.
40 Plato, *Republic,* edn cit., p. 170.
41 John Rawls, *A Theory of Justice* (Oxford: Oxford University Press, 1972), p. 143; Linda Colley, *Britons: Forging the Nation 1707–1837* (New Haven: Yale University Press, 1992), p. 35.
42 Jean Genet. 'Four Hours in Shatila', *For Palestine,* 29; extract from *Un captif amoureux* (Paris: Gallimard, 1986).
43 Shklar, *Faces of Injustice,* p. 29.
44 Ibid. p. 37.
45 Ibid. p. 101.
46 Ibid.
47 Ibid. p. 49.
48 Richard Dowden, 'Obituary', *Independent,* 7 January 1995.
49 Stephen Greenblatt, *Marvelous Possessions: The Wonder of the New World* (Oxford: Clarendon Press, 1988), pp. 37–8.
50 Sigmund Freud, 'Civilisation and its discontents', *Standard Edition* , vol. XXI, (1930), p. 104; Sigmund Freud, 'Das Unbehagen in der Kultur', *Gesammelte Werke* (Frankfurt: Fischer Verlag), pp. iv and 464.
51 Freud, 'Civilisation and its discontents', p. 95; 'Das Unbehagen in der Kultur', p. 455.
52 Sigmund Freud, 'Moses and monotheism' (1939), *Standard Edition,* vol. XXIII, p. 82.
53 Freud, 'Civilisation and its discontents', p. 143.
54 Ibid. p. 109.
55 Ibid. p. 102; 'Das Unbehagen in der Kultur', p. 461.
56 *'Civilisation and its discontents',* pp. 109–10; 'Das Unbehagen in der Kultur', pp. 468–9.
57 'Civilisation and its discontents', p. 143.
58 Judith Shklar, *Ordinary Vices* (Cambridge, Mass.: Harvard University Press, 1984), p. 41.
59 Annette Baier, 'Theory and reflective practices', in *Postures of the Mind* (Minneapolis: University of Minnesota Press, London: Methuen, 1985), p. 223.
60 Oz, *Black Box* (n. 8), p. 176.
61 Ammiel Alcalay, *After Jews and Arabs: Remaking Levantine Culture* (Minneapolis: University of Minnesota Press, 1993), pp. 272–4.
62 Amos Oz, *In the Land of Israel,* trans. from the Hebrew by Maurie Goldberg-Bartura (New York: Harcourt Brace Jovanovich, 1983), p. 140.
63 Alcalay, *After Jews and Arabs,* p. 118.
64 Amos Oz, *Touch the Water, Touch the Wind,* trans. from the Hebrew by Nicholas de Lange in collaboration with the author (London: Chatto and Windus, 1975; Vintage, 1992), p. 137.
65 Grace Halsell, *Prophecy and Politics: The Secret Alliance between Israel and the Christian New Right* (Chicago: Lawrence Hill Books, 1986), p. 37.
66 Max Weber, 'Politics as a Vocation', in H. Gerth and C. W. Mills (eds), *From Max Weber,* p. 122.

67 Hannah Arendt, *The Origins of Totalitarianism* (New York: Harcourt Brace Jovanovich, 1951; new edn, 1979), p. 462.

68 Alasdair Maclntyre, *Whose Justice? Which Rationality?* (London: Duckworth, 1988), p. 347.

69 Freud, 'Civilisation and its discontents', p. 142.

70 For one account of these connections and parts of this history, see Paul Gilroy, *The Black Atlantic: Modernity and Double Consciousness* (London: Verso, 1993), ch. 6.

71 Nelson Mandela, 'We must end the social order and bring in a new one', in *Intensify the Struggle to Abolish Apartheid: Nelson Mandela Speeches 1990* (New York: Pathfinder, 1990), p. 59.

72 Cited in Milton Shain, *The Roots of Anti-Semitism in South Africa* (Charlottesville, Va.: University of Virginia Press, 1994), p. 138.

73 Alcalay, *After Jews and Arabs*, p. 284.

3
Freud and Violence

C. Fred Alford

Violence is the biggest problem humans face in organizing their collective lives. 'Civilisation and its Discontents' makes violent aggression, and the guilt it engenders, the fundamental problem of civilization. Violence is not just a collective problem in Freud's account, however. The management of aggression is as much a personal problem as a group one. Nothing structures the psychic life of humans more than the need to turn our aggression inward, doing violence to ourselves so we might live with others.

Aggression begins in self-assertion and ends in malicious destruction. Violence occurs towards the latter end of the spectrum. Violence is that aspect of aggression that seeks the damage or destruction of the other. Later I shall argue that violence is best understood as the conjunction of aggression and hatred. For now it is enough to understand violence as aggression that aims to harm.

The origin of violence in what Freud called the *Todestrieb* is the first topic. Next I shall turn to the problem of individual violence, referring to studies, including my own, of those who have committed what the tabloids call 'hot-blooded murder'. Finally I shall turn to the problem of collective violence. In the end, all violence is one, an expression of the *Todestrieb*, but only in the end. Along the way it is helpful to distinguish the violence that leads towards self-destruction, the violence that would fuse with another in raging hatred, and the violence that would destroy the world.

Freud understood the appeal of violence, the way it satisfies a need much as sex does. It is a scary thought, that humans might want and need violence much as they want and need love. Today it is common for horrendous acts of violence, such as the Nazi Holocaust, to be explained as Crimes of Obedience (the title of a noted work on the topic), the outcome of men too cowardly to protest over their hate-

ful orders.[1] Against this explanation, Daniel Goldhagen wrote *Hitler's Willing Executioners: Ordinary Germans and the Holocaust*, a book that has received much attention of late.[2] Germans, he argues, did not reluctantly kill Jews. They eagerly killed Jews because they believed in a virulent strain of anti-semitism he calls 'eliminationist antisemitism'.

Even Goldhagen does not consider that German anti-semitism might have been an excuse. What if people find pleasure and satisfaction in hurting and killing others, particularly when these others are weak and vulnerable? Because we live in a civilized world, violence needs a good excuse, and that is what German anti-semitism provided: an excuse, not a cause. The cause was pleasure in violent destruction of others. It is a thought that all good citizens must reject when thinking rightly, and one that Freud leads us to reconsider. In order to explore the pleasures of violence further, I report later on the reflections of an imprisoned member of a motorcycle gang. He is not a good citizen, and for that reason more insightful than most into the appeal of violence.

Todestrieb

Freud's concept of the *Todestrieb*, introduced in 'Beyond the Pleasure Principle', has always been controversial, though we should not underestimate the number of analysts who have adopted it in one form or another,[3] including Ferenczi, Klein, Federn, Menninger, Eissler and Rosenfeld.[4] In general, however, the attitude towards the *Todestrieb* is that of the authors of *Psychoanalytic Terms and Concepts*, published by the American Psychoanalytic Association:

> The death instinct is perhaps Freud's most controversial assumption. It has been severely criticized by both psychoanalysts and others, and it remains a highly speculative formulation, thus far unconfirmed by any biological investigation. Freud did recognize and discuss extensively the fact that the death instinct can be observed only in aggressive, destructive actions directed either toward the environment or against one's own person.[5]

For this reason most analysts who hold to the concept of instinctual drives distinguish between libidinal and aggressive drives, while

ignoring or rejecting the metaphysics of the *Todestrieb*, Freud's postulation of a drive to *be* dead, an aspiration to deadness.

Freud did not employ the term *thanatos* in his writings, although Ernest Jones[6] reports that Freud occasionally used the term in conversation.[7] It has, however, become common to employ thanatos as a synonym for the *Todestrieb*, especially when contrasting the *Todestrieb* to eros, the two great principles of civilization. Thanatos is not just destruction, though it is this too, including self-destruction. In Greek mythology, thanatos is the twin brother of Hypnos, sleep. Silence, sleep, night and death, the eternal peace of non-being, the total cessation of stimulation – these too are dimensions of thanatos, dimensions that come frighteningly close to eros.

Not only did Freud say different things about the relationship between thanatos and violence at different times, as one might expect from a thinker whose theory was in constant evolution, but what Freud did say is not always so straightforward as first appears. In his early writings, Freud saw aggression as an expression of sadism, and thus bound to sexuality. However, he was not always clear as to whether aggression stems from the sexual drive, the position of the first of 'Three Essays on the Theory of Sexuality',[8] or whether aggression is independent, binding with sexuality, the position of the second of the 'Three Essays'.[9] 'It may be assumed that the impulses of cruelty arise from sources which are in fact independent of sexuality, but may become united with it at an early stage.'[10]

If aggression is independent, it stems in Freud's early view from the self-preservative drives. However, in the 1915 edition of 'Three Essays' Freud modified his claim, arguing there that 'the impulse of cruelty arises from the instinct for mastery', omitting the phrase about it being 'independent of sexuality'.[11] To interpret these different positions strictly in terms of the evolution of Freud's thought would be misleading. The complexity-cum-confusion-cum-richness was always there.

Already by 1909, in the Little Hans case history, Freud wrote 'I cannot bring myself to assume the existence of a special aggressive instinct alongside of the familiar instincts of self-preservation and of sex, and on an equal footing with them.'[12] It was not until 'Beyond the Pleasure Principle' that Freud explicitly posited an independent aggressive drive, derived from the *Todestrieb*, against which Freud set eros, which assimilates all that strives towards life, including the self-preservative instincts.[13]

This formulation was to be Freud's last, the history of civiliza-

tion, the struggle of life against death, of eros *contra* thanatos. 'And
now, I think, the meaning of the evolution of civilization is no longer
obscure to us. It must present the struggle between Eros and Death,
between the instinct of life and the instinct of destruction, as it works
itself out in the human species.'[14] It is not so simple. Only in theory
is aggression the outward expression of thanatos. In practice they
are distinct, as James Strachey suggests in his introduction to 'Civi-
lisation and its Discontents'. Only in theory is the aggression of
'Civilisation and its Discontents' an expression of the *Todestrieb* of
'Beyond the Pleasure Principle'. In reality we are faced with three
entities from 1920 on, eros, thanatos and aggression. Or, as Herbert
Marcuse suggests in *Eros and Civilization: A Philosophical Inquiry
into Freud*, perhaps it is just one, eros-cum-thanatos: the quest for
nirvana in all its guises.[15]

That silence, sleep, night and death might have an appeal much
like eros is the insight of poets from almost every age, from Sappho
(fragment 39), to Shakespeare's *Romeo and Juliet*, to Novalis, who
wrote:

> Dark Night. What're you holding under your cloak, that grabs
> so unseen at my soul? Costly balm drips from your hand, from
> a bundle of poppies. . . . I see a serious face startled with joy, it
> bends to me softly, reverently, and under the endlessly tangled
> hair of the Mother a lovely youth shows. . . . How poor and
> childish the Light seems now. . . . You called the Night to life
> for me . . . so I can mix with you more inwardly, airily, and then
> the wedding night will last forever.[16]

In 'Beyond the Pleasure Principle', thanatos is all turned in on itself.
Not the vast destruction of the First World War, but a little boy's
compulsion to repeat a simple game, throwing a spool out of his bed
and pulling it back again, is Freud's inspiration. Why, Freud won-
ders, do people repeat unpleasant experiences, reviewing them over
and over again in their minds, acting them out in reality, frequently
in symbolic form. Does this not violate the pleasure principle?

One might argue, as Freud recognizes, that the repetition com-
pulsion stems from the attempt to master a traumatic experience, in
this case the mother's leaving. But, says Freud, there seems to be a
deeper motivation. The compulsion to repeat is itself an expression
of a drive to restore the earliest state of things, and the earliest state
of all is non-being. 'Let us suppose, then, that all the organic in-

stincts are conservative . . . and tend towards the restoration of an earlier state of things.'[17] The earliest state is inorganic being.

> Seen in this light, the theoretical importance of the instincts of self-preservation, of self-assertion and of mastery greatly diminishes. They are component instincts whose function is to assure that the organism shall follow its own path to death, and to ward off any possible ways of returning to inorganic existence other than those which are immanent in the organism itself.[18]

From this perspective, we fight and kill each other not because violence is satisfying, but in order to be left alone to die in our own time. Freud has, as he puts it, steered into the harbour of Schopenhauer, for whom death is the purpose of life, sex the will to live just a little longer.[19] There is not one word in 'Beyond the Pleasure Principle' about satisfying an aggressive instinct for its own sake. Instead, aggression has the dual functions of protecting the organism's own path to death, while diverting some of the *Todestrieb's* energy outward, so that it will not overwhelm the organism too quickly.

Though the theory is ostensibly the same, the tone of 'Civilisation and its Discontents' is different. Here the evidence of the *Todestrieb* is historical, not psychological, ranging from the atrocities committed by the Huns to the 'horrors of the recent World War'. Aggression sounds much like sexual satisfaction, says Freud.[20] Several times he compares the use of others for sexual purposes with their use as objects of aggression. *Homo homini lupus*, man is the wolf to man, and he is running loose all over the world.

If aggression run rampant over the world is the theme of 'Civilisation and its Discontents', the solution is to turn aggression inward. This turning inward has nothing to do with the inward-turning of thanatos. Instead, aggression turned inward is the source of the superego, conscience the release of all the aggression one would have liked to have unleashed on father and others turned back against the self.[21] Here is the discontent of civilization, the price of a world of peaceful wolves, each wolf doing perpetual violence to itself in order not to violate those it loves or must live with. Civilization *is* aggression turned back against the self (that is, conscience), the alternative to the war of all against all. Superego or superstate: these are the choices we live with. Any other choice is to die.

To be sure, the superego draws upon the death instinct to do its punishing work, becoming a 'pure culture of the death instinct', as Freud put it when discussing melancholia.[22] But it is not just in melancholia that the superego becomes host to the *Todestrieb*. For Freud, the superego is the structural compromise given to the death instinct by the young boy's conflicting desires: to possess mother, to destroy father, to live, and to remain whole. Only it is a death instinct no longer connected to nirvana. The superego is all on the surface as far as aggression is concerned, receiving signals from unconscious fantasy, punishing us for our dreams, but seeking to do no more (and no less) than dominate us 'like a garrison in a conquered city', as Freud puts it.[23] Like the Spartans who occupied the Acropolis after Athens lost the Peloponnesian War, the conquering troops are inside the walls, but they do not really belong there, and never will. Similarly, the aggression of the superego has no depth, no attachment to the deeper world of silence, sleep, night and death, the world of thanatos.

In *Being and Not Being: Clinical Manifestations of the Death Instinct*, Otto Weininger argues that 'the harsher and more punitive the superego, the stronger and more destructive the death instinct'.[24] He assumes, in other words, that they are connected. Vitality, separateness, and creativity: all these and more are aspects of life that thanatos would destroy in order to preserve the tie with the beloved object. In order to preserve the object from one's rage, one obliterates the erotic, life-giving forces in the self. It is a good theory, the superego the residence of inner-directed thanatos, but it is no longer Freud, for the same reason that Klein's account of thanatos is no longer Freudian. Neither Weininger nor Klein have any place left for nirvana, thanatos balancing itself on the brink between eros and destruction, love and hate.

It is no surprise that those theorists who have taken thanatos seriously have found little place for nirvana, thanatos in the realm of eros. While aggression and thanatos remain connected in Freud's theory, aggression the outward manifestation of thanatos, the connection is strictly theoretical, designed to support the dualism of eros and thanatos. If aggression were not thanatos directed outwards, the dualistic theory of the instincts would hold no longer. In a letter to Princess Marie Bonaparte, Freud suggests that in the beginning of life all aggression is directed outwards; only later in life does it turn in.[25] Here is really a tripartite theory of the instincts, the dualism maintained only by dividing the life course in

two: eros contra aggression at the beginning of life, eros contra thanatos at the end.

Why Freud failed to unite aggression and thanatos is apparent. The goal of thanatos, as Freud states in several different places, is to dissolve combinations and structures, rendering the organic inorganic.[26] Thanatos has no object. It quite literally seeks no-thing, nothingness. Not only is thanatos unlike eros in this regard, but it is unlike aggression as well, which is defined by its object, much as eros is. In English, one is aggressive *towards* someone or something. In German, one is *Aggresiv gegen*, against or towards someone or something. As long as thanatos has no object but itself, it can never be the other half of aggression, and Freud's dualistic theory of the instincts must be less than fully coherent. Unless thanatos has an object after all, the lust for fusion.

The object of thanatos is fusion

Consider that what thanatos seeks is not dissolution per se, but the dissolution of boundaries, of distinctions. From this perspective, thanatos seeks not nothingness, but the dissolution of separateness – that is, fusion. For Freud, thanatos breaks the links that join entities, so that combinations dissolve into nothingness. I suggest that we think about it slightly differently, but only slightly: what thanatos would destroy is not links but boundaries. This would result not only in dissolution, but fusion – fusion as dissolution of distinctions, dissolution as the merger of all that must be held separate to preserve structure.

The theoretical advantages are clear, providing thanatos with an object that is both something and nothing, the something of fusion, and the nothing that is the self and other when the boundaries between them disappear. This grants to thanatos the quality possessed by every other drive, especially eros: that of having an object, not just an aim.[27] In this regard, Freud is the first object relations theorist, though some, such as Fairbairn would surely question this claim.[28]

To see the goal of thanatos as fusion accounts for the closeness of thanatos to eros, the way in which the nirvana principle that motivates thanatos also motivates the pleasure principle.[29] 'Never before has death been so consistently taken into the essence of life, but never before also has death come so close to Eros.'[30] Both eros and thanatos seek fusion, eros with the forces of life, thanatos with the forces of

death. But as the ideal of the *Liebestod* reminds us, they are not always distinct.

In thinking about thanatos in this way, we have entered the realm of primary process thinking, as Freud calls it, in which opposites no longer negate. It is a realm of primal words, as Freud calls them, words like 'cleave' which means both to cling and to separate.[31] A death drive that seeks dissolution of self through fusion with another life is one such contradiction, and not so contradictory as all that. A death drive that seeks its own death by killing another is only slightly more contradictory. 'In killing Jim I killed myself' is how one who murdered her lover put it, writing it on the card she pinned to his chest before calling the police.

It will be useful to turn to the real world of thanatos, the world of affective violence, in order to explain such thinking. In the end the theoretical advantages of seeing thanatos as aiming towards fusion are far less important than the practical advantages: such a formulation better accounts for experience, including the experience of affective violence. Such a formulation also better accounts for the hatred behind so much violence. Hatred seeks to destroy its object forever in both senses of the term. Hatred seeks the obliteration of its object forever, and hatred seeks to be forever obliterating its object, so that it will not have to be alone. Here is the telos of thanatos, hatred that binds self to its object in an infinity of destruction, nirvana in the realm of violence.

Violence and Hatred

My accounts of 'hot-blooded murder', what psychologists of crime call affective violence, stem (with one exception) from several hundred hours spent interviewing eighteen men and women who murdered relatives or loved ones, often in the course of an argument, always out of the blue, or so it first appears. Some were interviewed individually, others as part of a year-long group discussion of violence at a maximum security prison. Every account of violence whose source is not cited stems from this research project.[32] The purpose of these accounts is to illustrate what thanatos looks like in the realm of eros: the quest for nirvana marked by the collapse of any distinction between love and hate.

Against the relevance of such evidence one might argue that sudden murderers are hardly average citizens, their violence so

uncontained it can tell us little about the rest of us. In response I cite Freud's attitude towards neurotics.[33] They are like the rest of us, only more so. Freud addressed his remark to those who questioned whether his clinical experience with patients was relevant to understanding normal men and women. Inmates, particularly sudden murderers, are like the rest of us, only more so. What the rest of us dream of, they have done. It is a decisive difference, the difference between civilization and chaos, but it does not make sudden murderers fundamentally different. Or rather, they are different in ways that are only exaggerations of normal tendencies, which was Freud's point about neurotics.

On the morning of 28 May 1995, Sinedu Tadesse, a junior at Harvard, stabbed her roommate, Trang-Ho, forty-five times while Trang lay sleeping in her bed in their Harvard dormitory. By the time police arrived, Sinedu had hanged herself in the bathroom. Unlike most killers, the Ethiopian student left a detailed diary of her emotional state in the years leading up to the killing. My account is drawn from her diaries.[34]

Unlike her roommate, Sinedu was not a popular student. She had difficulty finding a roommate, and was elated when Trang-Ho agreed to share a suite with her. But they did not get along, and Trang was looking for another roommate. Sinedu found the humiliation intolerable. 'You know what I fear? I fear that shitty cringing feeling that accompanies me . . . should my rooming thing does [sic] not work out in a way that makes me hold my head high & speak of it proudly.' If she could have, Sinedu would have inflicted this terrible cringing feeling on her roommate, so that their positions might be reversed, Sinedu the strong and happy one. But Sinedu knew it was impossible. 'Our situations would never reverse, for me to be the strong & her to be the weak. She'll live on tucked in the warmth & support of her family while I cry alone in the cold.'

It was a situation made worse, or at least more pathetic, by the way so many seemed to confuse them, regarding the roommates as virtually identical non-Western exotics. 'Media accounts made them sound like twins: nice, petite, hardworking foreign-born premed junior biology majors.' Even at the memorial service, Harvard's minister could not seem to keep victim and executioner straight, referring to both as victims, asking the Lord to forgive them both.[35]

Unable to become Trang-Ho, Sinedu decided to kill herself, while taking Trang-Ho with her. Only that would feed her hatred. 'The bad way out I see is suicide & the good way out killing, savoring

their fear & [then] suicide. But you know what annoys me the most, I do nothing.'

In the novel *Immortality*, Milan Kundera has one of his characters state that 'hate traps us by binding us too tightly to our adversary'.[36] What Kundera, or perhaps just his character, fails to understand is that this is just what is wanted, hatred serving much the same function as love, allowing us to be trapped with the other while fighting against it, allowing us to pretend what we really want is to be free, but never giving us the chance.

Sinedu's diary suggests a revision to this thesis, or perhaps just an amendment. Hatred culminates in sudden violence when the one who hates comes suddenly and late to reality, recognizing that the intensely desired fusion is impossible. By then, however, the one who hates has given up so much of herself to the desire to be the other that there is no going back, not enough self left to go back to, or so it seems. The self of the hater has been destroyed, and no return is possible, only the perverse satisfaction that the one who is hated will share the obliteration, fusion in the realm of entropy, nirvana.

The hatred behind affective violence is a path to fusion, a hot relationship in a cold world. Affective violence seeks to fuse with the other, preserving the relationship in the absence of the other, without the bother of the reality of the other. 'I stood over them and watched them die,' said Mr Leotine. 'I shared their last moments, their pain, their sorrow. For once my family was close.' Mr Leotine is talking as if his parents died in a car wreck, as if he had rushed to the hospital to share their beautiful deaths, as if he hadn't shot and killed them. His eyes close for a moment. I think he is experiencing bliss, an oceanic merger with the idea of his parents separated from their awful reality.

He wanted to be close to his parents and free of them at the same time. Only he could not do the abstraction, the distinction between his real parents and their mental representation, internalizing their image while leaving their bodies behind. Or rather, the intensity of his hatred bound him to them so that the only way he could have their image was to destroy their bodies. He killed them to have them all to himself.

Since he killed his parents, Mr Leotine dreams about them almost nightly. He likes it that way. 'While they were still alive, I never dreamed about them. I was too angry. It's better this way. Now I can have them in my dreams.' Affective violence stems from fear of

abandonment, the unmastered terror of loss, one of the three lead-ing psychological dangers according to Freud.[37] It is no accident that Mr Leotine, who is in his late twenties, killed his parents shortly after they insisted he move out. Affective violence seeks to control abandonment, destroying the other so that he or she cannot leave. Even, or especially, if the killer wants to leave. Deep down in the psyche there is little difference between leaving and abandonment. Little difference, and all the difference in the world: the difference between control and its absence. It is no accident that of all prison-ers, 'sudden murderers' showed the strongest dependency needs, as measured by clinical experience and psychological tests.[38]

The structure of hatred

If the murder is sudden, the hatred behind it takes years to mature, wine aged to vinegar. It is important to try to understand this ha-tred, because so much of social and political life is built upon it. Freud did not grasp fully the complexity of hatred, defining it as an ego state that wishes to destroy the source of its unhappiness.[39] Why someone might want to hate, finding the meaning of his life in ha-tred, did not enter into Freud's conjectures.

Hatred is ego-structuring. It can define a self, connecting it to others, anchoring it in the world, while at the same time acting as a fortress. Otto Kernberg puts it this way: 'The underlying mecha-nism, I am suggesting, is the establishment of an internalized object relationship under the control of structured rage, that is hatred. . . . Hatred consolidates the unconscious identification with victim and victimizer'.[40] Hatred creates history, a history that defines the self and provides it with structure and meaning. Without history we do not know who we are. The history of one's hatreds, often expressed as an almost loving recitation of harms suffered and revenge inflicted, constitutes the single most important, most comprehensible, and most stable sense of identity for many people, and more than one nation.

Roger Lewin writes about a man in his thirties who had:

> as his defining passion in life a hatred for his father. . . . His world was utterly patricentric. . . . Intense hatred against his father represented the conflict over how and whether to break free not only of his father but also of an identification with his mother that was so global, so extensive, so infiltrative as to

amount to a virtual merger. The intensity of the hatred was in proportion to the internal feeling of helplessness and hopelessness over achieving a new status of increased autonomy and personal scope not only in the external world but also in the internal world.[41]

Consider the functions served by hatred in this one case. It energizes the self, keeping feelings of helplessness and hopelessness at bay, while imprisoning the self in its hatred in a way that is experienced as preferable to the terror of freedom, preventing a total fusion with mother by means of a partial fusion in hatred with father.

If hatred is a virtual ego state, an organization of the psyche, then sadomasochism is the drive behind it. It is tempting to think of hatred as primary, an expression of chronic rage, aggression stuck to its object. From this perspective, sadomasochism would be an eroticized expression of hatred. While having much to recommend it, such an interpretation deviates from Freud more than is necessary to account for the structure of hatred. From a Freudian perspective, the *Todestrieb* is not expressed in sadomasochism. It *is* sadomasochism. Only we should properly term it maso-sadism, as the *Todestrieb* is first of all an aspiration to deadness, subsequently turned outward in the form of aggression, so that the organism might live out its life. Sadism is a projective defence against masochism![42] Hatred is one way we organize our sadism, so that it serves, rather than attacks, the self.

Though hatred structures the ego, in the end it must corrode it, wearing away the self who hates.[43] Hatred corrodes the ego because it is built on a lie: that hatred can connect us with others as love does without risking love's vulnerability and heartache, love's dependence on the other. Hatred is not the opposite of love because hatred is the simulacrum of love, love in the realm of malevolence.

Hatred has many qualities analogous to love, establishing a connection between the hater and his world, giving meaning and purpose to his life, and providing an experience of transport and transcendence, being lifted up by one's hate to a higher and purer realm. Mr Johnson put it this way; 'Hatred is good for you. It puts you on a higher plane, where you don't care about all the crap the guards give you.' In the end, however, hatred chains an individual to those he hates, so that even when the victim dies the fetters remain. Its simile is the prisoners in 'administrative segregation' who wear

shackles everywhere they go, developing a strange, shuffling gait even when they are no longer chained.

Hatred promotes ego-shrinking rather than ego-enhancing relationships, in which there is no need to cope with ambivalence. Yet, it is only by dealing with ambivalence, the complexity of our feelings, how we love those we hate, and vice versa, that we integrate ourselves. It is only by accepting, rather than hating, the world as it is, with all its horrors and sufferings, that we can come to know our own separateness. It is a mournful knowledge, but an ego-enhancing one.

Ms Gans had been thinking about killing herself for months. The thing that stopped her was how terribly loud the gun would sound when she put it to her head and pulled the trigger. She experimented with different hairstyles, trying to find one that would let her put a bullet in her brain without messing up her 'do'. 'I had a date with the mortician,' she says with the ironic detachment that is more than just her style, but her way of being.

Instead of killing herself, she shot and killed her lover. It was Christmas Eve. Holding a beloved stuffed animal in her left hand, and a gun in the right, she shot him dead. Carefully placing his body under the Christmas tree, she placed a stuffed bunny in his folded arms before wrapping him in a crazy quilt. 'You know, the kind where the pieces don't fit together right, like there's no pattern.' Then she lay down beside him for a while, sharing the endless quiet. After years of struggle she had finally achieved nirvana. Eventually she called the police. When they arrived they found a note on his body that read 'In killing Jim, I killed myself.'

Evidently Ms Gans wanted to leave Jim and return to the parents of her childhood, whom she remembers so fondly, especially at Christmas. It is why stuffed animals and Christmas are such central themes in her murderous tableau, images of cuteness and family closeness juxtaposed with death. Irony is the logic of the borderline, playing both sides at once, while pretending to be elsewhere. Though it seems so hard-edged, Ms Gans's irony actually seems to protect her from the reality that Sindedu could know but not accept, the reality of human separateness.

Sinedu knows reality, and will obliterate herself along with the one she knows she cannot be. Ms Gans uses irony to try to have it both ways, transforming murder into a cosy family ritual. This is why she was so horrified when the rumour went around the prison that she had chopped up her lover into pieces, sending parts of his

body to his parents wrapped as Christmas presents. 'Jim was a beautiful and graceful man; I would never have disfigured him in any way. I cherished his body, even in death.' Especially in death one might say.

Because irony accepts and rejects reality, much as creativity does, it is important to know the difference. Not between irony and creativity, for much irony *is* creative, but between Ms Gans's irony-filled murder of her lover and genuine creativity. The difference is the way in which Ms Gans's murder is so bound to the body that it cannot escape it. Ms Gans knows that her crime tells a story, but she cannot decipher it. 'I know it means something. It's even kind of funny. But it's been two years, and I just can't crack the code.' When she finally does she will have done more than figure out the meaning of her act. She will have entered another conceptual world, in which symbols are more abstract, less embodied and thing-like.

The hatred of affective violence traps the victim and the executioner in a world of bodies. Not bodies that point beyond themselves to the richness of the world, the world suffused with erotic energy and promise. This is how romantic love experiences bodies. Just bodies. Rather than non-body symbolizing body, the direction in which artistic creativity flows,[44] body comes to symbolize a world reduced to its bare essentials, pain and power. 'Symbolize' is a misleading term, however, suggesting a degree of abstraction not present in most affective violence. It is not that the body comes to symbolize the world; the body becomes the world, it is the world. The hatred of affective violence traps the victim and victimizer in a world of bodies that is the world. It is the point, of course.

From bodies to the body politic

If the hatred of affective violence traps intimates within a world of bodies that point only to themselves, in what way does the hatred of politics trap its participants? In relationships that are the simulacrum of community, the bonds of common affection transformed into bondage: to those who hate with us, as well as those we hate.

Humans are creatures of attachment. Love is not universal, but attachment is: connection with others. That humans are creatures of attachment is the foundation of object relations theory, as it is called, but that really puts it too narrowly. It is an insight that begins with Aristotle's definition of man as *zoon politikon*: man realizes himself only in the community of others. It is an insight not overlooked by

Freud, who questioned not the bonds of attachment, but whether the bonds of destruction were even stronger.

Hatred too creates communities: the community of those who hate the same other, and the community between those who hate each other. It is the hottest relationship around, and in some ways the most reliable. You cannot always get someone else to love you, but you are much more likely to get them to hate you. Just act hatefully.

As hatred is the simulacrum of love, so it is the simulacrum of political community, creating bonds that last for years. Or as the Furies in Aeschylus' *Oresteia*, the playwright's paean to the Athenian *polis*, put it while encouraging the Athenians to unite, 'let them hate with a single heart. Much wrong in the world / Thereby is healed.'[45] Much wrong is healed, and as much or more will be done to others.

Hatred as a political force has received far less attention than love and fear, its emotional complements. Love, we learn early, may be translated into patriotism and loyalty, fear into obedience and the corruption of national spirit in divers ways, from militarism to appeasement. But what of hatred? What is needed is not a new subdiscipline, the political theory of hatred. Needed is a better understanding of how hatred infiltrates and corrupts all the political virtues, such as patriotism, community, loyalty, tolerance and citizenship. Needed is the analysis of the way in which each of these virtues has its dark side, its correlate rooted in hatred, as when loyalty to one's nation stems from hatred of others.

Hatred is capable of simulating not just love, but almost all the virtues. Sometimes hatred takes the place of these virtues, as when patriotism is defined as hatred of the enemy. More often, hatred infiltrates these virtues, so that hatred of the enemy becomes so confused with love of country that it becomes almost impossible to sort them out. A better understanding of hatred is not enough, but it is a good place to start.

Civilization and the Milgram Experiment: The Joy of Violence

Freud's great contribution to social theory is to show the price to individual and society of the modifications of the psyche necessary to contain the species' propensity to violence. Both Freud,[46] and his great critic Herbert Marcuse,[47] understood the self-defeating

quality of these modifications: by making society and existence even less pleasurable, they actually heightened the propensity to violence – violence as rage against the burden of civilization. In other words, both Freud and Marcuse understood history to be tragedy, the solution to violence likely to foster more violence in the long run. The difference between them was that Marcuse thought utopia was possible, a non-repressive civilization based upon the abolition of alienating labour.

Though Freud would never have understood this solution (for Freud, repression was strictly a psychological, not a social, phenomenon), he and Marcuse share more than one might expect in their analysis of how close eros comes to thanatos. This, at least, has been my argument. If we are to understand thanatos as a relationship to an object, then the quality of this relationship is that of fusion in hatred, the obliteration of boundaries in the service of destruction of self and other. It is not eros, as hatred is not love, but they are not opposites either. Both seek to be one with their object, one in love, the other in hate.

It would be misleading, however, to conclude that violence and hatred are always, or even usually, expressed in the quest for fusion with the hated object. In this regard, inmates convicted of affective violence *are* a misleading group. They have taken their violence freelance, rather than channelling it in socially approved directions, the path of the good citizen. It will pay to consider further how society stores and channels violence. Not because the psychology is different, but because the same psychology, that of thanatos, is more difficult to see.

In *The Civilizing Process*, Norbert Elias analyses the conditions under which the Freudian superego becomes the dominant force in civilization.[48] Like Marcuse, Elias's transformation of Freudian categories into social ones must misrepresent Freud, reversing the causal direction of repression. Freud did *not* argue that civilization causes us to be repressed. He argues that we repress ourselves in order to enter and remain in civilization, a process that begins in any family, be it a primal family of hunter-gatherers, or the bourgeois family. Repression begins in the family because the root of repression is the Oedipal conflict, which is universal.

While it would be mistaken to understand Elias's project as rendering Freud's argument in 'Civilisation and its Discontents' historical (if we make Freud's argument historical, it is no longer Freud), there remains much to learn from Elias's account of how societies

store and channel violence, an account that, much like Freud, assumes violence has a liquid quality: dam it up here, and it goes there.

Civilization, argues Elias, is not about people becoming nicer or more humane, even at the cost of repression. Civilization is a process of shifting powerful and disturbing emotions and experiences, such as sadism and violence, from the centre to the borderlines of society. Civilization is not so much about pressing things down, as Freud would have it, as pushing them outwards to the borderlines. There sadism and violence are not mitigated, but contained and stored up behind the scenes, in military barracks, police stations and prisons, ready to be called upon in times of unrest, and exerting a continuous threat to those who would challenge the regime. 'A continuous, uniform pressure is exerted on individual life by the physical violence stored behind the scenes of everyday life, a pressure totally familiar and hardly perceived.'[49]

Elias discusses the apparent paradox of the modern state in this vein. Day-to-day violence has disappeared from large areas of life (but not all; the 'inner cities', as they are called, remind us of that), while the state is capable of unleashing massive violence on a scale unprecedented in history. It is not just a matter of new technologies, but about the capacity of the state to 'store' its violence, and rationally channel it.

Consider, says Elias, the carving of meat. Once it was a spectacle, the host celebrating his guests by carving the whole animal at the table. Gradually, however, the spectacle is felt to be distasteful, an insult to civilized sensibilities. Carving does not disappear, however. People still eat meat. Rather, the distasteful is removed behind the scenes of social life. Specialists take care of it in the butcher shop or kitchen.

> It will be seen again and again how characteristic of the whole process of civilization is this movement of segregation, this hiding 'behind the scenes' of what has become distasteful. The curve running from the carving of a large part of the animal or even the whole animal at table, through the advance in the threshold of repugnance at the sight of dead animals, to the removal of carving to specialized enclaves behind the scenes, is a typical civilization-curve.[50]

Recall the famous Milgram experiments in obedience to authority, conducted in the late 1960s.[51] Stanley Milgram asked his subjects to

deliver what they believed were painful electrical shocks to a so-called learner, actually a confederate of the experimenter. In the 'voice-proximity condition', in which the 'teacher' could hear the 'learner' scream, yell, complain about his heart condition, and refuse to go on before falling silent, 63 per cent of the subjects continued to deliver the full array of more than thirty shocks, up to (what they thought was) 450 volts.

Often called the Eichmann experiment, Milgram's explanation of his experiment shares with many studies of the Holocaust the assumption that the problem is obedience, going along with malevolent authority, the loss of agency. Let us look at the Milgram experiment a little differently, from the perspective of Norbert Elias (originally published in 1939, *The Civilizing Process* was later dedicated by Elias to his parents who died in Breslau and Auschwitz). The Milgram experiment explores not just obedience. It explores the way civilization, in the form of scientific authority, contains, controls and channels human sadism and aggression. The Milgram experiment is an instance of a typical civilization-curve, as Elias calls it. Permitting us a glance behind the scenes, it shows us how sadism and aggression operate there, in the darkened laboratory, one of the backrooms of civilization, in the name of science and learning.

This is not how Milgram, and most others interpret the classic experiment.[52] Milgram argues that the experiment has nothing to do with sadism, and everything with obedience. The teachers do not want to deliver the shocks, appear not to enjoy it, frequently ask, even plead not to, then talk as if they refused. It is obedience that is being displayed, man's potential for slavish 'groupishness'.

In support of his argument, Milgram cites Freud's 'Group Psychology and the Analysis of the Ego' on man's propensity to give up his ego ideal to his leader.[53] It is an apposite citation, though citing Freud is much like citing the Bible or Shakespeare. The source is so rich and complex one can find support for virtually any position. In any case, Milgram does not cite Freud on the satisfactions of aggression.[54] Perhaps there should be a fair use doctrine as far as using Freud to support this or that is concerned: you must cite all the passages pertaining to your claim, particularly those implying an alternative explanation.

If you look at the films of the Milgram experiment long enough you will be struck by the grotesque laughter, the giggling fits at the shock generator. Not all subjects do it, but it is common. Sometimes it is subtle, frequently not. One teacher appeared to have a seizure

of laughter. What if these men are giggling in embarrassed pleasure at being given permission to inflict great pain and suffering on an innocent and vulnerable man? Milgram rejects this interpretation, but offers no reason.

What if this is what the teachers really want, what they long for, what satisfies: permission to hurt someone? Permission does not just mean someone saying 'Go ahead. It's OK.' The teachers have a conscience; they know it is not. They have to be virtually forced to do it, compelled by authority. But not really. The structure of the Milgram experiment protects them from knowledge of their own sadism, while allowing them to express it. That is what they want, that is what they do, and that is what they get pleasure from. Embarrassed pleasure, guilty pleasure, but it is still pleasure.

Though hatred may have mobilized Hitler's willing executioners, as Goldhagen calls them, it does not seem a likely explanation for the shocking behaviour of Milgram's 'teachers', who knew virtually nothing about their victim. Sadism, it appears, may be organized in forms more spontaneous and subtle than hatred of intimate others. Sometimes it is their anonymity that excites, a *tabula rasa* for our projections.

In the psychoanalytic tradition, sadism is generally associated with masochism, and both with sexuality, sadomasochism the sexualization of relationships of power and domination. In recent years, however, a number of analysts have applied the term sadism to the pleasure obtained from hurting others, regardless of whether sexual excitement occurs.[55] This actually fits well Freud's later speculations about the independence of the *Todestrieb* from eros. What distinguishes sadism from aggression is not the sexualization of domination and destruction, but the sadist's intense identification with his victim.

It is this that Milgram evidently captured, creating a world in which there are only two roles, or so it seems: victim or executioner. (The third role, that of 'experimenter', not devoid of sadism, was unavailable; subjects believed they had a fifty-fifty chance of being the victim. 'There but for the grace of odds go I. . .') It is a world in which one is drawn into the role of executioner step by step, shock level by shock level, encouraged not so much by the orders of the experimenter as the cries of the victim. As though the victim were whispering: 'you could switch places with me in a minute. Unless you kill me.' At least that is what it sounds like to the terrified executioner.

Sadism is the joy of avoiding victimhood, though that puts it too passively. Sadism is the joy of having taken control of the experience of victimhood by inflicting it upon another. Or, as Otto Rank put it, 'the death fear of the ego is lessened by the killing, the sacrifice of the other; through the death of the other, one buys oneself free from the penalty of dying, of being killed.'[56] Or so it sometimes seems.

Prisoners were asked to read a brief summary of the Milgram experiment, 'If Hitler Asked You to Electrocute a Stranger, Would You? Probably.'[57] The first thing Mr Acorn did was rework the title. 'If the State Asked You to Electrocute a Stranger, Would You? Hell, Yes.' Mr Acorn is covered with tattoos, some quite artistic, though not to my taste: a flaming death's head; a voluptuous woman with a skull between her legs; a swastika; and a rifle barrel encircled with the words 'white power'.

He wears a confederate flag as a bandana. A biker, he wants to open a little tattoo shop when he gets out. One might argue that all this disqualifies him from understanding the Milgram experiment. I think it qualifies him. Mr Acorn, like most prisoners, lives closer to the edge, including the hard edge of violence. About some things this makes him obtuse; about violence he is a savant:

Man, people love violence. Television and movie companies make millions on it. People love to watch violence, and they love to do violence. They just don't want to admit it. So, here this dude tells them to do it, and they most love it man, a fuckin' fantasy come true: a chance to do their violence and pretend its all in a good cause.

The other prisoners nod. One calls Mr Acorn 'caveman'. It is a term of affection; it means he speaks the primitive, brutal truth. Not just about their own potential for violence. But their sense that 'half the citizens of the State of Maryland would love to see us fry; hell, they'd be lining up for the job.'

Not so sheltered from the world's violence, or their own, prisoners know something of the boundary-shattering power of violence, and its allure. Mr Acorn continues:

Society likes violence. It just likes to be able to control it. Imagine that a guy built an electric chair in his basement, plugged it in, and then went out in the street and kidnapped people, dragging them into his basement, where he put them in his

homemade electric chair and electrocuted them. You know what would happen? After he did this a few times (the state's not too swift, it takes them awhile to catch on) they'd catch him, and throw him in jail. Then they'd put him in an electric chair and throw the switch, and his eye balls would pop out of his head. And we'd call that justice.

Freud would put it a little differently. He would call it civilization.

The state's executioner follows public procedures to exact revenge; the man with the electric chair in his basement is a freelance predator. One subjects his sadism to the demands of the state; the other takes his sadism freelance. It is the difference between subjects in the Milgram experiment and the criminal. It is the difference between civilization and chaos. But it is not the difference between sadism and obedience. Nor is it necessarily a difference in basic psychology, or motivation.

We can hardly distinguish the state from the violent criminal in terms of violence. Who is more violent than the state? Nation-states kill millions. The difference between prisoners and the state, the difference between inmates and good citizens, is the way inmates have taken their violence freelance. This makes the violence of prisoners less socially acceptable, less tolerable to a civilized society. It is not obvious that it makes it more evil or sadistic. It does make it more difficult to consider and confront the organized sadism and aggression of states and societies, as we tend to confuse organization, rationalization and legitimation with goodness. Or at least with rationality. Norbert Elias made this point in 1939, and it still stands.

In 1945, Dwight Macdonald warned that we must now fear the person who obeys the law more than the one who breaks it.[58] Yes, but it is important to be clear about why. Because those who obey the law are not just following orders. They are being given the opportunity to express, channel and implement society's sadism, its lust for destruction.

Conclusion

The *Todestrieb* is so abstract and abstruse, so 'metaphysical', so disconnected from experience, that it can safely be ignored. This, at least, is the dominant view, and I have hardly proven it wrong. Those who assert it would, however, be more convincing if the converse of

Freud's teaching about aggression were not also ignored, his obser-
vation of millennia of violence, leading to his conclusion that people
must like it. Freud is not just a metaphysician of violence and de-
struction. He is an observer, operating on the quite simple, non-
metaphysical premise that if people do it so much, they must like it.
There would be nothing surprising about this argument if it were
about sex. Why does it still surprise about violence?

The theorist who appears to come closest to Freud on violence is
actually Friedrich Nietzsche, particularly his appreciation of the
duality of violence – that sometimes civilization seems to be a choice
between suicide or homicide.[59] Despite Freud's claim that he turned
to Nietzsche only late in life, there is evidence that Freud knew more
Nietzsche earlier than he let on.[60] However, since my argument is
that Freud and Nietzsche are not as close as they first appear, the
question of priority is not so important as Freud himself sometimes
seemed to believe.

In *Genealogy of Morals*, Nietzsche writes of the pleasure of being
allowed to vent one's power freely upon 'one who is powerless, the
voluptuous pleasure of doing evil for the pleasure of doing it, the
enjoyment of violation'.[61] Nietzsche is writing not just about whip-
ping a debtor, but cutting his flesh, piece by piece, ounce by ounce.
Nietzsche is not just saying cruelty is part of life, a desire that must
be felt before it can truly be mastered – or rather, lived with. Nietzsche
is idealizing cruelty as the primordial pleasure of the truly strong.[62]
'How naively, how innocently their thirst for cruelty manifested it-
self.'

Unlike the weak, who are cruel and sadistic out of resentment,
the strong man slaps his slave, whips his debtor, and is done with it.
Why? So that resentment doesn't build up in him, so that he can get
it out, a nice, neat hydraulic exchange. 'I'm angry; I hurt you in my
strength that is abundant with life. I do this purifying deed so that
the anger does not build up in me, like wine souring to vinegar. Then
and I go on to bigger and better things.' Nietzsche does not put it in
just these words, but it is what he means.

In 'Carnivals of Atrocity: Foucault, Nietzsche, Cruelty',[63] James
Miller concludes that both Michel Foucault and Nietzsche 'seem
to be saying: Better externalized than internalized cruelty. It is
healthier, more 'active', rather than weak and 'reactive'.'[64] One
could read Freud this way, but it would be superficial. While as-
pects of Freud's thought possess this hydraulic quality, in the end
it is not central to his argument about violence and civilization. It

is *not* his argument that in directing our violence outwards we protect ourselves from its turning inward. On the contrary, Freud's concept of thanatos is so theoretically disconnected from aggression that such a connection, even were Freud to posit it (and he does not), would not be compelling. There are no hydraulics here. The battle is not between inner and external manifestations of thanatos, but between what Freud in one of his later works called the two fundamental principles of Empedocles, eros and thanatos, love and hate, one perpetually seeking to destroy what the other has created.[65]

Here is the difference between Nietzsche and Freud. Though Nietzsche writes lyrically about Dionysus, there is no place for eros in his scheme, only the attempt to master suffering by embracing it, the doctrine of *amor fati*.[66] Love your fate; will that every terrible thing that ever happened to you will happen forever more. Can one even imagine Freud saying 'love your fate'? There is a vast difference between loving your fate and accepting it, as you must accept reality if you are to respect yourself and the world, which is Freud's position.

Freud remains a child of the Enlightenment. Claiming to have gone beyond Enlightenment to Will, Nietzsche imagines that by embracing one's fate totally one might somehow become its stoic master. Anna Freud had a term for that.[67] She called it 'identification with the aggressor'. If you cannot imagine fate as something so personal it might be experienced as an aggressor, reread the Greek tragedies.

For Freud, unlike Nietzsche, violence is no source of rebirth and renewal. That is the task of eros. The more thanatos is loosed upon the world, the more the superego must direct its violence against the self, making both self and world a less hospitable dwelling for eros. If there is a hydraulics at issue here, it is not the hydraulics of thanatos, but the 'hydraulics' of eros and thanatos: the more violence eros must contend with, the less is available for creativity and culture.

My argument supports this point. If what thanatos really seeks is fusion, then it not only comes close to eros, but it may substitute for eros, as hate may substitute for love. What is necessary is the willingness to be clear about this, so that we do not fail to see the danger, either by overlooking the attraction of violence and hatred, or by idealizing violence and hatred as creative forces, as Nietzsche does. It is because he sees without idealizing that Freud's account of violence remains its most profound statement.

Notes

1 H. Kelman and V. L. Hamilton, *Crimes of Obedience* (New Haven: Yale University Press, 1989).

2 Daniel Goldhagen, *Hitler's Willing Executioners: Ordinary Germans and the Holocaust* (New York: Alfred Knopf, 1996).

3 Sigmund Freud, 'Beyond the pleasure principle' (1920), *Standard Edition*, vol. XVIII, pp. 3–66.

4 S. Akhtar, Discussion of Kernberg's chapter, 'Hatred as a core affect of aggression', in S. Akhtar, S. Kramer and H. Parens (eds), in *The Birth of Hatred: Developmental, Clinical, and Technical Aspects of Intense Aggression*, (Northvale, NJ: Jason Aronson, 1995), pp. 83–101, p. 86.

5 B. E. Moore and B. D. Fine (eds), *Psychoanalytic Terms and Concepts* (New Haven: American Psychoanalytic Association and Yale University Press, 1990), p. 101.

6 E. Jones, *Sigmund Freud: Life and Work* (3 vols; London: Hogarth Press, 1953–7), vol. 3, p. 295.

7 J. Laplanche and J.-B. Pontalis, *The Language of Psychoanalysis*, trans. by D. Nicholson-Smith (New York: W. W. Norton, 1973), p. 447.

8 Sigmund Freud. 'Three essays on the theory of sexuality'(1905), *Standard Edition*, vol. VII, pp. 125–248.

9 Ibid. p. 193n.

10 I am following Strachey's valuable Editor's Introduction to 'Civilisation and its discontents' closely here.

11 Freud, 'Three essays' (1915 edn), p. 193n.

12 Sigmund Freud, 'Little Hans', in 'Two Case Histories'(1909), *Standard Edition*, vol. X, p. 140.

13 Freud, 'Beyond the pleasure principle', pp. 3–66.

14 Sigmund Freud, 'Civilisation and its discontents'(1930), *Standard Edition*, vol. XXI, pp. 122–3.

15 Herbert Marcuse, *Eros and Civilization: A Philosophical Inquiry into Freud* (Boston: Beacon Press, 1966), pp. 21–31.

16 F. Novalis, *Hymns to the Night* (1800), trans. by P. Higgins (New Paltz, NY: McPherson, 1984), pp. 11–13.

17 Freud, 'Beyond the pleasure principle', pp. 37–8.

18 Ibid. pp. 39–40.

19 Ibid. pp. 49–50.

20 Freud, 'Civilisation and its discontents', pp. 112–15.

21 Actually the violence is directed against the identification with the father in the self: ibid. pp. 125–32.

22 Sigmund Freud, 'The ego and the id' (1923), *Standard Edition*, vol. XIX, p. 43.

23 Freud, 'Civilisation and its discontents', pp. 124–5.

24 O. Weininger, *Being and Not Being: Clinical Manifestations of the Death Instinct* (Madison, Conn: International Universities Press, 1996), p. 13.

25 Strachey, Editor's Introduction to Freud, 'Civilisation and its discontents', pp. 62–3; also *Civilisation and its Discontents* (New York: Norton, 1961), p. 8.

26 Sigmund Freud. 'Analysis terminable and interminable'(1937), *Standard Edition*, vol. XXIII, pp. 240–6.; 'Beyond the pleasure principle', pp. 42–4.; 'Civilisation and its discontents', pp. 125–6.

27 Freud, 'Three essays'; (1915 edn), p. 138.; Laplanche and Pontalis, *The Language of Psychoanalysis*, pp. 273–6.

28 W. R. D. Fairbairn, 'A revised psychopathology of the psychoses and psychoneuroses', *International Journal of Psycho-Analysis*, 22 (1941), pp. 250–79.

29 Freud, 'Beyond the pleasure principle', pp. 53–7.

30 Marcuse, *Eros and Civilisation*, pp. 28–9.

31 Sigmund Freud, 'The antithetical meaning of primal words' (1910), *Standard Edition*, vol. XI, pp. 155–61.

32 The 18 prison inmates interviewed ranged in age from 19 to 48; 5 were women. Most had killed a relative or loved one: mother, father, mother-in-law, brother, boyfriend, husband, girlfriend, child. One raped a relative. Most were 'sudden murderers', not previously in trouble with the law. We met in a group for over a year, the average size of which was a dozen inmates. Of the original group, 7 remained with it for over a year. In addition, I spoke with most individually. Each was paid $20.00, the equivalent of a month's wages.
Age Distribution: 18–25: 5; 26–35: 7; 36–48: 6
Ethnicity: 10 black, 8 white
Religion: The varieties of religious experience among inmates defy my attempts at categorization. Most were raised in nominally Protestant homes.

33 Sigmund Freud, 'Totem and taboo'(1913), *Standard Edition*, vol. XIII, p. 161.

34 N. Thernstrom, 'Diary of a murder', *The New Yorker*, 3 June 1996, pp. 62–71.

35 Ibid.

36 M. Kundera, *Immortality* (New York: Grove/Weidenfeld, 1990), p. 24.

37 Sigmund Freud, 'Inhibitions, symptoms, and anxiety' (1926), *Standard Edition*, vol. XX, pp. 75–174.

38 J. R. Meloy, *Violent Attachments* (Northvale, NJ: Jason Aronson, 1992), pp. 43–4.

39 Freud, 'Three essays' (1915 edn), p. 138.

40 O. Kernberg. 'Hatred as a core affect of aggression', in S. Akhtar, S. Kramer, and H. Parens (eds), *The Birth of Hatred: Developmental, Clinical, and Technical Aspects of Intense Aggression* (Northvale, NJ: Jason Aronson, 1995), pp. 53–82, 69.

41 R. Lewin, *Compassion: The Core Value that Animates Psychotherapy* (Northvale, NJ: Jason Aronson, 1996), pp. 298–9.

42 Sigmund Freud. 'The economic problem of masochism' (1924), *Standard Edition*, vol. XIX, pp. 163–4.

43 Following a long but sloppy tradition in psychoanalytic thought, I assimilate ego and self. Heinz Kohut, among others, would presumably disagree. Heinz Kohut, *The Restoration of the Self* (New York: International Universities Press, 1977).

44 G. Rose, *The Power of Form: A Psychoanalytic Approach to Aesthetic Form*, expanded edition (Madison, Conn.: International Universities Press, 1992).

45 *Eumenides*, ll. 986–7.

46 Freud, 'Civilisation and its discontents', pp. 134–48.

47 Marcuse, *Eros and Civilisation*, p. 83.

48 Norbert Elias, *The Civilizing Process*, trans. by Edmund Jephcott (Oxford: Blackwell, 1978).

49 Ibid. p. 450.

50 Ibid. p. 99.
51 Stanley Milgram, *Obedience to Authority* (New York: Harper Colophon Books, 1975).
52 A. Miller, B. Collins and D. Brief (eds), *Journal of Social Issues*, 51: 3 (1995) (special issue on the legacy of the Milgram experiments).
53 Sigmund Freud, 'Group psychology and the analysis of the ego'(1921), *Standard Edition*, vol. XVIII, pp. 67–145.
54 Freud, 'Civilisation and its discontents', pp. 110–15.
55 A. Cooper and M. Sacks, 'Sadism and masochism in character disorder and resistance'. *Journal of the American Psychoanalytic Association*, 39 (1991), p. 218; S. Pulver and S. Akhtar, 'Sadomasochism in the perversions', *Journal of the American Psychoanalytic Association*, 39 (1991), pp. 751–2; W. Grossman, 'Pain, aggression, fantasy, and concepts of sadomasochism'. *Psychoanalytic Quarterly*, 60 (1991), pp. 47–8; J. MacGregor, 'Identification with the victim', *Psychoanalytic Quarterly*, 60 (1991).
56 O. Rank, *Will Therapy and Truth and Reality*, vol. 1 (New York: Knopf, 1945), p. 130.
57 P. Meyer. 'If Hitler asked you to electrocute a stranger, would you? Probably', in J. Henslin (ed.), *Down to Earth Sociology* (New York: Free Press, 1993), pp. 165–71.
58 Zygmunt Bauman, *Modernity and the Holocaust* (Cambridge: Polity, 1991), p. 151.
59 Thanks to Victor Wolfenstein for this point, and more generally for his groundbreaking work on Nietzsche and Freud.
60 Walter Kaufmann, Nietzsche's great translator and biographer, cites the Minutes of the Vienna Psychoanalytic Society of 1908 in which Freud wrote pieces on Nietzsche's *Genealogy of Morals* and *Ecce Homo*. W. Kaufmann, *Nietzsche: Philosopher, Psychologist, Antichrist*, 4th edn (Princeton: Princeton University Press, 1974), p.499. About turning late to Nietzsche, Freud says: 'Nietzsche, the other philosopher [the first is Schopenhauer] whose premonitions and insights agree in the most amazing manner with the laborious results of psychoanalysis, I have long avoided for this reason. After all, I was less concerned about any priority than about preservation of my openmindedness.' Sigmund Freud, 'An autobiographical study' (1925), *Standard Edition*, vol. XX, pp. 59–60. Perhaps, or perhaps Freud's motivation was at least as complex and ambivalent as that of those he analysed.
61 F. Nietzsche, *On the Genealogy of Morals* (1887), in *Basic Writings of Nietzsche*, trans. by Walter Kaufmann, (New York: Modern Library, 1968), pp. 500–1.
62 Ibid. p. 502.
63 J. Miller, 'Carnivals of atrocity: Foucault, Nietzsche, cruelty', *Political Theory*, 18 (1990), p. 485.
64 Miller comments on Nietzsche's observation in *Ecce Homo* that 'cruelty is here exposed for the first time as one of the most ancient and basic substrata of culture that simply cannot be imagined away' (*Genealogy of Morals*). Quite right, but there is a big difference between the primordial reality of cruelty and its idealization. It is this that seems so hard to grasp. Miller, 'Carnivals of atrocity', p. 474.
65 Freud, 'Analysis terminable and interminable', pp. 245–6.

66 F. Nietzsche, 'The birth of tragedy', (1872) *Basic Writings of Nietzsche*, trans. by Walter Kaufman (New York: Modern Library, 1968), pp. 3–146.
67 A. Freud, *The Ego and the Mechanisms of Defense: The Writings of Anna Freud*, vol. 2. (New York: International Universities Press, 1966), pp. 109–12.

4
Freud, Feminism and Postmodernism

Anthony Elliott

The processional integrity of any object – that which is inherent to any object when brought to life by an engaging subject – is used by the individual according to the laws of the dream work. When we use an object it is as if we know the terms of engagement; we know we shall 'enter into' an intermediate space, and at this point of entry we change the nature of perception, as we are now released to dream work, in which subjectivity is scattered and disseminated into the object world, transformed by that encounter, then returned to itself after the dialectic, changed in its inner contents by the history of that moment.

Christopher Bollas

Postmodernity does not necessarily mean the end, the discreditation or the rejection of modernity. Postmodernity is no more (but no less either) than the modern mind taking a long, attentive and sober look at itself, at its condition and its past works, not fully liking what it sees and sensing the urge to change.

Zygmunt Bauman

Is the repressed unconscious, in some sense or another, the key to unlocking gender oppression?[1] The question is, of course, at the heart of the feminist debate over Freud. Many, including such authors as Simone de Beauvoir, Betty Friedan, Germaine Greer and Kate Millett, have given an answer in the negative. Always it was the phallocentrism of Freudian psychoanalysis that doomed it to failure in the eyes of such feminists. Freud's theories were seen as conceptually legitimating woman's social subordination. Indeed, Freud's dictum of 'penis envy' and his account of feminine sexuality as supplementary and derivative (the little girl as castrated and stunted) were upheld as definitive both of Freud's private fear of women, and the reactionary nature of psychoanalytic theory. Later, feminists adapted Freud's ideas to radical political ends. Juliet Mitchell's bold claim in 1974 that 'a rejection of psychoanalysis and of Freud's works

is fatal for feminism' signalled this sea-change. A sharp division sub-
sequently developed between the work of feminists influenced by
Jacques Lacan's 'return to Freud', and those more committed to
object-relational or Kleinian approaches. This division in psycho-
analytic feminism remains important. However, the rise of post-
structuralism and postmodernism in the universities has led,
ultimately, to the dominance of Lacan's Freud in feminist circles.

My purpose in this chapter is not to map the engagements with,
and attacks on, Freud in feminist theory. Rather, I shall restrict my-
self to a consideration of some of the more theoretically reflective
claims of contemporary feminism, which will direct us further to
the theories of post-structuralism and postmodernism. I want to use
these current theoretical controversies as a foil against which to ex-
amine, and thus elucidate, some of the functions of Freud in the
frame of feminism. Given that it is a two-way process between the
fields of psychoanalysis and politics, I want to consider some dis-
cursive paths opened in contemporary theoretical debate. This is
less a matter of trying to judge how well, and in what ways, psy-
choanalysis has been linked to feminism than it is a matter of de-
ploying Freud to think the advances and deadlocks of new feminist
discourses. Needless to say, this necessarily involves using Freud to
assess the limits of what psychoanalysis permits feminism to think
of itself.

Feminism, Post-structuralism and Postmodernism

Imagine, if you will, a society in the not too distant past, before the
eclipse of Reason, possibly before the rise of the Unconscious, and
certainly before the arrival of deconstruction and post-structural-
ism, when sexuality was connected unproblematically to gender hi-
erarchy. A society, that is to say, in which sexuality maps sharply
and cleanly onto gender differences. A society in which the catego-
ries 'women' and 'men' simply loop back upon themselves in an
infinite regress. A social world in which the scientific knowledge of
gender, regarded as more real than the Real, revealed the sexuality of
men as active and assertive, and the desire of women as passive and
submissive; a kind of deadlocked opposition that puts the sexes se-
curely in place to perform the business of social and sexual repro-
duction. And a world in which sexuality is treated as coterminous
with heterosexual genital sexuality, an equation that either banishes

or subsumes all non-heterosexual organizations of desire just as surely as it naturalizes 'woman' as a thoroughly sexualized category of Otherness.

That moment of society might be further imagined as a moment in which the women's movement comes to develop a form of social-historical knowledge that, somewhat paradoxically, transcends this ruthless and oppressive gender division; a kind of knowledge that not only outstrips existing historical constructions that serve to naturalize sexuality, but that also espouses a creative agenda for political transformation and revolution. This figuration of knowledge of which we are speaking is itself part and parcel of the modernist urge to unmask asymmetrical relations of power; the modernity of reified sexuality and distorted gender relations. For modernist feminism, this unmasking is to be performed through a problematization and dismantling of dominant dualisms which underpin Western ways of thinking about and organizing gender relations. Dualisms of self/other, mind/body, reason/emotion, nature/culture, private/public and science/ideology have been central to feminist critiques of epistemology, and also the analysis of sexually oppressive political relations. From problematizing the political processes involved in the naturalization of gender relations, and equipped with the maxim that 'the personal is the political', modernist feminism installs itself precisely within some imagined libratory space beyond the reaches of sexual domination.

All this takes place in the name feminism, but that is not to say that the discursive field of the women's movement unfolds without contradiction or ambivalence. To acknowledge the phallocentrism inherent in modern culture is to acknowledge a range of conceptual vocabularies that unmask regimes of gender power. This amounts to saying that feminism, in its modernist moment, initiated a number of conceptual raids on fields of knowledge such as anthropology, psychoanalysis and sociology in order to bring low the institutional regulation of the sexual and gender systems. For example Freud, that patriarchal father of the normalizing discourse of psychoanalysis, was put to use against himself, from which a psychoanalytically informed feminism could then reveal all circuits of desire as an outcrop of Oedipal repetition, and in which Woman functions as that prohibited signifier between men which secures the phallocentric social contract. Similarly, Lévi-Strauss's account of kinship systems was drawn upon to designate Woman as an object of exchange that founds the moment of masculinist culture itself.[2] But the significant

point here, in all of these feminist responses, is that the unmasking of sexual oppression is pitted against an apparently wholly structured, rationalized, universal system of gender division. Bring down gender, so the rallying cry went, and you'll bring down the repressive social system in which sexuality is encoded, if not today then at least in the supremely positive utopianism of tomorrow. But the cost of this global perspective was great indeed, wiping out the specifics of sexual difference in particular and the ambiguities of sexual power relations in general. Consequently, the sexual in modernist feminism simply became more and more the by-product of all social dialectics, from the laws of cultural exchange to the laws of capitalist modernization.

That such a conceptual and political understanding of sexuality was bound to go awry seems self-evident today, not only from any rigorous reading of, say, psychoanalysis or post-structuralism, but also from the range of social-historical institutional transformations which have profoundly altered the stakes of sexual knowledge itself. For sexuality is no longer exclusively tied to the ideological regulations of gender in recent rewritings of social and cultural theory, but increasingly comes to signify an excess or supplementarity, from which it might be re-imagined as occupying a semi-autonomous space. Dislodging the fetishized unity of sexual interlockings and gender, this semi-autonomous realm of desire – or, more specifically in Althusserian terms, this 'relative autonomy' – is at once linked to, and detached from, the solid structures of material institutions. This amounts to saying that the libidinal-sexual is sealed off into its own realm and yet constantly bursts out of this self-enclosure to dislocate the matrix of social-historical meanings. The doubleness of the libidinal-sexual is that it is at once narcissistically self-referential and experientially other-directed; a kind of 'subjectless subject', to borrow from Adorno; or perhaps simply a jack-in-the-box which always threatens to unmask the contingency of 'gender foundations'.

If all of this sounds a little too much like a replay of previous developments in radical critique – think, for instance, of Herbert Marcuse's utopian forecast of an emergent 'libidinal rationality' in the 1950s – it is worth bearing in mind that the transgressive potential of the libidinal-sexual in contemporary feminist theory has as its target not only discourses and practices but also the body and its pleasures. That is to say, the libidinal-sexual becomes characterized as a force that reverberates endlessly around all sites of human communication, fracturing conventional distinctions between rational-

ity and desire, masculinity and femininity, the cognitive and affective, the linguistic and non-linguistic. From this angle, the post-structuralism of Foucault, Lacan, Derrida, Lyotard, Deleuze and others outstrips traditional feminist thought, with its profound questioning of rational knowledge, its displacing of determinable truth, its flamboyant debunking of all major hierarchies, its privileging of the signifier and dislocation of symbolic meaning with libidinal intensities. In post-structuralist feminism this will be translated into a fully-blown dismantling of ideological closure in the field of gender relations, and matters relating to the ways in which the women's movement has proceeded to define its own goals through the marginalization and exclusion of sexualities has come to be understood increasingly in this light. Post-structuralist feminism then understands that the relation between sexuality and gender is not identical; they are certainly mutually imbricated, but their relation is not one of mere equivalence. Gender is always sexualized, and sexuality is shot through with gender power; but from a radical viewpoint it can be argued that sexuality and gender are mutually dislocating, conflicting, fracturing.

This dislocation brings us directly into highly contested and heterogeneous practices of contemporary feminist theorizing, or of what Fredric Jameson would call the 'post-contemporary cognitive mapping' of sexuality/gender relations.[3] In this context, the modernist search for an underlying disease which deforms autonomous gender relations gives way to a postmodern multiplication of conceptual and political interests such that, from one angle, contemporary feminism becomes every bit as dispersed and fragmented in its theoretical operations as the very structure and matrix of meanings it is seeking to understand. In this respect, a core political fear registered by many people is that, lost in the libidinal ecstasies of indeterminacy and erotic possibilities of sexual signification, feminism is in danger of losing the plot altogether. Contemporary feminist thought, in this view, seems to have fallen for the sterile political discourse of the academy, a conceptual move that in one stroke disconnects its interests and aims from the actual practice of gender struggle and transformation. All of this current feminist talk about the gap or lag between social practice and theoretical reflection is thus considered extraneous academic noise; and it is from this understanding of the contemporary critical climate that a number of feminists continue to hanker after a revolutionary political position that would somehow be magically identical-to-itself. This reaction, in other words,

continues to dream of certitude and transparency: if only feminism could get back to basics – perhaps in the manner that John Lennon condensed the spirit of the 1960s into the slogan, 'All we are saying is give peace a chance' – then surely it could dispense with the elitist and pretentious jargon of post-structuralism and postmodernism.

From another angle, however, the framing of matters in this way becomes possible only if one is still out to colonize, or perhaps even master, existing knowledge of oppressive patriarchal practices in line with the degrading demands of an instrumental rationality. Thus, postmodernist feminism proclaims: forget the Law of the Father – the problem of institutionalization is simply depressing and a dead end anyway – and try to glimpse the repressed stain of difference inscribed within the categories of opposition that perpetuate gender hierarchy. The interpretative strategies that emerge in recent works by Jacqueline Rose, Gayatri Spivak, Judith Butler, Drucilla Cornell, Rosi Braidotti, Lynne Segal and Elizabeth Grosz seek, in the broadest outlines, to unhinge our psychic and cultural identification of gender with core sex identity, to destabilize foundational understandings of sex and gender in favour of enacted, fantasized or contingent discourses of gender, and to attempt to turn the logic of sexual difference back upon itself to show how it reaches into the operations of desire itself.[4] This brand of feminist politics, basing its theoretical operations on a blending of post-structuralism, psychoanalysis and postmodernism, deals another powerful blow to patriarchal ideologies therefore by refusing to accept the requirements for formalization – psychic, social, cultural and political – at face value. And once again feminism seeks to imagine a path of sexual development beyond the dead weight of masculinist rationality, but this time without needing to submit its strategic blueprints to the terroristic pressures of Reason and totality.

It is this pluralization of the field of sexual difference – the dispersal of selves, bodies, sexualities, pleasures and fantasies – that has been politically underwritten as of core importance by contemporary currents of post-structuralist and postmodernist feminism. And one significant result of this rethinking of the cultural possibilities of sexuality as a utopic medium has been a recovery of vital political issues, such as the body and the problem of unconscious desire, which traditional feminism tended brutally to suppress.[5] Notwithstanding the more creative and subversive aspects of these recent political strategies articulated in some currents of feminism, however, many crit-

ics have wished to highlight the performative contradiction between asserting the death of the subject and of truth on the one hand, and then of still confidently maintaining that men oppress women on the other. This leads to an absurd political situation, or so many feminist critics have argued: the need to scratch where it should no longer itch. Focusing on the contradictory character of recent feminist writing – the split between the extreme particularism of post-structuralism and the universal claims of collective feminist politics – many critics have argued, in effect, that feminism will only make further political gains if it displaces the difficult ontological and epistemological questions raised by post-structuralism and postmodernism. For in so far as feminist thought influenced by these theories seems to lose contact with the 'realities' of the external world, or merely treats reality as some kind of displaced consequence of fantasy and sexual difference, it is surely better to be without the profound political pessimism of post-structuralist doctrine and return instead to the pressing historical realities of gender hierarchy. So, too, the postmodern critique of difference, sexual and intimate, is at the heart of contemporary anxiety about queer theory. Here there is a deep controversy about changes which link homosexuality to other critical concerns such as representation, desire, positionality, discourse and the body on the one hand, and the downgrading of movement politics and political action on the other. As Dennis Altman writes:

> Much of what has become known as 'queer theory' appears remarkably unaware of the history and writings of gay liberation, which is sometimes depicted as essentialist, despite a body of gay liberation work which explicitly drew on Freudian notions of polymorphous perversity. By 1995 I could read an honours thesis which spoke as if such notions had never occurred to anyone in the gay movement, and were the discovery of French intellectuals writing ten years after the early debates in the sexual liberation movements.[6]

Clearly, this is more than just a matter of getting our intellectual history right; it has to do instead with that cultural evasion or repression which contemporary critical discourses, from postmodernism to queer theory, have helped usher into existence.

Such a refusal to permit post-structuralism and postmodernism any political role in the crisis of contemporary feminism betrays, I

think, not only a wish to return to an earlier intellectual period of feminist confidence and surety, but also a radical rejection of complexity itself. This is a rejection of both the complexity of psychic life and the complex political world of human beliefs, values, sentiments, pleasures and desires. The very complexity of human sexuality, coupled to the uncontainability of the social imagination and cultural process, seems to call forth an overwhelming anxiety in certain currents of contemporary feminism; an anxiety which threatens to dislocate the political coherence of the women's movement itself. From this angle, the rush to take flight into feminist collective action as resolved project, when premised upon the mindless rejection of other points of view and states of mind, can be viewed as an institutional attempt to keep anxiety and ambivalence at bay.

Sexual Difference, or More of the Same?

It is one of the sad ironies of the feminist appropriation of psychoanalysis as a theory that it at once serves to unlock the fixity of gender positioning in the socio-symbolic order and also reinscribes desire into the binary logic – or if Derrida is right, the supplementary logic – of sexual difference. This political dilemma is especially acute in Lacanian feminist theory in which the construction of desire in and through language is viewed as co-extensive with the subject's submission to the Law of the Father, a submission which imprisons women and men within the repetitive discourses of phallocentrism. The strength of Lacanian-based feminism lies in its uncovering of the linguistic and sexual codes which perpetuate gender hierarchy; yet its central limitation is that, given its subjective determinism and political pessimism, the possibility of alternative gender relations is done away with in one stroke. From this angle, the emergence of post-Lacanian feminist writing can be seen as a political attempt to find some way out of this deadly impasse – usually by going further and further back into the subject's pre-Oedipal sexual history.

There is, however, another psychoanalytic view on the intricate connections between imagination and sexuality which potentially transfigures the inner complex of gender. I refer to the Freudian conception of 'unconscious representation', to those continuously moving fantasies of the unconscious imagination, especially as they pertain to emotional experiences of self and other. Freud's account of the psychoanalytical process, to be sure, is preoccupied by the complicity

between imagination and repression, desire and defence. For Freud, the unconscious is a representational flux of desire and affect, driving thoughts and associations along a multitude of pathways, displacing and condensing the forced unities of consciousness. This is the aspect of Freud's work that most powerfully underscores the creative workings of the self, and it is an aspect that I think is often insufficiently emphasized in post-Freudian psychoanalytical doctrines, as well as in the application of Freudian ideas to the social sciences and humanities more generally. This is not simply the result of a failure to grasp the 'essence' of Freud's teachings, because (as I have argued at length elsewhere[7]) the founding father of psychoanalysis neglected to explicitly *theorize* the more inventive, creative dimensions of the unconscious imagination. There were, of course, good reasons for such a conceptual neglect or displacement. Given that Freud was preoccupied with human suffering, it is hardly surprising that he dedicated his energies to uncovering the tropes of repression and mechanisms of defence that constitute blockages in the processing of affect – blockages which make themselves known through symptoms. Yet Freud also continually underscored the inventiveness of the unconscious imagination, pointing out in 'The interpretation of dreams' that no dream can be fully interpreted because it contains too many trains of thought and complexities of affect.[8]

In the writings of contemporary psychoanalysts such as Thomas Ogden, Christopher Bollas, Jessica Benjamin, Charles Spezzano and Stephen Mitchell, there is an explicit concern with the interconnections between desire, imagination and the notion of sexuality as an open-ended process.[9] A combination of desire and imagination, when available for psychic processing and reflective thinking, underpins the scanning of alternative selves and states of mind. The pleasures and dangers of self-experience, and of the self in its dealings with the social world, become available to reflective knowing only after an immersion in experience, in which emotional contact is created between the conscious and unconscious, inside and outside, identity and non-identity. This opening out to reflective knowing is open-ended in the sense that ambivalence and otherness are tolerated and explored in terms of their inner complexity; it can be thought of as a kind of internal celebration of the sheer diversity and plurality of human worlds. Thomas Ogden, for example, speaks of 'the fear of not knowing', a fear which (if not consciously perceived) can lead to the unleashing of destructive fantasy and of attacks on open-ended thinking. Toleration of 'not knowing', says Ogden, is fundamental

to a creative engagement with the self, others, and the social world. I have connected this 'fear of not knowing', in my *Subject to Ourselves*, to modernist desires for certitude, order, control and mastery, and have contrasted it with postmodern tolerance of ambiguity, ambivalence, uncertainty, contingency and difference.[10]

From this psychoanalytical recasting of radical imagination, we can begin to raise questions about whether contemporary feminist thought enables the recognition of our inner complexity as sexual, gendered subjects, or whether it has become a way of closing down on such questions, or at least of keeping that which is disturbing and overwhelming about ourselves at bay. The core issues which arise are these. How does contemporary feminism attempt to think the new and grasp the power of imagination? What kind of processing or remembering is feminism undertaking in its concern with the production and transformation of sexualities? What blockages and disturbances serve to limit or constrain the thinking of feminism afresh? Does feminism simply reiterate itself? How, and in what ways, has feminism become repetitive? Is postmodern feminism always more of the same, simply dressed up in new clothes? Or is the repetition of feminism part and parcel of the logics of sexual difference itself?

In *Social Theory and Psychoanalysis in Transition*, I outlined three levels of analysis with respect to the nature of unconscious desire which could offer a reflective and systematic framework for the study of self and society – namely, the representational flux of individual fantasy, the indeterminacy of social imaginary significations, and the socio-symbolic realm of received cultural meanings.[11] As concerns problems of sexual difference and gender complexity, I attempted to underscore the profound role of imagination and unconscious fantasy in both the perpetuation and the transformation of gendered subjectivities. Against the tide of much Lacanian feminist thought, I argued that our fantasized aspects of sexuality and of sexual difference necessarily imply transmutations in the socio-symbolic world of gender hierarchy, and I attempted to document such changes by reference to developments in the women's movement itself. I set out the intricate links between human imagination and social institutions (in this case, the women's movement) in the following way:

> The imaginary underpinning of women's political mobilization has both influenced social policies and in turn has been reshaped by new institutional resources. That is, women's collective action in society has, among other things, led to the

institutional redefinition of the objectives and aims of the women's movement. This is clear, for example, in the shift from the 1970s, when an essential female subjectivity was posited against male domination, to the growing tendency today for the women's movements to support a plurality of female subject positions (such as sexual, work, and political identities). At a theoretical level, then, it can be said that processes of imaginary transformation establish new symbolic possibilities from which a variety of gender issues come to be addressed anew.

In what follows I want to amplify on these connections between imagination and society, fantasy and institution, but I want to do this through a reversal of logics: that is, by considering what happens when there is a loss of imagination and a negation of the freedom to attach meaning to experience in open-ended ways. The task here is to describe some recent self-imposed restrictions on feminist theorizing and politics, and of how the disavowal of imagination is implicated in the destruction of difference, and especially alternative political possibilities implicit in sexual difference. Later in the chapter, I turn to consider a more open and combinatorial feminist approach to the complex linkages between identity, sexuality and society, or, as this can be framed in psychoanalytical terms, the production of psychic space, the making of radical imagination, and the composition of social relations or practices.

From Ambivalence to Inflexibility: The Fear of Difference

The rise of the concept of difference, as we have seen, is directly linked to the contemporary currents of postmodernism and post-structuralism, and its political significance is often measured against the linear, bureaucratic, well-ordered administered world of modernity. In contemporary feminism, the political value attributed to the recovery of difference is that it potentially opens the mysteriously repressed realm of sexual division to a kind of thinking that goes beyond modernist categories of opposition that serve to sustain gender hierarchy. Precisely because identity is no longer thought of as a stable entity, its meaning opening onto the problematic realm of ambiguity and indeterminacy, the discourse on feminist politics moves increasingly to consider what political possibilities arise from the troubled significations of identity and difference. But what kind

of love affair, we might ask, is feminism having with difference? Is it, for example, something that promotes a radical inquiry into the political construction of sexuality and gender? Or is it something that has simply developed into a fixed normativity, as a new kind of political correctness for feminism?

In order to take up these questions, let us turn now to examine Naomi Wolf's *Fire with Fire*.[12] The follow-up to her international bestseller *The Beauty Myth*, *Fire with Fire* – which is subtitled "The New Female Power and How it will Change the 21st Century" – continues Wolf's preoccupation with developing a feminist discourse which is somehow politically relevant to contemporary culture. Rejecting the idea that feminism can simply pick up pre-existing theories of power and oppression and apply them to our culture of gender inequality, Wolf instead tackles head-on the difficult problem of putting theory securely in the context of women's – and men's – everyday activities in order to think sexual politics afresh. Wolf claims that the urgent priority is to construct a feminist politics that can think positive and negative dimensions of the intricate connections between existing power networks on the one hand, and sexuality and gender hierarchy on the other. Furthermore, she asserts that a practical and useful language, rather than simply a more moralizing discourse, is required for the advancement of feminist action.

Wolf begins her discussion of power in *Fire with Fire*, appropriately enough, with the declaration that the 1990s have ushered in a 'genderquake'. Emerging against the backlash years of the 1980s, when women's personal and political gains were under attack everywhere, the new era of the 'genderquake' promises a radical transformation of sexual politics and of the distribution of power between the sexes. As Wolf explains this development:

> The 'genderquake' started in America with the eruption of Oklahoma law professor Anita Hill's charges of sexual harassment, rocked through the 1991–2's famous rape trials, flung into the light of day allegations of Senator Bob Packwood's sexual harassment of colleagues, and of the sexual abuse of US Navy women at the Tailhook Convention; and provided the impetus for 52 new women legislators to take their seats in the House of Representatives and the Senate.

That Wolf's narrative is set securely within recent political developments in the USA is, one might think, a curious opening move for

such an 'international feminist' to make – especially given that it is
part of her argument that the logics of 'genderquake' are increas-
ingly global in character. But if the geopolitical specificity of her
case is never adequately questioned, it is more than compensated for
in terms of Wolf's bold linkage between historical and sexual/politi-
cal knowledge. As she provocatively claims,

> we are at what historians of women's progress call 'an open
> moment'. Twenty-five years of dedicated feminist activism have
> hauled the political infrastructure into place, enough women
> in the middle classes have enough money and clout, and most
> women now have enough desire and determination to begin to
> balance the imbalance of power between the sexes.

There are, however, dangers and risks here as well; but for Wolf these
are less to do with the economic infrastructure governing sexuality
and gender hierarchy than with the cultural sphere of human social
relationships. Such a focus on the cultural sphere brings into play
the politics of feminism itself, and she certainly has damning things
to say about the rise of 'victim feminism' – that version of feminism
which constructs women as sexually pure and personally altruistic,
and only then considers the damage done to women in a world of
male oppression. For Wolf, the weakness of this case is that it estab-
lishes an identity-politics from the process of victimization it de-
scribes. That is to say, it draws all women under the sign of
victimization, riding roughshod over major personal, cultural, so-
cial and political differences between women; differences of sexual
orientation, race, ethnicity and class. The core limitation of this kind
of identity-politics for feminism then is that it obscures the differ-
ential effects of relations of domination and oppression, including
those between women. As such, it is unable to comprehend that
economic and cultural inequalities vary considerably among women,
in terms of the degree of oppression, exploitation of the body, re-
pression of desire and the like.

Against this backcloth, Wolf argues for expanding the concept of
difference to encompass women's and men's everyday activities, and
suggests the political urgency of attempting to talk across gender
differences in order to break the fixity of our current embattled per-
spectives. She scornfully rejects the anxiety that an attempt to think
power differently – to consider sexual and gender differences be-
tween women and also between the sexes – will lead feminism into

disarray, into a form of political impotence arising from partial per-spectives, in which each viewpoint on gender is considered as good as the next. Those who imagine that truth is absolute in the field of gender relations, says Wolf, are held helplessly in thrall to a fixed, monolithic conception of political change; indeed such rigid deter-minism is itself part and parcel of the destructive logics of 'political correctness'. Feminism, according to Wolf, if it is to become flexible and creative again, needs to reject, once and for all, the notion of political correctness; it needs to face up to ambivalence and ambigu-ity, not as some limit to the powers of intellectual clarity and know-ledge, but as central to interpersonal relationships and human sexuality; it needs to see that 'worldly power' is complex, ambigu-ous and indeterminate.

There is, then, another dimension beyond the dominant logic of 'political correctness' which frames the critical feminist capacity, but it does this through trying to *understand* the complexity and am-bivalence of unequal gender relations; it does not simply legislate in advance how such dramas and difficulties should be comprehended in the first place. Yet there is a tension in Wolf's work as to how thinking and acting might be related in terms of feminism today. At times, Wolf indicates that it is because of the complexity of the rela-tionship between self and society that feminist theory must resituate itself as a theory in connection with the lived experience of gender, sexuality, bodies, desire and the like. At other times, Wolf seems anxious about the potential deadlocks and dead ends that may in-hibit feminist action if notions of complexity, ambiguity and am-bivalence are fully embraced. Here, it might be said, the cognitive and normative elements of her discourse begin to enter into an em-barrassing contradiction. In other words, just as Wolf begins to re-think the connections between theory and practice in postmodernist culture, she gets hung up about the interlacing of these domains, deciding in the end it is better to stick with the devil you know than the one you don't.

By the conclusion of *Fire with Fire*, Wolf's discourse fully reflects a flight from the conceptual, as well as from a confrontation with the messiness and ambivalence of human social relationships. In a section entitled 'Psychological Strategies', Wolf writes: 'Power femi-nism cannot work until we try to make changes in the way we treat ourselves and others.' She then offers a kind of 'shopping list' re-quired for putting power feminism into action. The strategies she proposes include (and I quote her, again):

- Avoid generalizations about men that imply that their maleness is the unchangeable source of the problem.
- Never choose to widen the rift between the sexes when the option exists to narrow it, without censoring the truth.
- Resist the idea that sexual orientation is fixed and categorical, or that any one woman's sexual choices are more legitimate than any other's.
- Make it socially acceptable for women to discuss their skills and achievements.
- Remember and take possession of the girlhood will to power and fantasies of grandeur.
- Practise asking for more money, and urge our friends to so.[13]

By ranking these demands on the same level, as strategies which fit all social relations and institutions, Wolf takes up a reactionary political stance. For the effect of this normative performativity ('Never choose', 'Practise asking') is to reduce the very operating conditions of ambivalence and ambiguity to nought. Clearly, the pressure to offer some kind of *feminist solution*, however politically maladroit and culturally vacuous, managed to get the upper hand in Wolf's thinking – a psychic reaction which, in psychoanalytic terms, can be described as a 'translation into action'. Wolf's 'shopping list' creates, in effect, a really tight fit between feminist ideology and social action, thereby crowding out the very indeterminacy of the self/society link which she alluded to previously. No space for mind, imagination, fantasy – because the ideology processes the reality to fit the 'psychological strategies' on offer.

Consider, by contrast, the encounter between feminism, psychoanalysis and political theory staged by the British theorist Jacqueline Rose. In her book *Why War?* (1993), Rose takes up the question that so troubled Freud towards the end of his life: the origins or nature of violence in general, and of why violence figures so prominently in contemporary culture in particular.[14] (The title of Rose's book is taken from Freud's essay 'Why War?', which was part of Freud's public exchange with Einstein on the subject of war[15]). In a Freudian context, the problematic of war is that of a failure in emotional self-knowledge. Rose writes: "to suggest that war is in some sense the repressed of its conceptualization – that is, of any attempt to think it – might be one way of explaining why we are never prepared for the full horror of war."[16] War brings us face to face with our own inner darkness, the destructiveness we fear in ourselves. In

routine conditions of social life, the irrational and psychotic features of the psyche are held in check by the more constructive and realistic functioning of various cultural groups, dominant authorities and institutionalized expert-systems. In conditions of war, however, individuals and groups are easily overcome with paranoia and megalomania, projecting the destructiveness we fear in ourselves onto the other, the alien.[17]

Echoing Freud, Rose argues that violence and war represent the dissolution of society itself. 'War', writes Rose,

> makes the other accountable for a horror we can then wipe out with impunity, precisely because we have located it so firmly in the other's place. This saves us the effort of ambivalence, the hard work of recognizing that we love where we hate, that, in our hearts and minds at least, we kill those to whom we are most closely and intimately attached.[18]

Such an approach to thinking violence and war, it might be noted, has a long psycho-social tradition. Politics, according to the founder of political psychology, Harold Lasswell, is indeed about the regulation of anger and hatred. From the Stone Age to Star Wars, political identities have been made in the service of hate, and especially irrational hate. The key point about hatred is that it is other-directed; the hater is convinced that the source of the problem lies in the person or group or nation which is so despised and denigrated. Accordingly, political subjects can take pleasure in violence as legitimate State force, as war, while always projecting 'real' violence elsewhere: the displacement of repressed rage onto socially sanctioned public enemies. From this angle, the dreaded negative powers of modernity depend upon the continual eruption of repressed feelings of violent anger, hatred, of nameless dread.

In the concluding part of this chapter, I want to take the work of Rose as a prime example of an attempt to analyse the issue of the complexity of mind from a feminist perspective. Rose's work is of special interest in the present context, not because it is informed by psychoanalytical themes (in fact, Rose's work offers a powerful feminist critique of Freud and psychoanalysis), but because she seeks to keep questions about complexity, ambivalence and indeterminacy open for conceptual reflection and consideration. Rose situates the question of violence in relation to structures of power, and especially structures of gender power; and it is from this angle that her

writing makes for a powerful blending of feminist scholarship, psychoanalytic criticism and political theory. Developing upon her feminist and political critique of psychoanalysis in *Sexuality in the Field of Vision*, Rose argues that psychoanalysis elucidates not only the repression of sexual feelings, but, just as important for the women's movement, the repression of hate and destructiveness.[19] Violence, says Rose, is of fundamental significance to contemporary feminism and gender politics. On one level, this is so because of the rise of sexual violence during the 1980s and 1990s (ranging from sexual harassment to rape and body mutilation), underpinned by the cultural implosion of apocalyptic sexual fantasy. On another level, a level that is perhaps even deeper, Rose suggests that feminism has too often made violence and hatred the curse of male subjectivity alone. Utilizing psychoanalytic theory to destabilize the assurance of a stable, self-identical subject, Rose contends that both men and women fear a destructiveness within, and that therefore much of the rhetoric of feminism needs to be critically revised.

This point is superbly made in Rose's examination of the psychic and historical connections between Margaret Thatcher and Ruth Ellis. The link between these two women is well known: in 1955 Ellis was the last woman to be hanged in England, and Thatcher brought her back to public attention in 1983 in her effort to reintroduce capital punishment in the United Kingdom. Rose notes that this link between Thatcher and Ellis highlights that violence can be used by females in a dramatic fashion. Ellis occupies a location of sexual, physical violence (she shot her lover); Thatcher occupies a location of political violence, the authority of the State to kill. For Rose, the logic of fantasy in which these forms of violence operate are mutually imbricated. Ellis's femininity, says Rose, could only appear as an outrage to society because of the deadly consistency of her premeditation. (Ellis stated in court that 'I had an idea that I wanted to kill him'.) The premeditated rationality of Ellis was deeply problematical precisely because it too closely resembled that violence which the law is founded upon – the violence implicit in objectivism and rationalism. 'Murderers', writes Rose, 'who premeditate are therefore the most dangerous because they too closely resemble the symbolic and psychic structure written into the legal apparatus that comes to meet them.'[20] Rose argues that Thatcher's support for the return of capital punishment was underwritten by a kind of 'super-rationality', the point at which violence secures its own legitimation:

It is not the irrationality of Thatcher's rhetoric that strikes me as the problem, but its supreme rationalism, the way that it operates according to a protocol of reason elevated to the status of a law. In this case, we cannot counter that ideology with a greater rationality without entering into one of the predominant fantasies of the ideology itself.

Thatcher and Ellis can then be said to represent different forms of 'reason in excess' – the first State-backed, the second of the criminal code.

Rose's theoretical purchase on the contemporary political climate is one that is always at odds with itself. On the one hand, she wants to show that psychoanalytic knowledge is itself essential to the framing of a radical political vision. On the other hand, Rose insists that the more troubling effects of repression are deeply inscribed in everything we do – sexual, cultural and political. The upshot of this is a revised version of the relationship between politics, psychoanalysis and feminism, a version that breaks with the notion of utopian liberation (what would a 'collective liberation' of the unconscious actually look like?) and, instead, embraces the difficult antagonisms between sexuality and aggression, desire and defence, life and death. For if there is ambivalence in the field of identity and sexual life, a similar doubleness can be seen to lie on the side of (conscious) knowledge and politics. That is to say, Rose connects the dynamic unconscious, not only to those broad areas of gender activity with which feminism concerns itself, but to the discourses of knowledge itself, including those of theory and critique. In striving to figure the latent desire of cultural knowledge, Rose underlines the sexual and psychic stakes of the political in the strongest sense, capturing not just the fantasy component of aspects of society and history, but also the circuit of unconscious dislocation in the relationship between psychoanalysis and social theory more generally.

As might be expected from this kind of cultural diagnosis, much of the psychoanalytic emphasis centres on negativity and dislocation. Following Lacan's Freud, Rose seeks to analyse, not only our construction in and through the symbolic order of language, but also the ways in which this constitution of subject-positions and psychic locations fails, lapses, dissolves. This is a paradoxical theoretical endeavour, since it involves looking at how the interrelation between psyche and society at once succeeds and fails – or, at least, of how that interrelation is always in the process of redefining and

reconstructing itself. It is in this sense that Rose can be said to have followed faithfully Freud's notion of the death drive (*Todestrieb*), a primary aggressiveness in human beings which at once lurks within our narcissistic gratifications and drives the ego towards violent acts of self-undoing. The objectives or strategies of the death drive, carried out through the brutal directives of the superego, are essential for grasping the fantasy dimensions of the dark side of modernity, and it is precisely for this reason that Rose devotes much of her psychoanalytic and political attention to war and other terrors of recent history. For it is only by confronting the most painful and distressing aspects of our collective experience, says Rose, that we may come to understand better the psychic and the social-historical forms implicated in the production and formation of destructive political identities. Rose's work, then, represents a kind of applied psychoanalysis of feminist ethics, concerned as it is with the question of autonomy and its forms of realization. For Rose, autonomy is a question of neither rejecting nor appropriating the law, but of fostering an ambivalence that will allow human subjects to withdraw projections based on destructive urges, and thereby strengthen creative social and political relations.

Rose's *Why War?* and Wolf's *Fire with Fire*, though very different versions of feminist theory, attempt to grapple with the place of gender in the furthermost reaches of our personal and political lives. Both seek to engage with the increasing complexities of sexual life and identity in the postmodern age, and in a certain sense both have important and troubling things to say about notions of gender and social transformation. Unlike *Why War?*, however, *Fire with Fire* seeks to provide accessible and ready-made solutions for gender transformation, and to that extent Wolf's work can be considered simplistic and deterministic. Rose, by contrast, returns us to Freud's really insightful discoveries about the indeterminacy of the (critical) radical imagination, and of the complexity this carries for considering, as well as trying to enact, alternative social futures. For Rose, there is no final point of arrival, only interesting questions. Such questions, as I have sought to demonstrate, concern the operations of both psychoanalytic and feminist theory. As Rose develops this:

> the point at which psychoanalysis as a practice comes up against the limits of its own interpretative process, might be the point at which there could be the strongest dialogue between

psychoanalytic practice and the readings of psychoanalysis in the humanities which stress the ultimate failure of controlling interpretative procedures.[21]

Conclusion

In this chapter I have sought to portray the contributions of Freud to feminist and social theory in broad strokes, in order to consider some of the different ways in which psychoanalytic theory can be drawn upon to examine current intellectual discourses on gender, sexuality and intimacy. The connections between psychoanalysis and politics, as I have tried to indicate, involve a two-way traffic. That is, the application of Freud to feminist and social theory has led many authors to discuss problems of human subjectivity, desire, sexuality, fantasy and interpersonal relationships in more reflective ways than was the case before. At the same time, however, feminist and social theory has made important contributions to our understanding of the gains and losses of viewing social relations and cultural processes through a Freudian lens. In response to this intellectual interchange, I have sought to indicate how we might approach contemporary intellectual debates and deadlocks in feminist and social theory from the vantage point of psychoanalysis itself. Not in the sense of applying ready-to-hand formulas or dogma, but rather as a tool for keeping open difficult interpretative issues about those imaginary and symbolic forms implicated in the structuration of self and society in the late modern age.

Notes

1 An earlier version of this chapter was delivered in the welcoming environment of the Centre for Psychotherapeutical Studies at the University of Sheffield in December 1995; I would like to thank Nick Stevenson and Tim Kendall for their extremely useful comments.

2 The classic text here is Juliet Mitchell, *Psychoanalysis and Feminism* (Harmondsworth: Penguin, 1974).

3 See Fredric Jameson, *Postmodernism: or, The Cultural Logics of Late Capitalism* (London: Verso, 1991).

4 See Jacqueline Rose, *States of Fantasy* (Oxford: Oxford University Press, 1996); Judith Butler, *Bodies that Matter* (New York: Routledge, 1993); Drucilla Cornell, *Beyond Accommodation* (New York: Routledge, 1992); Rosi Braidotti, *Patterns of Dissonance* (Cambridge: Polity, 1992); Elizabeth Grosz, *Space, Time and Perversion* (London: Routledge, 1995). The best recent psychoanalytic critique of

sexuality in contemporary theory is Stephen Frosh, *Sexual Difference* (London: Routledge, 1994).

5 The question of the body has been of major importance for feminist theory and politics in recent times, and the key point of convergence between feminism and post-structuralism arises from the work of Michel Foucault. For a comprehensive overview of these developments, see Lois McNay, *Foucault and Feminism* (Cambridge: Polity, 1992). The problem of unconscious desire has also been paramount with regard to normative and political questions raised by some currents of feminist thought, and the key contributors in this area have been Julia Kristeva, Luce Irigaray and Hélène Cixous in French feminist thought, and Nancy Chodorow, Jessica Benjamin and Jane Flax in Anglo-American feminism. For a summary of these trends in psychoanalytic feminism see Anthony Elliott, *Psychoanalytic Theory: An Introduction* (Oxford and Cambridge, Mass: Blackwell, 1994); Jane Flax, *Thinking Fragments* (Berkeley: University of California Press, 1990).

6 Dennis Altman, 'On Global Queering', *Australian Humanities Review* (1996).

7 See Anthony Elliott, *Social Theory and Psychoanalysis in Transition* (Oxford: Blackwell, 1992), ch. 1; also *Subject to Ourselves: Social Theory, Psychoanalysis and Postmodernity* (Cambridge: Polity, 1996), ch. 2.

8 There is always a part of the dream, writes Freud, 'which has to be left obscure; this is because we become aware during the work of interpretation that at that point there is a tangle of dream-thoughts which cannot be unravelled and which moreover adds nothing to our knowledge of the content of the dream. This is the dream's navel, the spot where it reaches down into the unknown. *The dream-thoughts to which we are led by interpretation have to, in an entirely universal manner, remain without any definite endings; they are bound to branch out in every direction into the intricate network of our world of thought.* It is at some point where this meshwork is particularly close that the dream-wish grows up, like a mushroom out of its mycelium.' 'The interpretation of dreams', *Standard Edition*, vol. V, p. 525 (my emphasis).

9 See Thomas Ogden, *The Primitive Edge of Experience* (Northvale, NJ: Jason Aronson, 1989); Christopher Bollas, *Cracking Up* (London, New York: Routledge, 1995); Jessica Benjamin, *Like Subjects, Love Objects* (New Haven: Yale University Press, 1995); Charles Spezzano, *Affect in Psychoanalysis* (Hillsdale, NJ: Analytic Press,1992); Stephen Mitchell, *Hope and Dread in Psychoanalysis* (New York: Basic Books, 1993).

10 Anthony Elliott, *Subject to Ourselves: Social Theory, Psychoanalysis and Postmodernity* (Cambridge: Polity, 1996).

11 Anthony Elliott, *Social Theory and Psychoanalysis in Transition: Self and Society from Freud to Kristeva* (Oxford and Cambridge, Mass.: Blackwell, 1992).

12 Naomi Wolf, *Fire with Fire* (London: Vintage, 1994). The quotations that follow are from pp. xiv and xvi.

13 Wolf's section on 'Psychological strategies' is to be found in ch. 18, 'What we can do now'.

14 Jacqueline Rose, *Why War?* (Oxford: Blackwell, 1993).

15 See S. Freud, 'Why War?' (1932), *Standard Edition*, vol. XXII, pp.195–215.

16 Rose, *Why War?*, p. 24.

17 Rose cites Franco Fornari's classic claim that war is a 'paranoid elaboration of

mourning', *The Psychoanalysis of War* (London: Indiana University Press, 1975), p. xviii.
18 Rose, *Why War?*, p. 19.
19 Jacqueline Rose, *Sexuality in the Field of Vision* (London: Verso, 1986).
20 Rose, *Why War?*, p. 60.
21 Ibid. p. 255.

5

The Primal Leap of Psychoanalysis, from Body to Speech: Freud, Feminism and the Vicissitudes of the Transference

Jessica Benjamin

I

In reflecting[1] on the one-hundredth anniversary of the 'Studies on Hysteria',[2] I felt impelled to remember an earlier point, the seventy-fifth anniversary, in which the rebirth of the feminist movement occurred – a movement that had at least equal importance for the inventor of the 'talking cure', Anna O., a movement that has been shadowing psychoanalysis since its inception and has, in our time, called for and led to a massive revision in how we view ourselves and the subjects of those original 'Studies'. The inception of the women's movement brought the dialectical poles of psychoanalysis and feminism into violent contradiction, seemingly the contradiction between the acknowledgment of social oppression and the awareness of internal repression. The notion of rebellion opposed the notion of illness, making heroines, or at least protesters, out of patients. Not surprisingly, hysteria was among the first issues explored by feminist criticism, and the idea of the hysteric as an antecedent form of woman's protest against the constraints of the patriarchal family was among the earliest revisions proposed by feminist scholarship.[3]

Although we remember her primarily as Anna O., the patient of Freud's older colleague Breuer on whose treatment Freud based much of what he wrote in the 'Studies', this is not the only way she

is remembered in Germany today. Anna O., known to her world as Bertha Pappenheim, settled in Frankfurt after her recovery from hysterical illness in the 1890s. While we are all familiar with the story of her intense attachment to Breuer, which led to a precipitate end to the treatment by the frightened physician and so inspired the founding myth of transference love as Freud conveyed it to us, Pappenheim's reaction to this experience is also significant. She became the founder of the first feminist Jewish women's organization and a leader in the nascent field of social work, rescuing children and young women who might fall victim to the slave trade.[4]

In recalling Pappenheim's history it is not my intention here to create a counter-myth of the feminist heroine or to take an uncritical feminist revisionist version of hysteria at face value. Both as she appears to us in Breuer's recorded recollection and in the later histories that value her as the founder of the German Jewish women's movement and a forerunner of modern social work, Pappenheim is surely a difficult figure with whom to identify. A woman who saw the straight lines of needlepoint as a metaphor for the well-lived socially useful life,[5] who renounced sexual freedom in favour of social agency, she was a woman guided by an incredibly powerful superego. Nonetheless it was she who became a rebel against the role of women prescribed by her religion and family, who did not finally remain paralysed by unexpressed anger and desire, who strove valiantly to express them through her body and her speech. One could say that she overcame her incapacity by developing a position of active mastery in the world – a reversal which, in Freud's thought, would count as the characteristic masculine strategy for overcoming hysteria.[6]

The reversal of passivity and the overcoming of the feminine position will turn out to be quite important, indeed fateful to psychoanalysis. Pappenheim herself promulgated a feminism that founded women's active position in the virtues of maternal care as well as in economic independence and self-expression, the right to which she defended eloquently along with the right to freedom from sexual exploitation. Appignanesi and Forrester term this transformation from illness to health an 'inexplicable discontinuity'.[7] In fact, one could easily see her effort to forget her past, to repudiate her identity, as patient and assume that of an activist social worker as a kind of defensive reaction. Then again, one could say that it reflects an identification with the other side of the analytic couple, the position

of healer and helper, an identification Freud himself would later propose as a means of cure.

As historical figures, Pappenheim and Freud inhabit the same discursive world, the tradition of German enlightenment and humanism that secularized Judaism had made its own. In one respect their assessment of women's condition matched: even as Pappenheim saw the one possibility for equal self-expression and agency in the maternal, Freud too defined the maternal position as the one in which women are active rather than passive. However, the gap between their positions becomes evident when we consider Pappenheim's declaration (in her address to the German Women's Congress in Berlin, 1912[8]) that the only commandment which gives women a position equal to that of men in the Jewish community is the one which constitutes the main tenet of the Jewish religion, 'Love thy Neighbour as thyself', the very commandment that Freud uses to illustrate the naivety of religion and the nature of reaction formation.[9] The disjunction between Pappenheim and Freud marks the site of a tension between psychoanalysis and feminism regarding love and femininity. For Freud, love is to be deconstructed, revealing the terms of sexuality or libido – yet this endeavour will be fraught with the contradiction between the effort to identify woman's hidden desire and his relegation of her desire to passivity; for Pappenheim, altruistic love is to be liberated from a desire associated with sexual passivity and exploitation into a protective identification (or identifying protection) with the vulnerable Other. If you like, the tension between these positions may be seen as constituting an unfortunate kind of choice, between equally valid directions: on the one hand, Freud's attempt to liberate us from the ideal, on the other, a feminist effort to re-inhabit and so revalue the position of the cast-off Other.

Observing these pulls and counterpulls in the history of feminist thought one might well ask, what does it mean, in light of Pappenheim's trajectory, to found feminism in a flight from the primary leap into the arms of the male healer, from the unanalysed, unworked-through erotic transference? But my focus will be on psychoanalysis, its founding in a particular constellation in which femininity becomes imbricated with passivity. Does this not also reflect a flight from the erotic, from the confrontation with female sexuality? This essay, therefore, will query psychoanalysis, concentrating on the ambivalent legacy Freud bequeathed us, a kind of liberation, freedom from religious and moral strictures, from grand

ideals, from the temptation to save and redeem – but offered at a price: denial of the analyst's subjectivity and desire, which might mirror those of the patient; distance from the helpless, the passive, and for that matter, the feminine Other, identification with whom did not always come easily to Freud, did not fit with his notion of objectivity and science. (Although it will follow from his own thinking that such identification is ineluctable and can only be prevented by acting against it in some intrapsychic way.) Thus I shall ask, How has the history of psychoanalysis been marked by the move from passivity to activity, and how is this move fundamental to the problems of the transference, especially the transference between unequal persons – doctor and patient, male authority and woman rebel? How did Freud's way of formulating that move reflect his ambivalence about attributing activity to women,[10] especially sexual activity, and incorporate defensive aspects that the psychoanalytic project must continually bring to consciousness?

Beginning with 'The Studies', the issues of passive versus active – along with other complementarities such as identification or distance, empathy or objectivity – can be seen as gender underliners of the themes that recurrently trouble the evolution of psychoanalysis. The effort to clarify those themes, to overcome an old and shallow opposition between feminism and psychoanalysis, might be seen as the work of producing a more creative tension between the seemingly disparate personas of Anna and Bertha. So if psychoanalysis asks of feminism that it interrogate a founding gesture of liberation that denies the truth of dependency and desire, feminism asks of psychoanalysis that it reconsider its historical positioning of its Other, the one who is not yet able to speak for herself. Let us remind ourselves that in front of the Salpetrière where Charcot paraded his hysterics as a spectacle for popular audiences stands a statue of Pinel freeing the mad from their chains; indeed, Freud noted at the time that this scene was painted on the wall of that very lecture theatre.[11] Does that irony not enjoin such a reconsideration?

In our time, this reconsideration has led to a concern with the radical effects of perspective, the necessity of struggling to grasp the viewpoint of another as well as to strain our own view through the critical filter of analysis. Easily said, but not easily done. Seeking to grasp the real process involved in attaining an approximation of another's viewpoint (or even glimpses of it) as well as awareness of our own subjective view is central to our current efforts to elaborate an intersubjective psychoanalysis. Hopefully, we shall reach some clari-

fication of what this means by the end of this essay. Provisionally, I will say that grasping the other's viewpoint means striving to dissolve the complementary opposition of the subject and object that inevitably appeared and reappears in the practice and theory of psychoanalysis. As I shall try to show, Freud's work, beginning with the 'Studies', aspired to move beyond the evident constraints of this complementarity, but was nevertheless continually drawn back into that opposition because of the confluence of scientific rationalism and gender hierarchy.

If we, in hindsight, are more aware of what pulls us back into that complementarity, we are also more inclined to identify with Bertha's position in the story. This is not only because our theory of the unconscious teaches us that we cannot prevent such identification, that we can only split it off, repudiate it, in effect dislocate it and thus create a dangerous form of complementarity (one which, indeed, allows only a choice between immediate, unthinking, 'hysterical' identification or repudiation). It is also because of the contribution both contemporary feminism and psychoanalysis have made to our awareness of the necessity of taking in the position of the Other. As a result, we recognize that the only choice is to develop this identification, that the (re)admission of what was rejected is central to evolving the analyst's position as well as the patient's. The dialectic by which we undo repudiation is as important to psychoanalysis as it has been to the project of women's liberation, as it has been to each of the successive demands for recognition articulated in this century by the silenced or excluded.

The process by which demands are raised against those who already claim to be empowered as rational, speaking subjects is not identical with psychoanalysis. Nonetheless, the movement of psychoanalysis has a certain parallel with this project, which requires the self-conscious consideration of how to develop its forms of identification. As we see in social movements that found new identities, demands for recognition have their problematic side – a kind of entitlement or moral absolutism, which is always inextricable from and fuelled by the power it opposes.[12] It therefore always draws the Other into the relationship of reversible complementarity. In many ways, as I shall try to show, Freud's journey through the transference is an allegory of learning to traverse the unmapped and surprising (though oddly familiar) paths of such complementary relationships.

II

Lest the comparisons I have drawn between the movement of psychoanalysis and that of feminism seem forced, let me delay consideration of the history of the transference a moment and consider the background of psychoanalysis in relation to European thought. Our consciousness of who we are today should take into account the history of psychoanalysis as a practice indebted to the project of liberation rooted in the Enlightenment – and Freud despite all his political scepticism surely did see psychoanalysis as an activity only thinkable through and because of the Enlightenment project of personal freedom, rational autonomy, being for oneself. This project, as Kant described in 'What is Enlightenment', is that of freedom from tutelage, in German *Unmündigkeit*. Usually translated as attaining majority, adulthood, the term *mündig*, derived from the word for mouth, refers to speaking for oneself. To be *mündig* is to be entitled, empowered to speak, the opposite term to the one so often used today: silenced. It may thus fairly be understood as the antithesis of hysterical passivity, speechlessness. For the better part of the twentieth century this project of freedom from authority has been questioned precisely because – so the post-structural, postmodern critique goes – the subject of speech was never intended to be all-inclusive, was always predicated on the exclusion of an Other, an abject, a disenfranchised, or an object of speech. And yet precisely this critique of exclusion and objectification operates by referring back to a demand for inclusive recognition of subjectivity that the Enlightenment project formulated.[13]

Now this contradiction between rejecting and calling upon the categories of enlightenment makes for a particular uneasiness regarding the place of psychoanalysis. For the twentieth-century theory that rejects the enlightenment has invoked Freud himself in its efforts to show that the figure of the autonomous, coherent, rational subject is a deceptive appearance, which serves to deny the reality of a fragmented, chaotic, incoherent self, whose active efforts to articulate and make meaning are ultimately defensive. And yet the advocacy of meaning over chaos, thought over suffering, integration over splitting, symbolization over symptom, consciousness over unconsciousness remains essential to psychoanalysis. Finally, we can cite one more contradiction, one which arises regarding the psychoanalytic relationship: the achievement of autonomy is revealed to be

the product of a discourse that situates the subject in the oppositional complementarities – subject and object, mind and body, active and passive, autonomously rational and 'irrational' – which worked historically by splitting off the devalued side of the opposition from the subject. And, of course, by associating femininity with the devalued side. Psychoanalysis has thus continually re-enacted these oppositions, which are in fact reiterations of gender hierarchy, even as it offers the possibility of uncovering their meanings. As with Freud's frequent rehearsals and disclaimers of the association between passivity and femininity, psychoanalysis reproduces the splits it aims to analyse.

Thus, to pick up where I left off, it is useful to explore the identification with Anna O.–Bertha Pappenheim because she incarnates for the first time and in a most compelling way that dual identity which each psychoanalyst–patient pair, separately and together, must embody. The contradictions of Anna–Bertha, which appear through the split image of the helpless, fragmented patient and the articulate stalwart feminist who defends the helpless – reflect the split in every analyst, who is herself or himself subject to as well as subject of the analytic process. In Freud's own evolution as well as in psychoanalysis in general, we can see the problem of constructing the encounter as one between the Analyst-Subject who already speaks and the Patient-Other who does not yet speak for herself. This suffering Other requires recognition by the subject who does speak. But this recognition will be effective only if it incorporates a moment of identification, and so disrupts the enclosed identity of the Subject. Likewise, the Other's attainment of speech may only proceed by her identification with the speaking subject, by which she is in danger of losing her own 'identity' as Other. If the patient must 'become' the analyst, the analyst must also 'become' the patient.

Thus both analyst and patient have reason to resist the identifications that result from their encounter, for eventually the doubleness of identification leads to a breakdown of the rationalistic complementarities between knower and known, active and helpless, subject and object. And while this identification may in theory be laudably subversive of hierarchy, it is in practice a 'most dangerous method',[14] generating a muddle of boundaries, mystification, anxiety and old defences against it. To this analytic heart of darkness we will turn shortly. For now, speaking of theory, let us say that psychoanalysis and feminism may join in the project of inspiring this inevitable breakdown to assume a creative rather than destructive

form – to challenge the valorization of the autonomous, active, 'masculine' side of the gender polarity without reactively elevating its opposite.

I am highlighting this paradoxical movement in psychoanalytic history: that even in the moment of breaking down those oppositions through which the masculine subject was constituted, the psychoanalytic project necessarily participated in the hierarchical opposition between activity and passivity with its gender implications. This project, raising the symptom to articulation in the symbol, I have designated here as the primary move from the body into speech, referring to this founding form of psychoanalytic activity as the 'primal leap', punning on the German word for origin, Ur-sprung, Sprung meaning leap and Ur meaning original, primal, first, deepest. From body to speech. To make the inarticulate articulate, to translate the symptomatic gestures of the body into language, is incontrovertibly the first lesson of Freud and Breuer's work.

No sooner having said this, however, we must object, or at least ask, whose speech? For the leap that is psychoanalysis consists, properly speaking, in Freud's decision to give up hypnosis in favour of a more collaborative enterprise, one in which the patient herself becomes the subject of speech – and if Freud chose to attribute this transition to a certain resistance on the part of his patients,[15] perhaps in order to legitimate it as a necessity (or to occlude his fear of the erotic transference that hypnosis unleashed, as his autobiography later revealed), this makes the sharing of credit no less true.

How else could the value of collaboration be discovered, if not through the patient's refusal of the passive position of being hypnotized, even if that refusal appeared to be a resistance? In effect, the step out of passivity is framed as resistance. Subjected to her own symptoms and captive in her own body, the patient can nonetheless mobilize against surrender of consciousness. And so the origin of psychoanalysis, its decisive move, is ambiguous. I hope here merely to underscore a certain paradox in the evolution of psychoanalysis as a discipline, and in each individual analysis as well. (Each fresh resistance of the patient drives the process forward. Resistance itself becomes the revelation, as in Freud's discovery of the function of erotic transference, or any acting in the transference – but more of that later.)

So far I have been constructing a leading argument here, suggesting that the move from the body that suffers itself to be an instrument of unconscious communication to the speaking subject who

articulates insight seems to fit with a transition to active subjectivity
as long defined by the Enlightenment tradition. Thus Freud framed
his understanding of overcoming resistance and defence in the 'Stud-
ies' in characteristic fashion:

> What means have we at our disposal for overcoming this con-
> tinual resistance?. . . By explaining things to him, by giving him
> information about the marvellous world of psychical processes
> into which we ourselves only gained insight by such analyses,
> we make him himself a collaborator . . . for it is well to recog-
> nize this clearly: the patient gets free from the hysterical symp-
> tom by reproducing the pathogenic impressions that caused it
> and by giving utterance to them with an expression of affect,
> and thus the therapeutic task consists solely in inducing him to
> do so.[16]

So we see, the analyst has merely set the patient free, has in fact
found a way to make him (NB! when the patient is active, Freud
uses the male pronoun; when simply ill, he uses the feminine) a col-
laborator. The patient is to identify with the analyst in the overcom-
ing of resistance through self-reflection, a process of internalization
that implies both tutelage and freedom from tutelage. He is to col-
laborate in an investigation. By contrast, Breuer's use of hypnosis
with Anna O. seems of a piece with his medicating her, case manag-
ing her in the manner appropriate to the metaphor of an illness, still
embedded in a discourse of subject and object, actor and acted upon.
Such a discourse, sustained by the practice of hypnosis, could only
explore the patient's subjectivity by vitiating it of the qualities that
otherwise characterize it: agency and intentionality.

Of course, the transition from passivity to activity, from symp-
toms to being the subject of speech, turned out to be not a one-time
leap, but a process which Freud evolved slowly, for which the giv-
ing up of hypnosis was only a beginning. Indeed, we can see Freud's
subsequent elaboration of psychoanalytic practice as an ongoing ef-
fort to remove the analyst from the position of coercive authority
and enfranchise the patient.

But even as Freud reports his move away from hypnosis, he al-
lows us to discern the way that the patient exerted her power to
bring into being another force. This, the force of transference, is
already discernible, already beginning to destabilize the main event
of the 'Studies'. This event was meant to be Freud's discovery of a

formulaic equation: one symptom, one recollection. In any event, it is apparent in the first study that symptoms are not the only matter in hand. For it is not merely in her body that Anna O. offers up the encoded memories; equally important are the reliving of perceptions and feelings. These Freud will later figure as the main thing opposing language: 'acting', a term that evokes not merely doing, but dramatizing, representing in deed. When Anna O. refuses to drink water because it reminds her of the despised dog who drank from the bowl, this is not a bodily symptom, but acting.

Where speech, symbolic articulation, would constitute the true activity of the subject, acting has been seen as merely another form of representing without knowing what is being represented, of evacuating or expelling, hence not an expression of subjectivity. This distinction between communicating and acting is still subscribed to by many analysts, for instance Green.[17] Yet acting has also been seen as a stage between discharge and full representation that implicates the analyst in a new way.[18] In fact, in contemporary relational analysis, acting and interacting are the indispensable medium through which the analytic work proceeds. At the very least, acting constitutes a new intermediate position between unconscious and conscious, a different kind of effort at representation, which at once reveals and resists – to paraphrase what Winnicott says about destruction, it is only resistance because of our liability not to understand it, to become caught up in it.

Freud was at first sanguine about seizing this new opportunity for mastery through understanding. For although the patient, Freud tells us, is 'deceived afresh every time this is repeated . . . the whole process followed a law'.[19] The work follows a 'law', the law of logic, the law formulated for relieving symptoms through images or pictures produced under pressure: as soon as the images have been put into words, fully explicated, raised to the symbolic level, they disappear. In the same way, Freud contends, the illusion of the transference 'melts away' once he makes the nature of the obstacle clear. Freud has not yet confronted the intersubjective aspect of the phenomenon, the bi-directionality of unconscious communication; he believes that transference can be simply observed from without. He remains reassuringly within the law – according to which words must replace action, symbol replace symptom, each proceeding in order. Once the activity of speech – language – substitutes for action of the body or of the transference, everything follows. Where before the patient's resistance was overcome by the pressure of the physician's

hand, now the patient must be more consciously enlisted to over-come her own resistance.

Freud's move away from hypnosis is of a piece with a gradual process of lessening the doctor's grip on the patient's mental activity, of relinquishing coercion and control by the doctor, with a concomitant freeing of the analysand, whose autonomy should be realized within the analysis itself. Already, we have glimpsed the contradictions within the discourse of autonomy, and it should not surprise us that Freud continues to struggle with them, that the new technique does not remove these contradictions *but displaces them in the transference.* In his writings on the transference more than a decade later, we will observe in new form the reinstituting of the hierarchical binaries that have been so readily exposed in the paradigm of male doctor, female hysteric. Indeed, the transference gathers these contradictions together in a way that led Freud to the apt metaphor of explosive chemicals.

In 'Remembering, Repeating and Working Through' Freud looks backward on the path he has followed in order to relinquish charismatic authority, hypnotism and faith-healing.[20] Freud's narrative constructs a consistent, logically proceeding evolution of his method and aims. Notwithstanding this coherence, there are some significant points of difference between these later writings on transference and his earlier formulations in 'The Interpretation of Dreams'.[21] In particular, this is evident in his ideas regarding the surrender of the critical function of reason. In 'The Interpretation of Dreams' Freud tells us that 'we must aim at bringing about two changes in the patient, an increase in the attention he pays to his own psychical perceptions and the elimination of the criticism by which he normally sifts the thoughts that occur to him.'[22] Freud emphasizes the importance of *'relaxing deliberate (and no doubt critical) activity '*, of allowing ideas to emerge 'of their own free will'.[23] And here, following a suggestion made by Rank, who was particularly identified with the tradition of Romanticism and its aesthetic reflections, he invokes Schiller, who explained to a friend that his inability to be creative probably lay

> in the constraint imposed by your reason upon your imagination. . . . it seems a bad thing and detrimental to the creative work of the mind if Reason makes too close an examination of the ideas as they come pouring in – at the very gateway, as it were . . . where there is a creative mind, Reason . . . relaxes its

watch upon the gates, and the ideas rush in pell-mell, and only then does it look them through and examine them in a mass . . . you reject too soon and discriminate too severely.[24]

The relaxation described by Schiller 'of the watch upon the gates of Reason' is not all that difficult, Freud avers. He then goes on to discuss the two psychical agencies or forces, first the wish, expressed in the dream, which corresponds to the Imagination; the censor, the gate, which corresponds to Reason.

This text expresses what might be considered the first of Freud's two, antithetical theories of mental freedom: the first proposal advocates a freedom from the critical faculty that creates resistance, allowing the real, in other words unconscious, thoughts to emerge. The second theory, which emerges in his later writings on transference, emphasizes the freedom that comes in reorienting the mind to the reality principle and relieving it of preoccupations with unconscious thoughts which hold it captive to the past and the pleasure principle.

Now in the beginning, Freud intended that the patient abandon his critical faculty and, in effect, turn it over to the analyst, who retains a logical, organizing mentation, noting the logic of dream thoughts, following gaps and clues. In a sense, the division of labour here involves the alignment of the patient with the first psychic agency, imagination, and the doctor with the second, discriminating Reason. But soon Freud came to recognize that deliberate attention is as problematic for the analyst as for the patient. It is after he has formulated his theory of dream interpretation that he comes to realize that inner, mental freedom is necessary for the analyst, to prevent him from controlling the patient, and so losing the access to repressed material that would be gained from the patient's obeying the fundamental rule. We may speculate that Freud attained this realization through hard experience, his failure in Dora's case.

The case of Dora, we know, was the one Freud hoped would actualize his dream theory, but which, instead, came to exemplify the transferential difficulties that ensue when the analyst tries to retain all logic and reason on his side. It is easy to read Dora as an object lesson in the catastrophic results of attacking the resistance in the way Freud originally and naively recommended, of controlling the locus of attention in order to create a seamless narrative of cause and effect. Freud was disappointed in his expectation that Dora would,

as he wrote to Fliess, 'smoothly open to the existing collection of picklocks'.[25]

Dora has been understood by a multitude of authors to encapsulate what is problematic in any simplified understanding of bringing the hysterical patient to speech. Unlike Anna O., Dora and the unnamed female homosexual both reveal, more than Freud seemed to intend, a conflict in which Freud tries to penetrate woman's sexuality but the woman resists or rebels. If Freud thinks that he who disdains the key, which is sexuality, will never open the door to the patient's mind,[26] then Dora, as Jane Gallop remarks, is there to let him know that no one wants to be opened by a skeleton key.[27] Feminists and psychoanalysts alike have pointed out the way in which Freud pursued the unlocking of meaning, the mining of secrets, the connecting of event and symptom in a seamless narrative – without gaps and holes, or other feminine metaphors of incomplete knowledge – to the detriment of the analytic stance towards the patient.[28]

In any event, the recognition of the transference, Dora's particularly 'pointed' resistance, once again pushed Freud to reflect on his position and abandon a certain form of control. He moved towards the model of evenly suspended attention as he described in his own retrospective account. Nonetheless – and here we come to Freud's 'second theory' – Freud seems to reproduce the conflict between reason and imagination on a new level in his writings on the transference between 1912 and 1915. The old refrain of the conflict between language and action can be heard in his discussion of struggle between 'intellect and instinct, recognition and the striving for discharge'.[29] Yet again the problem emerges that action is indispensable, for 'No one can be slain in absentia, in effigy.'[30] Thus in order to put an end to the unconscious manipulation of the powerful forces, we must expand our permission, invite the patient to take certain liberties – not just the relaxation of judgement and freedom of thoughts, but now the actual re-enactment in the transference in 'the intermediate realm' or 'playground' of the analytic situation.[31] At the same time, the analyst must be able to go near the dark forces without succumbing to them, protect himself from the patient's effort to assert 'her irresistibility, to destroy the physicians's authority by *bringing him down to the level of the lover* [my italics]'.[32] And 'to overcome the pleasure principle . . . to achieve this *mastery* of herself she must . . . [be led to] that greater *freedom* within the mind which distinguishes conscious mental activity [my italics]'.[33] As I have said elsewhere, paradoxically the patient's autonomy emerges

out of the identification with the analyst's authority, which she accepts.[34] *She* makes the axiomatic move from loving him as an object to identification and puts him in place of her ego ideal.

But this is a dangerous project, and Freud must justify his persistence in unleashing the explosive forces.[35] As he does so often, he looks for legitimation not in the freedom of imagination, but in science, the discourse of objectivity, of reason over instinct. He compares the handling of the transference to the chemist who carefully handles the dangerous chemicals in the laboratory. Of course, the problem with this analogy is that the chemist is not the chemical, whereas the analyst does act as a force in the combustion of the transference. The psychoanalytic doctor is less like a chemist than like the priest who must encounter the demonic in order to exorcize it. Indeed, it turns out that psychoanalysis can refuse hypnotism and faith-healing precisely because the same force reappears in the transference – as Freud will say later, it is only a step from being in love to hypnotism.[36] For that matter, how could any German-speaker miss the connections between healing (*heilen*), holy (*heilig*) and redeemer (*Heiland*)?

III

What Freud's warnings scarcely conceal is the impossibility of the very objectivity that he prescribes. As these connections suggest, the psychoanalytic doctor is not able to heal without becoming implicated in the transference, and so in the illness itself. This could be the message to analysts offered by Kafka's story 'A Country Doctor': a story written as though in response to Freud, or perhaps, a doctor's dream. The doctor is called out to a distant village at night, but he has no horses of his own to pull his wagon. Seemingly in exchange for the team of horses that mysteriously appears in his barnyard, he must leave at home his maid, Rosa, to be raped by the groom who appeared along with the horses. While he is objecting, the horses simply carry him off. In a moment he arrives at the village, is surrounded by the patient's family and neighbours, who press him towards the patient, a young boy lying in bed who hardly appears ill, perhaps a malingerer. But as the doctor would leave he looks closer and discovers the patient is truly ill, he has a gaping wound in his side, pink – that is to say Rosa – which is alive with little worms (maggots). The family grab him, undress him and lay him in bed,

while outside the school choir sings, 'Unclothe him, Unclothe him, then he will heal, and should he not heal, then kill him. He's only a doctor, only a doctor.' But he, 'thoroughly collected and above it all', simply looks at them. As he escapes naked, his coat hanging from his carriage, the villagers triumph, 'Rejoice you patients, the doctor has been put in bed with you.' Still, as he flees, he knows his practice will go to pieces, he will never recover, his Rosa is sacrificed, and the stable groom is still rampaging in his house.

We might consider this dream story to evoke something of the danger Freud would have had in mind when he admonished the young physicians to heal by remaining covered, true to their cloth. To become unclothed, naked, is to be de-vested of one's authority, brought down to the patient's level. It is thus to have the parts of the self that have been split off into the patient – one's own dangerous instincts – exposed. Unavoidably, to face the way in which one's authority has been created out of this very process of projection. To be clothed, in-vested, is to have this process remain invisible, and in a sense to protect the authority of the official, the clergyman, the father, the physician, from exposure.[37]

If the patient and the doctor speak a dialogue that is actually made of two voices within one mind, still they are in competition with each other for space ('You're crowding my deathbed', says the boy) as well as recognition or pity ('What should I do? Believe me, it's not easy for me either', replies the doctor. 'I'm supposed to be satisfied with that excuse/apology?' complains the boy.) The doctor consoles him by suggesting that his wound is something others never get to have: 'Many offer their side, and never even hear the axe in the forest, let alone have it approach them.' Then the doctor snaps out of it. Too late, his authority can never be recovered.

As the symmetry of their dialogue implies, the level of action here reflects a complementarity that, like the erotic transference, first requires and then risks the analyst's authority. We might better grasp this form of complementarity by referring to a distinction well known in the detective genre.[38] In the 'Studies', Freud is still in the mode of Holmes, the investigator who is 'collected and above it all', who has a collection of picklocks and an eagle eye for holes in other's stories, who intends to construct a seamless narrative to which he knows the culprit will surrender. She will be able to object no further, she will have to admit the truth of her desire. Then there is the Noir detective, Marlowe or Spade for instance, who gets involved and is implicated in the whole story, and if he in the end places the guilt

where it belongs and refuses to take the fall with the guilty one, still, like the country doctor, he is not untouched – indeed, he is never quite the same. This might be seen as the passage Freud has to suffer in the Dora case, from a complementarity that establishes well-bounded opposites, to the reversible complementarity of 'It takes one to know one', the one that takes you into bed with the patient.

Freud's difficulty in accepting his identification with the passive, helpless position of the young woman Dora, struggling against her reduction to the position of object, leads him into the reversible complementarity of the power struggle. He becomes the complementary other to Dora's resistance not only by identifying with Herr K. but by becoming invested in proving that he knows what is really going on. One of the most striking points in his narration is the way that his own observation in the text – that one always reproaches the other with that which one does oneself – applies to his own ending: he reproaches Dora with wishing only to take revenge, while one can hardly see his refusal to treat her on that ground as any less vengeful. Dora's resistance, her cool rejection of Freud's perfect interpretations that mimics the rhetorical position of the scientific authority with its object helpless before it – like his unnamed 'female homosexual' – undermines his vestments of neutrality by provoking him to reveal his investment.[39]

The patient who acts, rather than thinks or speaks, pulls the analyst into the complementary identification and away from both representation and empathy. The analyst who resists identification with the patient's position engages the complementary aspect of the relationship and unwittingly stimulates action. The patient's action then painfully becomes an inverted mirror of the action that aspires to achieve through knowing or helping a security-in-control. As Racker made clear, the complementary position can be countered by the identificatory position in the countertransference, the analyst's ability to be on both sides of the divide.[40] By adopting the concordant position of identification with the patient's position, the analyst has the leverage to think about the patient. If the analyst does not identify with the patient in her or his own ego, 'recognizing what belongs to the other as one's own',[41] she or he will become identified with the patient's bad or good objects, and the split complementarity ensues: doer/done to, vengeful/ victimized, etc.

What does it mean to identify in one's own ego? In a sense, it means the opposite of hysterical identification, which involves a 'mapping' of self on to the other,[42] an unmediated assimilation of

other and self that Freud writes of in the 'Interpretation of Dreams' and later classifies as a phenomenon like mass contagion.[43] Such hysterical identification – which may be part of the inevitable feeling evoked by the relationship with certain patients and which we can sometimes divest only by cloaking ourselves with our role – can be distinguished from those identifications that are mediated by representation and so eventually become useful sources of knowledge for us and the patient. Another way to formulate this is to say that, properly speaking, not the act of identification, which is unavoidable and unthought, but the act of representing identification, creates a point of freedom.

In practice, we also distinguish identification that retains contact with the patient's multiple and conflicting positions from the kind that appears in split complementarities, in which we take one side of a conflict. As we see in Dora, the notion that enemies resemble each other applies, perhaps because the patient is also identified with the bad objects in her ego. Following the unconscious logic of 'I could be you and you could be me', complementarity often involves symmetrical responses, tit for tat, I'm rubber you're glue. Thus the complementary countertransference recreates an internal dialogue, as in Kafka's dream story, which captures both participants. In so far as the patient experiences the analyst's investment in being the one who 'understands rather than the one who is understood, who is needed rather than who needs',[44] to be the master or Lacan's 'subject supposed to know', the analyst may find herself or himself pulled ever deeper into the power struggle. In such a case, when the analyst is in-vested in omniscience, the basic fault in the idea of the patient making the analyst into her or his ego ideal is exposed.

For this ego ideal of analytic understanding has, to varying degrees, already been constituted through split complementary structures that devalue the one who is speechless, passive, does not know, is needy, the object of pity etc. What it means to pull ourselves out of such complementary power struggles by immersing ourselves in a very specific way, learning to swim in the countertransference rather than drown, can surely be seen as the psychoanalytic project of the last few decades of the century. Freud's notion that the patient could identify with the ideal side of analytic authority did not encompass the equally plausible reaction of rejecting authority: that the patient would also attack the analyst precisely in her or his effort to be a different kind of healer, would call forth the hidden dimension of

power in knowledge, that which Freud thinks can win out against unreason without the usual consequences of subjugating a binary opposite.

IV

In drawing a line between hypnosis/suggestion and analysis aimed at freeing the patient's subjectivity Freud instituted a crucial paradigm for dealing with binaries. As we shall see, regarding the idea of analyst as ego ideal, such simple opposites are likely to conceal or obscure the contradictions that inevitably arise in our practice. The strict equation of the analyst's distance and objectivity with the patient's freedom that Freud invoked seems to have been more successful in providing legitimation for psychoanalysis than it was in working with patients. A case in point is Riviere, whose reflections on the negative therapeutic reaction drew on her own experience with Jones and Freud and apparently inspired Freud's original discussion of that phenomenon.[45] In Freud's 1923 footnote on the negative therapeutic reaction in 'The Ego and the Id', he remarks that successful work with a patient whose unconscious guilt leads to narcissistic defences may 'depend on whether the personality of the analyst allows of the patient's putting him in the place of his ego ideal, and this involves a temptation for the analyst to play the part of prophet, saviour and redeemer to the patient'.[46]

Kris believes this statement refers to Freud's decision to be more supportive in order to penetrate beneath the patient's critical attitude to the unconscious guilt, which Riviere herself saw as tied to depressive love for the lost, critical object. In other words, the supportive stance aims to steer clear of the inevitable complementarity that ensues when an attacking object is on the screen and either patient or analyst is impelled to play its part. To this aim the therapeutic move will be to achieve concordance, an identificatory position, what is commonly called empathy, and so steer clear of being attacker or attackee. But, Freud objects, this move will foster the patient's feeling that the analyst is now the saviour from the critical object, and will be loved in its place. What is to be done? In the very next sentence Freud objects to his suggestion that the analyst's personality can play a role in counteracting the negative therapeutic reaction, stating that 'the rules of analysis are diametrically opposed to the physician making use of his personality in any such manner.'

Characteristically, he refers us again to the aim of giving 'the patient's ego *freedom* to choose. This, not making pathological reactions impossible, is the goal of analysis [my italics].'[47]

It is noteworthy that Freud, in referring to what we now think of as the classical rules, does not distinguish betweeen the analyst's countertransference fantasy of being a redeemer and the patient's fantasy of him as the saviour in the transference. It is as if use of one's own personhood were an avoidable stimulus to idealization, even though the erotic transference seems unavoidable. Having granted that the analyst who abstains will take on the role of the ego ideal in transference, one wonders how this could occur without idealization – are we to think that because the patient is to identify with the analyst's abstinence the analyst does not appear as 're-deemer'? The history of sainthood in Christianity hardly supports such an assumption. The practical issue is what to do with the patient who will have difficulties with the analyst's objective authority, who will experience such adherence to rules as withholding, critical of her needs, and so reinstitute the analyst as a guilt-inducing object. We may question whether such withholding of subjective response makes the analyst less exalted,[48] less a god, especially to himself – and for the patient, certainly, he may well appear to be the god who denies only this particular sinner the redemption she seeks.

Freud sets up a parallel between two sets of contrasting terms: between remaining objective/abstinent and using one's own subjectivity, between falling into the temptation to be a redeemer/healer and giving the patient freedom. But setting up those contrasts, as we see in this text, leads Freud to an impasse – he should like his personality to make him available to the patient, but it would tempt him to be a redeemer – which he must now resolve by falling back on the rules. This paradigm of objectivity, with its conflation of subjectivity and idealization, held sway over analytic work for decades. As a guide to those ensnared in the complementary transference this view of the rules of analysis may well have created the problems it claimed to solve.

V

Doubtless the clinical impracticality of holding the position of objective knower as well as the influence of postmodern challenges to

objectivist epistemologies have led to the intersubjective and relational revisions in contemporary psychoanalytic thought.[49] The idea of analytic neutrality is increasingly challenged[50] or subject to redefinition.[51] The intersubjective analyst's idea of freedom – the analyst's freedom – is to make use of one's emotional responses, one's subjectivity, in a knowing way.

To refigure what it means to use one's subjectivity rather than accept the polarity of subjectivity and objectivity is an important aim of contemporary analysis.[52] We aim to formulate a space in between suggestion and objective distance, which encompasses the analyst's emotional response to the patient and takes account of her or his involvement in the complementarity transference action as well as the means for extricating herself or himself from it. In the process, the distinction between speech and action necessarily breaks down,[53] as we become aware that all speaking has the impact of an action and all action communicates 'information' from a particular point of view. In other words, as we cease to privilege the analyst's perspective as objectively derived knowledge, we acknowledge the analyst's participation in an interaction of two subjects. The double action of intersubjectivity – recognizing the other's subjectivity and one's own – means that, as the patient becomes less objectified, the analyst becomes a more 'subjective' subject.

Such acknowledgment requires both a different understanding of mental structure, that is symbolic representation, and of the intersubjectivity of the analytic situation – each understanding furthering the other. The principle that informs both is the idea of transforming complementarities into dialectical tension, into tolerable paradox, instead of into antinomies that compel dangerous choices. Opposites are to some extent unavoidable because of the inherent psychic tendency to split, because, in fact, they allow the mind to think; it is the capacity to hold them in tension and overcome splitting that is at stake. This inevitable movement through opposites is what we need to hold in mind both in our theory and in the clinical situation.

Likewise, we may accept that the split complementarity inevitably re-emerges time and again in the transference, and consider how we re-solve it in our minds, modify it by restoring the sense of separate subjectivities. Frequently this occurs not through distance, conventional objectivity, but by one person trying to know what the other is feeling, so that identification becomes a recognizable effort to break up the enclosure in the paranoid position. In this case, iden-

tification functions as a channel allowing the flow and processing of emotion (in self-psychological terms, through empathic introspection.[54] The ability to symbolize emerges via the analyst's ability to survive the inevitable involvement in complementarity by making use of identificatory responses that bypass or dissolve it.

The analyst is always striving to represent both the patient's position and her or his own. Even if this representation is at best only an approximation of the other's meaning, and at worst a misrepresentation, it can nevertheless serve to create the two planes necessary for a third, a double-sided perspective that can support a third point of the triangle. It maintains a tension or space between self and other; it can be extended to the patient as an invitation to collaborative thinking. But since we also grant that knowing is intrapsychically filtered, we must tolerate the inevitable misrecognition that accompanies our efforts at recognition. To react to this inevitability by relinquishing the effort to know or recognize would simply reinstall the principle of objective knowledge as the only one worth having.

VI

The psychoanalytic efforts to deconstruct the dominance of an objectively knowing subject in favour of a personal subjectivity parallel recent feminist efforts to disrupt the conventional oppositions and their encoding in gender hierarchies. The question of how we envision dissolving the ever-recurring complementarities, especially the idealizations intrinsic to binary hierarchies, is common to each. Some important overlaps can be found in the reassessment of the maternal function and the maternal transferences that psychoanalysis and feminism have undertaken in the last decades.

For example, we may now reverse the movement we followed in considering how psychoanalysis evolved its focus on symbolic function, which I have put in the shorthand 'from body to speech'. Current theorizing about the use of the analytic space as an extension of the maternal body container suggests that this container is what holds and gives coherence to the self, what first makes symbolic thinking possible.[55] The formulation of this aspect of the psychoanalytic process sprang from the observation that many people suffered from an inability to represent affect except through acting; they could not 'use' the analyst,[56] that is, the intersubjective properties of the rela-

tionship. Whereas Freud had articulated the means of interpreting unconscious symbolization, it now became necessary to theorize the conditions that foster development of symbolic capacity. The person who remains unable to process bodily tension except through motoric discharge or somatic symptoms could be described not as lacking speech or symbolic capacity, but lacking a relationship that is a condition of that capacity.

This relationship in which subjectivity develops is predicated on certain kinds of activity by the other, variously described as recognition, attunement, holding. The mother acts as an outside other who is able to help the subject to process and tolerate internal states of tension.[57] The evolution from a concrete to a metaphorical experience is contingent on some achievement of bodily regulation and its intersubjective quality of recognition, through which the body metaphorically becomes the mental container.

In sum, the early two-body experience is seen as crucial to the way that representation emerges intersubjectively. Because communicative speech establishes a space of dialogue potentially outside the mental control of either or both participants it is a site of mediation, the 'third term'.[58] In the dialogic structure, mediated by symbolic expression, identification can become not a collapse of differentiation, but a basis for understanding the position of the other. The kind of separation that allows this symbolic development is predicated on a maternal subjectivity that is able to represent affect, specifically the pain of separation between herself and the child.

This view of the mother's mental work of representation or thinking (and work, as the nineteenth-century metaphor for transformations of energy, seems an appropriate term, as does Ruddick's maternal thinking) becomes an Archimedean point of the shift in the notion of the subject as active representer of the world.[59] We can recast Freud's original splitting between active and passive that has played such a role in psychoanalytic theory. The psyche's main work of representing and thereby digesting bodily/affective stimuli and tension may still be seen as the antidote or counter-pole to passive subjection. But this ability is better understood as derivative of the Other's response to one's acts and affects, thus requiring two subjects rather than a subject and an object. Maternal recognition fosters the overcoming of the active–passive polarity in the relation of two subjects.

Conceptually, this notion of recognition as activity indicates the basis for transcending the split complementarity in which the (traditionally female) other was, if not helplessly subjected to the

subject's power, relegated to the position of passivity in order to mirror his activity, contain his unmanageable tension. Providing mirroring for the subject, being his container would, in effect, compromise one's own subjectivity, disrupt one's own capacity for thinking.[60] By contrast in the intersubjective conception of recognition, two active subjects may exchange, alternate, in expressing and receiving, co-creating a mutuality that allows for and presumes separateness. The arena for this catching and throwing is the intermediate in-between space.

Historically, as long as the identificatory channel was blocked at the level of gender, as long as the intersubjective potential of the maternal dyad was insufficiently theorized, psychoanalytic theory could not really raise to the symbolic level this critique of complementarity. This insufficiency is intrinsically related to the inability to represent – in theory and in life – an identification with the mother as a subject: a desiring sexual subject, to be recognized as a person in her own right. It could not formulate a mother who is more than a mirror or evolve an idea of active femininity. Insofar as these divisions reflected the basic paradigm of subject and object, psychoanalysis remained captive to the active–passive binary in the analytic relationship.

VII

In conclusion, I will briefly sketch how the prohibition on representing maternal identification perpetuates the active–passive complementarity so fateful for psychoanalysis. The child's attempt to reverse the complementarity against the mother – by actively discharging into a controlled container as well as by controlling her – is an important (and, again, probably inevitable) piece of mental life. What is problematic is the institutionalization of this reversal as the predominant form of masculine activity. In accord with other feminist thinkers,[61] I have theorized that this reversal is consolidated during the Oedipal phase when the boy repudiates the identification with the mother, thus losing access to an important means of remaining in relation to her.[62] This, in turn, makes more dangerous the now sexualized stimulation that, in his mind at least, appears not as his own desire but as emanating from her – all the more so, because he cannot identify with her as a container of his own feelings. The boy does not so much strive to contain as mother contains, but rather

to project or split off the experience of being the passive, stimulated one – lodging this helplessness in the female and defining it as the feminine position. At the same time, the boy displaces the mother's envied activity onto the father with whom the boy identifies, rather than seeking to appropriate maternal activity directly as a form of power.

In the Oedipal transformation, then, the aspect of passivity, which absorbs the experience of being the helpless baby and the overstimulated Oedipal child, devolves onto the feminine position: it becomes 'feminine passivity'. This position becomes the structural basis for the figure of the daughter, as reflected in Freud's Oedipal theory of the girl's passive sexuality in relation to the father. This creation of a 'feminine' representation, which transmutes the boy's own position of dependency and powerlessness, is precisely represented in his idea of the Oedipal daughter's switch from being identified with the active mother to being the father's passive object.[63] (As Horney contended, one could see the whole set of propositions about the female Oedipus complex as mirroring the view of the Oedipal boy.[64])

We might well say that the 'Studies' provide an allegory of the way in which the daughter's position, the renunciation of activity and absorption in passivity, leads to the speechlessness, the *Unmündigkeit* of hysteria. Combined with the cultural prohibition on female aggression – cutting off recourse to any form of defensive activity, the well-known reversal out of passivity – this position makes hysteria the daughter's disease.[65] What is it in the daughter's passive position – the switch from mother to father – that dictates the form of her illness, even when the symptoms are not directly related to sexual passivity, to exploitation or sexual abuse?

I am implicitly suggesting a theory about the construction of femininity, one which overlaps in many essentials with ideas Brennan has formulated from a somewhat different perspective.[66] The gist of my argument is that the Oedipal switch to passivity be understood not as a product of the girl's search for the penis but her compliance with the father's search for a passive object, represented in the cultural norm of femininity (though often put in the service of the mother). Here father is read as a cultural, structural position, not necessarily an individual one, produced in the Oedipal boy's repudiation of his own passivity in the face of the exciting or abandoning maternal object, a move which sparks a fantasy of the daughter's passivity.

Consider briefly Freud's train of thought when he asserts, in a paper concurrent with the 'Studies', the 'Neuro-Psychosis of Defence',[67] that a repressed feminine passivity lodges behind the male obsessional's use of defensive, aggressive activity. In other words, a certain kind of activity is necessary in order to overcome helplessness, and this kind of defensive activity structures the masculine position.[68] If father–daughter incest represents the most egregious encapsulation of this defence, it is made possible by the generalized complementary relationship between the sexes, in which the daughter functions not merely as the split-off embodiment of the passive object, but also the missing maternal container into whom the father discharges and expels unmanageable tension. The dual function of embodying passivity and containing unmanageable projected tension gives form to femininity; this femininity takes the daughter, not the mother, as its defining figure. This structuring of the daughter position may be the missing link in explaining the equation of hysteria with femininity. It is worth noting here that both Anna and Dora nursed their fathers through long illnesses, clung to and identified with them, incorporated their symptoms. They became containers for the other, but were unable to contain themselves.

I have suggested that we understand the active–passive gender complementarity as an Oedipal form, not merely repudiating identification with feminine passivity but actually shaping it, in a reversal which negates the mother's activity. The masculine subjectivity that emerges from this move reflects both the absence of identification with a containing mother and the failure to represent the mother as a sexual subject.

For the moment it must suffice to suggest what might be recovered and represented beyond the dominance of the active–passive complementarity. I have elaborated elsewhere[69] how it is possible to theorize a different position in relation to gendered oppositions, formulate a different kind of complementarity than the one that emerges in the Oedipal, that of have and have not, phallus or no phallus.[70] To go beyond the polarization of the Oedipal might mean to change the form of complementarity – perhaps a parallel move to the way that sustaining identification with different positions transforms complementarity in the countertransference.

From this standpoint, true activity does not take the defensive form of repudiating passivity. Activity predicated on the activity–passivity split, directed towards a passive object, is merely action; it lacks the intersubjective space of a potential other. Such space, as we

have seen, is the very condition of symbolic activity; in other words, the counterpart to the representational activity of the subject is always a representation of the other subject (which need not be a real other, and could be nothing less than the world outside). Characteristically such activity can embrace receptivity to that other, responsive recognition of the other's impact on the self, and hence participation in the reality of two subjects. Of course, every psychoanalytic relationship has to work through oscillations between action and activity, split complementarity and mutuality, and so we are always rededicating ourselves to finding a path towards intersubjective speech, learning from action.

In so far as defensive repudiation of passivity helped to constitute the figure of ideal mastery that has burdened psychoanalysis, psychoanalysis must go beyond the Oedipal complementarity to cure itself. The characteristic of the post-Oedipal complementarity is that it can hold paradoxical rather than oppositional formulations. It is this that gives rise to a third position that neither denies nor splits difference, but holds it in a paradoxical state of being antagonistic and reconcilable at once. This is the position that can tolerate the incessant reversals of opposites by weaving from the attraction to both sides a net. A net that allows us to take the primal leap of psychoanalysis, the leap into the space between certain knowledge and unthinking action, the space of negative capability that is thought.

To become disinvested in any one position, in this way, is close to the goal of mental freedom Freud strove to formulate. To even imagine such freedom, Freud knew, requires a consciousness of our own investment; what we have added, perhaps, is that this is only possible by becoming aware of our inevitable participation in the split complementarities that organize our lives and our thought. Thus the reintegration of the missing half of the complementarity is always a necessary step to thinking through that splitting. Towards this end, I have called upon the figure of Anna/Bertha, alongside the figure of Freud, so that our imagination will continue to include whoever, whatever, appears in the guise of the complementary other and so that we may view afresh the reversal between analyser and analysed. Such reversals mark the dialogic encounter with those others, which is at the heart of the psychoanalytic endeavour, calling forth our own reaction to the action of the other, whose pain, passion and opposing otherness will inevitably unclothe us to ourselves, and tell us, Think again!

Notes

1 This chapter appears in extended form in J. Benjamin, *Shadow of the Other Subject* (New York: Routledge, 1998).

2 Josef Breuer and Sigmund Freud, 'Studies on hysteria' (1895), *Standard Edition*, vol. II.

3 H. Cixous and C. Clement, *La Jeune Née* (Paris: Union Générale d'Editions, 1975); see also C. Bernheimer and C. Kahane, *In Dora's Case: Freud–Hysteria–Feminism* (New York: Columbia University Press, 1985); E. Showalter, *The Female Malady: Women, Madness and English Culture, 1830–1980* (New York: Penguin, 1985).

4 U. Hillman, 'Bertha Pappenheim: Psychoanalyse–Frauenbewegung–Sozialarbeit', in *Frauensstadtbuch* (Frankfurt: WEIBH, 1992).; L. Appignanesi and J. Forrester, *Freud's Women* (New York: Basic Books, 1992).

5 Hillman, 'Bertha Pappenheim'.

6 Sigmund Freud, 'Further remarks on the neuro-psychoses of defence' (1896), *Standard Edition*, vol. III, pp. 162–85.

7 Appignanesi and Forrester, *Freud's Women*.

8 L. Wagner, S. Mehrwald, G. Maierhof and M. Jansen, *Aus dem Leben Jüdischer Frauen* (Kassel: Archiv der Deutschen Frauenbewegung, 1994).

9 Sigmund Freud, 'Civilization and its discontents'(1930), *Standard Edition*, vol. XXI.

10 L. Hoffman, 'Freud and women's subjectivity'. Paper delivered at the New York Pschyoanalytic Institute, February 1996.

11 Showalter, *The Female Malady.*

12 Jessica Benjamin, *Like Subjects, Love Objects: Essays on Recognition and Sexual Difference* (New Haven: Yale University Press, 1995).

13 Ibid.

14 J. Kerr, *A Most Dangerous Method: The Story of Jung, Freud and Sabina Spielrein* (New York: Random House, 1993).

15 Breuer and Freud, 'Studies on hysteria'.

16 Ibid. pp. 282–3.

17 A. Green, *On Private Madness* (Madison, Conn.: International Universities Press, 1986).

18 N. Freedman, 'The concept of transformation in psychoanalysis', *Psychoanal. Psychology*, 2: 4 (1985), pp. 17–39.

19 Breuer and Freud, 'Studies on hysteria', pp. 303–4.

20 Sigmund Freud, 'Remembering, repeating and working through'(1914), *Standard Edition*, vol. Xll.

21 Sigmund Freud, 'The interpretation of dreams' (1900), *Standard Edition*, vols IV and V.

22 Ibid. vol. IV, p. 101.

23 Ibid. p. 102.

24 Ibid. p. 103.

25 Ibid. vol. V., p. 427.

26 Sigmund Freud, 'A case of hysteria'(1905), *Standard Edition*, vol. VII, pp. 13–122.

27 Jane Gallop, 'Sameness and difference: an overinclusive view of gender con-

stitution', in *The Daughter's Seduction: Feminism and Psychoanalysis* (Ithaca, NY: Cornell University Press, 1982).

28 T. Moi, 'Representation of patriarchy: sexuality and epistemology in Freud's Dora', in Bernheimer and Kahane, *In Dora's Case: Freud–Hyteria–Feminism*.

29 Sigmund Freud, 'The dynamics of transference' (1912), in 'Papers on technique', *Standard Edition*, vol. XII, p. 108.

30 Ibid.

31 Freud, 'Remembering, repeating and working through'.

32 Sigmund Freud, 'Observations on transference love' (1915), *Standard Edition*, p. 163.

33 Ibid. p. 170.

34 Benjamin, *Like Subjects, Love Objects* (n. 12 above).

35 Freud, 'Observations on transference love', p. 163.

36 Freud, 'Group psychology and the analysis of the ego' (1921), *Standard Edition*, vol. XVIII, pp. 67–144.

37 E. Santner, *My Own Private Germany: Daniel Paul Schreber's Secret History of Modernity* (Princeton: Princeton University Press, 1996).

38 S. Zizek, *Looking Awry: An Introduction to Jacques Lacan through Popular Culture* (Cambridge Mass.: MIT Press, 1991).

39 A. Harris, 'Gender as contradiction: a discussion of Freud's "The psychogenesis of a case of homosexuality in a woman" ', *Psychoanal. Dial.*, 1: 2 (1991), pp. 197–224.

40 H. Racker, *Transference and Countertransference* (London: Maresfield Library, Karnac, 1968).

41 Ibid. p. 134.

42 J. Mitchell, unpublished colloqium, New York University, Jan. 1995.

43 Freud, 'Group psychology and the analysis of the ego'.

44 I. Hoffman, 'Reply to Benjamin', *Psychoanal. Dial.*, 1: 4 (1991), pp. 535–44.

45 A. Kris, 'Freud's treatment of a narcissistic patient', *International Journal of Psycho-Analysis*, 75 (1994), pp. 649–64.

46 Sigmund Freud, 'The ego and the id' (1923), *Standard Edition*, vol. XIX, p. 50.

47 Ibid.

48 E. Menaker, 'The masochistic factor in the psychoanalytic situation' (1942), in *Masochism and the Emergent Ego* (Northvale, NJ: Jason Aronson, 1996).

49 L. Aron, *A Meeting of Minds: Mutuality in Psychoanalysis* (Hillsdale, NJ: Analytic Press, 1996); S. Pizer, 'The distributed self: Introduction to symposium on "The multiplicity of self and analytic technique" ', *Contemporary Psycho-analysis*, 32 (1996), pp. 499–508.

50 O. Renik, 'The perils of neutrality', *Psychoanal. Quart.*, 63 (1994).

51 S. Gerson, *Psychoanal. Dial.*, 6 (1996).

52 S. Mitchell, *Hope and Dread in Psychoanalysis* (New York: Basic Books, 1993); Aron, *A Meeting of Minds*.

53 J. Greenberg, 'Psychoanalytic words and psychoanalytic acts: a brief history', *Contemporary Psychoanalysis*, 32: 2 (1996), pp. 177–84; Aron (1996) *A Meeting of Minds*.

54 R. Stolorow, B. Brandschaft and G. Atwood, *Psychoanalytic Treatment: An Intersubjective Approach* (Hillsdale, NJ: Analytic Press, 1987).

55 W. Bion, (1959); 'Learning from Experience' (1962), repr. in *Seven Servants* (Northvale, NJ: Jason Aronson, 1977).
56 D. W. Winnicott, *Playing and Reality* (New York: Basic Books, 1971).
57 Beebe and Lachmann (1995).
58 I have argued elsewhere (Benjamin, *Like Subjects, Love Objects*: see n. 12 above) that we can set the dialogue of the maternal dyad in the place of Lacan's third term that breaks the dyad, the symbolic father or phallus. This is significant because Lacanian feminists such as Mitchell took this point to mean that there was no escape from the 'dyadic trap' (Juliet Mitchell, *Psychoanalysis and Feminism* (Harmondsworth: Penguin, 1974)) other than the patriarchal form. Intersubjective space, I suggested more broadly, could be understood in terms of the dialogue as creating a third, something like the dance that is distinct from the dancers yet co-created by them (Jessica Benjamin, *The Bonds of Love: Psychoanalysis, Feminism and the Problem of Domination* (New York: Pantheon, 1988). Ogden's idea of the analytic third is the most intense exposition of this idea of a co-created yet independent relationship of two subjectivities: T. Ogden, *Subjects of Analysis* (Northvale, NJ: Jason Aronson, 1995).
59 S. Ruddick, *Maternal Thinking* (Boston: Beacon, 1989).
60 T. Brennan, *The Interpretation of the Flesh* (London: Routledge, 1992).
61 N. Chodorow, *The Reproduction of Mothering* (Berkeley: University of California Press, 1978).
62 Benjamin, *The Bonds of Love*; Benjamin, *Like Subjects, Love Objects*.
63 Benjamin, *Like Subjects, Love Objects*.
64 K. Horney, 'The Flight from womanhood' (1926), in *Feminine Psychology* (New York: Norton, 1967).
65 Showalter, *The Female Malady*, (n. 3 above).
66 Brennan, *The Interpretation of the Flesh*.
67 Freud, 'Further remarks on the neuro-psychosis of defence'.
68 A. Christiansen, 'Masculinity and its vicissitudes', paper presented at Seminar on Psychoanalysis and Sexual Difference, New York, New York Institute for the Humanities at New York University, 1993.
69 Benjamin, *Like Subjects, Love Objects*.
70 D. Birksted-Breen, 'Phallus, penis and mental space', *International Journal of Psycho-Analysis*, 77 (1996), pp. 649–57.

6
Reading Freud's Life

Madelon Sprengnether

Freud's Self-fashioning

Writing to his fiancée, Martha Bernays, in the spring of 1885, Freud declares that he has nearly completed a purge of his personal papers, having destroyed 'all my notes of the past fourteen years, as well as letters, scientific excerpts, and the manuscripts of my papers', an action 'which a number of as yet unborn and unfortunate people will one day resent'.[1] That Freud had in mind his future biographers becomes evident in the following comment:

> I couldn't have matured or died without worrying about who would get hold of those old papers. Everything, moreover, that lies beyond the great turning point in my life, beyond our love and my choice of a profession, died long ago and must not be deprived of a worthy funeral. As for the biographers, let them worry, we have no desire to make it too easy for them. Each of them will be right in his opinion of 'The Development of the Hero,' and I am already looking forward to seeing them go astray.[2]

According to Ernest Jones, Freud conducted a similar purge in 1907 on the occasion of his making some changes in his living arrangements,[3] while his departure from Vienna offered Anna Freud and Marie Bonaparte the opportunity (presumably at his direction) to sift through his papers and correspondence, 'burning masses of what they considered not worth taking to London'.[4]

Freud was consistent in his hostility towards the notion of being discovered or anatomized by his biographers.[5] When Marie Bonaparte approached him in 1936 with the idea of purchasing his letters

to Wilhelm Fliess from a Berlin bookseller, Freud countered with a proposal to obtain them himself, with the clear intention of destroying them. 'I want none of them to come to the notice of so-called posterity,' he told her, warning her further that 'with the very intimate nature of our relationship, these letters naturally dilate on just anything'.[6] Bonaparte (with her eye on history in this instance), resisted Freud's urgent pleadings to allow him to dispose of the letters, depositing them instead in the Rothschild Bank in Vienna, where they remained until after the Anschluss.

When Arnold Zweig suggested, on the basis of his close acquaintance with Freud and reverence for his work, that he write his friend's biography, Freud acted quickly to squelch the idea. 'No, I am far too fond of you to permit such a thing,' Freud responded with genial finality, adding somewhat testily that 'anyone who writes a biography is committed to lies, concealments, hypocrisy, flattery and even to hiding his own lack of understanding, for biographical truth does not exist, and if it did we could not use it.'[7]

The exuberance of Freud's comment to Martha concerning the obstacles he has set in the path of his future biographers, whose task it will be to construct a narrative of heroic development, contrasts sharply with his admonition to Zweig, which concludes with the sardonic observation: 'Truth is unobtainable, mankind does not deserve it, and in any case is not our Prince Hamlet right when he asks who would escape whipping were he used after his desert?'[8] Whereas early in his life Freud imagined his biography in somewhat mythic terms as 'The Development of the Hero', later he seems to have feared not only the depredations of false flattery and outright misrepresentations of fact, but also the kind of critical judgement that the disclosure of his intimate life circumstances might bring. While Freud is undoubtedly right to emphasize the 'impossibility' of biography, its pursuit of an unobtainable truth, his own efforts to lead his biographers astray, if not actually to prevent his life from being written, bears closer scrutiny. Specifically, for someone whose major theoretical concepts derive from his labour of self-analysis and whose published writings repeatedly refer to aspects of his own experience, such resistance to the notion of his own biography virtually cries out for interpretation.[9]

When Freud, who never wrote a formal autobiography, finally did produce a work focused explicitly on himself it was almost exclusively an account of his professional life, devoted to a description of his medical career and the way in which he was led to the found-

ing of psychoanalysis.[10] Indeed, in his 1935 postscript to this essay, he avers that his life has no particular status of its own apart from the history of that movement. 'Two themes', he writes, 'run through these pages: the story of my life and the history of psycho-analysis. They are intimately interwoven.' Further, 'This *Autobiographical Study* shows how psycho-analysis came to be the whole content of my life and rightly assumes that no personal experiences of mine are of any interest in comparison to my relations with that science.'[11] It seems that Freud wishes to subsume his life into his work and to be known henceforward only through this medium. Later, in the same postscript, he offers a rationale for this stance. 'The public', he states categorically,

> has no claim to learn any more of my personal affairs – of my struggles, my disappointments, and my successes. I have in any case been more open and frank in some of my writings . . . than people usually are who describe their lives for their contemporaries or for posterity. I have had small thanks for it, and from my experience I cannot recommend anyone to follow my example.[12]

Evidently wishing he had been more discreet, Freud now wants to spare himself further discomfort. By enfolding his life into the history of psychoanalysis, Freud not only protects his personal privacy, but in the same stroke he re-creates himself as a cultural icon, no small accomplishment, given his designs on posterity.

Freud's self-portrayal in his 'Autobiographical Study', while strikingly un-autobiographical in the commonly understood sense, does, however, convey significant information about how he wanted to be perceived by future generations. In this regard, his seeming detachment, and hence objectivity, betrays an undertone of urgent instruction. A cluster of statements dealing with issues of isolation, independence, and priority, for instance, attest to Freud's investment in his status as heroic founder or originator and hence his belief in his singular personal destiny.[13]

As a student at the university, Freud states that he stood apart from his contemporaries by virtue of his Jewishness, which conferred on him an alien identity. Refusing this characterization on the grounds that he has never felt any reason 'to feel ashamed of [his] descent', Freud nevertheless admits that he suffered from a degree of social ostracism. 'I put up, without much regret, with my non-

acceptance into the community; for it seemed to me that in spite of this exclusion an active fellow-worker could not fail to find some nook or cranny in the framework of humanity.'[14] Later, as if to congratulate himself for his ability to sustain himself in a hostile environment, Freud distinguishes between himself and his former friend and mentor Josef Breuer on the basis of the latter's thin-skinned response to criticism of their jointly published 'Studies on Hysteria'. 'I was able to laugh', Freud claims, 'at the lack of comprehension which [Strumpell's] criticism showed, but Breuer felt hurt and grew discouraged.'[15] When Freud finds Breuer, whose 'self-confidence and powers of resistance were not developed so fully as the rest of his mental organization', unable to follow him in his research into the sexual origins of the neuroses, he clearly also implies that the older man falls short of his own standard of intellectual courage and stamina.[16]

Freud returns to this theme in regard to the early reception of his psychoanalytic studies. 'For more than ten years after my separation from Breuer,' he states unequivocally, 'I had no followers. I was completely isolated. In Vienna I was shunned; abroad no notice was taken of me.'[17] Even after his work began to attract attention, Freud steadfastly maintains that its reception in Germany was 'nowhere friendly or even benevolently non-committal'.[18] 'After the briefest acquaintance with psycho-analysis,' he concludes rather bitterly, 'German science was united in rejecting it.'[19] Freud's description of his trip to the United States in 1909 contrasts with this portrait of nearly unrelieved isolation, yet it functions in part to draw out the full implications of his European disregard. 'Whereas in Europe I felt as though I were despised,' he tells us indignantly, 'over there I found myself received by the foremost men as an equal.'[20] Freud's summary of what he calls the 'first phase' of psychoanalysis is considerably more blunt. 'I stood alone,' he states flatly, 'and had to do all the work myself.'[21]

Freud's professions of his isolation, combined with his emphasis on himself as sole originator of psychoanalysis, constitute what I would call a profound labour of self-construction. In this otherwise modest summary of his life's work, Freud offers very clear instructions about how he wants to be viewed from the vantage point of history – as a quietly heroic figure, who has virtually single-handedly brought about a revolution in consciousness. For the most part rhetorically successful, Freud's narrative efforts are punctuated, however, by two instances of conspicuous anxiety: the first when he all

but blames his fiancée Martha for standing in the way of his achieving early fame for discovering the anaesthetic properties of cocaine, and the second when he goes out of his way to dismiss the work of Pierre Janet as in any way anticipating his own.

In an otherwise smooth description of his early scientific activities, Freud makes a sudden detour to describe why he did not become famous for advocating the use of cocaine as an anaesthetic in ophthalmic surgery. After introducing the subject of his marriage in 1886, he interrupts the flow of his narrative to dilate on the subject of this missed opportunity. 'I may here go back a little,' he begins, 'and explain how it was the fault of my fiancée that I was not already famous at that youthful age.'[22] His experiments with cocaine, he explains, were cut short by the prospect of a visit to his fiancée, from whom he had been separated for two years. During his absence in Wandsbek, a colleague, Carl Koller, to whom he had spoken about his work, conducted the crucial experiments which demonstrated the specific usefulness of the drug in anaesthetizing the eye. Koller published a paper on the subject and thus earned credit for the discovery.

There is evidence that Freud did not immediately resent his failure to achieve this distinction, but rather that his annoyance at having been superseded by his friend developed over time, as he became aware of the full significance of Koller's achievement and as his own rather uncritical advocacy of the use of cocaine for a variety of medical problems came into disrepute. Shortly after the publication of Koller's paper, for instance, Freud wrote to Martha that 'a colleague has found a striking application for coca in ophthalmology and communicated it to the Heidelberg Congress, where it caused great excitement,' concluding, evidently without rancour, that 'it is to the credit of coca, and my work retains its reputation of having successfully recommended it to the Viennese'.[23] Three months later, his attitude towards Koller's celebrity seems unchanged. 'On Sunday,' he writes to Martha, 'Koller was on duty at the *Journal*, the man who made cocaine so famous and with whom I have recently become more intimate.'[24] Most of what follows, as if to indicate Freud's lack of envy for his friend's success, is taken up not with cocaine, but with Koller's response to a personal insult.

Freud's attitude towards the issue of priority seems to have undergone a gradual transformation, until he came to regard himself as the virtual author of Koller's discovery. In retelling this story many years later, Freud emphasized his own awareness of the anaesthetic

properties of cocaine, thus enhancing his role in the critical finding
of its application to the eye, while downgrading that of Koller by
laying stress on his rather narrow medical aims in conjunction with
his obvious opportunism.

> One day I was standing in the courtyard with a group of col-
> leagues of whom this man was one, when another intern passed
> us showing signs of intense pain. [Here Freud told what the
> localization of the pain was, but I have forgotten this detail.] I
> said to him: 'I think I can help you,' and we all went to my
> room, where I applied a few drops of a medicine which made
> the pain disappear instantly. I explained to my friends that this
> drug was the extract of a South American plant, the coca, which
> seemed to have powerful qualities for relieving pain and about
> which I was preparing a publication. The man with the perma-
> nent interest in the eye, whose name was Koller, did not say
> anything, but a few months later I learned that he had begun to
> revolutionize eye surgery by the use of cocaine, making opera-
> tions easy which till then had been impossible.[25]

In 1924, when Freud composed his 'Autobiographical Study', he
was perturbed enough by his failure to gain credit for the one prop-
erty of cocaine which had proven of lasting medical use that he was
willing to implicate his fiancée in this lapse. Calling it an 'omission
[*mein damaliges Versäumnis*]', however, he took the final blame on
himself. By 1935, his judgement had once again changed. This time
he concluded his discussion of this episode by saying that he 'bore
[his] fiancée no grudge for the *interruption* [*die damalige Störung* –
emphasis mine]', clearly implying that she alone was responsible for
his not having pursued his research further.[26]

From this distance in time, Freud's need to assure his audience
that only his love for his fiancée stood in the way of his having be-
come famous at a relatively early age speaks more to his anxiety
about his personal distinction as well as to his reputation for having
indiscriminately endorsed cocaine, than it does to the truth of his
claim to have been the first to divine its specific anaesthetic proper-
ties.[27]

Freud's tirade against Pierre Janet, in the midst of an otherwise
dispassionate account of the early development of psychoanalysis,
betrays similar self-promotional concerns. Here it is the vehemence
of Freud's assertion that he owes nothing to the work of Janet, whose

studies he and Breuer had once cited as bearing on their own, which suggests something more than an impersonal judgement.

After carefully distinguishing between his and Janet's understanding of the dynamics of hysteria, Freud claims, in something of a *non sequitur*, that 'this distinction seems to me to be far-reaching enough to put an end to the glib repetition of the view that whatever is of value in psychoanalysis is merely borrowed from the ideas of Janet.'[28] Once having embarked on this topic, moreover, he cannot let it go. 'The reader will have learned from my account that historically psycho-analysis is completely independent of Janet's discoveries,' Freud continues, 'just as in its content it diverges from them and goes far beyond them.'[29] Janet's works, next to his own, he states, are negligible and 'would never have had the implications which have made psycho-analysis of such importance to the mental sciences and have made it attract such universal interest'.[30] While Freud himself has treated Janet 'with respect', moreover, Janet 'behaved ill, showed ignorance of the facts and used ugly arguments', finally destroying 'the value of his own work by declaring that when he had spoken of 'unconscious' mental acts he had meant nothing by the phrase'.[31]

Freud takes pains to deny Janet any claim to priority: through the content of his ideas, his terminology, or the chronology of his publications – in spite of the fact that his and Breuer's 'Studies on Hysteria',[32] along with their 'Preliminary Communication',[33] postdated several of Janet's major case studies.[34] Breuer's discoveries, Freud unabashedly maintains, 'had been made earlier but were published later than his'.[35] While Freud seems to have no difficulty acknowledging Breuer's contribution to the development of psychoanalysis, he also makes clear the limited nature of his friend's participation, along with his difficulty in coming to grips with the sexual content of the neuroses and his consequent defection from the field. Whereas Breuer has long since vanished as a rival, Janet evidently continues to pose a threat.

Freud's self-characterizations in his 'Autobiographical Study' benefit, no doubt, from hindsight. As early as 1914, however, he had established the main outlines of his later stance regarding himself as the prime originator of psychoanalysis and its beleaguered and solitary defender during its beginning stages. In his essay 'On the History of the Psycho-Analytic Movement', Freud declares baldly that 'psycho-analysis is my creation; for ten years I was the only person who concerned himself with it, and all the dissatisfaction which the new phenomenon aroused in my contemporaries has been poured

out in the form of criticisms on my head.'[36] Much of what follows is taken up with Freud's response to the defections of his followers Adler and Jung. In anticipation of this discussion, where he does active battle with his former disciples, Freud establishes an image of himself as a man who is wholly devoted to the objective pursuit of science and completely imperturbable in the face of hostile criticism. 'The void' which he claims formed itself around him owing to the unpopularity of his position regarding the sexual aetiology of the neuroses, for instance, only serves to confirm him in his sense of mission: 'I made up my mind to believe that it had been my fortune to discover some particularly important facts and connections, and I was prepared to accept the fate that sometimes accompanies such discoveries.'[37]

That Freud had an early and highly developed sense of personal destiny (he was born in a caul; he was his mother's favourite; predictions were made to his parents of his future greatness) has been commented on by many. What is less evident is the way in which Freud parlayed these family myths and expectations into a quasi-literary structure of self-portrayal, which not only served complex political aims in the development of the psychoanalytic movement but also substituted for the kind of deep self-analysis Freud claimed he had conducted on himself, yet refused (for the most part) to disclose.

Even Freud's name is a product of self-conscious manipulation. Like many adolescents, Freud experimented with his given name, alternating Sigismund (his birth name) with the shorter and more stylishly literary form Sigmund, until he finally settled on the latter.[38] As a child, moreover, he identified, not with his father, whose submission to a gesture of overt anti-semitism permanently disappointed him, but with great military heroes of history: Alexander the Great, Hannibal, Cromwell and Napoleon.[39] In later life, he was to form a passionate attachment to the figure of Moses, recreating him, however, according to a highly idiosyncratic fantasy of his non-Jewish identity ('Moses and Monotheism'). One might even argue that Freud's reconceptualization of the origins of religion, morality and civilization itself in 'Totem and Taboo' represents an attempt to recast his own history – from the beginning as it were. Not content with his specific family legacy – with its poverty, its ties to local Jewish culture, its lack of obvious distinction – Freud, first in fantasy, and then in theory, refashioned it to suit himself.[40] It is in this context that his obsession with matters of priority and

originality in his professional life reveals its urgency. Freud's whole theoretical endeavour was tied to his labour of self-creation.

Thus Freud himself set the parameters for the legend of the psychoanalytic movement and the cult of his personality that grew up around him. This was, I believe, a conscious (and partly retrospective) act to define his life which he offered to the world as autobiography, inviting his readers to identify him with his public existence, thereby effectively masking the private man, along with the details of his intimate personal life, while actively seeking to destroy the traces that might call his artfully constructed self-portrait into question.[41]

Unauthorizing Freud

I want to try out a biographical approach that unauthorizes Freud, one, that is to say, which not only displaces Freud as the author of his own self-portrait, but which also questions his theoretical mastery or authority. In order to do this, I will focus on relatively private (yet readily available) kinds of evidence, chiefly Freud's letters to his adolescent friend Eduard Silberstein and his published letters to his fiancée Martha, during the period of their engagement. I choose this material in part because it has not been discussed as extensively as the other major edition of letters to a single individual (Wilhelm Fliess), and because it covers a period in Freud's life in which he had not yet arrived at the fixed image of himself he later took such pains to project.

Freud corresponded with his friend Eduard Silberstein for a period of ten years, from the time he was fifteen until he was twenty-five. As adolescents they learned Spanish together, often writing to each other in this language, developed a coded means of address based on an episode in Cervantes' *Don Quixote*, and founded a secret society, which they termed the 'Academia Castellana'. Gradually their friendship waned, bringing the habit of regular correspondence to an end by the beginning of 1881. A year and some months later Freud met Martha Bernays, to whom he quickly became engaged. That Freud's involvement with Martha served in part to fill the gap left by Silberstein is evident from a letter to her in which he describes the course of this earlier attachment. Owing to their temperamental differences, Freud explains, he and Silberstein drifted apart. 'Then you appeared on the scene and everything that came

with you; a new friend, new struggles, new aims.'[42] In this light it makes sense to read the two sets of letters – to Silberstein and to Martha – in relation to each other.

Quite early in his correspondence with Silberstein, Freud expresses a desire for an almost encyclopedic exchange of information. Not content with the limitations of the letter format, he offers, on a trip to Freiberg, to keep a travel diary especially for his friend 'in which all the outings I shall ever make will be crammed'.[43] Even so, he feels impatient with the condition of separation, confessing that 'our evening saunters and nocturnal visits have so accustomed me to communication that I find it hard to do without it now.'[44] Often frustrated by the slowness of the mail or the tardiness of a reply, both of which contribute to the difficulty of sharing the fullness of his experience, Freud later reaffirms his desire to tell all, to know all, by proposing that both correspondents write once a week a letter,

> that is nothing short of an entire encyclopedia of the past week and that with total veracity reports all our doings, commissions and omissions, and those of all strangers we encounter, in addition to all outstanding thoughts and observations and at least an adumbration, as it were, of the unavoidable emotions.[45]

Normally somewhat shy in society, Freud opens his heart to Silberstein, taking care to warn him, however, 'not to let these notes fall into anyone's hands' if he wishes to retain Freud's trust.[46] Evidently anxious to protect his privacy, yet eager to enjoy a freedom and totality of communication which he will later recommend to his analytic patients, Freud concludes another letter with the mild admonition: 'I trust you do not show my letters to anyone . . . because I want to be able to write with complete candour and about whatever comes into my head.'[47]

When Silberstein writes sparingly Freud gently reprimands him. 'But someone who is self-possessed and feels affection for his friends', he chides, 'will always find something that engages his attention sufficiently to be considered worthy of taking up his friends' time', reminding him further that 'selfless sympathy with everything that concerns or happens to the other is often the most valuable, indeed the sole, contribution of a friend'.[48] Freud is correspondingly moved by 'affectionate words', confessing that separation is sometimes useful because 'writing makes it all easier', and 'it does one good to read warm and friendly words addressed to oneself'.[49] In an especially

expansive mood, Freud himself attests to the intensity of the bond he feels with Silberstein. 'I really believe that we shall never be rid of each other,' he writes. 'Though we became friends from free choice, we are as attached to one another as if nature had put [us] on this earth as blood relations; I believe we have come so far that the one loves the very person of the other and not, as before, merely his good qualities.'[50]

What Freud strives for in his relationship with Silberstein is a condition of openness of communication in which he can feel intimately known or understood. His first experience of romantic love evokes a similar set of responses. Contrary to expectation, however, his interest migrates from its first object (a girl more or less his own age) to her mother. Writing to Silberstein from Freiberg on 17 August 1872, Freud confesses that he has 'taken a fancy' to Gisela Fluss, the eldest daughter of his host family, although his reticence prevents him from speaking to her. Ignorant of his attraction, she departs on a trip. By 4 September Freud is moody owing to her absence, but he has found a new focus for his admiration – the extraordinary Frau Fluss, whose charms surpass even those of her daughter. 'It would seem that I have transferred my esteem for the mother to friendship for the daughter,' Freud explains, 'I am full of admiration for this woman whom none of her children can fully match.'[51]

What follows is an encomium to Frau Fluss's virtues: her head for business, her culture, her easy management of household and family. Yet Freud reserves his highest praise for her intuitive understanding of a young man's needs – both intellectual and emotional. 'Other mothers', Freud states, not shrinking from including his own, 'care only for the physical well-being of their sons; when it comes to their intellectual development the control is out of their hands.'[52] Frau Fluss shows her tact in countless ways, sparing Freud embarrassment when he passes out from alcohol taken for a raging toothache, then ministering to him tenderly when he falls violently ill in reaction. But most of all one senses that Freud is grateful for her sensitivity to his shyness and for the delicate way she has of putting him at ease. 'She fully appreciates that I need encouragement before I speak or bestir myself,' Freud confides, 'and she never fails to give it. That's how her superiority shows itself: as she directs so I speak and come out of my shell.'[53]

In contrast with the 'half-naive, half-cultured' Gisela, who is so oblivious of Freud's feelings that she plays a joke on him, Frau Fluss offers a warm and affectionate sympathy, precisely what Freud seeks

from his friendship with Silberstein and what he evidently finds missing from that most intimate of family ties, his relationship with his own mother. In his praise of Frau Fluss, Freud all but declares that his mother did not understand him; his experience of falling in love (first with Gisela, then her mother) brings this painful recognition to light.[54]

In his encounters with the Fluss women, mother and daughter, Freud experienced both the risks and the rewards of intimacy. His ambivalence about making himself vulnerable in this way manifests itself in his friendship with Silberstein, first in his efforts to control the course of the relationship (by advising, admonishing, setting rules), and later in his anxiety over the prospect of Silberstein himself falling in love.

Awkward, diffident, unsure of himself, Freud idealizes his friend's ease in society and in particular his attractiveness to women. Yet he sees danger in these same qualities. When Silberstein becomes romantically involved with a woman somewhat younger than himself, Freud responds with concern that he may be leading her astray. Passion is unpredictable, he warns, and besides women are easily seduced. 'Whereas a thinking man is his own legislator, confessor, and absolver . . . a woman, let alone a girl, has no inherent ethical standard; she can act correctly only if she keeps within the bounds of convention.'[55] Silberstein must eschew both 'rendezvous and secret correspondence' if he wishes to preserve his own honour and that of the young lady in question.

Freud's severity of tone may derive in part from a sense of personal betrayal, from an awareness of having been displaced from his position as privileged correspondent. Later, as the affair dissolves, the eagerness with which he seizes on Silberstein's annoyance with the girl's mother points to another level of anxiety. In Freud's crude fantasy-interpretation, mother and daughter have been in cahoots all along, scheming to entrap Silberstein into marriage.

> The old girl is a shrewd woman, or thinks that she is; she knows that beauty and youth alone cannot support her daughter, but that a wealth of coquetry is needed to vaunt these advantages and to captivate men with social graces. Her daughter may have shown few signs of this so far, which is why she sends her to dancing school, makes sure that she is in male company, and does her utmost to bring out the innate but latent coquetry of the sixteen-year-old daughter of Eve. In that she

quickly succeeds, the child takes to the game, and with obvious pleasure that you are taking notice of her small attentions, and this explains the apparent collusion of mother and daughter. In short, your part in the whole business was that of a dressmaker's dummy *masculini generis* that is, of a tailor's dummy.[56]

There is no question of love here. Silberstein has merely been played for a fool by a particularly unscrupulous mother–daughter pair. Whereas previously Freud had warned his friend against the danger of corrupting a young girl's innocence, the roles are now reversed. Mother and daughter appear in Freud's scenario as sexually knowledgeable, almost rapacious, little better than a prostitute and her madam.

Freud's anxieties about intimacy manifest themselves first in his difficulty over expressing his desires (his acknowledged shyness) and then in his fear of being manipulated or betrayed once they are known. Hence his multiple injunctions to the somewhat wayward Silberstein. Hence also, his suppression of his attraction to the indifferent Gisela, in favour of her openly responsive mother. Yet not all mothers are so gratifying. Freud's reference to his own mother's deficiencies of understanding, in conjunction with his portrayal of maternal interference in the Silberstein affair, point in the direction of unresolved conflicts likely to affect his adult love relations with women. Some of the more puzzling features of Freud's relationship to his fiancée Martha Bernays make sense in this light.

Commencing within a few days of their engagement on 17 June 1882, Freud's published correspondence with his fiancée spans a period of four years, stopping just short of their marriage in September 1886. A year after the engagement, Martha's mother moved with her daughters to Wandsbek, an obvious source of frustration to her future son-in-law, who opposed this decision, but also an occasion for extensive letter writing. While Freud had opportunities to visit Martha during this period, his impecunious circumstances prevented frequent travel. Hence, much of his relationship with his fiancée was negotiated by mail.

Freud seems to have fallen in love in a rather precipitate way, pursuing Martha with passionate determination until she agreed to an engagement – barely two months after they met. It was in the wake of this momentous decision that they began the arduous process of coming to terms with the differences in their personalities. Among

the many ups and downs Freud experienced during this time, one emotional dynamic in particular stands out.

Of the two lovers, Freud appears to be the more effusive – at least that is how he regards himself. Unlike Frau Fluss who responded to the adolescent Freud with a ready sympathy, Martha not only resisted his initial efforts at courtship, but she evidently continued to display a certain coolness or reserve well into their engagement. While frequently expressing a desire for total communication, in which neither holds anything back, Freud just as frequently chides Martha for falling short of this ideal. 'Please don't be taciturn or reticent with me,' he pleads with her on one occasion, sounding a plaintive note that runs throughout the correspondence.

Yet Freud praises Martha for precisely those aspects of her character which he finds most troublesome. 'I have always respected you highly for the very reticence of which I have so often complained,' he confesses, offering the explanation that 'I could never trust the love that readily responds to the first call and dismisses the right to grow and unfold with time and experience.' Here Freud's desire for intimate communication, as expressed in his next statement, 'Then I will tell you everything and you will understand me better,' comes up against an equally powerful counter-drive – to achieve a sense of well-being by overcoming resistance. 'You know, after all, how from the moment I first saw you', he reminds Martha, 'I was determined – no, I was compelled – to woo you, and how I persisted, despite all the warnings of common sense, and how immeasurably happy I have been ever since, how I regained my confidence and so on.'[57]

Freud's need to triumph over obstacles is so urgent, in fact, that it takes on the character of what he would later call a repetition compulsion. Once having won Martha, Freud seems to go out of his way to quarrel with her, provoking new outbursts of resistance, which he must then overcome. Letters in which he bares his soul to his fiancée, confiding his anxieties, his ambitions, and his love, alternate with ones in which he adopts an unaccountably hostile or angry tone. These in turn are followed by apologies and expressions of remorse. 'My beloved Marty,' one such letter begins, 'I dare to say my beloved although I do occasionally have bad thoughts and write so angrily. If I have offended you again, please put it down on the list with the others and think of my longing, my loneliness, my impatient struggle and the shackles that are imposed on me.'[58]

So consistent is this pattern of quarrelling and reconciliation that

Freud himself begins to comment on it. Two years into their engagement, he writes:

> I am so glad for quite a while now there has been no mention
> in our letters of any mutual indisposition, also that this time
> we have skipped our little monthly squabble which used to
> appear with such impressive regularity at the end of every first
> week, so that by the seventeenth we both had a chance to for-
> give each other.[59]

Six months later, he returns to this theme, expanding it into a medi-
tation on the course of their relationship as a whole, including its
inauspicious beginnings.

In a mood of sombre self-reflection, Freud writes: 'I really think I
have always loved you much more than you me, or more correctly:
until we were separated you hadn't surmounted the *primum falsum*
of our love – as a logician would call it – i.e., that I forced myself
upon you and you accepted me without any great affection.'[60] Prior
to their first lengthy separation, nothing in the relationship seems to
have warranted the extraordinary degree of Freud's emotional in-
vestment. Full of painful recollection, Freud reminds Martha of their
bitter quarrels, rooted, he believes, in her native reserve and self-
possession.

> Do you remember how you often used to tell me that I had a
> talent for repeatedly provoking your resistance? How we were
> always fighting, and you would never give in to me? We were
> two people who diverged in every detail of life and who were
> yet determined to love each other. And then, after no hard words
> had been exchanged between us for a long time, I had to admit
> to myself that you were indeed my beloved, but so seldom took
> my side that no one would have realized from your behavior
> that you were preparing to share my life; and you admitted
> that I had no influence over you. I found you so fully matured
> and every corner in you occupied, and you were hard and re-
> served and I had no power over you. This resistance of yours
> only made you the more precious to me, but at the same time I
> was very unhappy, and when at the corner of the Alser Strasse
> we said goodbye for thirteen months, my hopes were very low,
> and I walked away like a soldier who knows he is defending a
> lost position.[61]

This description is so negative that one cannot help wondering why Freud would fall in love with a woman so obviously cool towards him, then insist on making her his lifetime partner. Freud himself, in this letter, expresses doubts about his and Martha's future. Acknowledging the problems inherent in their long-term separation, Freud muses:

> if at the moment you love so fondly the me whom you haven't seen for such a long time and then you see me again, see the gesture, hear the voice and the opinions which invariably used to arouse your defiance, won't you discover that your fondness was directed at an idea that you made for yourself, and not at the living person who perhaps will have upon you the same effect he did a year or two ago?[62]

The lucidity of Freud's analysis in this instance did not prevent him from further antagonizing his fiancée. 'I just couldn't accept what you wanted to do,' Freud admits, on another occasion, 'without making serious objections', this in spite of the fact that he realizes 'how one can offend by love the person one loves most'.[63] Evidently helpless against his own impulses in this regard, Freud sues for forgiveness: 'Do you remember how once, after we had parted in anger, I soon came back to you, and you said you would never forget? In the same way I am not ashamed to come back to you now and ask once more for a kind word, a friendly glance.'[64] Freud's need to quarrel and reconcile emerges so powerfully in his letters that it begs interpretation. How can one account for this?

The letters themselves, I believe, offer clues to this emotional riddle. Towards the end of their long engagement, Freud humbly confesses: 'I am dearly happy that you have forgiven me; the idea that you were not thinking of me as affectionately as usual gave me a strange feeling of forlornness, a feeling I couldn't have stood for long, the less so because I had no one but myself to blame.'[65] Having alienated Martha, Freud feels anxious and bereft, a condition of inner desolation from which only she can rescue him. Yet Freud wants more than this; he wants not only the assurance that Martha still loves him, but that she loves him even more than before. 'You have forgiven me, and I am deeply grateful,' Freud continues gloomily, 'yet I am not quite satisfied, for I believe that when one has quarreled one ought to love the other more than ever, otherwise the relationship is no longer what it was.'[66] It seems that Freud needed to keep

testing Martha's affections, almost deliberately pushing her away in order to experience the gratification of her return. The very abuse of Martha's love, in this scenario, guarantees its authenticity. A less loving, less faithful, less true-hearted woman would simply not come back.

There is a highly charged and coded reference to this process in Freud's choice of a nickname for Martha: Cordelia. Within a month of Martha's removal to Wandsbek, he writes to her as his 'Cordelia-Marty', evidently a matter of recent inspiration, as he immediately adds 'Why Cordelia? This will be explained later.'[67] The letter then describes a visit with Josef Breuer, which includes a bath, a leisurely meal and an intimate conversation, culminating in a moment of personal revelation. The two men discuss a number of medical matters, 'moral insanity and nervous diseases and strange case histories', gradually moving into areas of mutual confidence: 'and then we became rather personal and very intimate and he told me a number of things about his wife and children and asked me to repeat what he had said only "after you are married to Martha".'[68] Stung by the notion that he and his fiancée keep any kind of secrets, Freud is quick to reply: 'This same Martha who at the moment has a sore throat in Dusternbrook, is in reality a sweet Cordelia, and we are already on terms of the closest intimacy and can say anything to each other.'[69]

Cordelia, of course, is the youngest, most seemingly intractable, and most deeply loved of King Lear's three daughters. She alone, among her sisters, refuses her father's demand to say how much she loves him and when pressed will admit only to loving 'according to her bond'. What can Freud mean by describing Martha as his 'sweet Cordelia', with whom he feels he can talk about anything? Evidently what he has in mind is not the silent and unbending Cordelia of the beginning of Shakespeare's play, but the devotedly affectionate daughter of its conclusion. The 'terms of the closest intimacy' which Freud claims to enjoy with his fiancée suggest as much. Yet the choice of the name 'Cordelia' is not without ambivalence, as Freud's next comment reveals. Breuer, too, he confides to Martha, 'calls his wife by that name because she is incapable of displaying affection to others, even including her own father'.[70] Far from 'sweet', Breuer's Cordelia seems rather cold and unresponsive.

Given what we know about Martha's resistance to Freud's courtship and the fundamental reserve of her nature, it seems odd that Freud should see his own Cordelia as different from Breuer's. Perhaps what is at issue here is not a contrast between two women, but

an oscillation within the image of a single woman, or even more suggestively a fantasy structure which Freud imposed on his relationship with Martha. Evidence for the latter may be adduced from the fact that Freud kept the image of Cordelia alive well into middle age and beyond, transferred, however, to the youngest and most devoted of his own three daughters, Anna Freud.[71]

Critics of Shakespeare's *King Lear* have commented on the transformation in Cordelia's character after her return from exile and the corresponding difficulty of reconciling her loving self-surrender with her earlier resistance.[72] Yet the emotional focus of the play lies elsewhere, with Lear himself, his rage, his madness and his grief. What matters to Lear is not whether his daughter's behaviour is consistent but whether it ultimately obeys his need. Viewed from this perspective, Cordelia's character does not have to make sense in its own terms. It simply has to further the aims of the plot, which admittedly revolves around Lear. Similarly, Freud did not have to 'make sense' of his inconsistently held views of Martha, as long as they did not interfere with the unfolding of his internal drama. What was the nature of that drama? On the basis of my reading of Freud's letters to Martha, I would suggest the following: that behind resistance, Freud fantasized the reward of unconditional love, that repeated validation of this fantasy was required through a cycle of quarrelling and reconciliation, and that this process in turn served as means of mastering a trauma of separation or loss.

Freud wrestled with bouts of despondency and self-doubt during his engagement, often confiding his anxieties to Martha and appealing for her sympathy. It is clear from these letters what he expects of her – a love that transcends the specifics of his character or achievements, that accepts him simply as he is. 'You will not judge me according to the success I do or do not achieve, but according to my intentions and my honesty,' Freud explains, in an elaborately spun fantasy of his and Martha's married life, adding somewhat wistfully: 'You will be able to read me like an open book, it will make us so happy to understand and support each other.'[73] Taking Martha to task on another occasion, Freud complains that she ascribes to him 'a measure of kindliness, decency, and I don't know what, which I have never possessed'.[74] Fearful that she will be disillusioned, he instructs her once again how she ought to respond. 'I don't want you to love me for qualities you assume in me, in fact not for any qualities; you must love me as irrationally as other people love, just because I love you, and you don't have to be ashamed of it.'[75]

In keeping with his ideal of total communication, Freud seems to have held a fantasy of unconditional love. The strength of this fantasy may be gauged by the effects of its absence or refusal as represented in the strange object lesson of his friend Nathan Weiss. Freud interrupts the normal flow of his correspondence to Martha to dilate on the story of Nathan's suicide, which, as he admits, has left him 'deeply shattered'.[76] So intense is Freud's response to this event that he is moved to construct a full explanatory narrative, bearing all the hallmarks of one of his later case histories.

Nathan's death, in Freud's view, is the direct result of his unfortunate marriage. In almost a parody of Freud himself, he insisted on courting a woman who was cold towards him. Though 'considered intelligent and sensible', she was 'a real Brunhilde, a reserved, not very yielding, extremely demanding creature', a young woman who 'didn't seem to feel any need for love'.[77] Unable to accept no for an answer, Weiss persisted, almost hounding her into marriage. Freud himself, convinced 'that she did not like him', advised his friend to think twice. 'But he just could not bear the thought that a girl could refuse him, and he sacrificed everything recklessly with the single object of not having to face the world as a failure'.[78] On his return from his honeymoon Weiss hanged himself. Freud's interpretation of the suicide strikes one as particularly urgent and impassioned.

> I believe that the realization of an enormous failure, the rage caused by rejected passion, the fury at having sacrificed his whole scientific career, his entire fortune, for a domestic disaster, perhaps also the annoyance at having been done out of the promised dowry, as well as the inability to face the world and confess it all – I believe that all this, following a number of scenes which opened his eyes to his situation, may have brought the madly vain man (who in any case was given to serious emotional upheavals) to the brink of despair.[79]

In the light of Freud's own situation, it is difficult not to read some degree of personal investment in this story. What is even more striking is the context in which he tells it – to his fiancée, as if to warn her beforehand of the potential for disaster in her not reciprocating his love. Read from Martha's point of view, this whole episode sounds quite threatening; it seems to represent Freud's worst fantasy of his own love life. 'The realization of an enormous failure, the rage caused by rejected passion, the fury at having sacrificed his whole scientific

career, his entire fortune, for a domestic disaster': these are all concerns (albeit muted in expression) that surface at one time or another in Freud's correspondence with Martha.

In courting a woman who was cool towards him, was Freud himself making a mistake? It is hard not to imagine some such thought passing through his mind as he considered his friend's fate. If so, he seems to be conveying an important message here – that he himself would feel, perhaps even act, like Nathan under similar circumstances. As if to reassure himself otherwise, Freud concludes his letter with a knock-on-wood type of remark, not without its own nervous 'what if' quality: 'Well, lucky the man who is tied to life by a sweet darling.'[80]

Too much seems to depend on Martha's devotion, so much that one wonders what other needs may have been served by Freud's falling in love with her. In choosing her, in fantasy at least, Freud seems to unite aspects of his first two adolescent loves: the indifferent Gisela Fluss, and her intuitively responsive mother, themselves representative of the two faces of Cordelia now joined in the single person of Martha. Yet the convergence is not perfect, nor does Freud himself appear to desire such a consummation. Instead he oscillates between states of anxiety and enjoyment, anger and reconciliation, acting out a paradigm of separation and reunion, very suggestive of the little spool game played by his grandson Ernst, which late in life he describes and attributes to the trauma of mother loss.

Both Freud and his grandson, it seems, play a push–pull game of 'disappearance and return', as a means of coping with difficult emotions. The little boy, as Freud describes him in 'Beyond the Pleasure Principle', has the habit of throwing a reel with a string attached to it over the side of his cot to the accompaniment of an expressive 'o-o-o-o' sound, which Freud interprets to mean 'fort' (gone), and then pulling it back with a corresponding 'da' (there). This, Freud states, 'was related to the child's great cultural achievement – the instinctual renunciation (that is, the renunciation of instinctual satisfaction) which he had made in allowing his mother to go away without protesting. He compensated himself for this, as it were, by staging the disappearance and return of the objects within his reach.'[81] By compulsively re-enacting the drama of his mother's departure and return, the child overcomes his feelings of helplessness, anxiety, and (presumably) loss. 'At the outset,' Freud explains, 'he was in a *passive* situation – he was overpowered by the experience: but by repeating it, unpleasurable though it was, as a game, he took on an *active* part.'[82]

Freud's emphasis on what he calls the boy's 'cultural achievement', that is his self-control, obscures to some extent the intitial condition for the game – a feeling of powerlessness or deprivation, which persists through repetition. Whereas Freud interprets the game as a sign of mastery, one might just as easily read it in opposite terms, as a failure to work through (in the sense of letting go of) the painful feelings surrounding separation or loss. That Freud's description of the game occurs as a digression from the subject of the traumatic effects of war injuries lends support to this interpretation; far from mastering their oppressive memories, the victims of war neuroses merely suffer from their recurrence. 'Now dreams occurring in traumatic neuroses', as Freud points out, 'have the characteristic of repeatedly bringing the patient back into the situation of his accident, a situation from which he wakes up in another fright.'[83] Such a person, he concludes, is 'fixated to his trauma'.[84]

Tempering Freud's optimism about the effects of 'instinctual renunciation', one might say that his grandson Ernst, though fixated on the problem of his mother's departure, attempted to come to terms with it through his obsessive play. That other feelings than mastery were involved becomes evident, moreover, through Freud's continuing analysis of the game. By 'playing gone' with his mother, the child may have been giving vent to his anger. 'In that case,' Freud states, the boy's actions 'would have a defiant meaning: "All right, then, go away! I don't need you. I'm sending you away myself".'[85]

The more Freud writes about this incident, the less of a 'cultural achievement' it appears. Instead of mastering his feelings, the child merely displaces them by 'throwing away objects instead of persons'.[86] Even more disturbing than this observation, however, is Freud's footnote concerning it. 'When this child was five and three-quarters,' he states coolly, 'his mother died. Now that she was really 'gone' ('o-o-o'), the little boy showed no signs of grief.'[87] 'It is true,' he adds in a stunning *non sequitur*, 'that in the interval a second child had been born and had roused him to violent jealousy.'[88] The information we have today that the boy's mother was Freud's Sunday child, his most cherished daughter Sophie, only adds to the psychological density and involution of this comment.

What I am suggesting here is that Freud's description of the *fort/da* game acts as a delayed form of self-observation, offering clues to his own emotional economy. Thus, through the child Ernst, we may catch a glimpse of Freud's own strategies for coping with loss – through anger, denial, displacement and compulsively repetitive

behaviour, all rationalized in the name of 'cultural achievement'. Missing from this scenario is any acknowledgement of grief. Little Ernst not only does not seem to mind his mother's temporary departure, but (more disturbingly) he shows no sign of distress at her death, an oddity which Freud makes only a feeble attempt to explain. Finally, the analogy between Freud's relations with his fiancée Martha and little Ernst's game of disappearance and return points to the possible maternal origins of Freud's difficulty in dealing with loss.

Read in the context of his letters to Silberstein, Freud's correspondence with Martha suggests some of the ways he negotiated his intimate emotional life. What Freud wanted from his friendship with Silberstein was not unlike what he sought in his relationship with his fiancée: a selfless and undemanding love, grounded in intuitive understanding, something approximating the ideal of responsive care that he describes in the ministrations of Frau Fluss. That Freud explicitly contrasted Frau Fluss with Amalie Freud in this regard would seem to indicate that Freud's own mother did not provide the model for his search. More likely, he was looking for something that was missing from this relationship.

Yet the idiosyncrasies of Freud's courtship of Martha bear the marks of a transference – a repetition, rather than a transcendence of an earlier emotional bond. Read this way, several of the more problematic features of this relationship fall into place. In pursuing a woman whose resistance he had to overcome, a drama endlessly recreated through the process of quarrelling and reconciliation, Freud offers us clues to his childhood disappointments. Like the repetitive play of his grandson Ernst, his actions speak symptomatically. To what event or set of circumstances can this possibly refer?

Leaving aside the issue, interesting in itself, of Amalie Freud's personality, I would like to look again at Freud's rather bizarre comment on his grandson's lack of response to his mother's death. Freud's footnote occurs in the context of a discussion of hostility. Little Ernst's throwing of his spool, Freud tells us, might be considered as a specifically *angry* gesture. 'Throwing away the object so that it was "gone" might satisfy an impulse of the child's, which was suppressed in his actual life, to revenge himself on his mother for going away from him.'[89] Amplifying this comment, Freud adds:

A year later, the same boy whom I had observed at his first game used to take a toy, if he was angry with it, and throw it on the floor, exclaiming: 'Go to the fwont!' He had heard at that

time that his absent father was 'at the front', and was far from regretting his absence; on the contrary he made it quite clear that he had no desire to be disturbed in his sole possession of his mother.[90]

Freud's footnote continues this train of thought, connecting the fact that the child showed 'no signs of grief' to the prior interruption of his blissful dyadic relationship due to the birth of a sibling. Yet there is a step missing. Why should the boy's 'violent jealousy' of his younger brother result in a failure to mourn his mother's death? Surely Freud does not mean to suggest that his mother's turning her attention to the second child deprived her permanent turning away of any meaning? It makes more sense, I think, in following Freud's buried train of thought, to look at anger.

Imagine, for a moment, that Ernst responds not only with a 'violent jealousy' directed at his intrusive sibling, but also with anger towards his mother for the loss of her attention. Is this not akin to her physical acts of departure to which the boy responds by symbolically throwing her away? Then imagine her permanent disappearance. Would it not make sense for the boy to experience an even more frustrating and debilitating anger? Yet Freud stops short of saying this. Why?

Perhaps because it was too close to his own experience. Freud too found his privileged relationship to his mother interrupted by the birth of a sibling. In a letter to Wilhelm Fliess, Freud confesses that 'I greeted my one-year-younger brother (who died after a few months) with adverse wishes and genuine childhood jealousy,' adding that 'his death left the germ of [self-] reproaches in me.'[91] The step that is missing in Freud's analysis of little Ernst's reaction to his mother's death is similarly missing here. Whereas Freud can admit to feeling hostility towards his infant rival (even blaming himself for his permanent removal) he cannot, or will not, acknowledge any such reaction towards his mother. As a result, only two sides of this relational triangle (Freud–Julius–Amalie) are emotionally cathected.

In the place of response, there is an absence, as in the case of little Ernst. Once more, what this mirror situation suggests is a contraction or inhibition of Freud's ability to deal with maternal loss. The closest he can get to the complex of emotions surrounding this issue is to posit anger, displaced either into obsessive rituals or onto an unwanted sibling. Such an interpretation would seem to call for a

serious revision of both the standard biographical understanding of Freud's relationship with his mother and his theoretical pronouncements concerning mother–son relations.

There is evidence to suggest that both are overly idealized.[92] Instead of providing the 'most perfect, the most free from ambivalence of all human relationships',[93] it seems more likely that Freud's own mother, while cherishing her firstborn son and expecting him to accomplish great things, did not provide the kind of unconditional love that Freud (judging from his correspondence with Silberstein and Martha) most fervently desired. The very fact that she gave birth to eight children (one of whom died in infancy) in the space of ten years would suggest the practical impossibility of any single child receiving her undistracted attention, much less her undivided love. Further, I would argue that Freud's need to overcome resistance in his love relations with Martha points to an earlier structure of frustration, one which I would describe as a loss Freud failed to recognize as such and hence was unable to mourn.[94]

One does not have to suffer the death of a parent in order to experience a profound sense of absence or loss. Hence it is at least possible that the death of Freud's father did not provide him with his first occasion for mourning. In any event, grief does not figure prominently in the ostensible product of this mourning – the Oedipal construct which underpins virtually all of Freud's future theorizing. Rather, the Oedipal theory performs the function of acknowledging anger towards the deceased (murderous wishes directed towards the father) while enshrining an idealized memory of maternal love (mother–son incest). Like his grandson Ernst confronting his first overwhelming grief, Freud seems to bypass sorrow in favour of hostility.

Conclusion

The standard biographical portrait of Freud, by using Freud's own self-constructions as a means of interpreting his life, serves, in a circular fashion, to validate his image of himself. More importantly, by taking Freud's self-analysis on faith, it insulates the Oedipus complex from inquiry into the process of its formation and hence from challenges to its transcendental status. Whereas the official biographical portrait views the relationship between Freud's life and his theory as mutually transparent and reinforcing, I see it as mediated and prob-

lematic. Such a reading, in turn, opens a new set of interpretative possibilities.

Assuming that Freud's self-analysis, while serious and sustained, was in some sense necessarily incomplete, offers a way of juxtaposing biographical information with statements about theory in order to gauge their mutual compatibility. This method, while inherently more speculative than the one employed by Freud's standard biographers, permits a simultaneous interrogation of biography and theory, and hence a problematization of both. Freud's difficulty acknowledging feelings of loss, for instance, may be read not only in terms of its impact on his most personal life but also in the way it informed his Oedipal construct. Challenging Freud's mastery of his own self-image in this way necessarily challenges the magisterial status of his theory. While some may be troubled by the implications of such a de-authorization of Freud, others will feel compensated by its result: a less mythologized portrait of the man, a more open and questioning stance towards his work.

Notes

1 Ernst L. Freud (ed.), *The Letters of Sigmund Freud*, trans. by Tania and James Stern (New York: Basic, 1975), p. 140.

2 Ibid. p. 61.

3 Ernest Jones, *The Life and Work of Sigmund Freud* (3 vols; New York: Basic, 1953), vol. I, p. xii.

4 Ibid. vol. III, p. 223.

5 It is hard to say whether Freud would have appreciated the notion of the 'death of the author' as articulated by Roland Barthes and Michel Foucault. Yet no contemporary reader can remain oblivious of the challenges to the practice of biography raised by post-structuralist theory. In my own practice of reading Freud's life, I wish first to disrupt the canonical version of his biography by demonstrating the way it derives from and legitimizes Freud's own heavily invested self-construction, and then to offer an equally plausible, competing version of one episode of Freud's life based on the same available evidence. I also hope to make clear how much is at stake not only in the interpretation of Freud's life, but also in the construction of biography generally.

6 Peter Gay, *Freud: A Life for our Time* (New York: Norton, 1988), p. 614.

7 Ernst L. Freud, *The Letters of Sigmund Freud and Arnold Zweig*, trans. by Elaine and William Robson-Scott (New York: Harvest/Harcourt, Brace Jovanovich, 1970), p. 127.

8 Ibid.

9 Frank Sulloway points to the uniqueness of psychoanalysis (among other intellectual disciplines) in its demand 'that its founder's life and intellectual insights obey the same general laws that he was the first to glimpse. Indeed, the myth of Freud's self-analytic path to discovery epitomizes this requirement.' From this perspective, questions of Freud's biography become relevant to considerations

of his theory. Frank J. Sulloway, 'Reassessing Freud's case histories: the social construction of psychoanalysis', in Toby Gelfand and John Kerr (eds), *Freud and the History of Psychoanalysis* (Hillsdale, NJ: Analytic Press, 1992), p. 159.

10 Sigmund Freud, 'An autobiographical study'(1925), *Standard Edition* vol. XX, pp. 7–74.

11 Ibid. p. 71.

12 Ibid. p. 73.

13 Frank Sulloway claims that Freud, in stressing his isolation and originality, laid the groundwork for his biographer's re-creations of his life in heroic and quasi-mythic terms. The labour of deconstructing this image, it seems, must come from the margins of the psychoanalytic establishment. For recent examples of such work, see Marie Balmary, *Psychoanalyzing Psychoanalysis: Freud and the Hidden Fault of the Father*, trans. by Ned Lukacher (Baltimore: Johns Hopkins UP, 1982); Phyllis Grosskurth, *The Secret Ring: Freud's Inner Circle and the Politics of Psychoanalysis* (Reading, Mass.: Addison-Wesley, 1991); Marianne Krüll, *Freud and his Father*, trans. by Arnold J. Pomerans (New York: Norton, 1986); William McGrath, *The Politics of Hysteria: Freud's Discovery of Psychoanalysis* (Ithaca, NY: Cornell UP, 1986); Paul Roazen, *Freud and his Followers* (1971; New York: Meridian/NAL, 1976); Estelle Roith, *The Riddle of Freud: Jewish Influences on his Theory of Female Sexuality* (London: Tavistock, 1987); Carl E. Schorske, *Fin-de-Siècle Vienna: Politics and Culture* (New York: Vintage, 1980; Random House, 1981); and Peter Swales, 'Freud, Minna Bernays, and the Conquest of Rome: New Light on the Origins of Psychoanalysis' (1982), *New American Review*, 1 (spring/summer 1992), pp. 1–23.; 'Freud, Martha Bernays, & the Language of Flowers' (privately published paper, 1983).

14 Freud, 'An autobiographical study', p. 9.

15 Ibid. p. 23.

16 Ibid.

17 Ibid. p. 48.

18 Ibid. p. 49.

19 Ibid.

20 Ibid. p. 52.

21 Ibid. p. 55. Sulloway's research flatly contradicts this view. He points out, moreover, that 'Freud never stopped feeling isolated, no matter how famous he became,' hinting at a psychological basis for Freud's self-perception. Frank J. Sulloway, *Freud: Biologist of the Mind* (New York: Basic, 1979), p. 478.

22 Freud., 'An autobiographical study', 14.

23 Jones, *Life and Work of Freud*, vol. I, p. 88.

24 Ernst Freud, *Letters of Freud*, p. 131.

25 Jones, *Life and Work of Freud*, vol. I., p. 86.

26 Freud, 'An autobiographical study', p. 15, n. 2.

27 For fuller treatment of this episode see Robert Byck, (ed.), *Cocaine Papers* (New York: NAL, 1975). E. M. Thornton covers much of the same ground, alleging further that Freud's invention of psychoanalysis was in part the product of his cocaine use: E. M. Thornton, *The Freudian Fallacy: Freud and Cocaine*, (1983; London: Paladin/Collins, 1986).

28 Freud, 'An autobiographical study', p. 31.

29 Ibid.

30 Ibid.

31 Ibid.

32 Josef Breuer and Sigmund Freud, 'Studies on hysteria' (1895), *Standard Edition*, vol. II, pp. 1–305.

33 Josef Breuer and Sigmund Freud, 'On the psychical mechanism of hysterical phenomena: preliminary communication'(1893), *Standard Edition*, vol. II, pp. 1–18.

34 In case histories published over a period of years, 1886–93, Janet described hysterical patients achieving relief by bringing subconscious ideas to consciousness and working them through. Freud and Breuer referred favourably to this work in their 'Preliminary communication' (1893) and in their 'Studies on hysteria' (1895). While Janet disagreed with Freud on other points, he publically claimed priority for the idea of the cathartic cure of neuroses at a meeting of the International Congress of Medicine in 1913. For this, he was vehemently attacked by Freud's followers, who have been successful over time in expunging his name from the psychoanalytic record.

35 Freud, 'An autobiographical study', p. 31.

36 Sigmund Freud, 'On the history of the psycho-analytic movement' (1914), *Standard Edition*, vol. XIV, p. 7.

37 Ibid. p. 22.

38 Freud's names, as inscribed in the family bible, were 'Sigismund Schlomo', Schlomo being taken from his paternal grandfather. For Peter Gay, all conjecture about the significance of Freud's name change 'must remain purely speculative', since Freud himself never commented on it. (Peter Gay, *Freud: A Life for our Time* (New York: Norton, 1988), p. 5n.) Ronald Clark makes the point that Sigmund is merely the German form of Sigismund, yet he also notes that ' "Sigismund" was Vienna's favourite name for abuse in anti-Semitic jokes.' Ronald W. Clark, (1980; *Freud: The Man and the Cause*, (1980; London: Paladin/Granada, 1982), p. 36.

39 William McGrath sees Freud's fascination with great heroes of history as prompted by his disappointment in his father's failure to stand up for himself in the face of Christian insolence. The story, as Freud tells it in 'The interpretation of dreams', involves his father's new fur cap being knocked off into the mud, accompanied by the insulting remark: 'Jew get off the pavement!' When Freud asked his father what he did in response, he replied simply, 'I went into the roadway and picked up my cap' (Sigmund Freud, 'The interpretation of dreams'(1900), *Standard Edition*, vol. IV, p. 197.) This incident, McGrath concludes, 'conflicted sharply with the heroic image Freud had had of his father, undermining it at a crucial moment in the boy's emotional development'. William McGrath, *The Politics of Hysteria: Freud's Discovery of Psychoanalysis* (Ithaca, NY: Cornell UP, 1986), p. 60.

40 Freud's standard biographers have tended to accept Freud's own representations of his family background as more assimilated than religiously orthodox. A number of other studies, however, challenge this view, pointing to his parents' orthodox upbringing, his father's Talmudic studies, and his mother's exclusive use of Yiddish as evidence of Freud's specifically Jewish heritage. See, for instance: Emanuel Rice, *Freud and Moses: The Long Journey Home* (Albany: State University of New York Press, 1990); Marthe Robert, *From Oedipus to*

Moses: Freud's Jewish Identity, trans. by Ralph Manheim (New York: Anchor/ Doubleday, 1976); Estelle Roith, *The Riddle of Freud: Jewish Influences on his Theory of Female Sexuality* (London: Tavistock, 1987); and Yosef Yerushalmi, *Freud's Moses: Judaism Terminable and Interminable* (New Haven, Conn.: Yale UP, 1991). Freud's attitude towards his Jewishness appears more complex and conflicted in these accounts than it does in the work of either Jones or Gay.

41 Frank Sulloway states: 'To Freud, the destruction of history was an essential part of becoming and remaining a hero in the eyes of posterity. He actively cultivated the 'unknowable' about himself in order to set himself apart from the nonheroic component of humanity.' Sulloway, 'Reassessing Freud's case histories', p. 155.

42 Ernst Freud, *Letters of Freud*, p. 97.

43 Walter Boehlich (ed.), *The Letters of Sigmund Freud to Eduard Silberstein 1871– 1881*, trans. by Arnold J. Pomerans (Cambridge, Mass.: Belknap/Harvard UP, 1990), p. 9.

44 Ibid. p. 11.

45 Ibid. pp. 57–8.

46 Ibid. p. 12.

47 Ibid. p. 24.

48 Ibid. p. 62.

49 Ibid. p. 77.

50 Ibid. p. 126.

51 Ibid. p. 17.

52 Ibid.

53 Ibid. p. 18.

54 Robert Holt speculates that, in contrast to Freud's mother, Frau Fluss was not narcissistic. 'She had the capacity to be directly, warmly affectionate, or as the psychoanalytic jargon has it, to form object relationships of the attachment type. If his own mother had been capable of loving that fully, it seemed doubtful that this lad of 16 years would have formed such a crush on a friend's mother.' Robert R. Holt, 'Freud's parental identifications as a source of some contradictions within psychoanalysis', in Gelfand and Kerr, *Freud and the History of Psychoanalysis*, p. 9.

55 Boehlich, *Letters of Freud to Silberstein*, p. 92.

56 Ibid. p. 96.

57 Ernst Freud, *Letters of Freud,* p. 153.

58 Ibid. p. 70.

59 Ibid. pp. 84–5.

60 Ibid. p. 117.

61 Ibid. pp. 117–18.

62 Ibid. p. 118.

63 Ibid. p. 161.

64 Ibid.

65 Ibid. p. 197.

66 Ibid. pp. 197–8.

67 Ibid. p. 40.

68 Ibid. p. 41.

69 Ibid.

70 Ibid.
71 I treat this topic more fully in my book, *The Spectral Mother: Freud, Feminism, and Psychoanalysis* (Ithaca, NY: Cornell UP, 1990).
72 See, in particular: Janet Adelman, *Suffocating Mothers: Fantasies of Maternal Origin in Shakespeare's Plays, Hamlet to The Tempest* (New York: Routledge, 1992), pp. 103–29; Marianne Novy, 'Shakespeare's female characters as actors and audience', in Carolyn Ruth Swift Lenz, Gayle Greene, and Carol Thomas Neely (eds), *The Woman's Part: Feminist Criticism of Shakespeare* (Urbana: Illinois UP, 1980), pp. 256–70; and Coppélia Kahn, 'The absent mother in King Lear', in Margaret Ferguson, Maureen Qûilligan, and Nancy Vickers (eds), *Rewriting the Renaissance: The Discourses of Sexual Difference in Early Modern Europe* (Chicago: University of Chicago Press, 1986), pp. 33–49. Both Adelman and Novy make the point that Cordelia's character becomes less fully realized as the play progresses, making her motivations necessarily opaque. Adelman and Kahn speculate on the way in which the play serves Lear's need to recover in Cordelia a mothering presence for which he longs.
73 Ernst Freud, *Letters of Freud*, p. 71.
74 Ibid. p. 89.
75 Ibid.
76 Ibid. p. 59.
77 Ibid. p. 63.
78 Ibid. p. 64.
79 Ibid. p. 65.
80 Ibid. p. 66.
81 Sigmund Freud, 'Beyond the pleasure principle' (1920), *Standard Edition*, vol. XVIII, p. 15.
82 Ibid. p. 16.
83 Ibid. p. 13.
84 Ibid.
85 Ibid. p. 16.
86 Ibid.
87 Ibid.
88 Ibid.
89 Ibid.
90 Ibid.
91 Sigmund Freud, *The Complete Letters of Sigmund Freud to Wilhelm Fliess 1887–1904*, trans. and ed. by Jeffrey Moussaieff Masson (Cambridge, Mass.: Belknap/ Harvard UP, 1985), p. 268.
92 Jim Swan's analysis of Freud's childhood relationship to his nurse offers an explanation of how the young Freud may have arrived at the idealized image of his mother he carried throughout his life. (Jim Swan, 'Mater and nannie: Freud's two mothers and the discovery of the Oedipus complex', *American Imago*, 31 (1974) pp.1–64.) In *The Spectral Mother* I discuss the consequences of this idealization for Freud's later production of theory.
93 Sigmund Freud, 'Femininity', in 'New Introductory Lectures on Psycho-Analysis' (1933), *Standard Edition*, vol. XXII., p. 133.
94 Given Freud's idealization of the mother–son relationship and his consequent inability to theorize hostile feelings of a son towards his mother, I am tempted

to speculate that his depiction of melancholy encodes a reaction to maternal loss – a loss caused not by death, but by 'those situations of being slighted, neglected, or disappointed, which can import feelings of love and hate into the relationship or reinforce an already existing ambivalence'. Sigmund Freud, 'Mourning and melancholia' (1917), *Standard Edition*, vol. XIV, p. 251.

7

Freud and the Dynamics of Modernity

Harvie Ferguson

There is more trouble in interpreting interpretations than in interpreting the things themselves, and there are more books on books than on any other subject. We do nothing but write comments to one another. The whole world is swarming with commentaries; of authors there is a great dearth.

Michel de Montaigne

Freud was a committed modernist. He sided unambiguously with the progressive forces of liberal democracy, subscribed to the universalistic values enshrined in the modern state and identified himself wholeheartedly with the cultural achievements represented by, and conveyed through, the German language. He was an ideal citizen of Vienna at a time when that city outstripped even Paris and Berlin in the range and novelty of its contributions to every aspect of the scientific, artistic and literary consciousness of modernity.[1] The whole development of Freud's work can be viewed as continuous with the Scientific Revolution of the seventeenth century and the movement of Enlightenment based upon its example. In this perspective his psychology, above all else, is an extension of the rational methods of the natural sciences to the task of explaining the bewildering diversity of human behaviour, and seeks to account for human functioning and self-awareness in terms of the structure and function of an underlying 'psychic apparatus'.[2] And, just as significantly, it provides a means of enlarging the domain of a rational and ethically responsible ego, bringing the awkward presence of the human body under its control.

At the same time, however, his analytic and theoretical work focused on dreaming, neuroses, jokes, parapraxes and the instinctual

life; on all those aspects of experience, that is to say, which, in their incoherence and irrationality, might be viewed as characteristically *pre*-modern. Furthermore, did not Freud's own work reveal the fundamental significance of early experience in the formation of the adult personality and mature conception of the world; and was not Freud's own early experience of a distinctively *pre*-modern kind? He was born in a tiny Galician village, Freiberg, which was then part of a rural, pre-modern, agrarian society, dominated by immemorial traditions; in his case by Jewish traditions. So that, rather than extending the dominion of Enlightenment, Freud can be thought of as reintroducing and rehabilitating just those elements of psychic life which modern culture had abandoned to the darkness of superstition and ignorance belonging to an earlier epoch. In this perspective Freud's writings emerge as a literal 'return of the repressed'; a significant pathway through which the forces of irrationality made their re-entry into the modern world and came, in time, to threaten the entire project of Enlightenment.[3]

Given the possibility of such opposed interpretations – and the above merely caricatures significant tendencies present in the literature on Freud – it is hardly surprising that commentators select different aspects of his writings as 'key' to the work as a whole, or that there is no agreement on what constitutes the fundamental insights upon which that work is based. There has developed an entire series of partial Freuds, each at odds with the others and none of which offers any likely resolution of such conflicts in a comprehensive vision of the psyche as a whole. There is Freud the analyst, the unsurpassed interpreter of dreams and neurotic symptoms; Freud the psychic economist; Freud the moralist; Freud the literary recreator of contemporary experience; Freud the biologist – and so on.[4] It would be foolish to suggest that the apparent inconsistencies and differences of perspective in his work could easily be harmonized, or synthesized through, for example, an appropriate 'sociological' reading of the text. It makes sense, rather, to use these internal differences as clues to an essential diversity in both the theory and the experience of modernity. Freud's work, it can be argued, is wholly modern; but modernity is not singular so that, in adequately grasping and representing the entire range of modern experience, it is forced into a number of different styles and approaches, each adapted to one of contemporary reality's several differentiated and related aspects.

The dichotomy between the modern and the pre-modern which has conditioned a good deal of the secondary literature is, in fact,

misleading. The contrast in Freud's work is not between a pre-modern Unconscious (instincts) rooted in his own early experience of the closed Jewish community, and a modern Consciousness (reason) reflected in, and reflective of, a market society and an urban way of life; it is, rather, a contrast founded on the distinction between modern 'ego-logical' socio-psychological relations and, equally modern, 'non-ego-logical' socio-psychological relations. And the distinctive and incommensurable styles of psychology found in Freud's work delineate not one (confused) but three (lucid) characterizations of modernity. These characterizations can be linked together and opposed to the experience of the pre-modern world through the emergence of the distinctive conception of dynamics they use to describe both nature and human action.

Modernity and Motion

Motion is central to the experience of modernity. Modern reality, in contrast to pre-modern Western conceptions of the world as a changeless essence of things distributed in a fixed spatial order, reveals itself in continuous movement.

The hierarchical structure of pre-modern, and particularly feudal, societies was hypostatized as a cosmological plan in which everything was ideally located 'in its proper place'. Motion, other than the perfect regular circular motion that characterized perfect heavenly bodies, was conceptualized as 'unnatural' or 'forced'. In terms of local displacements of matter it seemed obvious that all such motion was the outcome of some external and continually acting force. Put simply, it seemed evident that nothing moves unless it is pushed.[5] In this scheme of things nature and society intertwined in a singular chain of being in which the existence of reality at one level was dependent upon a more perfect reality located at a more inclusive level; a hierarchy terminating in necessary Being which was the source of all authority and the uncaused cause of all movement.[6] Socially, as well as naturally, the mass of the people were bound to particular communities and moved from them (for example in the conduct of war) only as a consequence of the external action of a superior individual.

Modernity, in the sense of the culture and typical forms of human self-understanding that emerged from the collapse of feudalism and developed along with the establishment of market relations,

the general production of commodities, the centralization of the state and the growth of bureaucratic social organizations, may be said to begin with the assertion that the human being ought to possess the freedom and capacity for *self-movement*. This is a central motif of The Italian Renaissance revival of Platonism which in many ways anticipated the later development of modernity in its full sense.[7] Pico della Mirandola's oration *On the Dignity of Man* viewed motion as immanent in the human condition, directly reflecting a moral and religious status which, while fallen from a state of grace, was not without hope or the means of self-improvement.[8] Made in the 'image and likeness' of Divinity, it was inconceivable that the human creature should be so deprived of perfection as to inhabit a motionless world in which all change was confined to the superficial transience of generation and decay.[9]

The Copernican Revolution was inspired by, and extended, Italian humanism into a more general theory of 'natural' motion which found its expression not only in new dynamic theories of nature but, equally, in dynamic conceptions of the human individual. Montaigne thus characterized the human soul in terms of its continuous inner restlessness, a view echoed in different ways in equally pioneering expressions of modernity found in the writings of Descartes and Hobbes.[10] The development of modernity, however, was marked not simply by a general acceptance of the natural immanence of motion but by (at least) three novel and distinctive conceptions of motion. These can be characterized briefly as *inertial, developmental* and *oscillatory* dynamics.

First, Copernicanism found its logical outcome in the concept of *inertia*.[11] This development represented a dramatic shift in the perspective and assumptions of pre-modern traditions. The new view held that 'absolute rest', if it is conceivable at all, is nothing but a theoretical limit to the natural condition of rectilinear motion. Again, to put it simply, things move and continue to move until they are acted upon by an external force. It is not movement which is problematical, but interruptions and changes of motion which require explanation. In its turn the concept of inertial motion provided a foundation for two distinctively modern tendencies within psychology: as part of the minimal assumptions of a reductionist science for which all reality was conceivable as 'matter in motion', it was directly transferred to psychology as the underlying dynamism of the psychic apparatus; and by metaphorical extension inertia played an even larger role as the *intention* of the human agent.

Secondly, a notion of *self-development*, which as 'self-fashioning' was equally central to Renaissance humanism, also developed within modernity as a description of rather different aspects of its inner dynamism.[12] If human beings were empowered to move themselves then, for a world not wholly liberated from a logic of place, it followed that every movement was simultaneously the expression of a corresponding inner movement of the soul. This movement, continuous and unavoidable, was self-willed rather than inertial and was immanent to the human in a unique way. It was this form of self-movement which was later given a characteristic ethical direction in the notion of *Bilding* as the realization in harmonious action of an implicit and unique selfhood. At the same time notions of growth and development, of a general process of unfolding of natural forms and their realization in mature physiognomic structures, played an important part in the emergence of the Romantic movement in both its literary and its scientific aspects.[13] The dynamics of development and self-development played an important part in modern psychology; again directly in the understanding of the growth of psychic forms, and indirectly through the metaphor of *desire*.

Thirdly, emerging at a somewhat later period, but of increasing significance for the understanding of the most advanced aspects of contemporary life as well as the most elemental processes of nature, a conception of what might be termed *oscillatory* motion provided another distinctive perspective on the dynamics of modernity. Oscillatory movements are typically unpredicted changes of state of some elementary body; a sudden gain or loss of energy. In terms of an underlying rational model of nature they have proved recalcitrant to the mechanization of the world picture which had received its greatest impetus from the success of Newtonian science.[14] Such movements could only be assimilated to the more practical sciences by considering them on a large scale, as statistical regularities that concealed a bewildered surrender to the mechanism of chance. As a model of human dynamism oscillatory motion again suggests a complex image. The individual psyche, as an elementary body, may be subject to a sudden access of energy or fall into a state of lethargy. Oscillatory movements, however, in relation to human experience are more generally conceived as reversible modalizations of 'normal' waking and fully conscious perceptions, among which the rhythmic movement between sleeping and waking is the most obvious and perhaps the most important. Such motion in principle does not involve either displacement or self-expression. Additionally, in terms

of the immediate content of human experience, oscillatory transitions are comprehended as *wishes*.

The emergence and development of modern psychology, or rather the varied psychologies of modernity, might be written in terms of these dynamic concepts. The inertial model is associated with the empirical and utilitarian traditions in both their Cartesian and their Lockean forms; the conception of self-development is central to the Romantic and idealist traditions from Rousseau to Hegel; and oscillatory motion plays a central role in the phenomenological psychology of Husserl and its derivatives. Freud's work belongs exclusively to none of these traditions, nor does it offer a synthesis of their differing perspectives; his originality and pre-eminence as the psychologist of modern life, however, becomes the more evident when his work is brought into relation with each of these conceptualizations and, through them, with all the fundamental conditions of contemporary life.

All Roads Lead to Rome

Before examining some of Freud's key ideas in relation to these fundamental dynamic concepts it will be helpful to illustrate their presence and subtle interconnectedness in a short series of Freud's own dreams which he reports and partially analyses in 'The Interpretation of Dreams'.

In a chapter illustrating the persistence of 'infantile material' in adult dreams Freud discusses a series of dreams whose connecting theme is his unfulfilled longing to visit Rome. The sensitive nature of these dreams is signalled by the fact that Freud prefaces his discussion with a transparent rationalization of his failure to realize this long-held ambition; 'For a long time to come, no doubt, I shall have to continue to satisfy that longing in my dreams: for in the season of the year when it is possible for me to travel, residence in Rome must be avoided for reasons of health.'[15] It is clear from his correspondence with Fliess, indeed, that he considered both the longing and its continuing lack of fulfilment to be 'deeply neurotic'.[16]

The text of the first dream is brief:

> I dreamt once that I was looking out of a railway-carriage window at the Tiber and the Ponte Sant'Angelo. The train began to move off, and it occurred to me that I had not so much as set

foot in the city. The view that I had seen in my dream was taken from a well-known engraving which I had caught sight of for a moment the day before in the sitting room of one of my patients.

Typically Freud's report includes his initial association, already identifying the 'well-known engraving' as the 'day residue' around which the dream condensed. Before continuing the analysis Freud reports further dreams: 'Another time someone led me to the top of a hill and showed me Rome half-shrouded in mist; it was so far away that I was surprised at my view of it being so clear.' In fact, he reveals, 'the promised land seen from afar' was not Rome at all, which, never having previously visited, he could hardly have seen clearly, but Lübeck.

In his third dream he had apparently arrived in Rome

as the dream itself informed me; but I was disappointed to find that the scenery was far from being of an urban character. There was a narrow stream of dark water; on one side of it were black cliffs and on the other meadows with big white flowers. I noticed a Herr Zucker (whom I knew slightly) and determined to ask him the way to the city.[17]

Freud offers an immediate interpretation of this material. The white flowers identified the city as Ravenna rather than Rome; a city which had once been the capital of the Roman Empire and where, during an actual visit, Freud had seen 'the loveliest water-lilies growing in black water'. Further associations with this dream connect 'Herr Zucker' with Jewish anecdotes exemplifying passivity in the face of anti-semitism, and a proposal that he and Wilhelm Fliess, the friend in whom he confided all his theoretical speculations, should meet shortly in Prague.

A fourth dream 'took me to Rome once more. I saw a street-corner before me and was surprised to find so many posters in German stuck up there.'[18] Freud connects this with the previous dream, expressing his preference for Rome over Prague as a meeting-place with Fliess. Prague, he felt, 'might not be an agreeable place for a German to walk about in'.

Thus far Freud has connected these dreams with his current life-situation; with his continued longing to visit Rome, his relationship with Fliess and his ambition to succeed professionally in spite of prejudice against Jews in the medical profession generally and, more

particularly, in the University of Vienna, at which institution (as many other of his dreams reveal) he felt an equally intense and similarly frustrated longing to become a professor. But, interrelating in a characteristic fashion dream-images with waking memories, he develops the underlying theme of all the associated material:

> It was on my last journey to Italy, which, among other places, took me past Lake Trasimene, that finally – after having seen the Tiber and sadly turned back when I was only fifty miles from Rome – I discovered the way in which my longing for the eternal city had been reinforced by impressions from my youth . . . I had actually been following in Hannibal's footsteps. Like him, I had been fated not to see Rome.[19]

Hannibal was the historical figure who had first inspired Freud, in his schooldays, with an aggressive attitude towards anti-semitism: 'To my youthful mind Hannibal and Rome symbolised the conflict between the tenacity of Jewry and the organisation of the Catholic church.'

His identification with Hannibal was at the same time a rejection of his father's 'pre-modern' subservience. Freud goes on at once to relate that, at the age of ten or twelve, 'when my father began to take me with him on his walks and reveal to me in his talk his view upon things in the world we live in', he had told him of an occasion when he had himself been a young man in Freiberg. Well dressed and with a new fur cap, he was out for a walk:

> 'A Christian came up to me and with a single blow knocked off my cap into the mud and shouted: "Jew! get off the pavement!" '
> 'And what did you do?' I asked. 'I went into the roadway and picked up my cap,' was his quiet reply. This struck me as unheroic conduct on the part of the big, strong man who was holding the little boy by the hand. I contrasted this situation with another which fitted my feeling better: the scene in which Hannibal's father, Hamilcar Barca, made his boy swear before the household altar to take vengeance on the Romans. Ever since that time Hannibal has had a place in my phantasies.[20]

Typical of other of Freud's dreams which make their appearance in 'The interpretations of dreams' the associative comments effortlessly expand, connecting with further dreams and the recollection of more

distant events. The dream becomes a point of reference for a potentially complete autobiographical revelation. In the case of the Rome series a considerable amount of new material has become available as a result of continuing biographical research.[21] At issue here, however, is neither the autobiographical 'truth' contained in the sequence, nor its definitive 'meaning', but, rather, the following characteristic dynamic features:

Inertial motion It is worth noting that both the dreams and their interpretation focus on the *failure* to complete a journey. Not going to Rome, given a subjective predisposition to visit the city, constitutes a problem. Thus, where in pre-modern society every movement immediately poses a question, in modern society it is interrupted motion, blockage, deviation and turning back on oneself which requires explanation. The need to interpret the dream at all reveals the assumption that inertial motion is ubiquitous. And inertial motion is the physical and social movement which most clearly expresses the immanence of rational self-interest.

Development These dreams, by revealing the peculiar reality of early experience which is embedded in them, are also organized around the dynamics of self-development. It is just in this context that Freud's contribution to understanding dreams and modernity has frequently been seen as most distinctive. The associations to the dreams lead back to the conditions of early childhood (not directly in the reverse straight line which led from the pre-modern community to the modern city, but in a series of eccentric movements more akin to Don Quixote's crazed journey, which is one of the literary prototypes of Freud's dreambook).

In this particular case Freud's revelation of his continuing identification with Hannibal links not only to his situation at the age of ten or so, but to a much earlier period and the recollections of his initial family situation. Directly following the story of his father's 'unheroic conduct' Freud tells us that 'I believe I can trace my enthusiasm for the Carthaginian general a step further back into my childhood', in fact to one of the first books that he read. And beyond that, 'It may even be that the development of this martial ideal is traceable still further back into my childhood.'[22]

Freud does not proceed with the analysis at this point, but provides clues to its completion in two contemporary works. In a passage in 'The Psychopathology of Everyday Life', published a year

after 'The Interpretation of Dreams', Freud draws attention to a curious error in the first edition of that work in which Hannibal's father is referred to incorrectly as Hasdrubal instead of Hamilcar. As Freud himself remarks:

> There must be few readers of my book who are better acquainted with the history of the house of Barca than its author, who penned this error and who overlooked it in three sets of proofs. The name of Hannibal's *father* was *Hamilcar Barca* – *Hasdrubal* was the name of Hannibal's *brother*, as well as of his brother-in-law and predecessor in command.[23]

He goes on to note that 'My brother's eldest son is the same age as I am. Thus the relations between our ages were no hindrance to my phantasies of how different things would have been if I had been born the son not of my father but of my brother.'[24]

And in an essay on 'Screen Memories', published just the year before the dreambook and now accepted as autobiographical in character, Freud locates the origin of the 'martial attitude' which was central to his identification with Hannibal in the initial constellation of his 'family romance' in which his older brothers Emanuel and Philipp did indeed play the role of father, and his nephew, John (Emanuel's son), appeared as his elder brother. Furthermore, it now seems likely that during this early period the Freuds' Czech maid/ nanny also doubled as Sigmund's 'mother'.[25]

Speculation abounds, but, certainly, Freud came to remember his first experience of life as an intoxicating freedom, and whatever its value, continuous reinterpretation has stimulated a considerable amount of detailed biographical research which is undoubtedly essential to a proper understanding of Freud's psychological writings.

What was later recalled as a pastoral idyll was disturbed by the arrival of a younger brother, Julius. In an important letter to his friend Wilhelm Fliess Freud later records that: '[I know that] I greeted my one-year-younger brother (who died after a few months) with adverse wishes and genuine childhood jealousy; and that his death left the germ of (self-)reproaches in me.'[26]

Freud points out that memories of such early events are almost always a reworking of an original impression in the light of *later* experience, 'a memory-trace from childhood ... translated into a plastic and visual form at a later date'.[27] In the recollection, the subjects see themselves as children, and remain outside the events, as

privileged observers of a world they cannot wholly enter. This, in fact, is a general condition of passing back beyond the normal threshold of childhood amnesia, and penetrating the experiential world prior to the formation of an ego. Such memories involve, in other words, a good deal of 'secondary revision', in which the original emotional currents are provided with appropriate images in which they can be addressed to a more mature state of consciousness.

It is important to realize that the dynamics of self-development is, for Freud, a two-way process. In his paper on screen memories he makes it clear that not only are emotionally laden recollections dating from early childhood 'disguised' in the contemporary associations to adult dream-images, but the reverse process is just as important. That emotionally charged recollections of contemporary events are 'projected' on to the 'indifferent' material of childhood memories where they can be harmlessly 'discharged'. All roads lead *both* to the Rome of early experience *and* to the Rome of adult autonomy.[28]

Inasmuch as recent biographical approaches to understanding Freud have stressed the importance of his own early childhood (believing, not quite correctly, that this encapsulates his psychological theory), they have tended to undervalue the significance which Freud attached to genuine self-development of a conscious type. Shortly after completing 'The Interpretation of Dreams', Freud did finally visit Rome and remarks in a footnote to the relevant passage in the 1909 and subsequent editions that 'I discovered long since that it only needs a little courage to fulfil wishes which till then have been regarded as unattainable.'[29] Furthermore, in conjunction with discussing Hannibal's plan to take Rome he mentions, by way of a reference to the Romantic writer Jean Paul, the equal impatience of Winckelman (who, with Goethe, was Freud's modern culture-hero and exemplar of *Bildung*), to conquer that city.

Oscillatory transitions The Rome sequence, both in terms of the dreams themselves and of their associative recollections, displays oscillatory movements. There are sudden and unpredicted changes in 'energy', experienced as an access of emotion of one type or another. The childhood relations which are not fully explored in the discussion of the Rome dreams come more fully to light in a section of the dreambook significantly devoted to 'Affects in Dreams', and it is clear from his letters to Fliess in which he explores them in greater detail that the memory, waking and dream-

ing, of these relations arouses strong feelings in Freud. Such variations in the 'state' of the psyche are not in themselves developmental and are not strictly bound to the conditions of time and space. They have the character, thus, of an undifferentiated modification of the total psychic domain and tend to be viewed in terms of 'timeless', or better 'Unconscious', dispositions.

Oscillatory modalizations of experience play an important part not only in the dreams themselves (he viewed a *picture* of Rome, rather than Rome itself, and found himself looking at Ravenna or Leipzig in disguise, so to speak, rather than the actual city 'of his dreams'), but in the discourse of which they form a part. Freud's text weaves back and forth seamlessly between reported dream-image, associative memory and interpretative comment; a discourse which formally acknowledges and utilizes the rhythmic transitions from waking to sleeping; from rational self-control to dreaming. Such recurrent shifts in the modality of experience had gone largely unremarked in the psychological literature (and remain largely unresearched). Freud's interest in the phase-like character of all psychic contents, in the formal characteristics of dreaming, in the daily submersion of the ego in sleep and its re-arousal, in the peculiarly unpredictable character of free associations and attention, in the sudden outburst of passion and feeling, in the formation and breaking of attachments, in the appearance and disappearance of symptoms of all sorts, makes him not only a pioneering psychologist of modernity, but brings him into a much closer relation with the phenomenological movement in philosophy than has generally been recognized.

The Rome series not only illustrates the characteristic forms of modern dynamism – inertial motion, self-development and oscillatory transitions – it alludes also to their complex interrelations. The ideal journey – the straight line from the pre-modern community to the modern city – is simultaneously a movement of self-discovery and self-realization which releases the inertial forces of the individual. In this context it is worth noting that the pre-modern can as plausibly be viewed as a suppression of the immanent powers of reason as can the modern be regarded as a repression of primitive and irrational forces. Self-movement is a process of identification as well as the establishment of psychic autonomy.

Freud's 'longing' to visit Rome, therefore, is composed of a complex interrelation of subjective movements which set in train dynamisms of a spatial, temporal and transcendental sort. These

movements, however, in themselves or in their interrelations, are not peculiar to this specific dream-text but play an organizing role in Freud's work as a whole, as they do, indeed, in the experience of modernity.

Modern Psychologies

Inertial, developmental and oscillatory movements are associated with, and might even be said to characterize, particular varieties of modern psychology each of which offers a specific perspective on the nature of modernity.

Empirical psychology

The inertial point of view is linked to an empirical tradition in terms both of a general commitment to materialism deriving from Hobbes and Descartes and of the associationist doctrine of Locke and Hartley. The fundamental principle that reality is ultimately nothing other than matter in motion underpinned this tradition and sustained a long-term programme of reductionist psychology. Consciousness would be explained adequately only when its physical correlates and underlying mechanical laws of combination and interaction were fully exposed. And while this remained a distant prospect it was at least possible to understand psychic operations in terms of the 'intermediate' mechanism of the association of ideas which, while retaining an aspect of unreduced immediacy in terms of its content, viewed consciousness in its totality as the outcome of a wholly mechanical process of interrelation.

By the time Freud became a student the dominant tradition of positivistic medical investigation was well established in Vienna. Laboratory studies, to which Freud was strongly attracted, were the foundation of an enormously expanded programme of medical education. It is tempting to see a number of Freud's most fundamental ideas as applications of the leading theoretical points of view with which he was familiar from these laboratory studies and the scientific traditions, in both Vienna and Berlin, which sustained them. Further, it seems plausible to argue that some of his more general and fundamental perspectives were formed through his education within this tradition. The embrace of Darwinism as an integrative theoretical framework for the biological (and psychological) sciences,

a commitment to non-vitalistic biological principles in which mechanical processes played the fundamental role and a view of medicine as primarily a scientific enterprise with which a variety of therapeutic techniques of limited value were loosely associated, might all be seen as the inheritance of the years he spent in the Physiological Institute headed by Ernst Brücke.[30]

It is no surprise, therefore, that at the outset of his career in psychology Freud attempted to bring this programme to a more fruitful stage of development. He tried to link a general perspective on reality as an inertial system of matter distributed in space and time with a new theory of psychic representations. The primary purpose of the 'Project for a Scientific Psychology', the completed draft of which Freud sent to Fliess in September 1895, was to 'represent psychical processes as quantitatively determinate states of specifiable material particles, thus making those processes perspicuous and free from contradiction'.[31] Though it was never published, Freud formulated many of his basic ideas for the first time in the 'Project', and never abandoned the hope that advances in physiological researches would contribute fundamental insights into the nature of consciousness.

The 'Project' may be viewed as an attempt to provide psychology with a workable model of the brain and nervous system as the material substratum of consciousness. The 'material particles' of which it is composed can be specified anatomically as neurones which, from an initial state of protoplasmic irritability, become differentiated into two fundamentally different types. What Freud termed φ (phi) neurones link the organism to the outside world through the simple transmission of sensory information; they are not altered by their functioning, and they can be identified with the more primitive parts of the brain. Those which he designated as ψ (psi) neurones discharge excitations of an endogenous origin. They are 'impermeable', are structurally altered by their continued functioning (that is, they possess the basic characteristic of memory) and can be identified with the more developed parts of the brain. Organic needs are transmitted through the system of psi neurones, giving rise to what at this point Freud refers to as 'the exigencies of life'.

The 'psychical apparatus' as a whole, operated in such a way as to 'discharge' excitations originating in both the external world and from within the organism. In the terse language of the 'Project', Freud asserts that 'the neurones tend to divest themselves of Q', that is, the psychical apparatus tends to reduce the total quantity of excitation

to which it is subjected. Ideally the nervous system would maintain itself in a tensionless state but, more realistically, maintains itself in a 'steady state' by balancing its inputs of excitations with energetically equivalent motor discharges. This Principle of Constancy, which Freud traced back to Fechner, was in various forms a widely held assumption at the period and one which, particularly as expressed by Simmel and Musil, made sense socially as well as biologically. Freud frequently refers to this Principle as the fundamental 'law of inertia' of the nervous system.

The fundamental difficulty of psychology, however, remained unresolved in this Principle. We are aware only of qualities; 'consciousness knows nothing of what we have so far been assuming – quantities and neurones.'[32] Freud argues that neither the phi-system nor the psi-system are adapted to register qualities, and we remain completely unconscious of their operation. The phi-system conducts excitations from the outside world, but qualities have no meaning in relation to the outside world, which is understood by the natural sciences in terms of a wholly abstract system of forces and masses. At the same time the psi-system is adapted to register memories, but as this also 'speaking generally, is without quality', Freud feels compelled to assume a third specific neuronal system, the ω (omega) system 'whose state of excitation gives rise to the various qualities'.[33] He ingeniously suggests that perceptual qualities are transmitted to the omega-system as periodic, rather than as energetic, motion. The omega neurones are seen as 'superconductors' which transmit tiny quantities of energy effortlessly in all directions. The system acts as a sounding board, registering the morphological features of the larger energetic excitations within the phi-system.

There is much in Freud's exposition which, he admits himself, is 'complicated and far from perspicuous', and he abandoned the materialist-reductive logic of the 'Project', but he retained from this whole approach the conviction that at least some of the elementary operations of the psychic life could be described systematically in terms of underlying laws, together with a somewhat vaguer commitment to the notion of 'force' as a unifying *concept* which spanned the physical and the psychological sciences with certain controlling ideas of equilibrium and inertia.

The background of inertial dynamics also justified an influential tendency towards utilitarianism in modern psychology. Here rather than seeking to analyse the internal processes of the psyche directly in terms of an apparently better-known and more completely

understood physical model, the conscious individual was taken as an 'atom' of a social order whose collective characteristics depended wholly on the given properties of what were fundamentally identical units. What characterized each unit was a capacity to experience pleasure and unpleasure, and an ability to reason. Individuals pursue their own self-interest in the sense of acting with foresight and understanding in such a way as to increase the probability of experiencing pleasure rather than unpleasure. Whatever physical processes gave rise to consciousness, intentional activities in the pursuit of self-interest could be understood, by analogy with the law of inertia in the dynamics of inert bodies, as the mechanical principle and unifying law of nature through which the singular 'body in space' could be interrelated with others to constitute an entire 'system of the world'.[34]

Classical political economy, indeed, emerged as a 'science' of society founded, on the one hand, on a Newtonian dynamics of nature and, on the other, on a rational utilitarian psychology of the psyche. Freud responded to and developed this 'economic' model of the psyche and sought both to extend its scope and to make it more realistic. It is in this context that the centrality of the Pleasure Principle in Freud's work is best understood. The fundamental law of the psyche is to seek pleasure, viewed as a satisfactory state of equilibrium rather than a perpetual process of assimilation and self-aggrandisement. This tendency is initially a 'blind' mechanism which is intolerant of delay, substitution or denial. A good deal of Freud's theoretical writing is concerned with the process of 'socializing' this mechanism into a flexible and directed system of motives which adapt the psyche to the conditions of nature and society.

Given the primordial role to which Freud assigns the tendency towards Pleasure, there is no possibility here that Reality can, so to speak, assert itself as an alternative and ultimately 'higher' principle. The weakness of the classical utilitarian position is just that, if the tendency to pleasure is immanent in the living organism, then 'reality' is defined in *its* terms and does not stand 'over against' that immanence as a conditioning element. Freud's significant theoretical advance is to suggest mechanisms through which the Pleasure Principle modifies *itself* and comes to create 'reality' as something outside of, though still subordinate to, itself. The political economy of psychic life is centred, thus, on a process of *self*-repression; only the Pleasure Principle can provide the 'energy' required to block the tendency towards immediate gratification, and it is from the Pleas-

ure Principle that Reality is constituted. It is this difficult issue of psychic economy which is at the root of Freud's developing theory of hysteria, which becomes understood in terms of disturbances in this economy, rather than in terms of the 'specific initial conditions' of a precipitating trauma. Both normal and hysterical functioning can be understood developmentally as deformations of an original Pleasure Principle. The entire process of 'reality' construction, whether its outcome is adequate or not, is set in motion by the manipulation of gratification by the adult upon whom the infant is wholly dependent. The immanent Pleasure Principle within the child subsumes, so to speak, both mother and child under a unity of gratification. But the mother's independence of action and lack of immediate responsiveness to the child's needs allows part of the Pleasure Principle to become 'detached' and form the nucleus from which 'objects' are created.[35]

In the development of Freud's work this picture becomes increasingly complex. From the present perspective what is of central significance is the *subordinate* status of reality. The Pleasure Principle represses itself – nothing else, after all, could do the job – and does so in the interests of pleasure itself. The 'higher' functions of reason and the capacity to form intentions are 'mediations' through which the Pleasure Principle procures ever new and richer sources of gratification. The emphasis in Freud's clinical and theoretical work (in contrast to his own late extrapolation of his theory to general issues of social theory in 'Civilization and its Discontents'), is of a view of repression as a process through which Pleasure is protected and enhanced. Pleasure is not repressed in the interests of society, rather, the higher arts of civilization develop as a means by which the sources of pleasure are increased and differentiated.

Late in his life Freud's modifications and elaborations of a systematic monism of the Pleasure Principle was finally rejected in favour of a dualism, not of Pleasure and Reality, but of Life and Death Instincts. The 'economic problem' of masochism and the 'compulsion to repeat' in a variety of life-contexts previously failed patterns of behaviour and relations with others convinced him that, in addition to a primordial drive towards gratification within the living psyche, there was an equally basic tendency towards organic regression. 'Reality' in some sense stood between, and was constructed from, the conflicting relation between these two primitive forces.[36]

Freud's elaboration of the empirical tradition in modern psychology thus goes far beyond its initial conceptual vocabulary and

assumptions. These aspects of his work, nevertheless, remain attached to that tradition and give it a distinctive and new impetus. From the Enlightenment optimism which nourished the source of this tradition Freud developed its psychology in a decidedly pessimistic direction; a direction which fitted it more adequately to the task of understanding the character of life in the twentieth century.

Romantic psychology

The second dynamic principle in Freud's work is linked with the general movement of European Romanticism, which is concerned with the delineation of human experience as the realization of an inner soul.

Romanticism might be viewed in the most general sense as an attempt to rediscover the infinity and freedom of the soul within a bourgeois culture which threatened to eradicate all genuine inwardness. For Romanticism the inner infinity of the soul was not, as it had been for Pascal, simply a mirror image of the infinity of space – a vast emptiness over which the self was, so to speak, suspended and into which it threatened to fall. These depths, rather, were filled with images of their own, with continuous and continuously productive psychic processes, of which the conscious self – the ego created by the practice of bourgeois discipline – registered only a fraction. Yet, in a curious way, just as the selection of sensory data to which one 'attended' was in some way controlled by the self, so the stream of inner images, which appeared with effortless spontaneity continually to renew itself, was also self-generated.

Dreams, myths and spontaneous imagery were revalued as the fundamental contents of the Romantic notion of consciousness and selfhood; contents which, though self-produced, could not wholly be brought under the control of a rational ego and thus remained enigmatic. The problem was to become aware of this process of self-formation; to wrest it from extraneous and superficial influence and to restore to it its proper autonomy. These themes emerge clearly in the work of Rousseau, the writer to whom all the Romantics turned for inspiration.

For Rousseau, the direct expression of authentic inwardness was frustrated by the institutions of public life in which everyone was forced to assume superficial and conventional roles. The preservation and purification of the soul depended, rather, upon the interior cleansing action of memory.[37] The self is formed, in this project,

through tracing out its own history. The 'secret train of its emotions' (emotions are the inner register of the soul as compared to perceptions of the outside world) provides, beneath and within the narrative of life events, a history of the unfolding selfhood which, in a thousand normally undetected ways, shapes this history of falsehood, preserving within it, nonetheless, a truth of its own.

Rousseau made far more sophisticated our understanding of biographical time. The self does not realize itself in a continuous process directed towards a specific object and cannot be the outcome of a plan or intention as plans and intentions can only be formulated as a consequence of its pre-existing history. The history of the self, rather, is a secretive and complicated narrative; a series of misapprehensions and mistakes through which it emerges only gradually, if at all, into a coherent self-image.

The followers of Rousseau were frequently less cautious. The self was identified with the soul as an indwelling actuality and its inner truth was made the ultimate value upon which every action should be based.

Thereafter Romantic selfhood was construed in terms of a gradual or not so gradual release from those stultifying conventions within and beneath which it was hidden. In the complex of discourses contained in German idealism, Romantic literary theory and Romantic literature from the 1770s to the 1820s this transformation took place in a quite remarkable way. The dialectic of self and other which emerged in this discourse provides a quite different picture of the self and its relation to the social world than had emerged in the rationalist and utilitarian positions. The primacy of the inner world of the soul was expressed in and through *desire*, which was both its fundamental reality and its immanent dynamic principle. Desire was an inherent tendency towards self-completion on the part of the soul which came to consciousness as an inner lack or want.[38] The self was necessarily linked to and dependent upon another self. And the social relation founded on interdependent desire, rather than on mutual self-interest, was the ideal human image developed within the Romantic tradition; a view which was also taken up and expressed with particular force and clarity by Hegel, its first important philosophical critic.

For the Romantics, dreams were viewed as expressive of the 'deepest' and most authentic elements of the soul; just those aspects of inner experience which found no expression in the conventions of everyday life. Like myths and folk tales, dreams belonged to a

remote reality more fecund of profound human images than were the rational constructions of the waking mind. The dreams of collectivities, the myths and symbols of past ages and of the contemporary world, could, then, be interpreted as the spontaneous outpouring of a superabundant and ultimately irrepressible soul.[39]

The 'longing for total revolution' which was characteristic of every aspect of modernity was, thus, a transforming vision of the inner freedom of the human soul as much as it was the submission of nature to rational laws.[40] At the very moment when science seemed to be on the point of defining and describing an order of autonomous objects, withdrawn into a cold, distant and empty space, Romanticism sank itself into modern subjectivity and sought to liberate the spirit from the obscurity of its self-enclosed depths. The Romantic dream was not, as it was for Renaissance writers like Giordano Bruno or Marsilio Ficino, a literal flight from the world into what the astronomer Kepler called the 'dull immensity of space'; it was, rather, an escape by collapsing inwards, upon the self, revealing in its interminable fall the inexhaustible immensity of the subjective world. This fall, and the domain of absolute freedom it opened to experience, was an inner journey mapped in the experience of dreams.

The inner world of human subjectivity knows the world of objects only through itself. It can become aware only of its own movements. The world of objects withdraws into itself, existing only as the dubious postulate of senses which, entirely reliable in their own terms, can convey nothing of the quality of created being. The human predicament is not so much to be confronted with a world of enigmatic, but interpretable, symbols, as to be wholly contained within a world of arbitrary signs, from which real presence is rigorously excluded. In this context the dream is not distinguished from waking reality directly as subject is to object; for waking reality too is wholly subjective. As the most notable student of Romantic dreams rightly points out, for them, 'the dream was not a phenomenon of sleep', but was, rather a privileged form of representation.[41]

Freud's interest in Romanticism was more than literary. It is important to realize the extent to which, in spite of the continuing rise of 'inertial' models, many of its fundamental ideas affected the development of the sciences, particularly medicine, throughout the nineteenth century.[42] The influence of the Vienna Medical School, important as it was in shaping Freud's basic intellectual position, was certainly not the sole source of this orientation, nor, significantly, was its impact as consistent and uniform as has often been

assumed. Its modern foundation coincided with the upsurge of Romanticism in European culture, and Vienna's leading physicians during this significant period, Johann Peter Frank and Franz Josef Gall, looked first to French and Scottish paradigms of medical practice. They championed the view that bodily health was based on an optimum degree of 'excitation' (conceived as a combination of the natural irritability of bodily tissues with suitable intensities of appropriate stimulation), rather than of the harmonious mixture of bodily fluids. John Brown, an Edinburgh graduate whose ideas were influential in Vienna, argued that diseases differed fundamentally only in the extent to which stimulation departed from the healthy norm, giving rise to symptoms of 'sthenia' (over-stimulation) or 'asthenia' (under-stimulation).[43] More general and theoretical approaches in biology sought in Kant and Schelling, rather than in the major empiricist traditions of modernity, for a comprehensive grounding. Intuitive reasoning, a general morphological approach to the understanding of living beings and the recognition of spiritual and non-material causes in both normal and pathological organic processes were accepted, as was a general perspective within which a parallel was drawn between the development of the individual and the evolution of the species.

A general 'romantic biology' extended its influence far beyond the brief and spectacular appearance of the *Naturphilosophen* and it was within this tradition that clinical medicine, with a strong humanistic background, non-invasive and non-interventionist techniques, became established in Vienna.[44]

It would be misleading, therefore, to view the 'School of Helmholtz' in a narrowly positivistic framework. Laboratory-based science never wholly ousted the humanistic clinical tradition, especially in terms of therapeutics. And, even more importantly, it must be remembered that, as the teachers of Freud and many others, they shared with their students not only a deep conviction of the scientific validity of their approach to biology, but confidence in a much broader German education which revered Goethe and classical studies as the inspiration behind *both* the literary *and* the scientific traditions of modernity.[45]

Brücke, like Billroth, was a painter, as well as a physiologist; Meynert, an authoritative figure in psychiatry, was the son of a writer and an opera singer; and Breuer, for several years Freud's senior colleague and collaborator, was deeply interested in music. Artistic interests, as well as scientific pursuits, characterized the Viennese

intellectual milieu throughout the latter part of the nineteenth century, as, indeed, they had during the Enlightenment and the Romantic movement.

It is, therefore, in no way contradictory to claim that Freud was attached *both* to the development of mechanistic biology *and* to the morphological-descriptive approach to clinical work which took its inspiration directly from Goethe. It was, in fact, his reading of Goethe's essay 'On Nature' that first dissuaded him from the study of law.[46] And it is only in retrospect that these seem to be sharply divergent traditions, and that Freud must belong exclusively to one or the other.[47]

Freud typically used botanical metaphors in describing the growth of psychic forms and botanical themes appeared frequently in his dreams, particularly in those for which his scientific ambitions formed a significant theme. He dreamt, for example, of a 'botanical monograph' which he associates again in part with visiting Italy.[48] This allows another connection with Goethe, whose 'botanical monograph', *Morphology of Plants,* presents a distinctively Romantic approach to the study of plant growth, and was written during his travels in Italy. Goethe, for Freud, represented a distinctive approach to understanding nature, and embodied in his person the cultural ideal of modernity as *Bildung,* validating in his person both scientific and ethical conceptions of dialectical self-development.

However, just as, in adopting the modern tradition of empirical psychology, Freud had significantly modified its basic theoretical schema, so his relation to Romantic psychology was far from critical. The Romantics had defined the 'authentic' self as universal humanity made concrete in terms of an idealized distant past and an equally idealized inner depth of soul. Freud rejected the symbolic method of interpretation which was central to the Romantic theory of dreams and myth. Certainly he invoked metaphors of historical distance and interior depth, but, for him, dreams were not formed from universally meaningful images, nor were they linked *exclusively* to the past but always referred simultaneously to the present situation. Dreams could only be interpreted by a process of decoding in which the dreamer played the central part.

Freud's lifelong interest in archaeology and his fondness for likening its problems and methods to those of his own work possibly misled some of his followers, as well as commentators, into identifying him too closely with a fundamentally Romantic notion of 'depth-psychology'. True, the archaeologist removes surface layers

to uncover what was buried, but this kind of excavation should be thought of as a gentle brushing aside of the obscuring shroud of human history, rather than as a forceful boring-down through the earth's crust. And the archaeologist can often read the past in visible monuments and relics which have been incorporated into new structures. In a much later and more general work than that quoted above Freud raises a 'hardly studied subject', the 'general problem of the preservation in the sphere of the mind'. He approaches the question through an extended analogy with the interpretation of the ancient history of Rome (for Freud the compelling, but by no means archaeologically most obvious, site) through its visible remains. Though a good deal of ancient material is 'buried in the soil of the city or beneath its modern buildings', for someone equipped with 'the most complete historical and topographical knowledge' the past can be traced in remains to be found 'dovetailed into the jumble of a great metropolis'.[49]

Archaeology, indeed, is a 'superficial' activity in comparison with mining, or palaeontology. It is preoccupied with reconstructing a picture of past life from the corrupted remains of that past itself. It is worth noting that Freud's fascination with archaeology, therefore, is consistent with the spirit of post-bourgeois modernity, and is quite distinct from the conservative spirituality of the Romantics which is revealed in their frequent recourse to the motif of life underground. Many of the Romantic writers were professionally involved with mining and engineering, and in their literary works reflected an idealized conception of life in terms of the discovery of living beings deep in the natural caverns at the heart of mountains.[50] Like the Baroque flight of fancy, this Romantic mining locates the human soul in a strange and inaccessible environment which is normally unconnected with the surface of modern life. But Freud's excavations are all carried out on the surface and consist primarily in interpreting what is already visible, and, where he reveals things previously hidden, they are always 'dovetailed' into surface features. The past which he unearths is linked to the present by an unbroken contiguity, and shows itself on the surface in morphological deformations and anomalies which betray the sites of ancient activities.

The hysterical symptom is a kind of archaeological ruin, the partial remains of a larger body–psyche morphological structure which has undergone a general transformation (incompletely in this case) into a new form. The Romantic theory of individuation as self-realization of an inward uniqueness is reinterpreted by Freud as a

one-sided view of a more general process of maturation. The 'normal' pattern of development and maturation is not only the unfolding of a unique dialectical process of self-actualization, it is also the continuous interrelation and assimilation of, on the one hand, individual concrete experiences and, on the other, a given series of body–psyche types and forms which provide ready-made schemata which both define and integrate these experiences. Similarly, hysterical symptoms – which are neither universal symbols nor tropes of a uniquely private narrative – can only be fully understood by relating specific life-contents of the patient to the archaeological remains of an earlier stage of psycho-sexual development which, in their case, persist as a fundamental conditioning element of their experience of 'reality'.

It is at this point, however, that Freud's writings take on a new significance and allude to the third characteristic dynamism of modernity.

Phenomenological psychology

Even as a student Freud did not fully accept the more aggressively reductionist programme of the 'School of Helmholtz', nor did he restrict himself to a narrowly scientific curriculum. He attended a course in philosophy given by Franz Brentano, and seems to have been considerably influenced by his distinctive phenomenological approach to the understanding of consciousness.[51] The distinctiveness and importance of this perspective can be grasped in terms of the larger context of the transformation of the bourgeois culture of modernity which Freud's psychology came to encompass.

Towards the end of the nineteenth century, while confidence in science, and the mastery of nature promised through its embodiment in the technology of the second industrial revolution, for many encouraged the most optimistic assessments of human progress, unresolved difficulties within the Newtonian paradigm itself threatened the entire edifice of modern rationality.

The development of the natural sciences, from the intellectual revolution of the seventeenth century, up to the mid-nineteenth century can be conceived as a dynamic theory of the closed body. The singular 'body in space' was not only the object upon which the enquiring scientist's gaze was fixed, it was, like the vanishing point of a perspective painting, a mirror image of the enquiring observer. But throughout the second part of the nineteenth century, as the bour-

geois ego became aware of itself as an unfounded and ultimately arbitrary bundle of sensations, and the singular and privileged point of view from which the classical sciences had reconstructed reality fractured into a multiplicity of perspectives, the natural bodies which had been the object of such precise observation themselves began to fragment and dissolve.

Two major developments in scientific theory, thermodynamics and electromagnetism, reflected a new difficulty in precisely locating objects in space. For the Newtonian scientist a 'body in space' was just that; an irreducible and indifferent lump of matter whose mass and position could be unambiguously stated, as could its change of position over any stated period of time. What characterized scientific explanation, indeed, was the belief (if not the fully vindicated practice) of accounting for any specific phenomenon in terms of mass and change of position. However, the development of thermodynamics – the branch of physics which deals with the phenomena of heat, including that generated and lost in machines – developed along two rather different lines which it proved to be impossible to reunite. At an elementary level heat was understood to be connected with the vibration of simple particles of matter; the faster they vibrated the hotter a substance became. And at the macroscopic level laws governing heat transfer, radiation, conduction and so on were specified to high degrees of precision. The real difficulty arose when the simple underlying mechanical picture was used as the model from which the macroscopic laws should be deduced. Good approximations were achieved using a statistical approach, and this was not generally thought to create a real methodological difficulty. It was assumed that our inability to specify precisely what would happen to, for example, each and every molecule of water in a basin when mixed with a certain quantity of water at a hotter temperature, was a result merely of our temporary ignorance of all the 'facts' of the case. With the advantages of modern high-speed computers it might be supposed that the problem would have been overcome. Towards the end of the nineteenth century, however, it was realized that the difficulty was more intractable. No mechanical principle could be specified which would lead in an unbroken chain of physical causes (upon which rested the claim to a rational explanation), from the characteristics of individual 'bodies in space', to the dynamic characteristics of the 'system of the world'.[52]

This break was all the more evident in the parallel development of electrodynamics by James Clerk Maxwell. In his revolutionary

physics there were no 'bodies in space' at all, no collisions, and no mechanisms. The fundamental observational data relating to electrical and magnetic phenomena were elegantly synthesized by him into a series of powerful equations which described their effects in terms of ever present, and effortlessly extended, fields of force, rather than in terms of the point-mass characteristics of bodies. This 'non-material' dynamics was the foundation of the subsequent dramatic transformation of the physical sciences.[53]

The 'physical world', that is to say, was no longer conceived as made up of interacting bodies precisely located in space. And what imprecisely located bodies did exist displayed unpredictable changes of state. The unbroken continuity essential to a purely quantitative science, on closer examination, and in conformity with both the new statistical laws of thermodynamics and the Maxwell field-equations, proved to be something of a mirage. Elementary particles of matter could be assigned an energy level, depending for example on their temperature and state of motion, but, while at the level of everyday observation we assume such energy levels to be arbitrary points on an infinitely divisible scale, in reality such states were discrete multiples of absolutely invariant quanta of energy. An elementary body, it seemed, could be in a limited number of states, and might spontaneously change from one to another without any evident intervening mechanical 'cause'.

This non-localized and dematerialized conception of matter reflected its new 'open' and dissociated forms, as clearly as classical mechanics had mirrored the previously 'closed' bourgeois form of the ego.

The implication was that, as no observable body could be finally 'pinned down' in space, neither could an observing subject. The relational mechanics of Mach expressed one half of this equation quite clearly. All bodies were relatively unfixed in relation to all others; but somehow amidst them all a classical ego kept watch upon the kaleidoscope, arbitrarily changing its point of view, but retaining, from each position, the momentary integrity of a first-hand observer. Rather than 'imagine a body in space', we were obliged to 'imagine a series of bodies in relative motion to each other'. But fully to take account of the psychological, as well as the dynamical, revolution, required that we abandon even a temporary claim to omniscience. Einstein thus dissolves the observing subject as effectively as the 'matter' being observed, asking us to 'imagine two observers in relative motion to each other'; scientific explanation took the form of

accounting for their differing observations, rather than in establishing an authoritative and objective statement of the 'facts'. A singular viewpoint was no longer realistic. The aim of science, therefore, was not to construct a theoretical model of a simple reality thought of as standing behind such observational variations – a true 'system of the world' in which all observational contradictions would be transcended – but consisted in the normalization of such differences themselves. This approach challenged not only the methodological naivety of the positive sciences, it also subverted the Romantic dream of reawakening nature's depths within us. 'Depth', the most alluring artefact of a singular point of view, proved to be as unfounded 'location' or 'substance'.

Classical physics was founded on laws of conservation; quantity was preserved through all the transformations possible to matter in motion. For classical mechanics, thus, time had no meaning. Newton's equations, for example, were reversible relations of identity for which time is irrelevant. This gave to classical physics its sense of eternity; it treated the cosmos as a vast perpetual motion machine.[54] But the new physics, one branch of which (thermodynamics) came into existence in an attempt to apply classical physics to actual machinery, disclosed an unavoidable arrow of time in every physical change and saw in the continual interchange of physical quantities the shadow of cosmological decay. Energy is continually lost, every interaction exacts a price; entropy increases.

Similarly for social experience which is dislocated and disorientated, fragmented beyond hope of recombination under the fictive unity of the ego, time has more significance than space. The elements of experience have nothing in common but duration. And the more intense the experience the more certainly does it confront the subject which is its momentary coeval with the certainty of once again passing into oblivion. Time, concentrated, so to speak, in the intensity of the moment, itself dissolves into insignificance.

And just as nature became dematerialized and its underlying continuity was sundered, so psychologists began to discover the strange and compelling phenomena of hysterical amnesia, double-consciousness and multiple personality. The fundamental problems of the new age thus became problems of memory and the representation of time, rather than those of epistemology and the representation of space.

Freud's psychology is part of this transformation in *fin-de-siècle* culture. Developing out of the positive sciences which had dominated nineteenth-century intellectual life, he provided an approach

to self-understanding which, in common with literary and artistic as well as with scientific movements of the period, focused directly on the paradoxical and non-rational elements of experience. And in addition to modifying both classical bourgeois rationality and its Romantic counter-image he simultaneously articulated a novel psychology which more adequately reflected upon the most 'advanced' features of social life in late imperial Vienna.

Perhaps the most radical sense in which Freud might, thus, be considered an early exponent of a *post*-modern psychology is in terms of his analytic method. The technique of free-association enlisted the assistance of patients in deciphering their own symptoms. The loss of unaided scientific authority came close, indeed, to surrendering to a chance (certainly to an unknown) diagnostic mechanism. Even when a dream or symptom were completely analysed a rational account of their formation (synthesis rather than analysis) presented formidable difficulties, as the 'Dora' case revealed.[55] For all practical purposes the associative pathways remained unpredictable and brought to light fragments of psychic life which the analyst had subsequently to integrate into a meaningful context which rarely achieved satisfying unity. The patient was instructed to abandon all efforts to control the spontaneous flow of psychic images and simply report its continuous becoming. The 'elementary' processes of psychic construction remained unexaminable and, though conditioned by a general process of psycho-sexual development, were subject to the contingency of concrete experience. Association, thus, far from being a rational underlying 'law' of psychic connectedness, reducible to purely mechanical principles, was characterized by wholly unpredictable and apparently undirected relationships. A typical feeling of 'drifting' thus characterized analysis.

Elementary connections involve the construction of objects and the maintenance of qualitatively distinctive relations with them. This process requires an expenditure of 'energy'; a cathexis which 'fixes' an object and relationship and 'binds' psychic energy to it. Freud's use of physical analogies does not indicate a lingering interest in his initial 'Project', but signifies, rather, the common context of cultural transformation in which classical concepts of continuous variation and systematic mechanism were being challenged by conceptions of reality as constructed from discontinuous quantities and processes. The individual exists in a number of possible energy states: conditions of greater or less 'excitation'. In contemporary society, it might be suggested, the frequency and intensity of states of heightened

excitation increase, allowing innumerable object relations to be formed and broken.

In an immediately meaningful way the discontinuous and labile character of psychic connectedness was expressed in *wishes*. Indeed, Freud's entire psychology of dreams is often (wrongly) reduced to a theory of wish-fulfilment, yet this most distinctive feature of his approach has all too frequently been assimilated to the fundamentally different dynamical concepts of desire or intention. The wish is neither an intention (in the sense of being a rationally deliberative and self-interested act), nor is it a desire (in the sense of a dialectical relation of self-development and self-actualization); it is, rather, an essentially *playful* form of subjectivity. Wishes are insincere and mobile, not because the wishing individual cannot 'make up her or his mind' (the typically adult response to children's continually changing requests) but because the wish is not at all related to the ego, and therefore cannot express selfhood in either its intentional or passionate form. The wish, equally, is inconsequential; there is nothing of the 'self' at stake in its fulfilment. Wishing does not involve 'commitment' or 'effort' and does not require or establish any sense of direction or directedness in psychic life. The wish projects identificatory 'phantoms' of itself rather than seeks to establish reality (and a relation to it) as an 'exterior' object. Wishing thus remains locked in participatory immediacy with and of the world.

The wish characterizes the psychic life of young children, and Freud's compelling demonstrations of the extent to which adult dreams, symptom-formation and recollections continue to invoke its hermetic world of incompletely differentiated processes has encouraged a 'biographical' reading of Freud's theory which is altogether too close to the tradition of Romantic psychology of which he remained critical and from which, in some specific respects, he distanced himself. The wish 'belongs' to childhood primarily because, for the young child, there is not yet an ego which becomes the evident centre of waking psychic life. The persistence of the wish, however, should not be interpreted as the long-range *effect* of early experience on the adult psyche, rather, and more simply, it refers to the co-presence of 'non-egological' psychic processes alongside those of the developed ego. By definition such process are not normally 'noticed' in the waking state and become evident only for a relaxed consciousness in which the effort of integrating psychic life in terms of a continuously present 'I' has been abandoned to the immediate flux of elementary connections and disconnections.

However, the coexistence of ego and non-ego states is equivocal. While, for the ego, its own periodic loss of being is present to it, so to speak, as a memory or a possibility, to dream, to fall ill, to wish, is to 'fall' into another world for which the ego and its world has no existence. What might be termed the 'non-transitive' relation between waking and dreaming states had been noted by Descartes, but Freud develops the full implication of this insight. The dream is, for the waking person, a recollection of an experience which remains beyond immediacy. The interpretation of dreams does not restore this experience, as if in some sense it had been lost; rather, in bringing its non-egological characteristics into focus, it reveals its wishful (preconscious) content. Freud does not, in other words, attempt to understand the dream by transforming its content into a rational 'ego-logical' narrative structure; instead he expands (or re-expands) the domain of meaning and significance beyond the confines of the narrowly intellectualistic ego to which it had been consecrated throughout the development of classical bourgeois culture. The unconscious is never experienced, and thus cannot be recalled, and Freud's psychology is, above all, an exploration of consciousness.

Wishing, for the adult ego, is an essential modalization of experience, the recognition of *another* world and its plenitude; while, for the pre-ego or dreaming state, it is simply the immediate being of that world (which is its *only* world).

Freud and Modern Society

Freud's eclecticism is not a chaotic jumble of ideas, but a clearly defined set of approaches, each of which can be invoked in an appropriate way. The interrelation of each of these approaches and the specific aspects of modernity in which they are grounded is far from simple. Empirical and Romantic psychologies each attempt to reconstruct the totality of the world from particular and mutually exclusive perspectives – from, respectively, the inertial character of the body and the passionate character of the soul – and are interrelated only in terms of a decisive 'either/or'. Phenomenological psychology, however, exists both 'for-itself', as an attempt to describe the continuous transitions within modern experience, and 'for-another', in recognizing the worlds described by empirical and Romantic psychology as existing possibilities of these transitions. Intention and desire are, so to speak, 'contained' in the open horizon of the

postmodernity but each, during their periodically 'active' phases within the life of contemporary subjectivity, defines the world wholly in its own terms.

The three dynamical models represent, furthermore, three phases in the emergence and development of modernity. The emergence of modernity required, above all, that the basic mechanism of social control be vested in individuals themselves. Only then could each individual be regarded as an identical unit in the process of production and exchange. Self-mastery, as Max Weber demonstrated, is a hidden assumption of capitalism, and the necessary counterpart to its explicit ideology of freedom. Individuals must become responsible for themselves; they must form 'clear and distinct ideas' of themselves and integrate their needs, feelings and actions into the coherence of a well structured ego. They must learn, in other words, to have and act upon *intentions*.

The establishment of mechanisms of self-control allowed the social institutions of bourgeois society to develop and become self-sustaining. The requirement of self-mastery was not dropped, but in many crucial respects it could be taken for granted. Where alternative models of society had been rendered fantastic and alternative ways of life had been systematically destroyed by the irresistible expansion of capitalism, 'reason' guaranteed conformity with norms which had previously depended, in part at least, on moral persuasion. This meant that the 'ego' could be allowed, as it were, to expand. The individuals' 'private' interests in art, religion and eroticism, for example, could be distinguished from their public duties as workers and citizens. This did not signal even a limited and contained liberation from the imperative of self-control. Rather, the demand for self-mastery, which had been so well instituted, became the model for an imperative quest for self-realization in the private sphere. The specific manner in which desire manifested itself in the individual's life was a matter of 'conscience' or 'taste', but individuals could no more avoid the prompting of desire than they could the imperative of intention; the individual was driven by both, yet (for a time) contrived to feel that the freedom in the undetermined nature of desire offered some solace for the powerlessness in the pre-given character of intention.

At the same time the cultivation of desire encouraged the search for personal distinction through the accumulation of commodities. This proved to be an important psychological mechanism for encouraging a limited increase in consuming as well as producing com-

modities. In the longer term, however, it was an insufficient encouragement of the wrong sort. The individualistic model of desire, fully developed within Romanticism, provided a psychological pattern for bourgeois accumulation of valuables which was, in fact, out of step with the growth of capitalist factory production. The stimulation of a corresponding mass consumption required, and brought forth, a quite different dynamical system. A new, evanescent and fortuitous relation to the world of commodities was established. Consumption was determined by a fleeting whim rather than a continuously acting intention or desire. The 'quality' of the commodity and its relation to the 'needs' of the consumer were reduced to an incidental aspect of the relation between production and consumption. The momentary cathexis with its little burst of excitement could be repeated many times over without so transforming the human subject that the wishing phenomenon might not renew itself. The liberation of the wish, rather than the deceptive freedom of desire, provided the psychic energy required by advanced societies and, incidentally, prepared the foundations for a postmodern culture.[56]

These 'phases' of modernity are both historical periods and coexistent forms of psychic life. The emergence of desire as a fundamental constituent of self-awareness and self-understanding did not fundamentally alter the role of intentionality, just as, by the end of the nineteenth century, the emergence of wishing did not absolve the individual from the duty of self-development.

Freud's psychology recognizes this coexistence and resists the temptation of providing a theoretical synthesis which could only result in abstract unreality. No such 'higher' synthesis could do justice to the continuous movement, varied dynamical interrelations and qualitative modalizations which make the real character of concrete modern experience.

Notes

1 William M. Johnston, *The Austrian Mind: An Intellectual and Social History 1848–1938* (Berkeley: University of California Press, 1972); Carl E. Schorske, *Fin-de-Siècle Vienna: Politics and Culture* (London: Weidenfeld & Nicolson, 1980); Jacques le Rider, *Modernity and Crisis of Identity: Culture and Society in Fin-de-Siècle Vienna*, trans. Rosemary Morris (New York: Continuum, 1993).

2 Frank J. Sulloway, *Freud: Biologist of the Mind* (London: Fontana, 1980).

3 Adolf Grünbaum, *The Foundation of Psychoanalysis: A Philosophical Critique* (Berkeley: University of California Press, 1984); Edward Erwin, *A Final Accounting: Philosophical and Empirical Issues in Freudian Psychology* (Cambridge, Mass.: MIT Press, 1996).

4 Paul Ricoeur, *Freud and Philosophy: An Essay on Interpretation*, trans. Denis Savage (New Haven, Conn.: Yale University Press. 1970); Robert R. Holt, *Freud Reappraised: A Fresh Look at Psychoanalytic Theory* (New York: Guilford Press, 1989).

5 Alexandre Koyré, *Galileo Studies*, trans. John Mepham (Hassocks: Harvester, 1978).

6 Etienne Gilson, *The Spirit of Medieval Philosophy* (London: Sheed & Ward, 1936); Arthur O. Lovejoy, *The Great Chain of Being* (Cambridge, Mass.: Harvard University Press, 1948); Michael Haren, *Medieval Thought: The Western Intellectual Tradition from Antiquity to the Thirteenth Century* (London: Macmillan, 1985).

7 Jacob Burckhardt, *The Civilisation of the Renaissance in Italy*, trans. S. G. C. Middlemore (Harmondsworth: Penguin, 1990).

8 Ernst Cassirer, *The Individual and the Cosmos in Renaissance Philosophy* (Oxford: Blackwell, 1963); Brian P. Copenhaver and Charles B. Schmitt, *Renaissance Philosophy* (Oxford: Oxford University Press, 1992).

9 Charles Trinkaus, *In Our Image and Likeness: Humanity and Divinity in Italian Humanist Thought* (2 vols.; London: Constable, 1970).

10 Jean Starobinski, *Montaigne in Motion*, trans. Arthur Goldhammer (Chicago: University of Chicago Press, 1985); Thomas A. Spragens, *The Politics of Motion: The World of Thomas Hobbes* (London: Croom Helm, 1973).

11 Koyré, *Galileo Studies*; Hans Blumenberg, *The Genesis of the Copernican World*, trans. Robert M. Wallace (Cambridge, Mass.: MIT Press, 1987).

12 Stephen Greenblatt, *Renaissance Self-Fashioning: From More to Shakespeare* (Chicago: University of Chicago Press, 1980).

13 Lynn K. Nyhart, *Biology Takes Form: Animal Morphology and the German Universities 1800–1900* (Chicago: University of Chicago Press, 1995).

14 E. J. Dijksterhuis, *The Mechanization of the World Picture* (Oxford: Oxford University Press, 1961).

15 Sigmund Freud, 'The interpretation of dreams' (1900), *Standard Edition*, vol. IV, pp. 193–4.

16 Sigmund Freud, *The Complete Letters of Sigmund Freud to Wilhelm Fliess*, trans. and ed. Jeffrey Moussaieff Masson (Cambridge, Mass.: Harvard University Press, 1985), p. 285.

17 Freud, 'The interpretation of dreams', p. 194.

18 Ibid. p. 195.

19 Ibid. p. 196.

20 Ibid. p. 197.

21 Max Schur, *Freud: Living and Dying* (London: Hogarth Press and Institute of Psycho-Analysis, 1972); Marianne Krüll, *Freud and his Father*, trans. Arnold J. Pomerans (New York: W. W. Norton, 1986); Alexander Grinstein, *Sigmund Freud's Dreams* (New York: International Universities Press, 1980); Didier Anzieu, *Freud's Self-Analysis*, trans. Peter Graham (London: Hogarth Press and Institute of Psycho-Analysis, 1986).

22 Freud, 'The interpretation of dreams', pp. 197–8.

23 Sigmund Freud, 'The psychopathology of everyday life' (1901), *Standard Edition*, vol. VI, p. 218.

24 Ibid. pp. 219–20.

25 Paul C. Vitz, *Sigmund Freud's Christian Unconscious* (New York: Guilford Press, 1988).
26 Freud, (1985) *Letters to Fliess*, p. 268.
27 Sigmund Freud, 'Early psycho-analytic publications' (1899), *Standard Edition*, vol. III, p. 321.
28 J. N. Isbister, *Freud: An Introduction to his Life and Work* (Cambridge: Polity Press, 1985), pp. 130–8.
29 Freud, 'The interpretation of dreams', p. 194.
30 Sulloway, *Freud: Biologist of the Mind* ; Lucille B. Rirvo, *Darwin's Influence on Freud* (New Haven, Conn.: Yale University Press, 1990).
31 Sigmund Freud, 'Project for a scientific psychology' (1895), *Standard Edition*, vol. I, p. 295.
32 Ibid. p. 308.
33 Ibid. p. 309.
34 Talcott Parsons, *The Structure of Social Action* (Glencoe, Ill.: Free Press, 1936), pp. 43–73.
35 Sigmund Freud, 'Repression' (1915), *Standard Edition*, vol. XIV, pp. 141–58.
36 Sigmund Freud, 'From the history of an infantile neurosis' (1918), *Standard Edition*, vol. XVII, pp. 3–66; 'The economic problem of masochism' (1924), *Standard Edition*, vol. XIX, pp. 157–72.; Norman O. Brown, *Life against Death* (London: Routledge & Kegan Paul, 1959).
37 Jean Starobinski, *Jean-Jacques Rousseau: Transparency and Obstruction*, trans. Arthur Goldhammer (Chicago: University of Chicago Press, 1988).
38 René Girard, *Deceit, Desire and the Novel: Self and Other in Literary Structure* (Baltimore: Johns Hopkins University Press, 1965).
39 Jacques Bousquet, *Les thèmes du rêve dans la littérature romantique* (Paris: Didier, 1964).
40 Bernard Yack, *The Longing for Total Revolution* (Princeton: Princeton University Press, 1986).
41 Bousquet, *Les thèmes du rêve*, p. 35.
42 Georges Gusdorf, *Le savoir romantique de la nature* (Paris: Payot, 1985).
43 Erna Lesky, *The Vienna Medical School of the 19th Century*, trans. L. Williams and I. S. Levy (Baltimore: Johns Hopkins University Press, 1976), pp. 8–11.
44 William M. Johnston, *The Austrian Mind: An Intellectual and Social History 1848–1938* (Berkeley: University of California Press, 1972), pp. 223–9; Edwin Clarke and L. S. Jacyna, *Nineteenth-Century Origins of Neuroscientific Concepts* (Berkeley: University of California Press, 1987), p. 3.
45 Lesky, *Vienna Medical School*, p. 280.
46 Johann Wolfgang von Goethe, *Goethe's Botanical Writings*, trans. Bertha Mueller (Woodbridge, Conn.: Ox Bow, 1952), pp. 242–4.
47 John E. Gedo and George H. Pollock, *Freud: The Fusion of Science and Humanism* (New York: International Universities Press, 1976).
48 Harvie Ferguson, *The Lure of Dreams: Sigmund Freud and the Construction of Modernity* (London: Routledge, 1996), pp. 63–7.
49 Sigmund Freud, 'Civilization and its discontents' (1930), *Standard Edition*, vol. XXI, pp. 69–70.
50 Theodore Ziolkowski, *German Romanticism and its Institutions* (Princeton: Princeton University Press, 1990).

51 William J. McGrath, *Freud's Discovery of Psychoanalysis: The Politics of Hysteria* (Ithaca, NY: Cornell University Press, 1986), pp. 94–5.
52 Ludwig Boltzmann, *Theoretical Physics and Philosophical Problems* (Dordrecht and Boston: Reidel, 1974).
53 John Hendry, *James Clerk Maxwell and the Theory of Electromagnetic Field* (Bristol: Hilger, 1986).
54 Emile Meyerson, *Identity and Reality*, trans. Kate Lowenberg (London: Allen & Unwin, 1930).
55 Sigmund Freud, 'A case of hysteria' (1905), *Standard Edition*, vol. VII, pp. 64–111; Hannah S. Decker, *Freud, Dora and Vienna 1900* (New York: Free Press, 1991).
56 Rosalind H. Williams, *Dream Worlds: Mass Consumption in Late Nineteenth-century France* (Berkeley: University of California Press, 1982); Daniel Miller, *Material Culture and Mass Consumption* (Oxford: Blackwell, 1987); Don Slater, *Consumer Culture and Modernity* (Cambridge: Polity Press, 1997).

8
Freud, Dreams and Imaginative Geographies

Steve Pile

The space of the dream is strange and alien, yet at the same time as close to us as is possible.

Henri Lefebvre

The interpretation of dreams is the royal road to a knowledge of the unconscious activities of the mind.

Sigmund Freud

Just as none of us is outside or beyond geography, none of us is completely free from the struggle over geography.

Edward Said

You're innocent when you dream.

Tom Waits

In some ways, this chapter sits uneasily in a book on the impact of Freud's work. Human geographers have (very) occasionally found it expedient to cite Freud, but nowhere has there been a sustained engagement with his ideas. This appears to be for three interrelated reasons: first, geographers have assumed that the unconscious is not dynamic; secondly, an abiding interest in the patterning of social relations over the surface of the earth has meant that psychoanalysis has been declared irrelevant because of its alleged fixation with the person and the personal; and, thirdly, psychoanalysis has not been seen as adding any value to critical analyses of power relations. Indeed, early reports on psychoanalysis by geographers for geographers were sceptical, scant and scurrilous.[1] If this chapter cannot be about the impact of Freudian thought on Human Geography as a

discipline, then it must instead open up a dialogue between Freud's ideas and the ways in which geography is imagined.

Let me begin with an anecdote, which might explain why I have chosen to explore Freud's interpretation of dreams.[2] It often happens that I am asked why I am interested in geography and psychoanalysis.[3] Commonly, this question takes the form: 'what (*on earth*) have *they* got to do with one another?' Recently, I was engaged in one of these conversations at a conference (attended solely by geographers), but late at night and after a few noisy drinks. What, I was asked, could psychoanalysis tell someone interested in geographies of consumption (not the lung disease, I hasten to add). Confident that I could demonstrate that an appreciation of psychoanalysis would inform and enhance an understanding of this field, I began to babble about the psychodynamics of desire, shopping and shops – backing this up with a quick reference to Rachel Bowlby's *Shopping with Freud*.[4]

Desire, I was told in reply, was quite simple and surely there was nothing psychodynamic about wanting to eat Indian take-away food. This train of thought rattled along: consumers expressed preferences and these were easily obtained, fairly consistent and structured by class, gender and race – and not by some personal neurosis. There was no such thing as the unconscious and, even if there was, it had nothing to do with geography. And, in a final flourish, my friend told me that he did not have a dynamic unconscious and that I couldn't convince him that he did. I certainly wasn't about to deny that power relations, constituted through divisions of class, gender and race, were significant in the production of geographies of consumption. But, I thought, I did have proof that there was a dynamic unconscious – so I asked my friend whether he had dreams. Without hesitation, he replied that he didn't. He smiled triumphantly and I wryly laughed. And the conversation turned to the chances of winning the national lottery. Sometime later, I met my friend at a seminar. With a large grin on his face, he told me that after our conversation he'd had a whole series of very vivid dreams and he admitted, in any case, that he had lied about not dreaming.

Dreams are fascinating. They may be one form of evidence that the mind is split: dreams prove that there is a part of the mind which works, apparently out of control, while our conscious selves sleep. And dreams *show* that the sleeping mind is dynamic and creative. Quite often, people also want to talk about dreams and what they mean, and get very excited about interpreting them.

Freud's ideas about dreams have, in part, filtered into people's common-sense understanding of what is going on in dreams.[5] It is because of this that my friend could anticipate where the argument was going when I asked him whether he dreamt. He knew that if he said yes to my question, then he would be admitting to having a dynamic unconscious. Meanwhile, psychoanalytic theorizing has become less and less concerned with dreams and more and more interested in the transferential dynamics occurring in the consulting room.[6]

I find something curious about this. Freud demonstrably had a substantive sense of the significance of dreams. There are some easy ways to justify this claim. *The Interpretation of Dreams* is Freud's largest book, which he revised eight times, returning to it regularly during his lifetime. Further, Freud continued to write on dreams, maintaining their place at the heart of psychoanalytic thinking and therapy.[7] Thus, in the first edition, he writes, 'Anyone who has failed to explain the origin of dream-images can scarcely hope to understand phobias, obsessions or delusions or to bring a therapeutic influence to bear on them,'[8] while, in the preface to the 1931 English edition of the book, Freud stresses that it 'contains, even according to my present-day judgement, the most valuable of all discoveries it has been my good fortune to make. Insight such as this falls to one's lot but once a lifetime.'[9]

In this light, *The Interpretation of Dreams* becomes significant not because Freud declined to revise it in the light of his later ideas – for example, concerning the death drive, and so on – but because he did not feel the need to rewrite it. For me, one of the most outstanding aspects of Freud's work is his readiness to challenge and reconsider his own presuppositions. Yet, his position on dreams remains, almost uniquely, remarkably consistent. The question, then, is why this might be so. It is not my aim to find the definitive answer to this question but, instead, to suggest that there was no need to revise his theories because of the way in which Freud thought *spatially* about the mind. I will argue that Freud conceptualized the mind as working spatially. This spatial imagination meant that Freud was able to use both his topographical (unconscious, preconscious and conscious) and structural (id, ego and superego) models of the mind without incongruity – and this is clear even in *The Interpretation of Dreams*.[10] Specifically, however, I will show that Freud implicitly draws on very distinctive understandings of space in his work, not

just in terms of the dream-work, but also in terms of the spatialities of dreams.

It seems to me that there are conceptual gains to be made by thinking through the ways in which Freud imagines the mind spatially. Understanding the spatial relationships within the mind might help say something more about symptoms, like dreams. Further, it may also show where the continuities in Freud's thought lie. However, I would like to stretch this argument into a cultural context. While Freud's understanding of dream-work has been re-deployed in the interpretation of literary forms [11] – an extension prefigured by Freud himself[12] – I will look at Edward Said's supposed use of Freudian dream-analysis.

It is widely known that Said's analysis of Orientalism describes the ways in which the Orient was produced as an imaginative geography.[13] However, I am interested in the moment when Said, somewhat uncharacteristically, draws a distinction between the unconscious latent content of Orientalism and its ever-changing manifest forms. The implication is that Orientalism produced a dream-like imaginative world of the East. To move from the space of dreams to imaginative geographies seems, at first sight, far-fetched. However, I will argue that the analogy between the production of dream-space and the production of space as dream-like holds better once a fuller understanding of Freud's spatial imagination is appreciated. The potential, here, is to re-conceptualize the ways in which our imagined interior worlds and our imaginative geographies are produced – that is, that they are produced in much the same way (though not in *exactly* the same way). This has direct consequences for how it might be that any politics concerned with the 'decolonization' of space is to be figured. In this understanding, there can be no decolonization as such, but only the re-working of spatial relationships – so that the point of political action is not to seize space, but to transform it.

The first step on this journey through imaginative geographies of interior and exterior worlds must be Freud's understanding of the ways in which dreams are produced. In my reading, the basic mechanisms of dream-work – displacement and condensation – are profoundly spatial. This provides the foundation on which to understand how interior and exterior worlds are articulated through very similar mechanisms – how each appears inflected in the other, even while they are very different scenes. Now, it is time to take the royal road and see where it goes.[14]

Dream Works

I find it very hard to read *The Interpretation of Dreams* without admiring the sheer quantity of meanings that Freud is able to wring out of even the tiniest of dream fragments.[15] Behind this continual and never-ending search for the meanings implicit in dreams are Freud's theories about how and why dreams are put together. Basic tenets of his dream-analysis are, by now, well known and I do not intend to dwell on these for too long. What I am looking for is the ways in which these mechanisms are, or are not, imagined spatially. Perhaps the best thing would be to start with a dream. Certain of Freud's dreams have attracted much attention, such as that of Irma's injection, but I would like to use a less well-known example as an illustration. From a report by Dr B. Dattner, Freud relates a woman's dream this way:

> . . . *Then someone broke into the house and she was frightened and called out for a policeman. But he had quietly gone into a church (1), to which a number of steps (2) led up, accompanied by two tramps. Behind the church there was a hill (3) and above it a thick wood (4). The policeman was dressed in a helmet, brass collar and cloak (5). He had a brown beard. The two tramps, who went along peaceably with the policeman, had sack-like aprons tied round their middles (6). In front of the church a path led up to the hill; on both sides of it there grew grass and brushwood, which became thicker and thicker and, at the top of the hill, turned into a regular wood.*[16]

Though Freud takes the trouble to insert this dream in his 1911 revision, uniquely there is no analysis.[17] Instead, Freud provides six footnotes: '(1) Or chapel (= vagina); (2) Symbol of castration; (3) *Mons veneris*; (4) Pubic hair; (5) According to an expert, demons in cloaks and hoods are of a phallic character; (6) The two halves of the scrotum.'[18] Freud gives no clue as to why he has not interpreted this dream. And, as a result, he invites the reader to do something that he is continually cautioning against: that is, to interpret a dream without reference to the dreamer's thoughts, feelings and associations.[19] Indeed, this 'decoding' of dream-elements – as if there is an unmediated relationships between the symbol and its meaning; where, for example, church = vagina – is quite un-Freudian! As a

result, the title of the dream seems to say it all: 'the male organ represented by persons and the female organ by a landscape'.[20]

In contrast, *The Interpretation of Dreams* generally painstakingly sets out sheer deviousness of the mind in the production of dreams. In this, Freud is assuming that

> in spite of everything, every dream has a meaning, though a hidden one, that dreams are designed to take the place of some other process of thought, and that we have only to undo the substitution correctly in order to arrive at this hidden meaning.[21]

For Freud, dreams are the '[*disguised*] *fulfilment of a* [*suppressed or repressed*] *wish*'.[22] However, dream-work responds to this imperative in such a way that the wish does not wake the dreamer. Dreams, therefore, are also '*the* GUARDIANS *of sleep*'.[23] It is presumed that the basic thought constituting the dream would trouble the dreamer enough to wake her or him up: so, the dream takes on a disguised form (e.g. the policeman enters the church by way of a number of steps) because the revelation of the dream's secret wish for sex (e.g. the penis enters the vagina by way of copulation) would, presumably, be disturbing and wake the dreamer up. Further, Freud suggests that dreams work mainly, though not only, through the use of images (so, the policeman is visualized as having a brown beard, a helmet, brass collar and a cloak): 'Dreams construct a *situation* out of these images; they represent an event which is actually happening ... they 'dramatize' an idea.'[24] Thus, the dream sets up a situation – i.e. a break-in – which requires the presence of the policeman. *At the same time*, the scene is set for the wish to be dramatized, but in a disguised way. It is evident that, even in such a seemingly transparent dream, some serious thinking has to take place: the wish has to be thought, then represented through images that disguise the thought, then the images have to be put together into a dream that has a clear story-line (however crazy the images and story seem once the dreamer has woken). Freud calls this mental process dream-work and identifies within it some key components: condensation, displacement, the means of representation and secondary revision.

For Freud, dream-work transcribes the dream-thought from one mode of expression into another mode of expression, the dream-content. After this transcription, dream-content appears to be 'brief, meagre and laconic in comparison with the range and wealth of the

dream-thoughts'.[25] Freud suggests that dreams are condensations of dream-thoughts such that, while dreams appear short and fragmentary, an almost unlimited amount of material can be reaped by further analysis. Thus, a single element, like a church, might refer to the vagina and also a vast array of other meanings (for the dreamer). Each association that the dreamer makes with the dream-symbol will, in turn, lead to further insights. Very soon, analysis generates a series of trains of thought, all of which radiate out from the dream-symbol. The dream-symbol, therefore, not only refers to many meanings, but also permits many, often contradictory, meanings to exist in the same space; that is, the space of the symbol. Condensation, further, refers to the way in which space within the dream is utilized not just as a container for meanings, but also as a medium of connection between one meaning and another – where the point of articulation, in the case of condensation, is the dream-symbol.

> Not only are the elements of the dream determined by the dream-thoughts many times over, but the individual dream-thoughts are represented in the dream by several elements. Associative paths lead from one element of the dream to several dream-thoughts, and from one dream-thought to several elements of the dream. Thus . . . a dream is constructed . . . by the whole mass of dream-thoughts being submitted to a sort of manipulative process in which those elements which have the most numerous and strongest supports acquire the right of entry into the dream-content.[26]

So, when the dreamer dreamt of a policeman, this may well have meant that the policeman was a penis, but the symbol might also have paths that led to other meanings, possibly stretching out from the related elements of the helmet, brass collar, cloak and brown beard. So, while the one path clearly walks over the male body, others might sweep out to other places – and one of these places might have something to do with the fact that the dreamer's husband was a policeman, who might represent more for her than simply 'copulation'. Further, the policeman appears in two related places in the dream: first, as someone who is called out to by a frightened woman whose house has been broken into (possibly by a burglar[27]); and, second, as going quietly into the church peaceably accompanied by two tramps. It may well be that these are produced by the same

dream-thought – possibly the woman's desire to have sex (with her husband?), or maybe the woman's desire to be *at peace* with sex (with her husband?). On the other hand, the slippage between robber/policeman and policeman/tramps might have been produced by a different dream-thought or by the progression from one dream-thought to another, possibly stemming from the meaning of the robber in the dream.

Associative paths, then, not only emanate from each symbol or element in the dream, but associative paths from different dream-thoughts intersect and intensify at specific points as these lines of thought interact (or not) with one another. These interlinkages between thoughts and symbols are characterized, therefore, 'by the specially ingenious interweaving of their reciprocal relations'.[28] This ingenuity extends, for example, to making composite people or words out of a range of associated people or words.[29] In condensation, dream-elements (such as 'the policeman' or 'a church') are much more than a substitution of one thing for another thing which is associated with it (in this case, a penis or a vagina). Instead, they are points of (psychical) density and intensity produced by their location in the interweaving of thoughts, feelings and meanings; produced, moreover, by their location in relation to spatialities of the psyche (see below).

There is a problem, here, however. If dream-thoughts with a particular intensity are converted into images with equal intensity and these images are woven without change into the dream, then dream-elements which have the most intense feelings associated with them would be readily identified by the dreamer and the dreamer would wake up. If the dreamer wished to have sex, but could not admit to this desire, yet dreaming of a policeman entering a church through a number of steps produced exactly the same intensity of desire, then the dreamer would not only wake up, but also know the meaning of the dream. Somehow, the disposition of intensities in the dream-thought must be disguised too. Freud calls this process displacement, which transfers intense psychical investments from one place to another by way of intermediate links:

in this way, ideas which originally had only a *weak* charge of intensity take over the charge from ideas which were originally *more intensely* cathected [i.e. charged with psychical energy] and at last attain enough strength to enable them to force an entry into consciousness.[30]

By shifting intensity through associative paths, it is possible to invest – or overdetermine – seemingly meaningless images with apparently inexplicable feelings, and this then ensures the symbols' appearance in the dream. Indeed, 'what is clearly the essence of the dream-thought need not be represented in the dream at all. The dream is, as it were, differently centred from the dream-thoughts – its content has different elements as its central point.'[31]

Both displacement and condensation work by using associative paths not only to combine and recombine thoughts, but also to decentre both meanings and feelings. In this way, dream-work enables the dream to be woven out of seemingly indifferent or bizarre elements. Indeed, it is through these transferences of intensity along chains of association – as produced and intensified by displacement and condensation – that there can be a difference between dream-thoughts and dream-content. In this way, dream-thoughts are both censored and helped to escape censorship. It is the processes of condensation and displacement, in essence, that both enable dreaming and produce the dream by transforming what Freud calls latent thoughts into manifest content.[32]

In therapeutic practice, then, dream-analysis is predominantly about discovering or restoring the connecting paths which lead from the latent dream-thoughts to the manifest dream-content – where these paths are produced in spite of, and disappear because of, the impossibility of expressing the latent thought. The production and re-production of the dream leads to

> the most intricate possible structure, with all the attributes of the trains of thoughts familiar to us in waking life. They are not infrequently trains of thought starting out from more than one centre, though having points of contact. Each train of thought is invariably accompanied by its contradictory counterpart, linked with it by antithetical associations.[33]

These 'trains of thought' can be set in motion by many different stimuli, each with distinct sources.[34] The main sources are experiences of the body (where stimuli can be internal, such as hunger, or external, such as an alarm clock), recent experiences while awake (dreams make use of trivial events during the previous day, but also respond to significant occurrences), infantile experiences, and significant experiences inside the mind (such as memories, fantasies and trains of thought). It will be clear that any dream might have

one, many or all of these points of departure – and that each source covers an almost infinite number of possibilities.

Nevertheless, it can be noted that any dream is 'localized' in, and through, its position within a web of associations which is itself made up out of a series of locations, nodes or points of intensity. In this way, the desire for sex which produced the dream of the policeman, the church and the landscape is located within a web of meanings which have 'anchoring points' not only in the fantasized topography of the male and female body and also in the imaginative spatiality of fucking (as a number of steps, whether peaceable or difficult), but also in the social construction of the male body as active (like a person) and the female body as passive (like a landscape) and also in the social relations of marriage, sexuality, religion, work, class, criminality and morality.

Dreams, evidently, are constructed out of spatial analogies and spatial relationships: i.e. there is a geography to dreams.[35] Famously, shapes are related to other shapes:[36] in this way, the church (and hall) becomes a vagina; while the policeman is a penis. Similarly, movements are related to associated feelings or associations, such as going up steps and walking (for copulation) or dreams about falling, flying and swimming (for infantile experiences of being thrown or dropped); while (ethical) choices can be presented spatially as taking either a left or right path, and so on. The point is that the spatial consciousness of the dreamer is the blending of the social and the personal and the imagined topography of the body that underpins the geography of the dream *and vice versa*. Thus, the female body appears as a landscape because the landscape and the female body are apparently passive, while the male body and the bodies of people are seen as being active and the dream enacts, *dramatizes*, this situation.

The imaginative geography of the dream is not, however, fortuitous: it marks the articulation of worlds of meaning, power and identity. The dream not only 'localizes' meaning, but also 'locates' it. In this way, it is not a surprise that 'localities are often treated like persons' or that a man should be a policeman or a burglar, because the imaginative geography of the dream is both a setting, a setting-up and a composition.[37] Indeed, it may be that the locality is almost a paradigm for dreams – for not only can localities be visited many times and the meanings of the locality change depending on the 'orientation' of the visit, but also such narratives are spatial in the ways that work either by bringing together elements from different places

or by (meaningfully) changing places. In this way, the dream fervently traces paths, makes connections, juxtaposes elements, composes symbols, in the dream space.

Dream Spaces

There are already accounts of what the dream space might be, or actually where it might be.[38] In this section, however, I would like to elaborate on Freud's spatial thinking, not only in terms of the systems and agencies in the mind, but also the ways that dreams are put together. It is this which will permit an alternative understanding of imaginative geographies – that is, specifically, of the imaginative geographies produced by Orientalism. This section moves the argument along: first, by examining Freud's thinking on space, time and causality; secondly, by looking at his spatial understanding of the relationship within the psyche; and, finally, by exploring the use of the expression 'associative paths'.

What is intriguing about Freud's explicit references to 'space' (and time) is that they become increasingly significant as the analysis of dreams becomes deeper and deeper.[39] What Freud is concerned with is the ways in which the mind takes 'impressions that impinge on it from outside' and remoulds them 'into the forms of time, space and causality'.[40] In an argument derived from Schopenhauer, Freud suggests that dreams remodel both interior and exterior impressions 'into forms occupying space and time and obeying the rules of causality'.[41] It soon becomes clear that dreams re-work causality by upsetting space–time relations. Time is not linear, while spatial relationships are redistributed (partly by condensation and displacement). The dream might, therefore, disguise causality by making outcomes appear before the happening and/or by making things that are close distant (and vice versa).

Dreams remodel experiences by bringing together thoughts, impressions and elements into the dream space, but in specific ways. They might 'reproduce logical connection by simultaneity in time'.[42] The sequence of events in a dream would, thereby, suggest logical connections between the images. However, common-sense temporal sequences and logical relations may also be altered. Nevertheless, when dreams show 'two elements close together, this guarantees that there is some specially intimate connection between what corresponds to them among the dream-thoughts'.[43] This sense of close-

ness and connection is simultaneously spatial: collocations in dreams do not exist by accident, but also reveal the intimate connection between things that are close in dream-thoughts.[44]

In Freud's understanding, spatial transformations occur in many ways, including through collocation, juxtaposition, fragmentation (using dislocated or uncanny dream scenes), recomposition, reversals (changing up for down, or inside for outside) and the use of the spatial analogies. Similarly, time can be reversed, speeded up, slowed down, edited, compressed and recombined. Thus, space and time can be reordered to disguise the connections between, or the causes of, thoughts.[45] The point I would like to make is that space and time are co-constitutive of causal relations *within* the dream – and, therefore, that it is the space–time production of dream-space that re-presents causal chains amongst dream-thoughts. From this perspective (in dreams) both space and time are dynamic, causal and eventful.

This does not settle matters. Freud also has a spatial understanding of the relationships within the psyche. It is widely known that Freud used two models to describe the different systems and agencies within the mind and, thereby, to understand the articulations of interior and exterior worlds: the unconscious, preconscious and conscious and the id, ego and superego. It is less well appreciated that Freud conceptualized mental apparatus spatially. While he believed that neither systems (such as the unconscious) nor agencies (such as the superego) had a specific location in the brain, Freud thought that they had a location which was determined, rendered significant, by their relations to each other. From this perspective, significant meanings in dreams lie in deeper parts of the mind. In a footnote added in 1914, Freud even went to the extent of warning against ignoring this:

> The fact that the meanings of dreams are arranged in superimposed layers is one of the most delicate, though also one of the most interesting, problems of dream-interpretation. Anyone who forgets this possibility will easily go astray and be led into making untenable assertions upon the nature of dreams.[46]

In this conceptualization, thoughts are changed (recomposed, disguised, dissimulated, inverted, reversed and so on) not only by the operations of any particular layer (or location in mental apparatus), but also as they move upwards and downwards between these lay-

ers. Thus, Freud argues that latent or unconscious dream-thoughts can only reach consciousness if they pass the scrutiny of the super-ego, which reserves the right to distort thoughts as it sees fit,[47] and even to generate its own dream-thoughts.[48] It is this spatial under-standing that gives rise to the idea of a psychic locality.[49]

Freud proposes that psychic locality refers to a point within each system and agency within the mind, though his use of an analogy with microscopes and photograph implies that this locality is a pro-jection from outside focused onto a psycho-spatial screen. It is the relationship between inside and outside and the apparatus as a whole that brings the image into focus 'at ideal points, regions in which no tangible component of the apparatus is situated'.[50] Freud ar-gues, partly following the analogy with a microscope, that elements of the apparatus work through their spatial relation with one an-other, just as the 'lenses in a telescope are arranged behind one another'.[51]

Paradoxically, Freud concedes that

> strictly speaking, there is no need for the hypothesis that the psychical systems are actually arranged in a spatial order. It would be sufficient if a fixed order were established by the fact that in a given psychical process the excitation passes through the systems in a particular temporal sequence.[52]

Space, nonetheless, is fundamental because it matters how 'excitations' pass through the system; it matters what paths 'excitations' take (or not), the points they pass through (or not), the connections they make (or not), the things they cross (or not), and the transformations that take place (or not), as they move around the psyche. Freud even uses diagrams to illustrate this 'behindness' (depth) and 'throughness' (dynamism) of the psyche.[53]

In these schemata, the unconscious lies behind the conscious and has no access to consciousness except through the preconscious.[54] A similar reading can be offered of the spatial relationship between the id, ego and superego: where the ego stands at the crossroads be-tween the impulsive id and the censorious superego. In each situa-tion, what becomes significant in these models are the frontier conditions between the various systems and agencies: what kind of frontier is there, for example, between the ego and the id – it matters whether the boundary weak or strong, fuzzy or clear, closed or po-rous.[55] And dreams become evidence not merely of the content and

dynamism of each 'layer', but also of the condition of the border-lands between systems and agencies.

If this argument is right – that Freud understands the relationship between and within various systems and agencies (each with their own internal/external relations) spatially – then it is not just frontier conditions that get thrown into sharp relief, but also the mutability and mobility of 'excitations' through the psyche. If these shifts can be traced, then this will not only show how dreams are produced, but also why they are so devious. However, this mutability and mobility should not be seen as confined to dreaming. Thoughts travel, not just because of the 'fact' of excitation, but also because of their (changing) 'location' – as mapped against the latitudes and longitudes of the mind's system and agencies.

Freud considered that dreams arose from a paradox: on the one hand, for a dream to take place, more than one system or agency needs to 'share' an investment in the dream-thoughts; on the other hand, dreams were represented as a 'compromise' *between* conflicting agencies and it is this sharing/compromise that describes and accounts for the fact that dream-thoughts are disguised.[56] Dreams, like hysterical symptoms, are a battlefield *agreed* by warring factions fighting over opposing wishes. The involvement of more than one system and agency in the production of dreams starts to explain why some people have described this as a dream space – because dreams become the screen, suspended between psychical locations, onto which images are projected, from many sides.[57]

However, the sense that dreams are a space suspended within the psyche fails to convey a sense of the dynamism and dissimulation involved in dream-work. When shared space becomes the ground on which the dream-compromise takes place, what is lost is a sense that the compromise is only taking place because two opposing elements have been connected despite their mutual antagonism; connected, that is, by a path that leads from one place to another, across a forbidden frontier. From this perspective, it is the transgressive spatial constitution of conflicts within the psyche that produces dreams, rather than dreams merely representing already conflicting internal antagonisms. In this light, I would like to look again at Freud's use of the terms 'associative path' and 'trains of thought', because these will yield a deeper understanding of the constitution of dream-elements and their movement through a network of meaning, involving a sense of their direction and the nodal or switch-points within the network.[58]

Dream Networks

Freud frequently and regularly gives the impression that thoughts
– whether conscious or unconscious, whether sleeping or waking –
travel down paths. Further, he suggests that these paths can be un-
covered or reconstructed. When these paths are traced out, it is then
possible to find the underlying thought process operating in the
psyche. In this understanding, dreams become the royal road to
unconscious thought processes precisely because they signpost the
intricate pathologies of the mind. The royal road, however, is not
so easy to follow. Not only are the paths circuitous, ever vanishing
and devious, but the representatives of underlying thoughts are also
mutable as they make their journey from one place (such as the
unconscious) to another (such as the conscious).

From this perspective, trains of thought move from one place to
another because they have motive power, 'cathectic energy', which
shunts them along the track. Not all thoughts move freely around
the network: some are too painful or too dangerous to be allowed to
go just anywhere or to move around without disguise. Thoughts
which are repudiated, repressed or suppressed cannot be simply done
away with: trains of thought run unconsciously – awaiting the pos-
sibility that a connection might be made with the conscious. Net-
works of meaning are, therefore, governed and controlled by
'agencies', such as the superego and the ego, but connections are
constantly being made, unmade and remade within and across the
mind.

Trains of thought can have many points of departure, whether
from the unconscious or the superego, but they must be able to es-
tablish a connection, an associative path, with another place in the
network and they have to be 'energized' – without energy, without
a place to go, trains of thought cannot leave the station. However,

> the energy attaching to the train of thought is diffused along all
> the associative paths that radiate from it; this energy sets the
> whole network of thoughts in a state of excitation which lasts
> for a certain time and then dies away as the excitation in search
> of discharge becomes transformed into a quiescent cathexis.[59]

Further intricacies arise because other trains of thoughts, travelling
on other psychic circuits, are always ready to take advantage of the

dispersal of 'motive' energy. These pirate thoughts 'may take control of the excitation attaching to the group of thoughts which has been left to its own devices, they may establish a connection between it and an unconscious wish, and they may 'transfer' to it energy belonging to the unconscious wish.'[60] It is the connections between thoughts and the transfer of 'cathectic energy' through these connections that puts the train in motion. I would like to stress that connections not only have to be established, but they also make dream-work possible: that is, it is the fabrication of a connection between one thought and another that makes condensation or displacement possible. Various kinds of connection are possible: an association can be made between one word and another, for example, because they sound similar or where two wishes are mutually contradictory – in dreams, this can lead to wordplay or the juxtaposition of images, respectively.

Thoughts, then, do not move around a stable system, like blood through the body. Instead, they take advantage of networks of meaning for which they are, in part, responsible. These networks are simultaneously well made and fragile; as liable to change and alteration as they are capable of conveying the thought from one place to another. The network may be under constant revision, but this does not mean that every point, every line, is ever fluid. And it could be that dream-analysis is about the discovery of 'fixed points' in this unreliable, mutating network of associative paths. As much as there is flux in the network, there are nodal points, or points of attachment. It is these points which provide the psyche with a basic pattern, whether this is seen topographically or structurally. Indeed, if the mind is seen as an energized network, then it is possible to see how distinctive systems and agencies might be connected to (or disconnected from) one another.

In this light, the spatial constitution of network becomes important: not only as it enables one thought to be associated with another (as either a juxtaposition or an approximation) or thoughts to be combined (condensed) or shifted from one place to another (displaced); but also as it enables energy (psychic investment) to be shifted through the system in specific ways, thereby permitting the defence mechanisms to operate (by blocking paths, by changing direction, by turning things upside down, by using diversions);[61] and also as it extends and contracts to 'localize' pleasure and conflict within the mind. It is this extendability and fragility of networks of meaning and the dynamism and mutability of trains of thought that underlie

the dream space. Indeed, dream spaces are properly conceived of as existing in the network of meaning, rather than as a screen onto which film-like images are projected. The telescope metaphor has illuminated one spatiality of dreams, but it should also be recognized that the telescope concentrates lines of light through a system of lenses. The telescope is too static a metaphor; add in some distorting mirrors which switch the lines of thought around the system creating unpredictable, but traceable, results; add light from different sources; add some photosensitivity and lights that go on and off as light strikes; then we might have something that looks a bit like a firework (as Freud would say).

It will help if I outline the threads of Freud's spatial thinking which I have drawn attention to. So far, I have suggested that dream-work is profoundly spatial, condensing meanings onto a specific location and/or displacing it onto others; and I have argued that dream space not only exists between systems and agencies in the mind, but exists as a dynamic network of meaning, where the connections between things have to be established, rather than believing that connections always already exist. In these ways (and many more), Freud interprets dreams by following the radiant and radiating paths that meaning takes back to their points of departure. Tracing fugitive thoughts is fraught with difficulties, because of their need, ever so often, to change direction or appearance, as they seek to evade capture and imprisonment.

If it is these spatialities that produce the imaginative geographies of the dream, then they do not disappear when the dreamer awakens. Paths may become dimly lit, or blocked, or disappear, while trains of thought can resume their normal direction. Orders of space, time and causality may be re-established, but the network of meaning persists as a trace: a forgotten path of memory. While the network of meaning might be better policed and managed when the dreamer is awake, thoughts persist, always liable to jump trains or to cross the tracks. In this way, it is possible for unconscious thoughts to suddenly erupt into consciousness – whether through jokes or slips of the tongue or symptoms – because connections can quickly be made and remade without warning. Without warning, a disused or closed-down line can suddenly carry a thought.

It is, therefore, not only the imaginative geographies of dreams that are produced by the spatial operations of the psyche. Geography, conscious experiences and the imagination are also bound up in an analogous way – as meanings are shifted around a network.

From one geography – within the mind – it is possible to move to another – in the external world – to show how they are articulated one in the other; as connections are established and fall away, as they are policed and maintained. In this discussion, a further element will be added to this interpretation of imaginative geographies: this is power; or, more properly, power as it works through networks of meaning.

Imaginative Geographies: The Latent and the Manifest in Orientalism

In dreams, I have shown that meaning travels. Now, I will change scale. In Orientalism, meaning travels too. In both dreams and Orientalism, images do not travel directly or easily – power which makes the journey possible, even necessary, is also responsible for policing and managing trains of thought moving from one place to another. In Said's classic work on Orientalism,[62] he draws a parallel between the journeys from East to West and from the unconscious to the conscious. It is this parallel which I would like to trace in this section, though the direction this eventually takes is somewhat different.

In the midst of his erudite study, Said draws a distinction between latent and manifest Orientalism. The use of the latent/manifest distinction has prompted some writers, especially Homi Bhabha and Robert Young, to suggest that Said is drawing on Freud's analysis of dreams. In this light, there would be a connection, on the one hand, between latent dream-thoughts and Orientalism's latent content and, on the other hand, between manifest dream-content and the manifest content of Orientalist texts. I would like to pursue this in two ways. First, I will argue that it is unlikely that Said was drawing on psychoanalysis but, secondly, that if Said had drawn more extensively on dream-analysis, then he would have been able to see other ways in which the imaginative geographies of Orientalism were constituted. These other ways not only include the constitution of networks of meaning and power, but also the (re)composition of different space–times (partly through condensation and displacement) *within* these networks.

For Said, the Orient is an imagined place, produced out of the encounter between Europe and its others. The other is constructed within a discourse, both materially and imaginatively; a discourse

which can be called Orientalism. Orientalism does not simply exist in the mind or in fiction, it is materially supported by 'institutions, vocabulary, scholarship, imagery, doctrines, even colonial bureaucracies and colonial styles'.[63] Out of these myriad practices, Orientalism produces an imagined place, the Orient, which is invested – even overdetermined – with meaning. However, Orientalism is not just some 'airy European fantasy about the Orient, but a created body of theory and practice'.[64] Through Orientalist theories and practices, an imaginative geography of the Orient was produced and circulated throughout the West. It was this imaginative geography that enabled the West to position itself as superior and enabled the West not only to conceive of its imperial projects but also to actually carry them out. Orientalism is, therefore,

> a *distribution* of geopolitical awareness into aesthetic, scholarly, economic, sociological, historical, and philological texts; it is an *elaboration* not only of a basic geographical distinction (the world made up of unequal halves, Orient and Occident) but also a whole series of 'interests' which, by such means as scholarly discovery, philological reconstruction, psychological analysis, landscape and sociological description, it not only creates but also maintains; it *is*, rather than expresses, a certain will or intention to understand, in some cases to control, manipulate, even to incorporate, what is a manifestly different (or alternative and novel) world; it is, above all, a discourse that is by no means in direct, corresponding relationship with political power in the raw, but rather is produced and exists in an uneven exchange with various kinds of power.[65]

The Orient became Europe's 'collective day-dream':[66] not only through the knowledges that Orientalism produced and the means through which they were circulated and maintained; but also through the anecdotes, tales, myths, stereotypes and so on which animated these knowledges, and also through the unequal exchanges between the West and the Rest. The imaginative geographies of the Orient allowed the West to dream of adventures, sexual encounters, fame and fortune – and of Empire.[67] In this daydream, imaginative geographies function in three related ways (according to Said). First, they dramatize and delimit the differences between the East and the West, partly by substituting (or condensing) meanings. Secondly, they localize and distance the East from the West,

partly by displacing meanings.[68] The border between East and West separates them off, so that the West can be sure that the other is somewhere else, outside. Nevertheless, the border joins as it divides. East and West lie side by side, simultaneously (too) close and far (away).

There is a third way in which imaginative geographies produce the Orient as daydream. The Orient becomes a real place (for the West) through its exploration, naming, classification and mapping. Through networks of meaning, identity and power, a universe of representations is used to fix the borders between East and West and to fix the meaning of the East. But, if Said is to hold this sense that the West fixes the meaning of the East, then he has to do so in full awareness of the diversity of Orientalist texts and, more importantly, of the conflicts *between* Orientalists. In order to find a fixed point of reference – the point of articulation which enables the West's flexible superiority – Said suggests that there is an 'unconscious positivity' underlying Orientalism, despite clear differences in the stated views of Orientalists.[69] So, while there is stability within latent unconscious Orientalism, manifest conscious Orientalism is in continual flux. In this way, Said is able to demarcate what stayed the same and what changed in Orientalist texts, without allowing this to destabilize his sense of the West's domination over the East.

Whatever the expressed views of the Orientalist, unconsciously the Orient was produced as a place without history, outside of time and progress. Significantly, 'Geography was essentially the material underpinning for knowledge about the Orient. All the latent and unchanging characteristics of the Orient stood upon, were rooted in, its geography.'[70] The slippage between Geography-as-discipline and geography-as-land is revealing if only because it does not matter. The latent dreams of the West were made real through both Geography and geography, but geography also grounded the manifest, flexible superiority within Orientalist texts:

> Every one of them kept intact the separateness of the Orient, its eccentricity, its backwardness, its silent indifference, its feminine penetrability, its supine malleability ... every writer ... saw the Orient as a locale requiring Western attention, reconstruction, even redemption. The Orient existed as a place isolated from the mainstream of European progress in the sciences, arts, and commerce.[71]

The Orient of colonial theories and practices was imagined in relation to a geography which dramatized it, localized it and made it (seem) true, even though it was far from real – just like a dream. For Bhabha, Said is clearly drawing on Freud to suggest that colonial discourses – and colonial subjectivities – are produced out of unconscious as well as conscious processes.[72] In this way, Said can be seen not only to properly identify both the unconscious fantasies and ideas that underlie Orientalism but also to situate the consciousness of the West within the historical and social conditions of its production. However, Bhabha criticizes Said for failing to extend his analysis to the ambivalences of Orientalism. This is a significant point, for Said's understanding of the unconscious does not appear to be psychoanalytic.

In psychoanalysis, the unconscious is energized, unstable and without negation. By failing to see latent Orientalism as dynamic, contradictory and mutable, Said places it both outside of history and outside of encounters with the other. In this way, it becomes the pre-eminent site of domination, but in a way that cannot reveal how 'unconscious positivities' might be manifested differently, either by the colonizer or by the colonized. In this way, latent ideas become as old as the hills, rooted in geography. The irony is that Said (*contra* most critiques) is able to see the manifest differences and conflicts within the West, but elides overt differences and conflicts within and between the rest, and thereby elides the different histories and geographies of imperial practices as seen from the perspective of the colonized.

Further, as Robert Young points out, Said's own use of the latent/manifest distinction slips between the beginning of the chapter and the end.[73] At the outset, a latent 'unconscious positivity' underlies the manifest 'stated views' of Orientalists. While this can be criticized, as Bhabha does, by the end of the chapter Said suggests that latent Orientalism is replaced by manifest Orientalism. In this sense, Said is suggesting that a positive engagement between East and West is replaced by Orientalism as a manifest epistemological framework for the institutions and practices of imperial power. If Said was briefly taken with a Freudian scheme for interpreting Orientalism, then he quickly abandons this in favour of a more Foucauldian analysis of the shift from one Orientalist 'vision' to another. More has been lost, though, than a sense of the dynamism within and between latent and manifest Orientalism.

To reinstate this dynamism, Bhabha's psychoanalytic interpreta-

tion of the colonial situation reveals its constitutive ambivalence as both the colonizer and the colonized are *positioned* in an unequal and uneven economy of exchanges: where each internalizes the other as its opposite, where each is alienated from the other. At the heart of this economy is both fear and desire: fear of the other, desire for the other. For Bhabha, then, it is the phobia and the fetish that characterize the nightmarish psychodrama of colonialism: they mark the site of displacement and substitution. Orientalism becomes, in this reading, the dream-like production of lands which are as exotic and erotic as they are savage and barbaric.

For both Young and Bhabha, Orientalism produces a dreamlike imaginative geography of the Orient – as a Western imaginary, characterized by internal conflict and tension, is projected onto the space of the Orient. The Orient becomes a theatre in which the West dramatizes its own pleasures and unpleasures, plays out its desires and fears, and territorializes its dreams of wealth, fame and power. Nevertheless, in order for the Orient to become the blank screen-space onto which Western fantasies can be projected, the West needs to establish connections, extending networks of meaning and power into worlds interior and exterior. However, these networks ruin the screen; the Orient cannot simply be the West's other, nor merely the result of the West's fantasies and internal conflicts.

In theory, Said and Bhabha lend strength to the idea that imaginative geographies inside the head and under the foot are articulated in relation to one other – but these relationships can be better understood once colonial imaginative geographies are conceptualized as dreamlike. If dreams are produced by networks of meaning (and power) which are themselves produced in relation to thoughts and wishes, then it is possible that the Orient too is produced by networks of (meaning and) power in relation to thoughts and wishes. This much is clear already: Orientalism was fashioned in relation to not only fantasies of wealth and fame, but also the sexual fantasies of Westerners. However, what becomes significant now are the dreamlike (net)works of Orientalism – not just as they connect or disconnect the external world, not just as they work in fantasy, ambivalently, but also as they construct or enable the reterritorialization of space and time. I will draw this section to a close by using an illustration, beginning with a story told by Bruno Latour.[74]

On 17 July 1787, the captain of the French ship *L'Astrolabe*, Lapérouse, landed on a beach somewhere in the East Pacific. While

Lapérouse was using the charts of earlier travellers, it was not clear whether this beach was part of an island or of the mainland. To his delight, the natives there told Lapérouse that this was indeed an island. Even better, they were able to draw a map of the island in the sand, giving Lapérouse a bird's-eye view of the shape of the island. With due accuracy, not only was the map copied down, but the island was quickly explored by scientists collecting as much information as they could. Within a day, Lapérouse had set sail and vanished over the horizon. Lapérouse's expedition was eventually lost, but the information gathered on that day was taken back to France – where it was interpreted. With more than a hint of irony, Latour puts it this way:

> In less than three centuries of travels such as this one, the nascent science of geography has gathered more knowledge about the shape of the world than had come in a millennia. The *implicit* geography of the natives is made *explicit* by geographers; the *local* knowledge of the savages becomes the *universal* knowledge of the cartographers; the fuzzy, approximate and ungrounded *beliefs* of the locals are turned into a precise, certain justified *knowledge*.[75]

For Latour, the Chinese fishermen and the French explorers had crossed paths, but they were going in very different directions and were connected into very different networks. It is the information that Lapérouse gathered that enabled a later expedition, this time by the British, to arrive at the island. However, the relationship of power has altered. In the first encounter, the explorer's position is fragile, dependent on the native for information and possibly more. Only in later encounters is the geography of colonization imaginable. In Latour's telling of the story, however, it would seem that Lapérouse and his scientist companions were perfectly, seriously rational men. And that the information that is gathered at the centres of interpretation – that is, in the map-rooms of Europe – is sorted and collated by cool, calculating cartographers.

In this way, Latour suggests, a great divide is opened up between the 'local' beliefs of natives and the 'global' knowledge of the Westerners. As the West accumulates knowledge, so power accumulates in the West. In this account, Latour echoes Said's sense of the shift from a latent Orientalism (characterized by positivities) to a manifest Orientalism (characterized by domination). For both Latour

and Said, further, power subsists at the centres of interpretation, in the hands of imperial map-makers.[76] However, imaginative geographies – and, therefore, the power relations embodied in colonial theories and practices – cannot be understood if they are not also understood as dreamlike. Let us have another story.

Simon Schama tells of another voyage of discovery.[77] In this story, these discoverers seem much less like sensible men gathering information to be interpreted back home. Rather, these men are adventurers, acting on their wits and instincts, accustomed to risking their lives for their dreams. These dreams were woven out of the tiniest scraps of information, associated with other beliefs and turned into imaginative geographies – of lost worlds, a golden age. In this case, the discoverer-dreamer is Sir Walter Ralegh, an Elizabethan privateer. In 1586, during one of his raids, Ralegh had snared Pedro Sarmiento de Gamboa, who was the Spanish governor of Patagonia. While captured, the Spanish governor told Ralegh about the amazing tale of Juan Martin de Albujar.

Juan Martin de Albujar had been responsible for munitions on an expedition, led by Pedro Maraver de Silva, in search of the Incas, somewhere east of the Cordillera and somewhere north of Peru. The expedition had become hopelessly split up into small bands of desperate men. Though Juan Martin de Albujar was banished for negligence, he was actually the only one of the expedition to survive. And he was discovered, some twenty years later (in 1568), living with the natives. According to Pedro Sarmiento de Gamboa, Juan Martin de Albujar had told of being led blindfolded by the natives to a place where everything was golden – the natives' bodies were covered in gold, all the ornaments were gold-plated – where the land itself seemed to be made of gold. This was El Dorado. In Juan Martin de Albujar's story, El Dorado was 'the golden one': a native chief, whose body had been covered in oil and gold dust. But this is not the El Dorado that Ralegh dreamed of. Instead, Pedro Sarmiento de Gamboa's version of the tale had conjured up images of a golden city, with unlimited wealth. As 'El Dorado' travelled through networks of meaning, along chains of association with gold links, it mutated: the golden one, the golden city, the golden age, gold.

From Said, we can learn that El Dorado is discursively constituted: a material fiction which underpinned a geopolitical awareness and embodied a will to power. From Bhabha and Young, it is possible to see the fetishes and phobias that determined and constituted Ralegh's never-ending desire to return to El Dorado. For,

as Schama shows, dreamy undercurrents of sexuality flow through Ralegh's accounts of his first expedition. From Latour, it is possible to see the importance of the time that Ralegh spent at home studying and drawing maps and charts of the Orinoco river, plotting possible positions for El Dorado, and plotting his expedition. All these are part of the story. Further, however, we can see that they entail a dreamlike imaginative geography, that is not just the backdrop against which the story takes place, but it actually determines the actions of the adventurers. In this, maps of meaning reveal the contours not just of possible paths through the terrain, but also of the desire and fear that (trans)form the landscape. Meanwhile imaginative geographies situate and dramatize – simultaneously – the latent and the manifest, condensations and displacements, fetishes and phobias, desires and fears, the material and the fantasized.

Ralegh inhabits a dreamed-of world, which he is struggling to realize, rather than to wake from. And, when he hears from a captured Spanish soldier, Antonio de Berrio, information that apparently confirms the location of El Dorado, Ralegh collates and correlates the 'evidence' in order to convince others of any expedition's success. Of course, Antonio de Berrio's information was not first-hand, but itself gleaned from stories told by the Caribs about a place they had heard about somewhere in the Guiana highlands. There were even claims to have seen the walls of El Dorado – from afar. Once again, 'the golden one' had travelled, unreliably, along trains of thought, driven by desire, through a dreamlike imaginative geography. From this perspective, El Dorado is like a dream-element: a mutable collocation, a point of attachment, connected into other sites of meaning and desire through chains of associations, dynamic and energized. And, like dream elements, El Dorado was true enough. By 1595, after a great deal of preparation (and some nine years after first hearing of it), Ralegh was himself exploring the delta of the Orinoco, searching hopefully for the route to the lost city of gold.

Sailing up the Orinoco river, however, was no easy matter: its navigation is difficult, the sailors were beset by disease, by strange creatures, by the uncomfortable climate – and by a seemingly malevolent river. After weeks on their forlorn quest, the expedition was almost at death's door when, by surprise, they captured a native. Under threat, the native promised to take the exhausted men to a village, but to get there Ralegh must divide the men into small groups. A fierce argument breaks out amongst the men in Ralegh's expedition

– should the native be trusted or was this a plot to bring about their doom? One way lies a dream, the other a nightmare.

Conclusion: Minding Dreams

This chapter has travelled some distance – from the interpretation of dreams to the dream of El Dorado – but this journey has consistently followed a path *inside* the networks which articulate interior and exterior worlds. That is, I have shown that, whatever their differences, dreams and imaginative geographies both produce, and are produced by, articulations of interior and exterior worlds. Further, these worlds do not exist in relations of space and time that are somehow 'outside' of the subject. Instead, different spaces and times are produced inside networks of meaning and power. Interior and exterior worlds are themselves the products, therefore, of fragile networks built to make the ('real') world real. I have implied that meanings are 'energized' by their flow through networks, while power operates in part by 'localizing' meanings within a network. It is this that the imaginative geographies of dreams and dream-like imaginative geographies share. I have also argued that these networks are far from static, stable grids with already established connections between all possible nodes in the system: the journey from London to El Dorado might seem impossible; the connection can be a dream. 'Yet Ralegh's first journey to Guiana did indeed produce gold: not the clinking metal of his dreams, but a breathtaking narrative; the prototype of all imperial upstream epics. It was, of course, packed with lies, boasts, fables, and fancies.'[78]

Ralegh made it back from his first expedition, but a second attempt led eventually to his downfall – he lost his head (in a world of dreams). Of course, I am deliberately allowing the dream of fame and fortune to be allied with the dream of a policeman going into a church. Let me be clear, I am not saying that one dream (of El Dorado) is exactly that same as the other (of sex). There are differences, for example concerning the different circumstances involving the production, circulation and reception of dream-narratives and dreamlike narratives. On the other hand, I am placing them side-by-side in order to suggest possible ways in which they might be related. If Ralegh's boastful fable caught the imagination, then maybe this is because it tied up with the unconscious longings of the Elizabethan court. If the dream of the policeman/church says anything,

then it might be the impossibility of voicing certain desires within the moral and personal world of the dreamer. I am not arguing that interior and exterior worlds are the same, but that they are produced as spaces in relation to one another. And, I am suggesting, this can only be so because – like any border – the boundary lines between interior and exterior join as much as separate. Further, like many borders, you can only tell where it is when things cross, or threaten to cross, it. Further still, these boundaries are drawn at different scales, deploying different cartographies of meaning, identity and power. If there is a politics in this, then it will be found not just in the ways boundaries are drawn, but in the trains of thought, the paths of association that simultaneously mark them out and transgress them.

Ralegh's expedition set out with compasses, sails and a full-blown dream, a map drawn from the imagined knowledge of stories about a city of gold, of gold dust glimmering seductively on the body of a native chief; natives drew their maps in the sand for Lapérouse and, before the sea could wash it away, he was able to imagine himself on an island; a policeman, accompanied by two tramps, walks step by step into a church. None of these narratives are innocent of their circumstances, innocent of desire, innocent of social and moral codes, innocent of the social production of meaning, identity and power. Nevertheless, each innocently traces out connections that have to be established and re-established, each connection leading forward to new associations and backwards to earlier ones. It is here, then, that politics might work.

Of course, political rhetoric has often made use of the word 'dreams', as a counter-image to the world as it is: sometimes to suggest a better future (need I cite Martin Luther King?) or to convey a sense that reality itself is a delusion (what about Walter Benjamin?). Indeed, dreams themselves have been seen as a 'liberation' from reality (as Freud noted). But I would suggest that the significance of dreams is not to have them nor to wake up from them. If dreams are a royal road, then this is a two-way street, and what we might have to learn is to see the dreams in our realities and the realities of our dreams – in this, a blend of geography and psychoanalysis should be invaluable. And, if this is a political project, then dreams are not to be naively valued; one person's dream is so easily another's nightmare. Instead, politics might be about locating dreams and dreaming again about transforming networks of meaning, identity and power. As the (neatly ambiguous) T-shirt slogan, which I saw hanging in a London shop recently, puts it: *Learn to Dream*.

Notes

1 See Steve Pile, *The Body and the City: Psychoanalysis, Space and Subjectivity* (London: Routledge, 1996), pp. 9–15, 81–8.

2 Sigmund Freud, *The Interpretation of Dreams* (Harmondsworth: Penguin Freud Library; vol. 4, 1976).

3 Dreams have attracted little serious attention in geography. A notable exception is Sack's categorization of dreams as a purely subjective space (R. Sack, *Conceptions of Space in Social Thought: A Geographic Perspective* (London: Macmillan, 1980), pp. 105–8). Since Sack draws heavily on Freud, he is able to see the creativity, mutability and dynamism of dreams. Nevertheless, Sack believes that they are also insubstantial and illusory – and, further, fails to assign to them anything but personal meanings.

4 R. Bowlby, *Shopping with Freud* (London: Routledge, 1993).

5 Sigmund Freud, *The Interpretation of Dreams*, pp. 57–165.

6 S. Flanders (ed.), *The Dream Discourse Today* (London: Routledge in association with the Institute of Psycho-Analysis, 1993).

7 See: Sigmund Freud, 'Fragment of an analysis of a case of hysteria: "Dora" ' (1905), for a demonstration of his use of a dream fragment in therapy in *Case Histories I: 'Dora' and 'Little Hans' vol. 8.* (Harmondsworth: Penguin Freud Library, vol. 18, 1977), pp. 35–164; Sigmund Freud, 'Delusions and dreams in Jensen's "Gradiva" ' (1907), on the use of dreams in literature in *Art and Literature: Jensen's 'Gradiva', Leonardo Da Vinci and other works* (Harmondsworth: Penguin Freud Library, vol. 14, 1985), pp. 33–118; Sigmund Freud, 'Creative writers and day-dreaming' (1908), for his analysis of the difference between a dream and a day dream and why a dream is not a work of art, in *Art and Literature: Jensen's 'Gradiva', Leonardo Da Vinci and other works* (Harmondsworth: Penguin Freud Library, vol. 14, 1985), pp. 131–41. For later additions to his work on dreams see: Sigmund Freud, 'A metapsychological supplement to the theory of dreams' (1917) in *On Metapsychology: The Theory of Psychoanalysis* (Harmondsworth: Penguin Freud Library, vol. 11, 1984), pp. 229–43. Sigmund Freud, 'Beyond the pleasure principle' (1920), in *On Metapsychology: The Theory of Psychoanalysis*, (Harmondsworth: Penguin Freud Library, vol. 11, 1984), pp. 275–338; Sigmund Freud, (1933) *New Introductory Lectures on Psychoanalysis*, (Harmondsworth: Penguin Freud Library, vol. 2, 1973). Other significant writings by Freud on dreams include: Sigmund Freud, 'On dreams', (1901), *Standard Edition*, vol. V; Sigmund Freud, 'The handling of dream-interpretation in psycho-analysis' (1911), in 'Papers on technique', *Standard Edition*, vol. XII, pp. 91–6; Sigmund Freud, 'Introductory lectures on psycho-analysis' (1916–17), *Standard Edition*, vols XV–XVI, ; Sigmund Freud, 'Remarks on the theory and practice of dream-interpretation' (1923), *Standard Edition*, vol. XIX; and Sigmund Freud, 'Some additional notes on dream-interpretation as a whole', *Standard Edition*, vol. XIX.

8 Freud, *The Interpretation of Dreams*, p. 44.

9 Ibid. p. 56.

10 Indeed, Khan has suggested that it is the relationship between intrapsychic agencies in the mind that creates a 'dream-space'. M. Khan, 'The use and abuse of

dream in psychic experience' (1974), in Flanders, *The Dream Discourse Today*, pp. 91–9.

11 See E. Wright, *Psychoanalytic Criticism: Theory in Practice* (London: Methuen, 1984); and L. R. Williams, *Critical Discourse: Psychoanalysis and the Literary Subject* (London: Edward Arnold, 1995).

12 Freud, 'Delusions and dreams in Jensen's "Gradiva"' in Penguin Freud Library, vol. 14; 'Creative writers and day-dreaming', ibid. pp. 131–41.

13 D. Gregory, *Geographical Imaginations* (Oxford: Blackwell, 1994).

14 This quote is so familiar, it has become a cliché. It is most often used to support the idea that dreams are a privileged (royal) resource in therapeutic settings. The fact that this is also a spatial (road) metaphor has not attracted any attention.

15 For example, Freud's dream of Irma's injection takes one page to recount (p. 182), the preamble a page and a bit (pp. 180–1) and the analysis just about 12 pages (pp. 183–95), and even this is supplemented by over a dozen further references.

16 Freud, *The Interpretation of Dreams*, p. 485.

17 The absence of an analysis cannot be explained by the dreamer being neither Freud nor one of his patients. Everywhere else, he interprets dreams, from whatever source.

18 Freud, *The Interpretation of Dreams*, p. 485.

19 See, for example, Ibid. p. 92.

20 Ibid. p. 485.

21 Ibid. p. 169.

22 Ibid. p. 244. This idea also appears throughout *The Interpretation of Dreams*, see especially pp. 201–13 and 701–27.

23 Ibid. p. 330. See also pp. 330–1, 722 and 736.

24 Ibid. p. 114.

25 Ibid. p. 383.

26 Ibid. p. 389.

27 On page 529, Freud suggests that 'robbers, burglars and ghosts . . . all originate from one and the same class of infantile reminiscences. They are nocturnal visitors who rouse children . . . In every case the robbers stood for the sleeper's father, whereas the ghosts corresponded to female figures in white night-gowns' (paragraph added, 1909).

28 Ibid. p. 390.

29 See, for example, pp. 195, 400–3 and 411–12.

30 Ibid. p. 263.

31 Ibid. p. 414.

32 Ibid. p. 215.

33 Ibid. p. 422.

34 Ibid. pp. 82–105 and 267.

35 Freud clearly demonstrates that scenes are set up using spatial images and an imaginative geography – the sexualized, gendered dream of the policeman and the landscape is only one example amongst very many. Further, the body – specifically, the sexed body – is a significant and frequent referent for much dream-thought (see, for example, pp. 95–102, 156–7, 237–8, 320–2, 462–3, 471–

91, 509, 521–7). Moreover, the body is spatial: for example, mapped as 'up above' and 'down below' regions (see p. 536). About all this, I would have liked to have said more, but there is not space to do so.

36 Sack, *Conceptions of Space in Social Thought*, p. 107.

37 Freud, *The Interpretation of Dreams*, p. 432.

38 See Flanders, *The Dream Discourse Today*; M. Khan (1974), Ibid. pp. 91–9.

39 The use of 'depth' is not accidental: Freud uses this metaphor on many occasions (see, for example, pp. 654 and 677). For an alternative understanding of Freud's depth psychology see H. Ferguson, *The Lure of Dreams: Sigmund Freud and the Construction of Modernity* (London: Routledge, 1996).

40 Freud, *The Interpretation of Dreams*, p. 99.

41 Ibid. p. 99.

42 Ibid. p. 424.

43 Ibid. p. 425.

44 Ibid.

45 See, especially, the analysis of 'A lovely dream', pp. 390–5.

46 Sigmund Freud, *The Interpretation of Dreams* (1900), pp. 312–13.

47 Ibid., p. 226.

48 Ibid. p. 711n.

49 Ibid. pp. 113, 684–5 and 702.

50 Ibid. p. 685.

51 Ibid. p. 113.

52 Ibid. p. 685.

53 Ibid. pp. 686, 687 and 690.

54 Ibid. pp. 690–1.

55 It is no accident, therefore, that contemporary psychotherapy is preoccupied with 'borderline' patients.

56 Freud, *The Interpretation of Dreams*, p. 724.

57 See Flanders, *The Dream Discourse Today*.

58 Freud makes so much use of these metaphors that there is no point in citing specific examples.

59 Freud, *The Interpretation of Dreams*, p. 752.

60 Ibid. pp. 752–3.

61 In case this is too cryptic, these relate to the defence mechanisms of repression, reversal into opposites, inversion and sublimation. See Sigmund Freud, 'Inhibitions, symptoms and anxiety' (1926) in *On Psychopathology: Inhibitions, Symptoms and Anxiety and Other Works* (Harmondsworth: Penguin Freud Library, 1979), vol. 10, pp. 237–333; also Sigmund Freud, 'A metapsychological supplement to the theory of dreams' (1917) in *On Metapsychology: The Theory of Psychoanalysis*, (Harmondsworth: Penguin Freud Library, vol. 11 1984), pp. 229–43.

62 Edward Said, *Orientalism* (Harmondsworth: Peregrine, 1978).

63 Ibid. p. 1.

64 Ibid. p. 6.

65 Ibid. p. 12.

66 Ibid. p. 52.

67 See Edward Said, *Culture and Imperialism* (London: Vintage, 1993), p. 95; M. Green, *Dreams of Adventure, Deeds of Empire* (London: Routledge & Kegan

Paul, 1980); and G. Dawson, *Soldier Heroes: British Adventure, Empire and the Imagining of Masculinities* (London: Routledge, 1994).

68 Said, *Orientalism*, pp. 55 and 209.

69 Ibid. p. 206.

70 Ibid. p. 216.; Said, *Culture and Imperialism*, p. 93.

71 Said, *Orientalism*, p. 206.

72 Homi Bhabha, *The Location of Culture*, (London: Routledge, 1994), ch. 3., pp. 66–84.

73 R. Young, *White Mythologies: Writing History and the West* (London: Routledge, 1990), p. 130.

74 Bruno Latour, *Science in Action: How to Follow Scientists and Engineers through Society*, (Cambridge, Mass.: Harvard University Press, 1987), ch. 6.

75 Ibid. p. 216.

76 Following Said, *Orientalism*, p. 222; see also D. Wood, *The Power of Maps* (London: Routledge, 1992).

77 S. Schama, *Landscape and Memory* (London: HarperCollins, 1995), pp. 307-20.

78 Ibid. p. 312.

9

The Humanist Freud

Joanne Brown and Barry Richards

The aim of this chapter is to argue for a particular approach to un-
derstanding and shaping the psychoanalytic contribution to con-
temporary culture, one which acknowledges the destabilizing and
decentring effect which analysis can and should have on the sense of
self, but which argues nonetheless that a centred self can hold, rooted
in the enduring moral structure which the deepest explorations of
the unconscious have revealed.

Our argument starts with a distinction between two broad con-
ceptions of the unconscious. We suggest that the unconscious can
be conceptualized both as a field of associative activity and as the
core of human morality, and that an exploration of this distinction
can sharpen our understanding of what psychoanalysis is and of the
role of the ego. We go on to link this distinction to a number of
others made between varieties of psychoanalytic thought, and to an
overarching tension between humanist and anti-humanist tenden-
cies in social thought, and argue that it is a reconceptualized ego
which can best contain and integrate these ambivalences.

This consideration of how Freud might be leaving this century,
and of what he takes with him into the new millennium, will begin
with a look at how he entered the world. A number of Freuds were
to be encountered in the early decades of this century, and some of
them have constantly reappeared as protagonists (at times in oppo-
sition to each other) in some of the key intellectual debates of our
times. There is still much to be resolved concerning the kinds of
ideas, practices and values which 'Freud' is believed to embody or
to be responsible for, and the areas of social life in which he has most
influence.

Hinshelwood has reviewed the 'points of cultural access' through
which psychoanalysis entered British culture in the years up to and

including the First World War.[1] He identifies seven such points or conduits. There were the professional and scientific domains, mainly the psychotherapies emerging in psychiatry, but also academic psychology. There were the worlds of literature (particularly the Bloomsbury circle) and progressive education. There was philosophy (though this was on the whole a rather unreceptive field in Britain). And, reaching into the wider culture from the researches of early psychologists and others, there were the interests in spiritualism and in sexuality.

It may have been very difficult to predict, from the standpoint of the 1920s, which of these fields might have provided the most fertile soil for psychoanalysis to grow in during the rest of the century. The process by which psychoanalysis became encapsulated within a highly professionalized enclave had not begun to dominate developments, and it might have seemed as likely that Freud would be best known by the millennium as psychology's Darwin, or as a rival to Dewey in the field of education, as that his name would signify a mythical encounter with a sexualized version of truth in a bizarrely formal setting. Yet the last is, for the most part, what has happened this century. Freud did not provide a new basis for the discipline of psychology, which continued along other paths, albeit at times shaped by a reaction against him. (One of us has written previously about the great lengths to which psychology has sometimes gone to ensure that Freudian thought did not influence it in any serious way.[2]) In education it was Piaget who had the greatest impact from psychology, while in literature and philosophy Freud has remained a marginal presence. Spiritualism did not prosper for some time, and in its New Age prosperity has little time for someone as sober and difficult as Freud.

So it is only in the therapeutic professions and the 'sexual revolution' that the initial access has led on to a major and lasting influence. Foucault and others have argued that the changing mores and meanings around sexuality, and its new centrality to self and identity, are of profound importance. Yet it is not clear whether Freud can take much credit for bringing these changes about, or whether he is himself a part of them. Moreover in recent years psychoanalysis has come to stand more for sexual conservatism than liberation, as in the debates around the views of some analysts on homosexuality. There has anyway never been much doubt amongst most analysts (Reich notwithstanding) that anything more than very moderate promiscuity is pathological.

We can conclude then that it is really only in the sphere of professional therapeutics that Freud has stood clearly as a major figure. We can think diagrammatically of the progress of psychoanalysis this century as through a funnel, broad and open at both ends but narrow along its central passageway. At the start, there was a wide set of instances and possibilities. By the 1930s, in Britain and the United States at least, these had narrowed into a professional specialism, heavily insulated from other knowledge and practices despite the ubiquity of bits of 'Freud' on the surface of the wider culture. If Freud had become a 'climate', as W. H. Auden suggested, it was not one to which many regions were directly subject. Since the 1970s, there has been a fanning out of the influence of psychoanalysis, across the welfare professions and the intelligentsia, with Freud (and now also his successors) reclaiming a broader place in cultural life.

This last phase is what might have been expected given cultural changes of recent decades, specifically the growth of 'therapeutic culture' – the increasing attention paid in nearly all major social institutions (of education, welfare, leisure and even commerce) to the importance of emotional life, and the strengthening of belief in the value of self-reflection and self-knowledge. While Rieff's phrase 'the triumph of the therapeutic' might be an overstatement, it is not hard to see that many spaces have opened up in both professional and everyday cultures into which psychoanalytic ideas can flow.[3]

What further widening and variety, exhaustion or transmutation of the psychoanalytic influence there may be in the future is as difficult to predict as the last century's developments, though it is the task of this book to foresee and contribute to the future.

The Unconscious as Association

There is wide agreement that the fundamental concept of psychoanalytic theory is the unconscious, and that as a therapeutic technique psychoanalysis is distinguished by a consistent focus on unconscious process. The unconscious is a domain of mental life that is not normally available to consciousness. There is less consensus on the questions of what it contains or consists of.

One of Freud's answers to this question seems to settle the matter. The unconscious is full of mental processes which are subject to the 'Pleasure Principle', and which conform to the 'primary

process'. They are not subject to time, reason or any other of the constraints of external reality or rationality; they are free from both the logic of necessity and the necessity of logic. Contradictory impulses exist side-by-side; images fuse and split in kaleidoscopic patterns formed by the constant collisions of internal forces (impulse and anxiety) with the external world (the contingent materials of everyday life). Thus chance events from the day before provide the raw material for dreams; the circumstances of a trauma help shape the consequent neurotic symptom. This is the unconscious as association, as the process by which links between diverse elements of experience are continually made, reactivated and remade.

The centrality of association to the very nature of the unconscious is confirmed by the fact that the fundamental principle of psychoanalysis as a therapeutic technique is free association. This is the 'fundamental rule' for the analysand: to speak whatever comes into the mind. It is based on the assumption that to do so will bring the workings of the unconscious into view; it will allow the matrices of associative connections which comprise the unconscious to be expressed, at least in part. The self so revealed is easily construed as the continually shifting and decentred self now familiar in theories of the postmodern.

The unconscious as association is the dominant model in Freud's own work. Though we will show that a competing understanding was to emerge in his later writings, as late as in his 1915 essay 'The Unconscious' it was this model alone that was present.[4] The system Ucs. has no order, and is subject only to the Pleasure Principle. There is no structure of any kind, least of all a settled structure of moral constraint. 'In the Ucs. there are only contents, cathected with greater or lesser strength.'[5] The mobility of cathexes via the associative processes of condensation and displacement is the only activity at this level of the mind. True, the occasions for this mobility were typically concerned with what might be called moral issues. In 'The Interpretation of Dreams' and 'The Psychopathology of Everyday Life', where Freud documents profusely the associative work of the mind in hundreds of diverse examples, it is often a wish or a prohibition that channels the energy and so produces the dream image or the deflection of memory, speech or action.[6] However, these are fragmentary episodes, in which the manifest content of the dream or the waking parapraxis arises from a contingent clash between mental forces, or expresses a circumscribed dilemma. It is the discrete quan-

titative strength of the episodic forces that matters, and there is no sense of an overall moral agenda, a coherent matrix of developmental struggle.

The most famous result of the psychoanalytic use of associative links to explore the underlying matrix of experience is the opportunity thus provided for revealing the sexualization of everyday life. The pleasures of eating or of sport, and many ordinary worries, for example, could be shown to have sexual origins or meanings, at least within the expanded definition which Freud gave to the term 'sexuality' as sensuality. While another form of psychology – behaviourism – was also based on the principle of association, psychoanalysis had a distinctive vision of the mind as association. Firstly the ultimate ground of reference was the body and sensual experience. The associative chains had to end up there sooner or later. Secondly, these chains had to traverse a field of structured relationships between people, particularly the three-cornered Oedipal relationship. The importance of castration, for example, as one of the bodily referents could be explained only in terms of the Oedipal conflict. Behaviourism, in contrast, saw association-forming as a process in which the monadic individual (seen as an organism, not a mind) made links between discrete stimuli and events (including the actions of other individuals) in the environment, links that did not have to refer to the individual's bodily experience. However the implication of its structuring by relationships for the theory of the unconscious is not recognized by Freud until much later.

There is then a common source of psychoanalytic and behaviourist theories in the philosophy of associationism, in the belief that association is a fundamental process in mental life. However the development of the idea in the two theoretical frameworks is radically different; psychoanalysis sought to interpret the flow, treating it as an internal, psychic production, while behaviourism saw it as matter of external circumstances modifiable through environmental manipulation.[7]

While this idea of the unconscious as association remains essential to psychoanalytic work, there is a different conception of the unconscious, rooted as deeply in the development of psychoanalysis, though crystallizing later and never achieving the same pre-eminence in Freud's thought. Both conceptions have long been axiomatic, but the relationship between the two has borne little examination.

The Moral Unconscious

Quite different from the image of the unconscious as a place of unrestricted associative activity, and even at one level apparently in opposition to it (yet often existing alongside it without any sense of contradiction!), is the understanding of the unconscious as the location of the moral core of selfhood. Implicit from the beginning in the idea of repression, this idea crystallized clearly in the theory of the Oedipus complex and then came to fuller fruition in the concept of the superego as the seat of morality, part conscious and part unconscious, in the individual. By the time he wrote the 'New Introductory Lectures', Freud was able to see that his earlier formulation of the ego as distinct from, and often opposed to, the unconscious was misleading.[8] It had become clear that parts of the ego, and of the more recently-identified superego, were unconscious, *'without possessing the same primitive and irrational characteristics' of the id* (emphasis added)'.[9] Freud himself made this discovery rather too late for there to be much time for its radical impact on the theory of the unconscious to be worked out. The project of this chapter is to draw attention to this transformation of the concept of the unconscious, and its links with changes in the theory of the ego. It has been the major task of much of the post-Freudian development to explore its implications, taken up particularly in British psychoanalysis, and in so doing to complete the transition from psychobiological or instinctivist perspectives to object relational ones, and from a theory of the ego as embattled and marginal agency to one of it as a more inclusive structure built of internalized containments.[10] While this metapsychological transition has been frequently discussed, its implications for the understanding of the unconscious are not so well recognized.

In the individual as pictured by the later Freud, the main moral scenario broadens out from the efforts of the superego into a cosmic struggle between the forces of life and death, a struggle which though often impacting upon conscious experience was constantly taking place in the unconscious. Freud's biologized Manichaeism, whereby the forces of good and evil were represented as biological drives, was the basis for Klein's development of psychoanalysis into an explicitly moral schema of psychic 'positions'. The Kleinian conception of the unconscious has to be understood in relation to the concept of 'unconscious phantasy', which is 'the primary content of

unconscious mental processes'.[11] An unconscious phantasy is a sce-
nario based on a subject–object relationship; the (unconscious) sub-
ject experiences objects and what they are doing to him (nurturing,
attacking, engulfing, abandoning . . .). Thus Hinshelwood states that
'The unconscious is made up of relationships with objects.'[12] All
'higher' mental activity is accompanied by the rudimentary narra-
tives of these relationships, which constitute unconscious phantasy.
While there is a continuity between the conception of phantasy as
the mental representative of instinct and that of Freud in 1915,
for whom the 'system Ucs.'consisted of impulses,[13] or rather their
mental representatives, the notion of phantasy as developed in the
Kleinian tradition clearly adds a great deal to that of impulse – cru-
cially, the sense of relationship and therein the moral question of
how the subject and object treat each other.

The unconscious in this sense is relationally structured; it is not
the 'seething cauldron' of popular Freudianism, nor the bizarre uni-
verse of surrealism, nor a fluid domain of the multiplicity and dif-
ference seen as excluded from the patriarchal order, nor the site of
the unrepresentable 'Real'. It is, rather, a finite set of relational nar-
ratives, organized around a fundamental developmental task. The
conceptualization of that task varies at least in emphasis from one
theorist to another; it may be understood basically as the acceptance
of the reality of the other (as the movement out of narcissism), or as
the acceptance of psychic reality, especially the toleration of destruc-
tiveness (as the movement from the paranoid-schizoid to the de-
pressive position), or in other ways. However, these varying accounts
all pose it as a moral issue, in that what is at stake is the development
of a subject capable of responsible social membership and of giving
and receiving love. To live without damaging others, though it may
seem either too modest or too ambitious an aim for therapy, would
be one way of summarizing the moral project of psychoanalysis,
informed by its various theories which focus on the struggle required
within the subject to achieve such an aim, and on the unconscious as
the site of this moral struggle.

The Dialectical Nature of Psychoanalysis

While seeing the shift from the associative to the moral unconscious
positively, as part of the fruitful transition from an instinctivist to a
relational framework, we also want to argue that the associative model

needs to be retained within the moral one. Of course it could not be otherwise; the fundamentally associative nature of much mental activity and the extensive influence of 'primary process' or 'id' functioning remain indisputable. However, the extent to which this model must qualify or complement the moral, relational perspective is not always explicit. Our argument is for a bifocal understanding of the unconscious; though one focus is dominant, the other is necessary.

The significance of the distinction between the associative and the moral unconscious may be illustrated with reference to the dangers of one-sided concentration on either. The general proposal we offer here is that the 'Freud' to be carried across the millennial threshold should be one in which the intellectual and cultural tensions represented by this distinction, and by other, similar binary analyses of psychoanalysis, are held in check and contained within an inclusive framework. Though we wish to some extent to set up an opposition between two different theoretical Freuds, or models of the unconscious, we argue for an interdependence rather than a split between them. At the same time, we posit the primacy of one model – the moral unconscious – and link it to the ego's capacity for observation.

Our distinction between an associative and a moral conception of the unconscious and between two Freuds will now be linked to Rustin's delineation of a positive and negative psychoanalysis,[14] and to Phillips's distinction between an Enlightenment and a post-Freudian Freud.[15] We suggest that running through these various distinctions there is a choice between moral-humanist and anti-humanist Freuds, and we argue in favour of the former. We take humanism to refer to doctrines in which human nature is knowable and in which the coherence and worth of the self is a central value. Freud's humanism can be seen in his attempt to describe the fundamental dispositions of humanity and his belief in our capacity for self-realization. A moral discourse can be described simply as one which conforms to ideas of right and wrong human conduct.

Rustin, in 'Lacan, Klein and Politics', analyses the two psychoanalytic traditions of Lacan and the British object relations school. He analyses them as they apply to politics, but this distinction between two schools is generally helpful for our purposes, because it echoes and extends the choices between a moral and an associative unconscious.[16]

The Lacanian tradition, Rustin argues, is seen as negative, antagonistic and focused upon the inherent limits of self-understanding,

and the inherent distortions involved in its representation (this is similar to Phillips's description of the post-Freudian Freud). However, the object relations and Kleinian traditions postulate a positive core of ideas about human nature, positive in the sense both of proposing empirically demonstrable developmental positions, and in the sense of specifying preferred emotional states (Phillips's Enlightenment Freud). Lacanian psychoanalysis prescribes an unending investigation of the inauthentic, idealized and self-regarding aspects of human consciousness. The object relations perspective, however, while recognizing illusions and human omnipotence, also attempts to understand authentic states of feeling.[17]

We could rephrase this to say that, whereas for the Lacanian tradition narcissism (with accompanying misrecognition, decentredness, and shifting associations) is inevitable, for the object relations and Kleinian traditions, it is not: narcissism is seen as a defence, not the a priori human condition.

Rustin looks at how this distinction between modernist and postmodernist views of the unconscious applies to politics, while Phillips analyses it in relation to the question of expertise and epistemology. Also, although Phillips plays with the ambiguous status of psychoanalytic knowledge, he does not say which psychoanalytic school is more responsive to the Enlightenment and post-Enlightenment Freuds, while Rustin does. He believes that the British psychoanalytic tradition is attached to both the 'negative' and 'positive' poles of psychoanalytic thinking, but he points out that this tradition does carry a risk of moralism and intellectual rigidity.[18] This is also our position, from which we will argue that the choice of a moral unconscious or humanist Freud does not necessarily lead to intellectual rigidity or a split from the 'negative', post-Enlightenment Freud, or from, in our terms, the associative unconscious.

Arguing for an interdependence between a modern and postmodern view of psychoanalysis or theoretical Freud(s) raises the question of how what Rustin calls the positive appropriation of psychoanalysis, with its sense of moral purpose, can meet the deconstructive moment of negative psychoanalysis. Can we describe the mind in logical or empirical terms and still pay heed to the inevitable limits of self-understanding? Can we ironize expertise without losing all authority? Can we, as Brunner asks in *The Politics of Psychoanalysis*, find metaphors of the mind which can cope with the dialectical nature of psychoanalysis?[19] (For him, political theory provides this.)

There is not an exact match between Phillips's and Rustin's accounts, but Phillips's work highlights the dialectical nature of the psychoanalytic project, which for our purposes implies that within itself it contains both modern and postmodern views of the self. The dialectical nature of psychoanalysis is revealed by the fact that, while the analysis of the psyche is its own aim, this study of the unconscious mind questions the self as an object of knowledge. What we find in psychoanalysis then is a peculiar ambivalence between the modernist notion of truth and the ironizing of expertise which Phillips enjoys. Indeed it is this very dialectical nature of psychoanalysis in the first instance which allows for the sort of dialectical vision (thesis and antithesis, modernism and postmodernism) we are proposing.

Phillips maintains that the contemporary analyst or student of psychoanalysis must contain within themselves the Enlightenment Freud and the post-Freudian Freud, the knowing and the problem of knowing.[20] And this is where we agree with him and find his discussion of the language of psychoanalysis, expertise and morality useful for our purposes. The kind of self-realization we argue for has to be tempered by the important questions Phillips asks. He asks, for example, what Freud's idea of the unconscious does to the idea of expertise, and of being a skilled practitioner of anything, including psychoanalysis itself:

> With his description of the unconscious and dreamwork, Freud gave the expert – the expert in any field – a new agon and a new collaborator; and, of course, a new source of terror. If we are not, as Freud insisted, masters in our own houses, what kinds of claims can we make for ourselves? In what senses do we know what we are doing? From a psychoanalytic point of view, people are not only the animals who can make promises, but also animals who can't help breaking them.[21]

For Phillips the Enlightenment Freud instructs us in a new science of self-knowing, whereas the post-Freudian Freud questions the very idea of the self as an object of knowledge. With what he calls the post-Freudian description of the unconscious the idea of human completeness disappears. The moral 'to thine own self be true' becomes an attempt at self-closure, the symptom, Phillips explains, masquerading as the cure. There is, he says, no cure for the unconscious, no cure for unconscious desire. Dreams are what Phillips calls Freud's

exemplary objects', because they are at once unintelligible and unknowable in their original form.

The unacceptable (the repressed) can be known, he goes on to say, but the unintelligible (the site of the Lacanian unrepresentable Real?) can only be acknowledged.[22] Thus, for Phillips, we have to find 'good' ways of bearing our incompleteness. Tragedy, he says, 'is when we are ruined by our insufficiency, comedy is when we can relish it'.[23]

In our view a balanced conception of selfhood is one in which our capacity for self-realization is necessarily incomplete, but nevertheless possible. In Winnicott's terms we might say that we are in search of an ego capable of tolerating paradox and, therefore, capable of play (like the signifier), and in this context we therefore agree with Phillips, who talks of a good way of bearing our incompleteness. However, he possibly fails to pay enough attention to Rustin's point that negative psychoanalysis at its worst turns into nihilism. There is a danger, as Hoggett highlights, of irony turning into cynicism.[24] Using Kleinian terms, Hoggett criticizes those intellectuals who have become complicit in a broader sentiment of political hopelessness, and maintains that to be scornful of those who still believe in a background teleology (which humanists do) is a pre-depressive attitude. Specifically, he suggests that it is an outcome of failed dependency, in which there is a fantasy of an exhausted breast which can no longer be turned to for nourishment.

We are not suggesting that this is the mood in Phillips's text, but we are trying to caution against a one-sided applause for a shifting, timeless view of subjectivity, leaving only a weak and insubstantial or ironic role for the ego. Our choice of a moral-humanist Freud is also based on the recognition that people need to be able to move towards more self-realization and integration. Indeed not everyone is in a position to relish their insufficiency, and Phillips does not say what enables people to find this comic, rather than tragic. It is, as Rustin points out, the object relations school which can speak of developmental stages and preferred emotional states which represent a move away from human omnipotence and illusion.

The Observant Ego

Our position differs from that of Phillips, because we acknowledge the primacy of a moral unconscious based on Freud's second topo-

graphy of the mind, in which the ego plays a central role. We agree with Coltart, who says that the ego has to be relatively strong in the first instance, in order to enjoy its own imaginary status.[25] In her essay on psychoanalysis and Buddhism, she argues that therapeutic help may be needed to repair and stabilize the ego before embarking seriously on meditation practice.

However, where there is an exclusive focus on an associative view of the unconscious the role of the ego which emerges is weakened. Our preference for a moral unconscious involves a role for the ego which is neither that of an authoritarian leader nor that of a weak powerless monarch (see Brunner). And although, as Coltart reminds us, Freud persistently maintained that he was not constructing a philosophy of life, nor trying to derive an ethical system from the study of the unconscious, he did posit a developmental aim that 'Where Id was, there shall Ego be' (or, according to Chasseguet-Smirgel and Grunberger, 'Where Narcissus was, there shall Oedipus be').[26]

Freud's idea that the id, ego and superego are like colours melting into each other gives credence to Phillips's point that students of psychoanalysis must be friends of ambiguity, or in Bion's terms be capable of binocular vision. This is why we refer to the ego as observant. Enlarging the field of the ego is no longer an Enlightenment, imperialist gesture and becomes more a case of enlarging the ego's capacity for observation and self-realization.

The self-realization described is not one of closure, but it involves developing an internal observer.[27] This observer can, as Meltzer points out, watch the play of the mind as we may watch the play of children, without forcing their attention.[28] That is, it is at once both the children playing and it is not; it has responsibility, without a will-to-power.

Bollas describes this as a stage when the ego or the Oedipal child discovers the semi-independent it-ness of its own mind, which then problematizes the narrative authority of its own voice.[29] The superego is not, therefore, just formed out of the relation to the father, intrapsychically standing in his place. This, Bollas maintains, is a narrow reading of an important psychic development in which the child comes into the presence of its own mind, which is, he alleges, a very arresting moment and a disturbing journey.

The curse that Oedipus uncovers, Bollas tell us, is that we have minds which can make us suffer, get us into trouble, be lost, abuse us and others, produce nightmares, etc. The Oedipal child develops

a conscience when it realizes that like Oedipus it created the nightmare. Hence, Bollas thinks that the Oedipus play 'places the audience in the position of the gods who could see the full course of events and yet, by identification with Oedipus, be drawn into the inner texture of his specific dilemma'. This, he points out, mirrors the oscillation we all endure in life between our reflective self states and the 'location of the simple experiencing self'.[30]

Thus Phillips argues that when the language of psychoanalysis gets caught up with the language of 'will', it becomes a covert moral injunction – 'try to be good (Klein); try to be spontaneous (Winnicott); try to be eccentric to yourself (Lacan)' – forgetting that, as he puts it, it is unwise to try to give the unconscious elocution lessons.[31]

This does not mean, however, that what Bollas calls our reflective consciousness cannot be attuned to the language of the unconscious. It is not the unconscious that is given elocution lessons, it is the ego. Although, according to 'negative' psychoanalysis or the postmodern Freud, we are irretrievably lost to ourselves, odd, host to the other within, we believe that the ego can learn to listen to the language of the id (to dreams) and perhaps become a welcoming host, as Phillips suggests.

Hence, to base a robust and flexible understanding of the individual on the moral-humanist Freud it is necessary to temper it with elements of the other Freud(s) – associative, post-Enlightenment, post-Freudian, negative, postmodern. In the following material we take theory and commentary in two rather different fields – in studies of modern advertising, and in some recent discourse on the nature of love – and trace in each the influence of different models of the unconscious, and the drawbacks of one-sided understandings in which necessary tensions are not sustained. Where it is only the associative unconscious which is recognized, the likelihood is that a somewhat cynical or even nihilistic picture will emerge, while attention to the moral unconscious alone will tend to produce scenarios of oppression and claustrophobia.

Manipulation or Moralism: The Case of Advertising

The recent history of attempts to understand advertising illustrate the need to hold together the two, potentially divergent, frames of reference. Academic critics of advertising have tended to see it only

in terms of one or the other. Though not always using explicitly psychoanalytic terms, they have shown a tendency to think in terms equivalent to both of our models of the unconscious, but not both at once.

Although it is hardly a *locus classicus* for the deployment of analytic theory, advertising is a cultural field in which the manipulative possibilities afforded by an understanding of the associative unconscious are relatively familiar. Through the influence of the 'motivation research' school of market research,[32] psychoanalytic ideas have had some influence on advertising techniques, though it is probably more through the intuitive efforts of advertising professionals that use is made in advertisements of the associative activity of the unconscious. By whatever means, frequent use is made of the basic principle of association by contiguity, or co-location, which is the basis for many 'Freudian' associations. In her book *Decoding Advertisements*, Judith Williamson gives many examples of such associations, and a number of other writers following the loose methods of 'semiological' analysis have since added many more, whether or not they have drawn directly on analytic theory as Williamson did.[33] Typically, the product in these advertisements is presented in a way which links it to other objects bearing desirable symbolic meanings. This may be done by portraying it in a material, social environment shared by other objects and/or people, and by the detailed construction of the advertisement which places the commodity adjacent to something else, or linked to it by a shared quality such as colour. Association by contiguity or similarity then produces what Williamson called the 'transfer of meaning', the filling of the commodity with the meanings of the setting in which it is placed and the people and objects with which it is associated.

This is the main process involved in reading such advertisements, and is for the academic critics of advertising a paradigm of the cynical manipulation of associative activity, yet also an inevitable consequence of the vulnerability of the unconscious to such manipulation. A circuit of desire is seen to be formed, from which values can be excluded. No questions are raised about whether the reader will benefit from the product, and what the social and environmental effects of its manufacture or use are. Just as the behaviourist psychologist in the laboratory manipulates the pigeon into pecking now at a blue disk, now at a red one, so the consumer is manipulated into buying now a blue pack, now a red one. There is an important dif-

ference in the way that the intervening processes are thought about, but the effect in terms of social engineering is similar.

The most extended application of psychoanalytic theory to advertisements, by Haineault and Roy, is much more sophisticated and intensive in its theorization, but follows the same basic idea: that the associative activity of the mind renders it endlessly exploitable by the contrived stimulus to association.[34] The un-centred consumer can be shifted and reconfigured, a process seen in some of the earlier analyses as constrained by the structures of myth within which advertisements had to work,[35] but in some later ones as operating freely in the increasingly dense circulation of signs.[36]

Yet in the time since the earlier studies of advertising appeared, it has been recognized that this is an inadequate, and at times even paranoid, vision of the processes involved in the design and reception of advertisements. In particular the capacity of readers to refuse to enter the libidinal circuits is appreciated (like the observant ego which we discuss below), as is their capacity to generate different meanings from those intended – in other words, to produce different associations.[37]

There remains a legitimate concern that the associative unconscious is vulnerable to exploitative forms of address, and it is in the domain of commercial communication that these have most clearly proliferated. It is also the case that the study of associations is the key to understanding the impact of advertisements, as Haineault and Roy have convincingly shown. Overall, though, this critical perspective on advertising now lacks credibility because of its failure to take account of the morally-grounded subject who is reading the advertisements, that is of the psychic context in which the associations are generated. While an instrumentalism bordering on the cynical may not be uncommon in the world of marketing, and manipulability not unusual amongst the general public, these factors do not amount to the whole story of the place of advertisements in culture. That story must also include the work of the reader in assimilating advertising imagery and the associative chains it provokes into a stable and comprehensive psychic agenda organized around moral questions of relationships – attachment and loss, guilt and responsibility.

We can now ask whether studies of advertising may also provide us with some contrasting evidence, that is some indication of an applied conception of the unconscious which carries problems of a different sort, namely a one-sided use of the notion of a moral unconscious. Here the risk is again of seeing only one element, this

time not cynical manipulation but rigid moralism. The same litera-
ture does in fact provide examples of this, for alongside the tradi-
tional critique of advertising as immoral and destabilizing there has
grown up a later critique of it as ideological and conservative, and as
one of the main cultural supports of an oppressive familial morality.
This later critique was developed in much of the early (i.e. 1970s
onwards) academic work on advertising, which found easy targets
in the homilies typical of much advertising up until the 1970s. On
British television, many foodstuffs and household products, for ex-
ample, were tied in to scenarios or story-lines in which the duties of
the woman to her family were absolute. And while the housewife
was the most frequent addressee of sermons on her moral duties to
buy particular things, husbands and children were also enjoined to
commit themselves to their prescribed roles in both the family and
the market-place. It is well documented that a particular and highly
rhetorical conception of family life was woven into the discourse of
advertising for many decades.

However, in equating the content of these advertisements with
their impact, that is in assuming that readers/viewers would inevita-
bly be enthralled by them, the critics erred, drawing upon a model
of psychic life in which the subject or ego is again construed as pas-
sive. Here the unconscious is understood as an ossified moral struc-
ture which the subject cannot modify or escape from. Instead of
being trapped inside the Freud of 1915, we are saddled with a simple
reading of the Freud of 1933, wherein the ego is crushed from within
by a rigid superego. Since no other meanings are possible (all sym-
bolic roads lead to the family complex and the tripartite structure of
the mind), the marketing of commodities must try to tie them to the
power of these dominating objects, and thereby to the continued
infantilization of the subject.

Again, however, the critique usually fails to register the other di-
mensions of subjective response to such advertisements – in this case
the capacity of the reader to be at a distance from the identifications
on offer and to resist the injunctions, and the scope for the associa-
tive unconscious to generate meanings subversive of the advertisers'
intentions. (Indeed it was this process which could be said to have
undermined over time the credibility of the 'ideological' ads, by link-
ing their content to rejected objects.)

As before, we do not imply that there is no reality corresponding
to the critics' visions of moralizing advertisements. Such reality can
be seen if we turn to another advertising strategy, one still with us in

the appeals made to tradition and the past as unchallengeable positive values. There are many variations and nuances here. We can distinguish nostalgic themes, which frequently have a strongly regressive tone as they invite the reader or viewer into the enfolding warmth of the past (some food advertising makes frequent use of this strategy), from those in which a respect and admiration for the past and its achievements is uppermost (as is more common in advertisements for manufactured goods). Idealizations of maternal and paternal imagos respectively are the main operative psychic content of such ads, and though these may have positive functions as ego-ideal components they may also cover, and belong to, an internal scenario of submission to tyrannical parental objects whose presence and pleasure are the highest values.

So in external as well as internal reality, in cultural forms as well as in individual mental states, there do exist processes or conditions aptly described by just one model or the other. For an overall understanding of the subject, however, in both ideal and more typical states, there is needed the blend of models which it is our purpose to identify.

Though it is secondary to the main purpose of the chapter, we hope to have indicated here the potential use of psychoanalytic insights in the study of everyday culture. We predict, albeit with some element of hope, that beyond 2000 there will be an increasingly wide and sophisticated use of post-Freudian psychoanalytic ideas in the social sciences and humanities, in the study of culture, social process and politics. Specifically, as promotional communications intensify and imagery in the public domain becomes even more dense and demanding, understanding the impact of this imagery will be a priority for those wishing to reflect helpfully on social change, and psychoanalysis will show itself to be valuable in this endeavour. In many other areas of study and practice as well, though, the bridgeheads gained recently by psychoanalytic ideas in intellectual culture will be the basis for extensive influence, as can already be seen in some areas in the fields of health and welfare.

So far our main intention has been to outline a polarity between two different understandings of what the unconscious is, and to have extended this into an illustration of the risks attached to one-sided applications of either model. Illustrations of these two conceptions of the unconscious from the field of advertising studies could lend credence to the view that the Freudian conception of humanity is a bleak one; people are seen only in abusive relationships, in which

they are either manipulated or imprisoned. The manipulation may be through seduction via tantalizing images and their associations, or through inducing fear via imagery likely to associate to anxiety; in each case there is the same enslavement of the subject to contingencies of stimulus and to prescribed patterns of association. The imprisonment is within an iron cage of emotional necessity; here the scenario is of permanent subjugation to tyrannical moral authority. We contend that thinking in terms of a fusion or articulation of the two models might yield a more complex and balanced conception of the subject, and reflect the dialectical nature of psychoanalysis.

Manipulation or Moralism: The Case of Romantic Love

We will now look at how an associative or moral view of the unconscious, that is, of selfhood, also informs theoretical positions with regard to the possibility of 'mature', 'authentic' or reparative love in social theory.

In Barthes's *A Lover's Discourse* we can see the application of our view of an associative unconscious to the subject of love.[38] The self is seen as a dramatic sequence, rather than an authentic unity, and life is, therefore, characterized by an ambiguous instability, which is both tragic and farcical. Lovers, therefore, live in a tragicomic theatre in which love becomes an interesting piece of fiction, merely played out by one of our many parts. This is our associative unconscious, which by a process akin to dream-work forever produces new patterns. This infinity of associations, signifiers, texts or codes means that for Barthes (influenced by Lacan and Sartre) the origin of the self (the signified, the instinct) is lost. Just as we can only know the instinct or unconscious phantasy through its psychical representative, so too we can only know the self through associations and signifiers which are shifting.

The question therefore is: how can two people who lack being (their origin is lost) demand wholeness? Narcissistic misrecognition of oneself and others is inevitable if we can assume only the existence of a narcissistic as opposed to a realist or reconceptualized ego. For negative psychoanalysis, the lover's discourse becomes an antihumanist paradise. Here we find endless examples of the inauthentic, of self-idealizations and of self-delusions. Hence, 'I love you has no usages. Like a child's word, it enters into no social constraint; it can be a sublime, solemn, trivial word, it can be an erotic pornographic

word. It is a socially irresponsible word.'[39] It has too many associations; the latent content can never reveal itself, and the narrative (like the dream) may change daily. In this associative view of the unconscious and, therefore, the self, we are cast as passive victims of our own and each other's otherness (rather like the 'organism' at the centre of the behaviourist's stimuli and responses). Monogamy becomes, according to Phillips,[40] a way of keeping the versions of ourselves down to a minimum, trying to keep the true story of who we really are in circulation.

But Barthes's exclusive focus on the unconscious as promiscuous association leads him to conclude that the lover was forsaken by Freud and becomes 'poor, derided, weak, tormented, a tyrant and a fool'. In the lover's relation to the associative unconscious, we find the same enslavement of the subject to contingencies of stimulus we found in the paranoid vision of the reception of advertisements. The associations here are to both sexual release and terror (hate is older than love, Freud tells us). The lover according to the negative appropriation of psychoanalysis can be represented only by blind Narcissus and murderous Oedipus, or in Bollas's terms, the 'simple experiencing self'. 'Where Id was, there shall Ego be' becomes the Enlightenment fallacy. The ego can only be manic or melancholic (the heir of narcissism), but not mourn, because it cannot mourn what it cannot see (its own internal world of identifications and object cathexes dovetailing with the external world).

The lover's ego, according to the associative view of the unconscious, is in the terms of Brunner's political metaphors the weak, constitutional monarch, with only an illusion of control and power. If the ego is dethroned and manipulated by id impulses, where does this leave the moral, thinking self? Freud's humanism, as already stated, can be seen in his belief in our capacity for self-realization, but in anti-humanist views of love, with an exclusive focus on the associative unconscious, we yet again find ourselves trapped in the Freud of 1915. Just as some critical perspectives on advertising fail to take account of the morally-grounded subject who is reading the advertisements, so too anti-humanist views of love fail to take account of Freud's commitment to the role of the ego in relation to the id and superego.

There is, as already discussed, a danger of a one-sided concentration on a view of the ego either as the weak, powerless monarch in relation to the mob rule of the id, or as the absolutist, patriarchal ruler with no relationship to its own people. That is, in our wish to

carry through a moral or humanist Freud we need to resist what Craib refers to as the controlling fantasy and moralism evident in a management of the emotions (the illusion of the all-powerful self).[41] Craib explains that in some areas of sociology,[42] and in some forms of therapy, there is an attempt to manage that which negative psychoanalysis, our post-Enlightenment Freud and our view of the associative unconscious tell us is unmanageable. It is this desire to control our terrors which can drive us into the arms of the experts, which Craib bemoans.

De Botton similarly warns us against the extremes of what Rustin calls a positive appropriation of psychoanalysis, by referring to the work of 'romantic positivists'.[43] These works, De Botton maintains, argue that with enough thought and therapy, love can be less painful, and practical steps are offered which can remedy heartache and disappointment. De Botton describes the tone as one of triumph and brave optimism. Thus we find in them the champions of the Enlightenment in which knowledge becomes redemptive:

> Hamlet's fate could have been avoided with the help of a good Jungian analyst, Othello could have gotten his aggression out on a therapeutic cushion, Romeo might have met someone more suitable through a dating agency, Oedipus could have shared his problems in family therapy.[44]

Within this irony is the point that romantic positivism, with its assortment of practitioners, preachers, gurus, therapists and writers, depicts a kind of defensive knowingness and a denial of the importance of disappointment. It is important to remember Klein's work on integration, in which she argues that integration ushers in depressive anxieties due to the damage caused by, for example, projective identification. Whereas in Barthes the ego can only be fragmented and reparative love is impossible, in what Craib and De Botton describe, it becomes all too easy and effortless. What De Botton lampoons is the extreme of a positive appropriation of psychoanalysis, in fact a distortion of it, in which we can be given a step-by-step guide to virtually any area of our intimate lives, an emotional quick fix, and be led to believe that the semi-independent it-ness of our minds (Bollas) can be overcome. This id quality is what Craib accuses Giddens of neglecting in his picture of the 'pure relationship'. Indeed for Chasseguet-Smirgel and Grunberger the genital position requires instinctual maturity, that is, an acceptance of anality, messi-

ness, ambivalence, rather than a courtly love which is beyond the vicissitudes of the flesh, the mortal body or the shadows of the instincts.[45]

So far, then, the extreme point of a negative or a positive appropriation of psychoanalysis leads us to the end point of narcissism. In the former case, the lover is a thinly disguised version of Narcissus (the ego is not recognized), while in the latter we find a narcissistic denial of our instincts, emotions and disappointments (the id is not recognized).

Love in the Depressive Position

Klein's concept of the depressive position can hold this ambivalence and provide a suitable home for our reconceptualized ego, which acts as a bridge between humanist and anti-humanist Freuds. The depressive position is also a metaphor which can provide a container for the dialectical relationship between the modernist and postmodern view of the self, the associative and moral unconscious and the positive and negative appropriation of psychoanalysis.

We do not have the time here, nor is it the aim of this paper, to give a detailed description of the depressive position. For our purposes it is sufficient to summarize it as an acknowledgement of psychic reality, that is, of the way in which our unconscious is made up of relationships with objects. Rather than imagining the unconscious as the seething cauldron of faceless instincts, we now find an internalized family album, with all its attendant absences, distortions, loves and hates. However, the existence of conflict (hate) problematizes our relationship to our own internal world, and complete internal honesty is hard to achieve (as is, therefore, a perfect internal state).[46] The key developmental task thus becomes one in which the ego can bear, as Klein said, the

> unconscious knowledge that the hate is indeed also there, as well as the love, and that it may at any time get the upper hand (the ego's anxiety of being carried away by the id and so destroying the loved object), which brings about the sorrow, feelings of guilt and the despair which underlie grief.[47]

Klein's emphasis on guilt and destruction follows the movement of Freud's own thought from thinking about sexuality in 1905 (albeit

with an aggressive impulse) to destruction or death in 1920, thus pre-empting a change in the therapeutic aim. Catharsis as an aim is replaced by a new and strengthened role for the ego. It has been our task to think about what this role for the ego can be, as we approach the next millennium. Associative links may reveal the grand narratives of sexuality, love and hate (humanistic essentialism?), but more importantly for our postmodern times, they also reveal our problem with knowing – something from within, as the above quote from Klein suggests, can get the upper hand.

We are returned to Bollas's point about recognizing the semi-independent it-ness of our own minds and to Phillips's suggestion that analysts, analysands and students of psychoanalysis become friends of ambiguity, or of the negative appropriation of psychoanalysis. The view of the unconscious as associative is there to remind us that knowledge is not redemptive if it becomes defensive, and that our omnipotence is challenged by both psychoanalysis and postmodern theory. Although Klein emphasizes the importance of recognizing psychical reality, which means that we are in a position to know something of ourselves, we cannot know everything, and this in itself may be an important disappointment. So the replacement of id by ego is no longer a definitive achievement. The resolution of the Oedipus complex may be about learning to look at our unholy desires, but this does not mean, according to the depressive metaphor, that we will never be in the grip of them again.

However, what cannot be in dispute in our postmodern times is the evident harm we are capable of doing to ourselves and others. The connection between the moral unconscious (the blueprint for our idiosyncratic ways of relating) and the reconceptualized ego is in the concept of responsibility. It is this concept of responsibility which we are in danger of losing if we cast ourselves as passive victims of signifiers, instincts, associations, or unconscious fantasies.

Craib notes that 'Freud the Romantic' (the one who has opened up the door to our emotional, primitive life) has received far more attention in 'popular' culture than 'Freud the Rationalist' (a dualism traversed by Bion). And yet, for Craib, it is the 'thinking self' which is the 'moral self'. This is similar to our position, in which the moral task we assign to the ego is one of observation and containment.

Indeed, Klein's concept of the depressive position is about containment and not catharsis. It leads to an ethical system which declares that if we can think through our feelings, and develop an internal observer,[48] then we will be less likely to act them out. How-

ever, a facile moralizing ('be good') can be avoided by holding onto the idea that this position is never achieved once and for all; it is a position, not a stage, and one we are likely to move in and out of.

At the same time, integration and structure can be moved towards; they are not fictions or self-delusions. What Klein maintains is the idea that, as the ego becomes more capable of accepting psychic reality, it will be able to apprehend the external world with more accuracy.[49] That is, the 'external' may always be imbued with the kaleidoscopic colours of our own imaginations, but we may nevertheless be able to watch the changing shapes it assumes. Here then is the compromise between the Enlightenment and post-Enlightenment reading of Freud: a depressive metaphor which argues for a vision of the ego with its roots deeply sunken in the id, but not driven or blinded by it.

Conclusion: The Future of Therapeutic Culture

Just as the ego in the depressive position can contain the ambivalences between such contradictory feelings as love and hate, it is our hope that a reconceptualized ego can contain the ambivalences between knowing and the problem of knowing, the positive and negative poles of psychoanalysis and the moral and associative unconscious.

We have argued for a conception of selfhood as rooted, knowing and moral, *and* as qualified by a vital state of unknowing, contingency and indeterminacy. We might say that moral selfhood is not coterminous with self-experience. However, while Freud produced the basic conceptual tools to explore both selfhood and the dark oceans around it, psychoanalysis affirms the former. This is demonstrated by the usual affiliation of clinical work, as a therapeutic practice, to a positive, humanist vision of the self, and if the major influence of Freud in the next century continues to be via the therapeutic, then we can expect the humanist influence upon and of psychoanalysis to become stronger. (This is perhaps a better reason for the primacy of the clinical in the development of psychoanalysis than the contentious epistemological one, based on the argument that it is only through clinical experience that enough intimacy with the psychic realities which the theory tries to grasp can be acquired.)

On the other hand it is in the therapeutic domain that there is greatest risk of flooding psychological discourse with a moral language

that places all action and experience into a frame of knowable judgement. This is perhaps the tendency in many of the classical traditions of psychoanalytic theory, where the frame of reference is often exclusively that of clinical practice and where the centrality of core developmental issues in the unfolding of individual patients' lives is necessarily paramount. When the clinical experience is systematized into theory, the paramountcy of those issues is even more sharply defined. Where there is a fairly direct inheritance from the Christian tradition, as in the object relations theory of Harry Guntrip,[50] there is predictably an especially strong tendency to totalize a moral struggle across the whole of mental life such that the self is no more than a vehicle for the working through of a universal human task. For Guntrip, it is the task of reaching, and bringing into the warmth of human connectedness, the terrified regressed ego. The moral issue here, in Guntrip's development of Winnicott, is not so much one of guilt but of trust; the struggle for us all is to trust the other.

Given the broad location of the therapeutic in the cultural space of religion, it can be expected that similar totalizations are to be found as well in the works of writers with no obvious affiliations to a theological tradition. In Winnicott the moral issue is one of truth, and the struggle is to be spontaneous, while in the Kleinian tradition, also organized around a notion of truth, it is one of confronting the hatred at the heart of psychic reality. A morally-toned emphasis on reality is also basic to the work of Chasseguet-Smirgel and Grunberger,[51] though for them the key struggle is to accept the otherness of external reality (i.e. a version of the Freudian Reality Principle). That there is a tendency in such works towards a totalizing moralism can be freely acknowledged by those who, like ourselves, derive much of their psychoanalytic understanding from some of these same works. There is also of course a recurrent place in the same psychoanalytic schools for voices of uncertainty, for eccentric or alternative formulations and for reflection on the limitations of the formally theorized concepts and the codes of technique. Nonetheless it is necessary to acknowledge the dangers of reductiveness which have often been observed in these schools, perhaps especially in Kleinian theory with its distinctive and demanding concepts, and we are suggesting that this reductiveness can be seen as emanating from moral positions. The unconscious is seen as a site of moral enunciation, and the moral imperative (usually to secure a developmental achievement) is endorsed by the theorist.

Where the conception of the unconscious as morally structured is

untrammelled by sufficient sense of its existence as contingent asso-
ciative process, a certain one-dimensionality exists and there is scope
for dogmatism and a closure of discourse. In the case of the human-
istic psychologies, which we can see as a partial effect of psycho-
analysis, this closure is often obscured by a bright therapeutic
optimism, in which the morality of the true and the spontaneous
pulls itself away from the darker realities of the psyche in which
Winnicott embedded it and becomes a self-sufficient discourse of
growth. In the case of Guntrip, the consequence is a somewhat milky
therapeutic in which the moral duty of the therapist is to dispense
agape, and of the patient to receive it. The moral conception of the
unconscious has therefore been at risk in the therapeutic domain of
legitimating somewhat pious forms of essentialism. As postmodern
influences unfold, however, and grow in their influence on clinical
theory, we can hope that the kind of moderation of the Enlighten-
ment ego which we have been recommending will be a predominant
outcome, in theory and in the world of lived selves.

In any event, the quality of the therapeutic is now set to be an
increasingly important social issue. In a therapeutic culture, the na-
ture of therapeutic understandings is a matter of wide importance,
since such understandings inform many practices and are crucial to
how the society as a whole understands and administers to itself. So
while the therapeutic may remain the principal conduit for the ac-
cess of psychoanalysis to the general culture beyond 2000, this will
no longer limit its influence in the way it has done for much of the
twentieth century. A beneficial influence of psychoanalysis within
the wider culture can thus be imagined, strengthening the possibili-
ties for the acknowledgement and containment of feeling in a vari-
ety of contexts from everyday consumption practices to political
choices. Freud approaches the millennium as the confidant and critic
of an enlarged and moralized ego, and as the advocate of a problem-
atic human selfhood.

Notes

We would like to thank Dr Amal Treacher for comments on a draft of this chapter.
 1 R. D. Hinshelwood, 'Psychoanalysis in Britain: points of cultural access, 1893–
 1918', *International Journal of Psycho-Analysis*, 76, 1 (1995), pp. 135–51.
 2 Barry Richards, *Images of Freud: Cultural Responses to Psychoanalysis*
 (London: Dent, 1989).
 3 P. Rieff, *The Triumph of the Therapeutic* (1966; Harmondsworth: Penguin,
 1973).

4 Sigmund Freud, 'The unconscious' (1915), *Standard Edition* vol. XIV.

5 Ibid. p. 186.

6 Sigmund Freud, 'The interpretation of dreams' (1900), *Standard Edition*, vols IV and V; 'The psychopathology of everyday life' (1901), *Standard Edition*, vol. VI.

7 For further discussion of the way in which psychoanalysis appropriated the concept of association see Richards, *Images of Freud*, ch. 2.

8 Sigmund Freud, 'New introductory lectures on psycho-analysis' (1933), *Standard Edition*, vol. XXII.

9 Ibid. p. 75.

10 For different accounts of this transition see, for example: Harry Guntrip, *Schizoid Phenomena, Object Relations and the Self* (London: Hogarth, 1968); J. Greenberg and S. Mitchell, *Object Relations in Psychoanalytic Theory* (Cambridge, Mass.: Harvard University Press, 1983).

11 S. Isaacs, 'On the nature and function of phantasy' (1948), in M. Klein et al. (eds), *Developments in Psycho-Analysis* (London: Hogarth, 1952).

12 R. D. Hinshelwood, *A Dictionary of Kleinian Thought* (London: Free Association Books, 1989), p. 34.

13 Isaacs. op. cit.

14 M. Rustin, 'Lacan, Klein and politics: the positive and the negative in psychoanalytic thought', in Anthony Elliott and Stephen Frosh (eds), *Psychoanalysis in Contexts: Paths between Theory and Modern Culture* (London: Routledge, 1995).

15 A. Phillips, *Terrors and Experts*, (London: Faber, 1995).

16 Rustin, op. cit.

17 Ibid. p. 226.

18 Ibid. p. 243.

19 J. Brunner, *Freud and the Politics of Psychoanalysis* (Oxford: Blackwell Publishers, 1995).

20 Phillips, *Terrors and Experts*, p. 8.

21 Ibid. p. xii.

22 Ibid. p. 17.

23 Ibid. p. 7.

24 P. Hoggett, *Partisans in an Uncertain World: The Psychoanalysis of Engagement* (London: Free Association Books, 1992).

25 N. Coltart, *Slouching towards Bethlehem . . . and Further Psychoanalytic Explorations* (London: Free Association Books, 1992).

26 J. Chasseguet-Smirgel and B. Grunberger, *Freud or Reich? Psychoanalysis and Illusion* (1976; London: Free Association Books, 1986).

27 J. Trowell and M. Rustin, 'Notes on infant observation', *Infant Mental Health Journal*, 12: 3 (1991), pp. 233–45.

28 D. Meltzer, *The Psychoanalytical Process* (Perth, Scotland: Clunie Press, 1990).

29 C. Bollas, *Being a Character* (London: Routledge, 1992).

30 Ibid. p. 219.

31 Phillips, *Terrors and Experts*, p. xv.

32 Barry Richards, *Disciplines of Delight: The Psychoanalysis of Popular Culture* (London: Free Association Books, 1994).

33 Judith Williamson, *Decoding Advertisements: Ideology and Meaning in Advertising* (London: Marion Boyars, 1978).
34 M.-L. Haineault and J.-Y. Roy, *Unconscious for Sale:Advertising, Psychoanalysis and the Public* (Minneapolis: University of Minnesota Press, 1984).
35 V. Leymore, *The Hidden Myth* (New York: Basic Books, 1975).
36 R. Goldman, *Reading Ads Socially* (London: Routledge, 1992).
37 For a review of developments in advertising theory, see M. Nava, 'Framing advertising: cultural analysis and the incrimination of visual texts', in M. Nava et al. (eds), *Buy this Book: Studies in Advertising and Consumption* (London: Routledge, 1997).
38 R. Barthes, *A Lover's Discourse* (1978; Harmondsworth: Penguin, 1990). For a relevant discussion of Barthes's depiction of the lover, see R. Rylance, *Roland Barthes* (Hemel Hempstead: Harvester Wheatsheaf, 1994), ch. 4.
39 Ibid. p. 148.
40 A. Phillips, *Monogamy* (London: Faber, 1996).
41 I. Craib, *The Importance of Disappointment* (London: Routledge, 1994).
42 For example, A. Giddens, *The Transformation of Intimacy* (Cambridge: Polity Press, 1992).
43 Alain De Botton, *Essays in Love* (London: Picador, 1993).
44 Ibid. p. 241.
45 Chasseguet-Smirgel and Grunberger, *Freud or Reich?*
46 M. Klein, 'On the sense of loneliness' (1963), in *Envy and Gratitude* (London: Virago, 1993).
47 M. Klein, 'A contribution to the psychogenesis of manic-depressive states' (1935), in *Love, Guilt and Reparation* (London: Virago, 1991).
48 Trowell and Rustin, 'Notes on infant observation'.
49 Klein, 'A contribution to the psychogenesis of manic-depressive states'.
50 Harry Guntrip, *Psychoanalytic Theory, Therapy and the Self* (1971; London: Maresfield Library, Karnac, 1977).
51 Chasseguet-Smirgel and Grunberger, *Freud or Reich?*

10
The Future of Freud in Law

David S. Caudill

Psychoanalysis is not the system of stereotypical interpretations to which it is too often
reduced by certain of its adepts, to the great advantage of its detractors, who have made
things very easy for them.

Jean Laplanche

Given the recent onslaught of criticism of Freud in academic as
well as in popular literature, this seems to be either the worst pos-
sible time to reintroduce the term 'psychoanalytic jurisprudence',
or an opportune moment, with Freud on everyone's mind, to dem-
onstrate the usefulness of certain psychoanalytic conceptions for
legal theory. While I believe the latter is the case, the spectre of the
former makes me cautious. Of course, Freudian psychoanalysis has
always had its critics, but it was until recent decades a respectable
and influential explanatory paradigm – intellectuals studied and
discussed Freud, the 'psy' professions adopted and (with some re-
visions) applied Freudian clinical models, psychoanalytic notions
became common sense in popular culture and, not surprisingly,
psychoanalysis found a home in legal processes, institutions and
texts. In the past thirty years, however, the respectability and
influence of psychoanalysis has gradually dwindled, and for sev-
eral years now, 'Freud-bashing' is far more fashionable than seeing
one's analyst. While the debate concerning psychoanalysis is not
over, it cannot be ignored, and a certain defensiveness is appropri-
ate among those of us who see a future for psychoanalytic juris-
prudence.

Significantly, the recent attacks on Freud are focused on the clini-
cal utility and scientific status of psychoanalytic theory (though an
indirect attack on the social, historical, literary or philosophical uses
of Freud is certainly implied). Tom Wolfe, enamoured of recent ad-

vances in neuroscience, concludes that 'Freudian psychiatrists are now regarded as old crocks with sham medical degrees, as ears . . . that people with more money than sense can hire to talk into.'[1] Frederick Crews is likewise convinced that analysis as a whole remains powerless and understandably so, because 'a thoroughgoing epistemological critique, based on commonly acknowledged standards of evidence and logic, decertifies every distinctively psychoanalytic proposition.'[2] Defenders of psychoanalytic theory and practice, none of whom wish to defend Freud in all of his hypotheses, techniques and speculations, are themselves divided over the problem (or necessity) of the scientific status of psychoanalysis. Howard Shevrin, intent to satisfy sceptics, links psychoanalysis to neurophysiology and cognitive science;[3] Morris Eagle is optimistic about 'systematic outcome research' to address 'the issue of accountability';[4] and Jean Laplanche argues that psychoanalytic theory, as a metapsychology, is open to refutation and falsification[5] – the supposed mark of scientific inquiry. Others, including Jonathan Lear and Eugene Goodheart, question whether the standards of empirical science are decisive in assessing the value of psychoanalytic theory, given that all sorts of scholarly enterprises are not empirical sciences.[6]

Some contemporary assessments of psychoanalysis are more modest and lacking in the certitude either that Freud is ready for the dustbin of history or that his insights remain important for psychopathology. Alan Stone argues that psychoanalysis has failed, scientifically and medically, as a form of treatment, but predicts it will survive as an art.[7] John Horgan, on the other hand, observes that Freudians are not alone in their failure to 'point to unambiguous evidence that psychoanalysis works' – 'neither can proponents of modern treatments, whether Jungian analysis, cognitive-behavioral therapy or even medications'.[8]

Reviewing the literature attacking, defending or just wondering about Freud, one quickly realizes that psychoanalytic theory is, quite clearly, not a single 'thing'. There are the early Freud, the late Freud, dozens of neo-Freudianisms, numerous clinical variations of psychoanalytic practice, social theories and literary theories based on or inspired by psychoanalysis and, of course, psychoanalytic jurisprudence. To say that psychoanalysis is a moving target is not just a ploy to deflect criticism – it *is* a moving target.

Psychoanalytic Jurisprudence as Critical Social Theory

Psychoanalytic jurisprudence, a term having no fixed meaning, is best distinguished from the evidentiary uses (in court) of psychoanalytic clinical theory and practice. The latter came into the legal establishment in the 1930s and 1940s, because it became a dominant framework among psychologists and psychiatrists, and then left the legal establishment, roughly in the 1960s, because it was no longer dominant. Indirectly, of course, Freudian notions are all over the place in the contemporary practice of psychotherapy, and therefore in law as well, and whether one wants to give Freud credit, or to hold that we would have discovered everything that is true in Freud without him, is beside the point. Direct appeals to Freud or even to contemporary neo-Freudian scholarship are generally speaking not going to work in the courtroom or hearing chamber; when a judge needs medical science, he or she needs either currently accepted (by most scientists in the field) views or cutting-edge research, *not* controversial ideas. If the use of psychoanalytic experts at trial was ever called 'psychoanalytic jurisprudence', the label is now available for other purposes.

The questions of the scientific status of psychoanalysis and of its status as a provider of useful courtroom evidence are discussed in detail in the next section of this chapter. Briefly, while law relies on science to stabilize rhetorical instabilities, critics have lately highlighted the rhetorical instability of science itself. Psychoanalytic theorists, under attack by legal theorists and scientists, are themselves divided over the nature of psychoanalytic knowledge. Any neo-Freudian movement (and I will consider Lacanian theory as an example) presenting itself as useful to law will be caught in a web of disciplinary and evidentiary crises – in the fields of law, science and psychoanalysis.

I prefer to think of psychoanalytic jurisprudence as coexisting alongside analytic theory and practice, roughly since the publication in 1930 of Jerome Frank's *Law and the Modern Mind*. Frank integrated psychoanalytic theory into his realist critique of law, for example, by identifying the myth of law's coherence (reinforced unconsciously by lawyers) and the desire for social stability that finds rest in law's authority as a father-figure. Such thinking culminated in the 1960s and early 1970s with the appearance of Bienenfeld's lengthy 'Prolegomena' (to an unfinished book),[9] which reconsid-

ered the Oedipus complex, Goldstein's article entitled 'Psychoanalysis and Jurisprudence',[10] and Ehrenzweig's 'psychosoply' of criminal law, torts and civil procedure,[11] but started to fizzle out with C. G. Schoenfeld's *Psychoanalysis and the Law* (1973), when a certain modesty and defensiveness set in.[12] All of these works are characterized by their use of psychoanalysis to explain how law works – how law gets into people's heads, how authority is projected onto law, how the law functions to create and/or satisfy demands and desires, and, most significantly, how many aspects of law are unconscious, repressed and irrational.

Nowadays, the tradition of appropriating Freud continues in legal scholarship, but only in a scattered fashion – there is no identifiable movement or association or annual conference, and the occasional reference to Freud (or to some neo-Freudian school, such as object relations theory or self-psychology) is far more common in legal scholarship than sustained reliance on psychoanalytic theory. One recent survey of the many interactions between law and psychology mentioned neither Freud nor psychoanalysis.[13] While it is not the purpose of this chapter to survey all the uses of Freud in recent legal scholarship, they appear with regularity albeit at the margins of mainstream law and psychology scholarship.

Critical legal scholarship, to the extent that it remains an identifiable category, sometimes employs psychoanalytic terminology, which is not surprising given that Frankfurt School Neo-Marxism and French critical theory, which have inspired critical scholars in law, each betray psychoanalytic influences. The 'Law and the Post-Modern Mind' conference at Cardozo School of Law (Yeshiva University) in the fall of 1993 became a focal point, of sorts, for critical scholars interested in psychoanalysis; Derrida gave a keynote address about Jacques Lacan, and many of the conference papers were Lacanian or simply Freudian in orientation.[14] The recent symposium issue of *Legal Studies Forum*[15] on the future of psychoanalytic jurisprudence is also representative of the ongoing discourse about the critical potential of psychoanalysis in law, a discourse that is influenced if not always dominated by the work of Lacan. In the remainder of this section, I discuss how the contributors to that *Legal Studies Forum* symposium attempt to create, within the psychoanalytic tradition, a point of leverage for critical legal scholarship.

Peter Goodrich's introduction to the work of Pierre Legendre, a legal historian influenced by Lacan, is also an introduction to one style or form of contemporary psychoanalytic jurisprudence.

Goodrich's *Oedipus Lex: Psychoanalysis, History, Law*[16] described
a psychoanalytic methodology for interpreting the history and texts
of legal institutions, which was exemplified in *Law in the Courts
of Love: Literature and Other Minor Jurisprudences,*[17] where
Goodrich identified certain repressed and forgotten episodes, im-
ages, and texts of the common law. Specifically, Goodrich shows
how early (sixteenth- to seventeenth-century) images of law as
unitary, ancient, and rational eclipsed and exiled other images – the
foreign, the feminine, the plural – and therefore other 'jurisdic-
tions'. In his contribution to the *Legal Studies Forum* symposium
(entitled 'The Unconscious is a Jurist: Psychoanalysis and Law in
the Work of Pierre Legendre'), Goodrich acknowledges the
influence of Pierre Legendre on his own work and describes
Legendre's compelling conception of psychoanalytic jurisprudence.
Legendre reads the institution of law, in its early texts, as if it were
a subject – with an unconscious, with a body exhibiting symptoms
of madness and, most importantly, with the capacity to capture
other subjects.

> [Legendre's] psychoanalytical jurisprudence is . . . a theory of
> law which seeks to understand the legal order as the structural
> mechanism or social form of reproduction of subjects. Law,
> for Legendre, is intrinsic to the formation of the individual sub-
> ject, and law is both historically and theoretically at the center
> of the symbolic order in relation to which individual identity
> is formed. Where Lacan referred to the unconscious as being
> structured like a language, Legendre adds that the unconscious
> acts like a lawyer.

Goodrich's introduction to Legendre is part of a larger English trans-
lation project that culminated in the publication of *Law and the
Unconscious: A Legendre Reader.*[18]
 Legendre's methodology is exemplified in his *Legal Studies Fo-
rum* article (translated by Peter Goodrich) on the sacraments (enti-
tled 'Id Efficit, Quod Figurat: The Social Constitution of Speech
and the Development of the Normative Effect of Images'), which
sends us to theological discourse in the twelfth and thirteenth cen-
turies in search of founding images of contemporary law. In that era
of religious authority (but also lively theological debate), not scientific
or secular-legal authority, we can observe the unconscious dimen-
sion of representation, figuration, ritual, and staging that persists

but is denied – we resist the uncomfortable knowledge of how discursive, indeed religious, the foundations of our social institutions are.

> Understood . . . as a progressively secularized universal symbolic order, the contemporary managerial and rationalist forms of institution of images, the social status of scientific knowledge and the ideology of self-foundation so successfully promoted in the twentieth century, would all be understood as the products of [an] a-genealogical theology that sprang from the medieval interpretative Revolution.

For both Legendre and Goodrich, contemporary law's unconscious – that which has been repressed, denied, exiled or forgotten – is revealed in historical analyses.

Shaun McVeigh and Peter Rush, in their *Legal Studies Forum* symposium article (entitled 'Cutting our Losses'), are concerned with contemporary representations of criminal legal doctrine, an inquiry that touches on delirium, dream, repressed histories and an unconscious order of images. Read alongside Goodrich and Legendre, McVeigh and Rush demonstrate carefully how to raise questions of institution, address and judgement – generally assumed away, effaced or forgotten in doctrinal discourse – and thereby to create a critical space for alternative representations of law.

Renata Salecl's article in the *Legal Studies Forum* symposium (entitled 'Love me, Love my Dog') is a version of her contribution to *Psychoanalysis and Jurisprudence: Essays in Law and the Postmodern Mind*.[19] The Russian artist Oleg Kulik's performance as a dog at European art shows, which act included barking at and biting visitors, may seem an unlikely touchstone for psychoanalytic jurisprudence, but Salecl manages to reveal certain assumptions of 'deep ecology' with reference to Freudian, and particularly Lacanian, themes concerning human enjoyment of suffering, human losses upon entrance into language, human dilemmas about desire (as in hysteria) and the unique burdens of the human subject in addressing, needing and finding himself or herself in the Other. (That notion in Lacanian theory, the 'Other', is only mentioned in passing by Salecl, but deserves attention in any discussion of psychoanalytic jurisprudence conceived as an attempt to reveal law's unconscious. The term is notoriously ambiguous in Lacan's seminars and among his commentators, but variously refers to the unconscious, or the

collective unconscious, and to the place where we *find* ourselves – in the mother, in the law of the father, in the conventions of language, family, school, workplace, relationships and society, including the institutions and processes of law. To name those things 'unconscious' is to interiorize them, in the subject, and to deny any space between identity (or 'self') and the Other.)

Several more Lacanian notions are explicated in some detail in the contributions to the *Legal Studies Forum* symposium by Dragan Milovanovic and Helen Stacy, both of whom work within distinctively Lacanian frameworks (Milovanovic uses Schema R, the Borromean Knot, and various Lacanian mathemes or algorithms; Stacy uses the Four Discourses – Master, University, Hysteric and Analyst). Milovanovic, in 1992, wrote the first book on Lacan and law, *Postmodern Law and Disorder*,[20] and is known for his synthesis of Lacan and chaos theory. His essay (entitled 'Rebellious Lawyering . . .') in the symposium is an argument for alternative discourses in law and against dominant discursive structures; Gerald Lopez's notion of rebellious lawyering is given a complex psychoanalytic justification with reference to Lacan's three orders of being (Real, Symbolic, Imaginary), legal semiotics, Paulo Freire's dialogical pedagogy, and various chaos diagrams. Helen Stacy, in 'Lacan's Split Subjects: Raced and Gendered Transformations', is likewise concerned with the potential of discursive structures to destroy and create identity, voice and power in the subject of law. Her appropriation of Lacanian discourse theory to analyse a recent Australian legal controversy (the Hindmarsh Island Affair) provides a rare and impressive example of practical-legal analysis in terms of a theory, Lacan's, which is usually inaccessible to all but Lacan's disciples.

The *Legal Studies Forum* symposium concluded with a review essay (entitled 'Psychoanalysis Becomes the Law') by Costas Douzinas, who reflects on the future of psychoanalytic jurisprudence with reference to Peter Goodrich's *Oedipus Lex*, Jeanne Schroeder's *The Vestal and the Fasces: Psychoanalytical and Philosophical Perspective on the Feminine and Property*[21] and my own *Lacan and the Subject of Law: Toward a Psychoanalytic Critical Legal Theory*.[22] Against a 'background of misunderstanding and missed opportunities', Douzinas sees an emerging field of scholarship concerned with how the

> unconscious and desire both create and disrupt consciousness and subjectivity and, as a result, [how] the understanding of

human experience, action and meaning always involves 'another scene' and demands a 'double reading' of the causes and effects of 'free will'. Psychoanalysis and in particular its Lacanian revision are fast becoming the last great frontier for jurisprudence.[23]

From beginning to the end of the *Legal Studies Forum* symposium, a particular model of psychoanalytic jurisprudence is at issue (and there are doubtless other models, orientated, for example, to more traditional Freudian categories or to particular schools of neo-Freudian theory and practice). The recurrent themes include Lacan's revision of Freud; the *turn* in legal scholarship to hermeneutic/semiotic/linguistic/narrativity/discourse theory; the identification of law's unconscious operations, functions and guiding images, both in the individual and in society, both historically and in contemporary institutions; and, most importantly, the search for a critical position – for ethics, justice, diversity – between the failures of mainstream jurisprudence and the perceived excesses of postmodern theory. That orientation is, for these critical psychoanalytic legal theorists, both theoretical and practical, both social and individual, both Freudian and (yet) highly revisionistic, and both legal and interdisciplinary. We are still in, and not at, the wake of psychanalytic jurisprudence.

On the other hand, the future of psychoanalytic clinical theory in law presents an entirely different set of questions. The popular conception of law's relationship to psychological and psychiatric *knowledge* is that of an institutional process – law – in need of outside guidance. Ideally, scientific 'truth' is imported, when necessary, to settle disputes over causation or mental capacity. Of course, legal processes and institutions develop, over time, their own version of psychology and psychiatry, while scientific institutions and processes are themselves divided and full of controversies over matters psychological, so the ideal falters.

Rhetorics of Objectivity: Law, Science, Psychoanalysis

Three crises

We cannot look at every picture, read every book; critical evaluation is not so much ideological as practical. Some of the past has to be suppressed for the rest to become visible.[24]

Identifying crises is risky business – crises are relative, contextual and named on the basis of a particular perspective. From my vantage, my peculiar constellation of disciplinary associations, the last few years have framed an interrelated set of crises – at least, mini-crises – in the institutions of law, science and psychoanalysis (the latter, which might appear to be less complex when compared to the first two, is equally difficult to define even while its cultural 'weight' or influence is significantly less and its history briefer). I refer to the 1993 *Daubert* opinion by the US Supreme Court, the arrival of 'science studies' as a subdiscipline and the debate over the planned, cancelled (postponed?), and re-scheduled Freud Exhibition at the US Library of Congress.

Each event can be trivialized to challenge its status as a crisis. Historically, each can be characterized as merely the next chapter in three already lengthy stories – the attempt in *Daubert* to clarify the evidentiary standard for admission of scientific, expert testimony is hardly a new effort; 'science studies' is, perhaps, merely the culmination of a decades-long debate (among historians and philosophers of science) over the social construction of scientific knowledge; and the attack on psychoanalysis as unscientific is a perennial phenomenon. Any crises here are old and ongoing affairs of the twentieth century. Moreover, from the perspective of a practising scientist who is enjoying the credibility of his or her paradigm's dominance – say, a heavily funded neuroscientist at the Salk Institute – the events might be seen as encouraging (in the case of *Daubert*, as formal and official condemnation of junk- and pseudo-science by law), irrelevant (in the case of science studies, as hyper-theoretical busywork by non-scientists), or both (in the case of the Freud Exhibition, as another coffin nail that should not be necessary but somehow is).

Even conceding the twin dangers of a-historical surprise and failure to acknowledge multiple perspectives, the events I identify are remarkable as institutional identity crises. Theorists in law, science and psychoanalysis argue nowadays about the proper characterization of their respective discipline as primarily either a rational or a rhetorical enterprise. The hermeneutic *turn* in philosophy and historiography, which divided those disciplines because not everyone turned, was followed by the hermeneutic turn in law, science and psychoanalysis, which also left most practitioners behind. Examples of the turn in law include critical legal studies (which dissipated into feminist criticism, critical race theory, social psychoanalytic theory, and so forth) and the law and literature movement;

both emphasize law's inevitable ideological and discursive character, yet both are marginal enterprises in professional legal education. Science studies just as clearly emphasizes the social and narrative aspects of scientific knowledge. And the controversy over the Freud Exhibition effectively divided the friends of psychoanalysis between those who defend it as science and those who concede it is hermeneutical.

To explore the interrelations of these disciplinary crises, I consider below the sporadic reliance of law on science to stabilize rhetorical instabilities, the efforts of psychoanalytic theorists to define or to distinguish analysis by reference to science, and the law's response, as an officiator of scientific validity, to psychoanalysis. I hope to show that judgements – whether based in legal, scientific or psychoanalytic enterprises – concerning the scientific status of psychoanalysis depend entirely on particular and tentative models of science and psychoanalysis that are presumed to be characteristic and stable.

Law and science

DAUBERT V. MERRELL DOW PHARMACEUTICAL[25]

Far from settling matters, *Daubert* has triggered an outpouring of speculation.[26]

The issue in the initial *Daubert* litigation was, briefly, whether the drug Benedictin causes birth defects, and the trial court and a federal appellate court ruled in favour of the defendant Merrell Dow Pharmaceuticals on the basis of experts who testified that published epidemiological studies showed no link between Benedictin and birth defects. That testimony was admissible since it was based on techniques generally acceptable in the relevant scientific community. The plaintiffs offered expert witnesses to challenge the published studies, but their reanalyses of the studies were not published in scientific journals and were therefore kept from the jury. On the plaintiffs' appeal to the US Supreme Court, various associations of scientists submitted briefs to help the Court understand the nature of scientific credibility, but the briefs reflected two different perspectives.

Some scientists argued that the trial judge was correct in limiting scientific testimony to that reflecting sound methodology as it ap-

pears in scientific journals, in contrast to scientific rhetoric prepared for trial. Another group reminded the court that dissenting views often lead to progress in science, and thus viewed judicial screening as suspect.[27] The court compromised by upholding the importance of widely accepted and published scientific evidence but encouraging flexibility in judicial acknowledgement of unconventional views. That solution pleased neither camp of scientists and thus served to keep legal institutions and processes distinct from those of the scientific community. Judges, not scientific 'guests' in our courts of law, will be the gatekeepers between science and law.

FLORIDA BAR V. WENT FOR IT, INC.[28]

What is it about certain accounts . . . that grants them the authority of objectivity, while others are held to be deluded or deceived? . . . If one fails to ground decisions in objective appraisal, one is said to be ill adapted to the world's contingencies. . . . Yet [objectivity] as an achievement is primarily a matter of rhetorical practice. [29]

Florida Bar v. Went For It upheld as constitutional a thirty-day blackout period after an accident during which lawyers may not, directly or indirectly, contact accident victims or their relatives in order to solicit their business. Significantly, the opinion can be viewed primarily as an opinion concerning professional responsibility (regulation of lawyer advertising and solicitation) and constitutional law (restrictions upon commercial speech and protection of privacy rights). The striking feature of *Went For It*, however, is the justices' sharp disagreement over the reliability of the Florida Bar's two-year study of lawyer advertising and solicitation, which justified the thirty-day rule; the study established that accident victims (and their relatives) are traumatized by early contacts by attorneys, *and* that such contacts hurt the image of the legal profession. Justice O'Connor, writing for the (5–4) majority, credited the statistical data in the record (including surveys by a 'nationally renowned consulting firm') as significant, and also highlighted the 'breadth and detail' of the anecdotal record. Justice Kennedy, in his dissenting opinion, questioned the 'productive' usefulness of the statistical data (in 'the so-called Summary of Record') and highlighted the incompetence of the 'anecdotal matter'. Such contradictory assessments call to mind

Justice Blackmun's confidence in *Daubert* that federal judges are capable of assessing scientific reliability; while Chief Justice Rehnquist was less confident about trial judges' fitness to perform this 'gatekeeping' function,[30] both justices joined O'Connor in *Went For It*. Trial judges aside, all of the US Supreme Court justices seem to view themselves as capable of assessing the scientific reliability of the Florida Bar's data, and each did – five found it reliable and four did not.

From several viewpoints, these contradictory assessments might appear unremarkable. Disagreements about the evidence, or what the evidence shows, are common enough in US Supreme Court opinions, as is the deference to state regulators. Moreover, the respondents in *Went For It* (the original plaintiffs) challenging the thirty-day ban did not mount a substantial challenge to the reliability of the Florida Bar's empirical and anecdotal studies –for example, by doing their own studies – so Justice Kennedy had little to work with in his expression of grave doubts about the basis for the regulation. Nevertheless, the reliability debate in *Went For It* is a significant example of how social science evidence can be mediated, through its translation into legal categories, through its interpretation to support a story, and through judicial common sense, to the point of its irrelevance for law. The mediation of scientific studies by judges leads to the criticism that when

> some high principle of justice collides with the messy realities disclosed by a study, the courts are tempted to deny the reality rather than sully the principle. In fact, even when the studies are not uncongenial to the chosen path there is strong resistance to making constitutional judgments turn on anything but the broadest and simplest of social facts.[31]

At that point, the distinction between good science and bad science quickly fades. One might consider the *Went For It* opinion as consisting of two contradictory stories. The majority tells us that the victims of an accident do not want to hear from attorneys, will be traumatized if they hear from one (or more), and will think negatively about the profession following such a trauma; therefore, since we need to preserve confidence in lawyers, we should restrict solicitation of accident victims. On the other hand, the dissent tells us that victims of an injury may well welcome a letter from an attor-

ney, and even if they do not they can throw the letter away without suffering trauma; furthermore even if they suffer trauma there is no indication that such trauma will hurt the profession, and even if it hurts the profession there is no indication that the profession will not save itself from such harm by acting in a manner that causes people to hire attorneys. In short, an attorney who elicits hatred will not get the client and therefore brings about his or her own ruin without regulatory assistance. Both stories are highly constructed and based on inconsistent anecdotal evidence that is typically available in an adversarial trial.

From a scientific perspective, this scene is unacceptable. While the evidence during the *Went For It* proceeding was limited, existing research indicates that the dissent's story is more accurate: people generally do not react negatively to attorney advertising and solicitation, even though attorneys generally *believe* that people react negatively.[32] We might then conclude that judges could get the story straight by using good science, but science is itself in some contemporary accounts merely a set of stories or persuasive narratives, just like law. Indeed, Bruno Latour, after characterizing science in action as a move from weaker to stronger rhetoric, strongholds and networks, identifies a tribunal of reason whose jury is the enlightened public, whose prosecutors file 'accusations for breaking the laws of rationality' for the benefit of those of us not in the networks of scientific practice.[33] The controversy over the Freud Exhibition is exemplary of the caseload of that tribunal.

Science and psychoanalysis

Eugene Goodheart recently condemned the 'total assault' on Freud's achievement by revisionist scholarship, including an essay by Frederick Crews in the *New York Review of Books* and *Time*'s 'Is Freud Dead?' issue in the fall of 1993.[34] Goodheart, in response to the view that Freud lacks scientific credibility, questioned the stability of science and compared Freud favourably to other great thinkers whose work, while not 'scientific', is suggestive, heuristic and persuasive. Crews responded in the fall 1995 *Dissent*, pointing out that 'Freud is becoming less persuasive with every passing year',[35] and Goodheart replied, wavering between his concession that Freud is not a scientific (but an 'interpretive') thinker and his criticism of Crews' 'easy scientism':

I agree with Crews that Freud's work doesn't meet contemporary standards of scientific achievement. . . . [But truth] is not the exclusive property of science, so it doesn't follow that Freud's narrative power and theoretical gifts can't be the source of truths.[36]

The interchange confirms the ambiguity of the debate and its multiple positions – defenders of Freud will have to decide whether their strategy is to emphasize the social and narrative construction of science, in which case Freud *is* scientific (but that is no great achievement), or to concede that Freud is not scientific but then limit the scope of science as an arbiter of truth (or of something else like theoretical suggestiveness or 'fertility'). Critics, likewise, will have to decide whether the standard that Freud fails to meet is scientific credibility, or truth, or fertility.

In December 1995, the *Washington Post* reported that the Freud Exhibition (scheduled by the US Library of Congress for the fall of 1996) had been postponed owing to budgeting constraints and perhaps also to the sharp criticism contained in a petition signed by about fifty scholars (initially 42 and later 52, including Peter Swales and Frederick Crews). In response to the postponement, the President of the Washington Psychoanalytic Society wrote two letters of protest to the *Post* and to the Library of Congress, respectively; Sanford Gifford wrote an editorial for the *American Psychoanalyst* deploring the cancellation as hypersensitivity and timidity; and Jonathan Lear immediately published a lengthy essay in the *New Republic* defending psychoanalysis against the anti-Freudian campaign. Just over two months later, the Library of Congress re-scheduled the exhibit for the fall of 1998, explaining that inadequate funding was the only reason for the postponement; the media had erroneously characterized the affair as a 'cancellation or as a response to outside controversy over the show's content'.[37] Oliver Sacks, one of the original petitioners identified by the *Post*, gladly agreed to write an essay for the catalogue and 'bridled at being linked to angry anti-Freudians'.[38] Fourteen other signatories of the petition wrote letters saying the exhibition should proceed, and the President of Division 39 (Psychoanalysis) of the American Psychological Association, Morris Eagle, wrote a lengthy editorial defending himself from criticism (for signing the petition) and correcting misrepresentations by reporters who obviously did not read the petition. On the question of science, Eagle remarked that the psychoanalytic community

cannot respond to calls for accountability and some kind of appropriate empirical validation with a blanket rejection and an attitude of victimization and beleaguerment. . . .

If we want to [argue for] the value of long-term treatment, then we are acknowledging that some kind of systematic outcome research is vital in addressing the issue of accountability. We cannot reasonably select only positive findings and ignore all other findings and challenges.[39]

The idea that psychoanalysis needs empirical, scientific validity to overcome criticism of analytic principles was the subject of a plenary address by Howard Shevrin at the December 1993 meeting of the American Psychoanalytic Association.[40] Shevrin is known for his attempt to link psychoanalysis to neurophysiology and cognitive science to 'increase its acceptance among skeptical scientists'.[41] His address was a 'play' with characters representing his own (Dr Link) and various other views – Dr Case, who believes in the 'primacy of the clinical situation as the bedrock of psychoanalytic science'; Dr Sample, who believes in systematic clinical research but is concerned about the scientific foundations of psychoanalysis; and Professor di Sapienza, who believes analysis is rational but not scientific:

Teaching and governing are both rational enterprises with worthwhile goals involving bringing about change in individuals or in society at large, and yet are not sciences, neither applied nor basic. Nor are teaching and governing to be confused with hermeneutic sciences. . . .[42]

Arnold Goldberg's response to Shevrin, which highlighted the 'various inquiries that go under the name of' science, included the claim that 'everyone [in Shevrin's dialogue] is right and justified, [since being] right and correct flow essentially from a tradition, which comes from a community of scholars with shared procedures and a common vocabulary.'[43] William Grossman likewise responded that psychoanalysis 'is a term covering too many more or less scientific, or unscientific, activities, interests and points of view to be characterized by a single term like "science"'.[44]

Different activities are called science, and different activities are called psychoanalysis. The case-study method, for example, is considered scientific by some and denigrated as anecdotal by others.[45]

The links with neurophysiology and cognitive science confirm essential elements of psychoanalysis, but even though 'the alphabet is essential to Shakespeare . . . we might balk if asked to conclude that alphabetology is the essential basic science of English literature'.[46]

Jonathan Lear's defence of psychoanalysis recognizes two valuable enterprises: empirical science like experimental physics and interpretative activities like history, economics, social science and psychoanalysis.[47] Jane Flax similarly distinguishes psychoanalysis from the medical science model, and advises analysts to concede their terrain is unique; my concern with Flax is her notion that there is a 'broad area of consensus among analysts about which claims are false, irrelevant, or unworthy of attention'.[48] It is precisely this point that I find problematic, and I will explain why by reference to Lacan, who does not, I believe, fit within the broad area of consensus that Flax identifies. Having been both a candidate at an American psychoanalytic institute and a fellow-traveller of Lacanian theory, I think that the issue of whether analysis is scientific is different in each context.

Consider Richard Powers's latest novel *Galatea 2.2*, which might be read as a 'Lacanian' assessment of current brain research and artificial intelligence ('AI') modelling. I use the term 'Lacanian' the way Terry Eagleton does when referring to a 'Lacanian Irish rebel song', the lyrics of which indicate displaced rage and compliance as a way of not complying with a mother (England) who misconceives a child's (Ireland's) need for recognition:

> *When we were savage, free and wild she came like*
> *a mother to her child*
> *And gently raised us from the slime . . .*[49]

Powers can be read in light of Ellie Ragland's remark that Lacan 'makes these AI "scientific" researchers seem like nineteenth-century mechanists in their assumptions and presumptions.'[50] Maybe so, until Powers becomes the AI researchers' reporter.

Powers's autobiographical main character, a novelist trained in literary theory and criticism, becomes involved in the construction of a computer who/that is 'taught' to take a comprehensive exam for a graduate degree in English literature. The scene of the novel is a university with a major scientific research facility, where the discussions between the novelist and various scientists concerning how the brain works is supposed to reflect the latest in neuroscientific

research. Powers is familiar with Lacan, and while it is not clear that the novel develops by intention an analogy between Lacanian theory and neuroscientific research, the analogy is there. Lacan's fading subject, lacking autonomy and freedom, returns in the deterministic monism of neurophysiology. Lacan's identification of the human subject as 'the slave of language', his reduction of culture to language, and the primacy he gives to the symbolic order of existence[51] are echoed in Powers's description of the brain:

> [S]ymbols are all that become of the real. They change us. They make us over, alter our bodies as we receive and remake them. The symbols a life forms along its way work back out of the recorder's office where they wait, and, in time, they themselves go palpable. Lived.[52]

Again, while Lacan remarks that symbols, the order of language, 'envelop the life of man in a network so total . . . that they bring to his birth the shape of his destiny',[53] Powers observes that

> Every sentence, every word I'd ever stored had changed the physical structure of my brain. Even reading [a scientific journal] article deformed the cell map of the mind the piece described, the map that took the piece in.
> At bottom, at synapse level, I was far more fluid than I'd suspected. As fluid as the sum of things that had happened to me, all things retained or apparently lost. Every input to my associative sieve changed the way I sieved the next input.[54]

The conversations in the novel between the protagonist and brain scientist remind readers familiar with Lacan of his famous notions that subjects meet only through their 'signifiers', that the subject misrecognizes itself as an autonomous actor, and that rational self-control is an illusion:

> 'We humans are winging it, improvising. Input pattern x sets off associative matrix y, which bears only the slightest relevance to the stimulus and is often worthless. Conscious intellect is smoke and mirrors. Almost free-associative. Nobody really *responds* to anyone else, per se. We all spout our canned and thumbnailed scripts, with the barest minimum of polite segues. Granted, we're remarkably fast at indexing and retrieval. But

comprehension and appropriate response are often more on the order of buckshot.'

'I'm beginning to see. You're not elevating the machine. You're debasing us. Took me long enough.'[55]

Indeed, Lacan's notion of *méconnaissance*, a critique of Freud's adaptive ego,[56] is given a neuroscientific justification in Powers:

'We've endured this incredible capacity for lying to ourselves. It's called intellect. Comes with the frontal lobes. In fact, we've gotten so good at the walking-on-water bit that it no longer requires any energetic pretense to keep the act afloat.'[57]

Finally, Powers's protagonist realizes that consciousness provides the myth of a unified and coherent subject, a function of Lacan's *imaginary*:[58]

It occurred to me: awareness no more permitted its own description than life allowed you a seat at your own funeral. Awareness trapped itself inside itself. The function of consciousness must be in part to dummy up and shape a coherence from all the competing, conflicting sub-systems that processed experience. By nature, it lied. Any rendition we might make of consciousness would arise from it, and was just about as reliable as the accused serving as sole witness for the prosecution.[59]

Reliance on Powers's novel for neuroscientific insights is, of course, of little ultimate value, but Powers successfully popularizes the radical implications of contemporary brain science. The analogy with Lacan is similarly limited, but I make it to raise the question of whether a neo-Freudian explanatory paradigm like Lacan's would fare better as a supplement to legal processes and institutions if such a paradigm was in accord with mainstream science. Lacanians, significantly, are divided over the scientific status of their work, just as traditional Freudians are, and both schools are divided over what the 'work' of psychoanalysis is or can become. In addition to the problem that expert testimony based on Freudian theories will be discredited as unscientific, that is, as not representing either generally accepted views (of scientists in the field) or cutting-edge research, there is always concern, perhaps unjustified, that scientific evidence will overwhelm the jury.

Even if a trial judge found a piece of evidence well grounded in science and helpful to the trier of fact, [evidentiary rules permit exclusion if there is] the potential for unfair prejudice and the possibility that the evidence will confuse or mislead the jury. Concern has been expressed that juries may overvalue scientific evidence.... This concern is unfounded ... [S]cientific studies have demonstrated that juries actually tend to *undervalue* scientific evidence. Additionally ... any danger of confusion is virtually nonexistent in the social sciences.[60]

Another factor is introduced, therefore, insofar as the jury may not be moved at all by scientific evidence. For reasons that are unrelated to science – reasons, by the way, for which psychoanalytic theories of the unconscious are especially relevant – juries may decide that a particular expert witness is not credible:

Credibility [the exclusive province of a trial jury] is considered to be the product of the jury's 'view of the diverse ingredients it has perceived at trial, combined with experience, logic, and an intuitive sense of the matter.'

Recent experience suggests, however, that this confidence may be misplaced. Cases where their 'intuitive sense of the matter' were mistaken ... or ... their 'common sense' views were simply racist or sexist are all too familiar. Social science research further [suggests] widely held myths and stereotypes. [61]

Setting aside the question of whether Lacanian theory is in accord with cutting-edge neuroscience, we might ask whether Lacanian theory is in accord with social science research concerning the myths and stereotypes that judges, lawyers and juries hold. That question was recently raised by Richard Redding, a mainstream law and psychology scholar orientated to empirical social science but familiar with Lacanian theory.

Why would a Lacanian socio-legal analyst care about scientific validity?

IS LACANIAN THEORY SCIENTIFIC?

Richard Redding's recent evaluation of the scientificity of Lacanian theory is a unique and compelling attempt by a mainstream law and psychology scholar to engage Lacan.[62] Interest in Lacan, whether to

appropriate or to criticize his views, is usually limited to critical legal theorists whose field of discourse is decidedly distinct from the terms of interaction between law and empirical psychology. Redding has attempted the near-impossible task of becoming, in McCloskey's terms,[63] a trilingual scholar who can translate among the disciplinary discourses of law, mainstream psychology and Lacanian psychoanalysis. The difficulty for Redding is the temptation to become a monolinguist by criticizing certain legal conceptions by the standards of empirical psychology – which Redding did in earlier work[64] – or by his present assessment of how Lacan's views accord with recent progress in empirical psychology. Redding is, however, aware of this temptation, as he has also recently criticized the law and psychology movement for its failure to be truly interdisciplinary – each discipline can learn from the other's knowledge of the subject of law.[65] Likewise, Redding is cautious, indeed generous, in his evaluation of the usefulness of Lacanian theory for law.

The difficulty persists, however, because the term 'scientifically valid' is used so differently in the respective discourses of law, empirical psychology and Lacanian psychoanalysis. In one recent formulation, there

> are important differences between the quest for truth in the courtroom and the quest for truth in the laboratory. Scientific conclusions are subject to perpetual revision. Law, on the other hand, must resolve disputes finally and quickly.[66]

Significantly, Redding complicates the above distinction by bracketing the questions of the scientific validity of Lacanian theory for the courtroom or for legal reform efforts, concluding that psychoanalysis has no place in those activities, and instead asking whether Lacanian social theory provides scientifically valid insights for legal theory.

We are thus returned to the notion of psychoanalytic jurisprudence as distinct from clinical theory, introduced at the outset of this chapter; Redding, interestingly, finds a *scientific* basis for psychoanalytic *social* theory, not clinical theory. I agree with Redding that Lacanian clinical theory is an unlikely supplement for courts and legislatures, but not because, as Redding suggests, Lacan is just another Freudian. Lacan's clinical theory is based on a unique reading of Freud and is hypercritical of the American tradition of Freudian and post-Freudian psychoanalysis. Nevertheless, Lacanian

clinical theory is so radical, complex and out of sync with the terminological conventions of contemporary law and psychiatry scholarship that one can hardly imagine expert trial or legislative testimony in Lacanian terms. That is not to say, however, that Lacanian clinical theory is out of sync with contemporary neuroscience or cognitive theory; Redding's own conclusions suggest certain parallel enterprises, and others (discussed below) see some hope for Lacanian 'science' without regard to courtrooms and legislatures.

Even if one becomes bilingual by recognizing and translating the different standards of scientific validity in law and in empirical psychology, the Lacanian discourse concerning science is unique and even, in keeping with Lacan's own trademark, ambiguous. One finds in Lacan's seminars and in the commentaries of some Lacan scholars both the claim of scientific status *and* a critique of the scientific enterprise; moreover, neither argument is simple or straightforward. For example, in an early seminar, Lacan explained that

> operating in this [psychoanalytic] field we have constituted a knowledge, and one which has even proved itself to be exceptionally efficacious, as is quite natural, since any science arises from a use of language which precedes its own constitution, and that it is through this use of language that the analytic action develops.[67]

Even as psychoanalytic knowledge is identified as scientific, scientific knowledge is reduced to a linguistic construction, which might appear as an indictment of psychoanalysis itself. However, the very object of psychoanalysis here is the manner in which language constitutes our truths, including scientific knowledge. The error of science is

> believing that what science constitutes by the intervention of the symbolic function has always been true, that it is given.
> This error exists in all knowledge, in as much as it is only a crystallization of the symbolic activity, and once constituted, it forgets it . . . which is the forgetting of the creative function of truth. . . . That it is forgotten in the experimental domain is just about understandable, since it is bound up with purely operant activities. . . . But we analysts, we cannot forget it.[68]

Over a decade later, Lacan remarked that 'Science, if one looks at it closely, has no memory. Once constituted, it forgets the circuitous patterns by which it came into being; otherwise stated, it forgets the dimension of truth that psychoanalysis seriously puts to work.'[69] Lacan thus initiates a psychoanalysis of science alongside his claim that such analyses are scientific.

Ellie Ragland's recent work provides an example of the Lacanian psychoanalysis of science – the scientific researcher is, in some senses, in the position of the hysteric. One might

> describe the hysteric as a seeker after knowledge. . . . This comparison of science and hysteria might be extended further because the hysteric seeks to hold on to her symptom (taking her suffering as a way of 'knowing' . . .) that protects her from having to address her desire. The scientist seeks to prove the answers already in vogue or in his private hypotheses, not to know what really causes an enigmatic effect.[70]

But Ragland is also an apologist for psychoanalytic science – which suggests we are talking about two different conceptions of science:

> In the process of defining the status of psychoanalysis as a science . . . Lacan placed the epistemological status of science itself in question. Against the criteria of positivism (empirical confirmation, validation, grounding) Lacan . . . directed his argument towards an emphasis on the grounding and scientific status of psychoanalysis as a *problem of formalization*. This . . . leads to the provocative claim that it is precisely the mathematization – that is, the formalization – of claims about the natural world that is the essence of natural science, rather than the positivist idea that these sciences owe their status to empirical confirmation.[71]

Alexandre Leupin's essay on the 'scientificity of psychoanalysis, as distinguished from Lacan's alleged scientism'[72] argues in favour of Lacan's rigorous and logical mathematizations:

> If psychoanalysis is to attain the status of a science, it will have to be formalized in a mathematical way in order to put the accent not on meaning and quantity but on relation (structure) and quality . . . Lacan therefore renews Freud's ambition of

scientificity, but at the same time radically transforms the
modalities of legitimization of this rationality . . . medicine
and biology . . . are replaced, in Lacan, by mathematics and
topology.[73]

That transformation, necessitated by the effect of language on 'an
organic given',[74] assures transmissibility.[75] However, Lacan's mathe-
matization also assures that Lacan will be criticized, not by scien-
tists (who, apart from Redding, pay no attention to Lacan) but by
postmodern theorists.

Mikkel Borch-Jacobson, an able scholar of Lacanian theory, at-
tacks Lacan's mathematical formulae (*mathemes*) as having 'nothing
to do with authentic formalization'.[76] Drucilla Cornell, who is more
generous towards Lacan, finds Lacan's understanding of the science
of physics outmoded; despite his claim to reject traditional notions
of causality, 'Lacan remains caught up in its pictorial representation
with the addiction [*contra* modern physics] of a strong sense of de-
terminism.'[77] In defence of Lacan, on that point, Tony Jackson re-
cently analogized Lacanian theory to modern physics: 'Lacan's
description of the linguistic subject may also be called a relativising
of the subject, an attempt to reveal the essentially relativistic nature,
not only of what is known, but also of the knower.'[78] Jacques Derrida,
who is also a proper relativist in Jackson's account,[79] might bristle at
the association with Lacan – after all, he found Lacanian discourse
to be in 'spectacular' use of 'all the motifs that in my eyes were
. . . most deconstructable', for example, phonocentrism, logocentrism
and phallocentrism.[80] Again, however, Lacan has his defenders against
the charge that his works describe a systematic and closed order.
David Pettigrew, for example, highlights

> The extraordinary fluidity of Lacan's discourse, the incessant
> transformations that it underwent along the years . . . indeed . . .
> how various theoretical orders have affected the elaboration of
> Lacan's theory and the extent to which its main axioms are be-
> ing 'disseminated', so to speak, in other discourses and regis-
> ters. Lacan's very style seems to defy the structure of a system.[81]

The foregoing discussion suggests a virtual geography of positions
concerning Lacan's relation to science – he tries to be scientific, and
sometimes succeeds, and that is good (Redding); he is scientific, and
that is bad (Derrida); he pretends to be scientific, but is not, which is

bad (Borch-Jacobson); he inaugurates a new science, which is good (Ragland); he is a postmodern critic of science, which is good (Pettigrew); or he tries to be a postmodern critic, but fails, which is bad (Cornell).

Redding is to be commended for venturing into this morass, since many law professors may wonder about the appropriation of Lacan by legal theorists *and* since Redding brings a unique perspective to a new controversy entering the gates of legal scholarship. Significantly, Redding is not simply evaluating Lacan. He uses the occasion to make some arguments concerning the polarization of traditional and critical theorists, the nature of evidence and proof in social psychology, and the post-*Daubert* crisis of science and law. The 'trial' of Lacan that he sets up, assuming both the position of prosecutor and defender, raises questions about interdisciplinary research in law that go beyond his judgement of Lacan. In the remainder of this essay, I attempt to contextualize Redding's various arguments to show both their timeliness and their relevance, but also what I believe to be their limitations. The contexts I address include the debates over social construction of scientific knowledge, the recent Freud controversy concerning the Library of Congress exhibit, and the post-*Daubert* evaluations of the relationship between science and law.

Social constructivism

Take the supreme good of method, the controlled experiment. The choice of the experiment, its operation, its interpretation, and its use all depend on human contexts of argument. The human contexts, happily or not, can be tilted. In fact there is no way to untilt them. Better to be aware that argument is going on than to pretend that theory can protect us from evil as though by machine.[82]

Redding identifies the ongoing debates concerning the status of scientific knowledge, which are often described too simply as between those who believe in objective scientific truth and those who believe science is no different from religious mythology. Things are, of course, more complicated, but a distinction remains between the view that scientific knowledge is linear, progressive, testable, falsifiable and descriptive of reality, and, on the other hand, the views that scientific activity is all too human and that scientific knowledge

is not only historical, social and rhetorical, but even moral, political and gendered. The clash between those perspectives is no small affair, as a recent issue of *Social Text* (thematically entitled 'Science Wars') makes clear;[83] the new discipline of science studies (or, more pejoratively, 'science-bashing') elicits a backlash typified by Paul Gross and Norman Levitt's 'Higher superstition: The Academic Left and its Quarrels with Science'.[84]

How interesting, then, that Redding should argue that, with respect to Lacan, such fierce divisions are somewhat beside the point. The theme in Lacanian theory that Redding seeks to evaluate, scientifically, is the notion that legal ideology socializes its subjects, often unconsciously, and thereby provides support for beliefs about law and society. Redding's conclusion that Lacanian theory has scientific merit is actually surprising given how his argument proceeds: (1) Lacan is a structuralist, but structuralism has come under attack; (2) Lacan assumes that structures are cultural, but some structures are innate; (3) the legal system assumes, wrongly, that certain structures exist. The conclusion would seem to be that Lacan, like the law, is wrong about structures. Redding, however, argues that the illusions offered by law as to how human beings mature and think are precisely the type of illusions identified by Lacan – the unconscious socialization of (legal) subjects by (legal) ideology. Thus Redding navigates between the postmodern view that science is *ideological* and the traditional view that science describes *reality*. For Redding, the allegedly scientific knowledge of human growth and behaviour offered by law is ideological, and law fools its subjects into believing its 'science' stories. But Redding does not believe, as social constructionists do,[85] that the tribunals of science are like the tribunals of law. Science, in contrast to law, can in some sense rise above ideology (by empirical methodology) both to disprove legal pseudoscience and to prove that Lacan's theories of socialization have scientific merit. Hence Norman Holland's rejection of Lacan as out of step with science is called into question, as also is the view among postmoderns that Lacan would, thankfully, never meet the standards set by elite scientism.

Redding's mediation of the science debates is similar to Catherine Wilson's recent assessment of both social constructivists *and* their critics:

[S]ocial constructionism is correct in a number of its particular claims – that inanimate nature is not a repository of know-

ledge, that the acquisition of knowledge depends on commu-
nication and trust, that . . . the content of past science has been
influenced by political and social beliefs, that current science is
also so influenced, though we have no way of knowing where
and to what extent. However, it fails to acknowledge the com-
plementary role of instruments and artificial procedures in (1)
extending our everyday epistemology into formerly inaccessi-
ble regions and (2) *confounding and challenging* beliefs and
belief-systems that have their basis in ordinary and enhanced
experience. Both modes of narration . . . are legitimate.[86]

Redding's views also echo Sheila Jasanoff's argument that scientific
'truth' is often socially constructed through law,[87] although Jasanoff
has less trouble than Redding with the dissonance between 'the pref-
erences of the nation's scientific and technological elite' and the at-
tempts of courts and legislatures to maintain justice and democracy,
and to assign responsibility.[88] Finally, Redding's views are not so
different from those Lacanian scholars who indeed do see Lacan as a
mediator between Western scientism and postmodern relativism. Tim
Dean, for example, whose work is heavily influenced by Lacan, re-
cently criticized the assumption that the only 'viable alternative to
the conservative notion that sex is grounded in nature' is the view
that 'sexuality is a product of rhetoric, discourse, culture, social re-
lations',[89] and attempted to 'outline a theory of rhetoric, sexuality,
and embodiment that is both immoderately antifoundationalist *and*
antirhetoricalist.[90] Likewise, Ellie Ragland is critical of both scientism
and antiscience:

> [I]n empirical research, negatively verifiable data are taken as
> valid and true research answers. And, in deconstruction,
> skepticism itself becomes the proof against which there is no
> possibility of there being truth: possible, contingent, necessary,
> or otherwise.[91]

Redding's point, of course, is that the polarization between empiri-
cists and social constructivists can be mended, in part, by the recog-
nition not only that some claims of constructivism (like Lacan's)
find support in the scientific enterprise, but that some scientific claims
(like those reified in the law of evidence or of children's rights) *are*
socially constructed in the worst way.

THE FREUD CONTROVERSY

Redding's study of Lacan is also relevant for the Library of Congress controversy over the Freud Exhibition. Redding avoids this controversy in large part by focusing on certain aspects of Lacanian psychoanalytic theory, which remains a marginal influence within the various American psychoanalytic establishments (notwithstanding Lacan's popularity among literary theorists and cultural studies scholars). Despite his claim to be Freudian, Lacan was highly critical of almost every American school of psychoanalysis (classical, ego psychology, self-psychology and so forth). More significantly, Redding attempts to avoid addressing the scientific status of Lacanian clinical theory – the pathological and diagnostic categories (hysteria, psychosis etc.) – by treating Lacan as a social theorist. Critical theories of unconscious socialization by legal ideology, of course, usually fall on the side of the history and philosophy, not empirical psychology. A paradox is created, however, when Redding confirms the scientificity of Lacan's theory of how the self is constructed in symbolic (language) and imaginary (identity) relations, because that *is* the foundation of Lacanian clinical theory. After Redding's work, why could Lacanian clinical theory not enjoy the influential status in courts and legislatures that Redding observes is denied to Freudian psychoanalysis? The answer is that legal institutions identify with mainstream science – 'generally accepted techniques' – such that Redding's empirical support (for Lacan) is a welcome supplement to law but probably not the unconventional theory itself.

POST-*DAUBERT* REFLECTIONS ON LAW AND SCIENCE

While Redding strongly identifies himself with empirical science in his law and psychology scholarship, his interest in Lacanian theory – the seeming epitome of unconventionality – betrays an awareness not only that law often certifies unjustifiable theories as scientific, but that legal and scientific establishments often unjustifiably decertify novel scientific theories. Of course, validating certain Lacanian theories by appeals to empirical psychology could be viewed by adherents of French critical theory as a domestication of Lacan, whose work can be seen as a challenge to Enlightenment rationality;[92] others in the same critical tradition, who think that Lacanian structuralism is not so unconventional, would not be surprised that

Lacan is at home with empirical psychologists.[93] Redding, understandably confused by Lacan's contradictory (1) appeals to conventional science,[94] (2) criticism of conventional science,[95] and (3) proposals for a new view of science,[96] wisely chooses to ignore epistemological claims and to test the theory irrespective of what Lacanians may think. And as to the fear of domestication, Redding leaves out plenty of unconventional Lacanian theory from his scientific evaluation.

Conclusion

Redding, who would agree that 'legally admissible' science is not necessarily scientific, and that the law is an unstable enterprise, seeks to correct and stabilize the law with empirical science. If a Lacanian scholar is ungrateful for Redding's validation of Lacan's theory of socialization by law (and other ideological institutions), it will be because Lacan also theorizes Redding's own socialization into mainstream psychology. Some Lacanian theorists, however, even granting the social and institutional contexts of science, are less enamoured of the wholesale critique of scientific knowledge by social constructivists, and they will appreciate Redding's effort to close the gap between empirical psychologists and critical theorists in law.

In his commentary on Pierre Legendre, Anton Schütz warned that scientific explanations bypass 'the law and [tend] to replace it', echoing Legendre's concern over the exclusion by science of the psychoanalytic notion of symbolic determinism.[97] Redding, just barely, eludes Legendre's criticism by confirming how the discourse of law at times bypasses the discourse of science and tends to replace it, thereby deluding the subjects of law. If and when the law is unscientific, that is no longer the fault of psychoanalytic theorists and practitioners. Freud, for decades, has been exiled from law, and the question is in what form he will return.

Because psychoanalytic theory is influential in critical social theory and cultural studies circles, critical legal scholarship will reflect that state of affairs – indeed, the future of psychoanalytic jurisprudence as a critique of legal processes and institutions is quite promising. On the other hand, there are continuing doubts as to the reputation of psychoanalytic theory in the courts of law and in the institutions of science, and as to whether the judgements in those fields even matter.

Notes

1 Tom Wolfe, 'Sorry, but your soul just died', *Forbes ASAP,* 2 Dec. 1996, p. 218.
2 Frederick Crews, 'The verdict on Freud' , *Psychological Science,* 7 (1996), pp. 63 and 66.
3 See Howard Shevrin, 'Is psychoanalysis one science, two sciences, or no science at all?', *Journal of American Psychoanalytic Association,* 43 (1995), p. 963.
4 Morris Eagle, 'From the President's Desk'. *Psychologist Psychoanalyst,* (spring 1996), p. 7.
5 Jean Laplanche, 'Psychoanalysis as anti-hermeneutics', *Radical Philosophy* (Sept./Oct. 1996), p.12.
6 See Jonathan Lear, 'The shrink is in', *The New Republic,* 25 Dec. 1995, pp. 18– 25; Eugene Goodheart, (1995) 'Eugene Goodheart Replies [to Frederick Crews]', *Dissent* (fall 1995), p. 531.
7 Alan A. Stone, 'Where will psychoanalysis survive?', *Harvard Magazine,* Jan./ Feb.1997), pp. 35–9 (distinguishing medical *treatment* from the therapeutic realm of dealing with ordinary human suffering).
8 John Horgan, 'Why Freud isn't dead', *Scientific American* (Dec. 1996), p. 106.
9 Franz Rudolf Bienenfeld, 'Prolegomena to a psychoanalysis of law and justice', *Calif. Law Review,* 53 (1965), Part I – p. 957. and Part II – p. 1254.
10 Joseph Goldstein, 'Psychoanalysis and jurisprudence', *Yale Law Journal,* 77 (1968), p. 1053.
11 A. Ehrenzweig, *Psychoanalytic Jurisprudence: On Ethics, Aesthetics, and Law – On Crime, Tort, and Procedure* (Leiden: Sijthoff, 1971).
12 C. G. Schoenfeld, *Psychoanalysis and the Law* (Springfield, Ill.: Thomas, 1973), p. 7 (psychoanalytic explanations 'are at best *partial*').
13 See Mark Satin, 'Law and psychology: a movement whose time has come', *Ann. Survey of Annotated L.* (1994), p. 581.
14 See *Cardozo L. Rev.,* 16 (1995), p. 699 (conference proceedings).
15 See 'Symposium: the wake of psychoanalysis', *Legal Studies Forum,* 20: 4 (1997).
16 Peter Goodrich, *Oedipus Lex: Psychoanalysis, History, Law* (Berkeley: Univ. of Calif. Press, 1995).
17 Peter Goodrich, *Law in the Courts of Love: Literature and other Minor Jurisprudences* (New York: Routledge, 1996).
18 Peter Goodrich (ed.), *Law and the Unconscious: A Legendre Reader* (London: Macmillan, 1997).
19 David Carlson and Peter Goodrich (eds), *Psychoanalysis and Jurisprudence: Essays in Law and the Postmodern Mind* (Ann Arbor: Univ. of Michigan Press, 1997).
20 Dragan Milovanovic, *Postmodern Law and Disorder* (Liverpool: Deborah Charles Publishers, 1992).
21 Jeanne Schroeder, *The Vestal and the Fasces: Psychoanalytical and Philosophical Perspective on the Feminine and Property* (Berkeley: Univ. of California Press, 1997).
22 David Caudill, *Lacan and the Subject of Law: Toward a Psychoanalytic Critical Legal Theory* (Atlantic Highlands, NJ: Humanities Press, 1997).

23 Costas Douzinas, 'Psychoanalysis becomes the law', *Legal Studies Forum*, 20: 4 (1997), p. 323.

24 Charles Rosen, 'The scandal of the classics', *New York Review of Books*, 9 May 1996, p. 27.

25 *S. Ct.*, 113 (1993), p. 2876.

26 Stephen Landsman, 'Of witches, madmen, and products liability: an historical survey of the use of expert testimony', *Beh. Sciences & the Law*, 13 (1995), p. 131.

27 See: Steven Goldberg, *Culture Clash: Law and Science in America* (New York: NYU Press, 1994), pp. 20–1.

28 *S. Ct.*, 115 (1995), p. 2371.

29 Kenneth Gergen, 'The mechanical self and the rhetoric of objectivity', in Allen Megill (ed.), *Rethinking Objectivity* (Durham, NC: Duke Univ. Press, 1994), p. 265.

30 *S. Ct.*, 113 (1995), p. 2800 (Rehnquist, J., dissenting).

31 Michael Finkelstein and Bruce Levin, [review of *Reference Guide on Statistics* (reference manual on scientific evidence)]: 'Non Lasciare Esperanza', *Jurimetrics Journal*, 36 (1996), pp. 201and 211.

32 See William Hornsby, Jr, and Kurt Schimmel. 'Regulating lawyer advertising: public images and the irresistible Aristotelian impulse', *Georgetown J. Leg. Ethics*, 9 (1996), pp. 325–58.

33 Bruno Latour, *Science in Action: How to Follow Scientists and Engineers through Society* (Cambridge, Mass.: Harvard Univ. Press, 1987), p. 186.

34 Eugene Goodheart, 'Freud on Trial', *Dissent* (spring 1995), pp. 236–43.

35 Frederick Crews, 'Freud's time has passed', *Dissent* (fall 1995), p. 530.

36 Goodheart, 'Freud on Trial', p. 531.

37 'Library reschedules Freud Exhibition for 1998', *American Psychoanalyst*, 30: 2 (1996), p. 2.

38 Ibid.

39 Eagle, op. cit. (n. 4), p.7.

40 See Shevrin, op. cit. (n. 3), p. 963.

41 Ibid. p. 964.

42 Ibid. p. 968.

43 Arnold Goldberg, 'Commentary', *J. Am. Psychoan. Assn*, 43 (1995), pp. 1001 and 1003.

44 William Grossman, 'Commentary', ibid. pp. 1004 and 1007.

45 Paul Meehl, 'Commentary', ibid. pp. 1015 and 1017.

46 Robert Michels, 'Commentary', ibid. pp. 1023 and 1025.

47 Lear, op. cit. 'The shrink is in'.

48 See Jane Flax, *Disputed Subjects: Essays on Psychoanalysis, Politics, and Philosophy* (New York: Routledge, 1993), p. 43.

49 Terry Eagleton, *Heathcliff and the Great Hunger: Studies in Irish Culture* (London: Verso, 1995), p. 142.

50 See Ellie Ragland-Sullivan, 'Stealing material: the materiality of language according to Freud and Lacan', in A. Leupin (ed.), *Lacan and the Human Sciences* (Lincoln: Univ. of Nebraska Press, 1991).

51 Jacques Lacan, 'The agency of the letter in the unconscious or reason since Freud', in *Écrits: A Selection* (New York: Norton, 1977), p. 148.

52 Richard Powers, *Galatea 2.2* (New York: Farrar Straus & Giroux, 1995), p. 204.
53 Jacques Lacan, 'The function and field of speech and language in psychoanalysis', in *Écrits*, p. 68.
54 Powers, op. cit., p. 56.
55 Ibid. p. 86.
56 Jacques Lacan. 'Aggressivity in psychoanalysis', in *Écrits*, p. 22.
57 Powers, op. cit., p. 169.
58 Jacques Lacan, 'The Mirror Stage as formative of the function of the I . . .', in *Écrits*, pp. 5–6.
59 Powers, op. cit., p. 218.
60 Krista Duncan, 'Lies, damned lies, and statistics?: psychological syndrome evidence in the courtroom after Daubert', *Ind. L. J.*, 71 (1996), pp. 753 and p. 757.
61 John Norris and Marlys Edward, 'Myths, hidden facts and common sense: expert opinion evidence and the assessment of credibility', *Crim. L. Q.*, 38 (1995), pp. 73 and 79.
62 Richard Redding, 'Socialization by the legal system: the scientific validity of a Lacanian socio-legal psychoanalysis', *Oregon L. Rev.*, 75 (1996), p. 781.
63 See D. McCloskey, 'The essential rhetoric of law, literature, and liberty', *Critical Rev.*, 5: 2 (1991), p. 217.
64 See Richard Redding, 'Children's competence to provide informed consent for mental health treatment', *Wash. & Lee L. Rev.*, 50 (1993), p. 695.
65 See Richard Redding, 'How common-sense psychology can inform law and public policy' (unpublished manuscript).
66 'Recovered memories of childhood sexual abuse: applying the Daubert standard in state courts', *S. Cal. L. Rev.*, 69 (1996), pp. 855 and 878.
67 Jacques Lacan, *The Seminar of Jacques Lacan, Book II: The Ego in Freud's Theory and in the Technique of Psychoanalysis* (1954–5), ed. J.-A. Miller, trans. S. Tomaselli (New York: Norton, 1991), p. 19.
68 Ibid.
69 Jacques Lacan, 'Science and Truth' (1965 lecture, trans by B. Fink), *Newsletter of the Freudian Field*, 3 (1989), pp. 17–18.
70 Ellie Ragland, 'Sexuality and science in *Television*', *Bien Dire*, 1 (1991), pp. 6–7.
71 Ellie Ragland et al., Editorial, *Newsletter of the Freudian Field*, 3: 1 (1989), p. 1.
72 Alexandre Leupin. 'Introduction: voids and knots in knowledge and truth', in A. Leupin, *Lacan and the Human Sciences*, p. 1.
73 Ibid. p. 2.
74 Ibid.
75 Ibid. p. 3.
76 Mikkel Borch-Jacobson, *Lacan: The Absolute Master*, trans. D. Brick (Stanford, Calif.: Stanford Univ. Press, 1991), p. 162.
77 Drucilla Cornell, 'Rethinking the beyond of the real', *Cardozo L. Rev.*, 16 (1995), pp. 729 and 780–6.
78 Tony Jackson, 'Nihilism, Relativism, and Literary Theory', *Sub-Stance*, 78 (1995), pp. 29 and 44.
79 Ibid. pp. 41–3.
80 Jacques Derrida, 'For the love of Lacan'. *Cardozo L. Rev.*, 16 (1995), pp. 699 and 713.

81 David Pettigrew and François Raffoul, Editors' Introduction, in *Disseminating Lacan* (Albany: SUNY Press, 1996), p. 2.

82 McCloskey, op. cit. (n. 63), p. 215.

83 *Social Text*, 46–7 (spring/summer 1996).

84 Paul Gross and Norman Levitt. (1994) *Higher superstition: the academic left and its quarrels with science*, (Baltimore: Johns Hopkins University Press, 1994).

85 'The legal and literary style of reasoning is already how scientists argue. The official descriptions and surface rhetoric of science obscure the fact, but fact it is' (McCloskey, op. cit., p. 219).

86 Catherine Wilson, 'Instruments and ideologies: the social construction of knowledge and its critics', *Am. Philos. Q.*, 33 (1996), pp. 167, 178–9.

87 Sheila Jasanoff, *Science at the Bar: Law, Science, and Technology in America* (Cambridge, Mass.: Harvard Univ. Press, 1995), pp. 6–7.

88 Ibid. pp. 13–16.

89 Tim Dean, 'Bodies that matter: rhetoric and sexuality', *Pre/Text*, 15 (1994), pp. 81 and 83.

90 Ibid. p. 84.

91 Ragland, op. cit. (n. 70), p. 7.

92 See, for example, Ellie Ragland-Sullivan, *Jacques Lacan and the Philosophy of Psychoanalysis* (Chicago: Univ. of Illinois Press, 1986), p. xvii: 'After Lacan, reality, rationality, and objectivity appear as comforting illusions . . . amid the truths of plurality, ambiguity, and uncertainty.'

93 See, for example William Kerrigan, 'Terminating Lacan', *S. Atl. Q.*, 88 (1989), pp. 993 and 1001–2.

94 See, for example, Jacques Lacan, *The Seminar of Jacques Lacan, Book III: The Psychoses* (1955–6) trans. Russell Grigg (New York: Norton, 1993).

95 Ibid. p. 296.

96 Ibid. p. 63.

97 Anton Schütz, 'Sons of writ, sons of wrath: Pierre Legendre's critique of rational law-giving', *Cardozo L. Rev.*, 16 (1995), pp. 979 and 997.

Index